Physics for Animators

Achieving believable motion in animation requires an understanding of physics that most of us missed out on in art school. Although animators often break the laws of physics for comedic or dramatic effect, you need to know which laws you're breaking in order to make it work. And while large studios might be able to spend a lot of time and money testing different approaches or hiring a physics consultant, smaller studios and independent animators have no such luxury. This book takes the mystery out of physics tasks like character motion, light and shadow placement, explosions, ocean movement, and outer space scenes, making it easy to apply realistic physics to your work.

- Physics concepts are explained in animator's terms, relating concepts specifically to animation movement and appearance.
- Complex mathematical concepts are broken down into clear steps you can follow to solve animation problems quickly and effectively.
- Bonus companion website at www.physicsforanimators.com offers additional resources, including examples in movies and games, links to resources, and tips on using physics in your work.

Uniting theory and practice, author Michele Bousquet teaches animators how to swiftly and efficiently create scientifically accurate scenes and fix problem spots, and how and when to break the laws of physics. Ideal for everything from classical 2D animation to advanced CG special effects, this book provides animators with solutions that are simple, quick, and powerful.

Michele Bousquet is a longtime animator and instructor, and the author of more than 20 books on computer animation. Her freelance animation work has served clients like Autodesk and the Australian Broadcasting Corporation, and she has taught university-level animation classes at countless locations, including several art institutes. After years of answering questions about physics from animation students, Michele took on the task of formulating the answers into this book. Michele holds a Bachelor's degree in Mathematics and Computer Science from McGill University.

Physics for Animators

Michele Bousquet
with Alejandro Garcia

CRC Press
Taylor & Francis Group
Boca Raton London New York

CRC Press is an imprint of the
Taylor & Francis Group, an **informa** business

A FOCAL PRESS BOOK

CRC Press
Taylor & Francis Group
6000 Broken Sound Parkway NW, Suite 300
Boca Raton, FL 33487-2742

Library of Congress Cataloging-in-Publication Data
A catalog record for this book has been requested.

ISBN: 978-0-415-84298-3 (hbk)
ISBN: 978-0-415-84297-6 (pbk)
ISBN: 978-0-203-75825-0 (ebk)

Typeset in Myriad
by Apex CoVantage, LLC

Visit the Taylor & Francis Web site at http://www.taylorandfrancis.com and the CRC Press Web site at http://www.crcpress.com

Printed and bound in the United States of America by Sheridan Books, Inc. (a Sheridan Group Company).

Contents

Acknowledgements

Many people assisted me in bringing this book to completion.

The person who gets the bulk of my thanks is Alejandro Garcia, who was with me every step of the way. Alejandro supplied not only the basis for much of the content via his videos, but also helped me work out the best way to accurately explain topics without getting confusing or overly technical.

I enlisted many other experts to help me with the specifics of physics as it pertains to animation. Jinyu Liu and Zifu Zhu, two Ph.D. candidates in Physics at Tulane University, looked over many of the topics in the book to review them for accuracy and understandability. Jinyu in particular got what we were going for, and eventually became a devotee of the concept of science-for-art.

A couple of other experts checked specific topics and gave some great input for making the text more accurate. Michael Roney, B.A. in Geography, a double major B.S. in Resource Conservation, and a Master of Science in Forestry from the University of Montana, looked over the Earth geology sections. Melissa E. Cheatwood, B.S. Soil, Atmospheric, and Environmental Science, University of Columbia, checked out the Environment sections and helped me gain a better understanding of the many and varied outcomes of weather phenomena. Tamil Periasamy, B.S. Aerospace Engineering with a focus on Fluid Dynamics, checked out the Liquid Effects chapter. A bonus of having these experts on board to answer my questions was that I can now determine a landscape's history just from looking at it, predict whether a storm is likely to produce lightning, and get ketchup out of a bottle much faster.

A number of animation professionals also looked at the book from the standpoint of usefulness for animators. Noted VFX animator Wayne Robson read through much of the text for accuracy, and John Howard contributed to and edited the Outer Space chapter. Longtime CG and VFX artist Kim Lee looked over various chapters, and in particular helped me explain Gamma Correction in a way that made sense. David Drew, a traditional artist and amateur geologist, contributed a significant portion of the Earth chapter and pointed me toward some important concepts, such as why an Earth mountain can be gray but not blue or green.

I'd also like to thank my editor at Focal Press, Haley Swan, for her unending patience with me. We went through some ups and downs getting this book to press, and I thank her for believing in me and giving me the chance to make this book as informative, accurate, and useful as possible to animators around the world.

Foreword

Why would animators need physics? This is a question I was asked many times over the course of the last few years, whenever I told a non-animator I was working on this book. But whenever I mentioned the book's title to an animator, or any kind of artist for that matter, I got smiles, laughs, and the occasional hug.

In formal studies of animation, such as university courses, science is often given short shrift. In the same way that students of nude drawing and sculpture are encouraged to study anatomy, animators, with the need to represent motion convincingly, should be well grounded in the basics of physics. However, university courses and physics books are aimed at future engineers and scientists—they include a lot of information that artists don't need, and leave out vital points that an artist does need.

When seeking the assistance of physics professionals for this book, I had to explain over and over that an animator wants to know *how it is going to look* and *how will it move*. Should it be blue or red, light or dark? Is it big or small, and what is its shape? Does it move fast or slow? Physicists aren't accustomed to thinking this way, and more than one asked why artists don't just read physics books to get what they need. But college-level books are heavy on equations and require knowledge of advanced mathematics, and science books aimed at middle school or high school don't address the questions most important to artists in a way they can easily understand.

I've taught computer graphics for over 20 years, and questions about physics have frequently come up from both traditional animators and visual effects artists creating photoreal animation. My degree is in Computer Science, and while I've taken a few university-level physics courses, I found that I couldn't answer all the students' questions. So I looked for a book on the subject, and there wasn't one. Realizing that such a book would be greatly useful to animators (including me), I decided to undertake the task of researching the answers to all the questions I've heard, plus a whole lot more. And here we are now.

Working on this book required sifting through volumes of information on the physics of common animation scenarios. Early on I enlisted the help of Alejandro Garcia, a longtime teacher of Animation Physics at San Jose State University, and both a Ph.D. in Physics and an accomplished artist. Alejandro is also a frequent consultant on physics for animated films at the big studios.

He has a series of videos for his students which he has made freely available at http://animationphysics.com. Alejandro graciously allowed me to use the information in his videos as the basis of the Character Design and Animation section of this book and many other chapters. He also read through the entire book and helped me explain many of the finer points of physics in a way that's both accurate and helpful to artists.

I'd love to hear from you at the book's website: http://www.physicsforanimators. com. On the website are some interesting physics tidbits that aren't in the book, as well as a way to tell me about your own experiences with physics in animation and even ask further questions.

I hope you find this book as useful as I intended it to be, and that you're able to use your newfound knowledge to create more convincing animation and keep your audience engaged in your story.

Michele Bousquet

Introduction

Animation is inherently fake. It's not real actors on real sets—it's entirely out of someone's pen, or more commonly these days, from a computer.

In the early days of animation, Disney animators asked themselves an important question: "How do we convey the essence of this character/motion without having to portray every single detail?" A simpler way to ask this question is, "How do we fake this?"

While it's not too hard to copy a drawing of Bambi, the adorable deer that stars in the animated film of the same name, arriving at that particular representation of a young deer took Disney character designers weeks of studying live deer to arrive at a simple, appealing representation. Effects like water and fire weren't practical to animate with complete detail, as each drawing would take far too long to complete. Conveying these effects convincingly while keeping drawing times reasonable was a big challenge for early animators. Artists who specialized in these effects studied them endlessly in real life, and learned the science behind them.

Nowadays we have software to help with the science and produce renderings, but no software can do all the work for you. Like animators before you, you'll need to understand what goes on in real life so you can make decisions about how to convey motion and effects in your work.

Animation, Physics, and Suspension of Disbelief

The representation of any story, be it through live theater, film, animation, or even a grisly tale told around a campfire, succeeds only because of the audience's willingness to ignore the fact that it's just a story. Have you ever cried at the end of a movie, or perhaps were moved by an actor's performance to the point where you thought about it for days? You are aware, in your logical mind, that the emotional scene you were watching was fake, and that out of view there was probably some sound technician yawning and thinking about what he was going to serve his kid for dinner. But you got so involved in the story that you forgot all that for a period of time.

Tom Hanks and Tim Allen, the voices of Woody and Buzz in Pixar's *Toy Story* films, both wept while watching the scene in *Toy Story II* where the Jessie doll gets left in a donation bin. They were involved in its production, and still they cried! That is suspension of disbelief at its finest.

This *suspension of disbelief* is what every storyteller strives for. The viewer forgets for a time that it's only a story. It's what keeps you glued to the screen to see what happens next. It's what makes you say, "Wow, that was great!"

Action films in particular walk a very broad line between reality and fiction while still maintaining suspension of belief. The hero gets in a gunfight in a public place, and somehow manages to avoid all the unpleasant repercussions (injured civilians, lawsuits, police investigation, etc.) that would ensue in reality. And a few laws of physics are violated when the bad guy, when hit by a bullet, is projected backward and off a rooftop. But if the gunfight looks real enough, we get caught up in the action and respond emotionally when the hero finally gets the bad guy.

To keep suspension of disbelief going, the artist has to avoid introducing too many elements that will distract viewers and remind them that it's just a story. You have probably been at the receiving end of this type of distraction a few times. The scene is supposed to be happening at night, but it kind of looks like it's daytime. The giant boulder is falling and everyone is terrified, but when it finally lands it looks like a sponge. The character is supposed to be struggling to carry a heavy box, but the box somehow doesn't seem very heavy. You were enjoying the story until you got distracted by these errors. Too many errors, and you lose interest.

Slapstick comedy doesn't strive for suspension of disbelief in the same way, but even a comedic story with unbelievable action needs motion that's recognizable for what it's supposed to be. The animated Road Runner series is a great example of this. Wile E. Coyote's inventions disobey the laws of physics on a regular basis, but there's still enough real physics for you to understand what's happening.

At first glance, a science like physics might not seem like a natural partner for the emotional concept of suspension of disbelief. However, the two have been walking hand in hand since the early days of filmmaking. "How do I make this convincing?" is a question asked by the first directors of dramatic stories, whether live action or animation. As audiences become more sophisticated and new software tools are introduced, the bar for faking reality continues to inch up.

With a firm grasp of physics for animation, you'll be in a good position to make your scenes convincing enough to keep your audience interested and achieve suspension of disbelief.

About *Physics for Animators*

This book contains physics concepts for animators. It is not tutorial based or software specific. It's designed for animators who work with traditional media, computer graphics, or both. Principles of physics are universal in that they can be applied to cartoon-style drawings as well as photoreal CG renderings. Where the occasional concept or technique is specific to

traditional or CG animation, it is denoted as such. However, by and large the concepts in this book can be applied to any animation regardless of style.

Both beginners and advanced animators will find information they can use to improve their work. The concepts described here can be used to animate in any media from hand-drawn flipbooks to games to movie-resolution photoreal backdrops and scene enhancement.

HOW TO USE THIS BOOK

This book is divided into three sections:

Section 1—Classical Physics includes the laws and rules about things we observe and experience every day like gravity and color. Much of classical physics was developed by familiar names like Galileo and Newton before we had a means for looking at objects at the atomic level. In this book, the Classical Physics section covers the building blocks for later topics, such as Newton's Laws of Motion and basic atomic theory.

Section 2—Character Design and Animation looks at the physics of character scale and balance, and common character motion like jumping and fighting. Many of these topics are covered in great detail in other animation texts, but strictly from a visual standpoint. When a character's motion or balance is a bit off in a way that's hard to pinpoint, the culprit is often a law of physics that's been violated. This section is designed to complement visual texts by helping you make informed decisions about character design and animation, and thus keep your audience focused on the story rather than distracting them with bad physics.

Section 3—Visual Effects covers common VFX needs like animated weather and oceans, explosions, drawn or generated landscapes, and trips through outer space. You, like visual effects artists before you, can certainly take liberties with reality; we are all accustomed to seeing movies and games where the weather, explosions, or space scenes are technically unrealistic but still compelling. The key to such scenes is to have enough real physics to make it convincing, and make the story and visuals interesting enough that your audience will happily ignore any departures from reality. Understanding the physics behind these phenomena will not only help you figure out how to animate them, but also where to draw the line between reality and fantasy to keep your audience engaged.

If you have some knowledge of physics and you're interested in animating a specific type of scene, you can skip right to the topic in Section 2 or 3. In these sections, if a topic requires particular concepts from Section 1, these topics are outlined at the start of the section or chapter.

If your knowledge of science is limited, you should start with Section 1 and work your way through those topics first. Along the way, you'll probably

figure out some ways you can apply them to your animation work immediately. Then move on to the topics of specific interest in Sections 2 and 3.

WEBSITE

This book is not software specific and does not use tutorial files. However, you can find lots of great information at our companion website: http://www.physicsforanimators.com

On the website, you'll find:

- Examples of physics in movies and games, and discussions of what's wrong and what's right
- Links to helpful sites with gravity calculators, images and videos, easy-to-understand physics explanations, and everyday physics studies
- Useful physics tidbits that aren't in the book.

You can also ask a question about physics in animation, and we'll answer it on the blog if we can. We're also interested in hearing about how you applied the concepts in this book, and will feature selected submissions in our blog.

Stay Focused and Carry On

Two physicists and a ditchdigger walk into a busy bar, order some beers, and sit together at a table. The first physicist sees a waitress coming toward them, holding a large tray with several glass mugs of beer above her head. He exclaims, "Look at her, balancing that tray! What an excellent example of balanced forces."

The second physicist shakes his head as the waitress reaches their table. "Her muscle strength is insufficient. She can't counter the downward force from the weight of the beers, so the forces are unbalanced. Look, she's lowering the tray now! That proves it."

While the two argue, the ditchdigger is busy taking beers off the tray and drinking them. By the time the physicists are done with their argument, all the beer is gone.

This silly joke illustrates an important point about physics, and about science in general. There are often several ways to look how things work, leading to various formulas or diagrams or theories about what's going on. But if you spend too much time getting mired down in technical details, you'll miss the party.

Go with the simplest and most direct approach, the one that will get you the best animation with the least amount of work. In this book we strive to do just that, but you might find even simpler ways to work with physics in your animation's motion and timing. Does your animation convey the story, and does it engage your audience without distracting them with bad physics? These are the important questions.

Classical Physics

In this section, we'll go over basic physics concepts that apply to animation. Any motion in animation generally calls upon more than one physics concept at a time. But in order to use these concepts in concert with one another, you'll need to understand the individual concepts and the terminology that goes with each one. If there are previously discussed topics that pertain directly to the subject, these are listed at the start of the section. This will enable you to review any topics necessary before you dive in.

Some concepts relate directly to the "Twelve Basic Principles of Animation" put forth by Disney animators Ollie Johnston and Frank Thomas in their 1981 book *The Illusion of Life: Disney Animation*. These relationships will be noted as they come up.

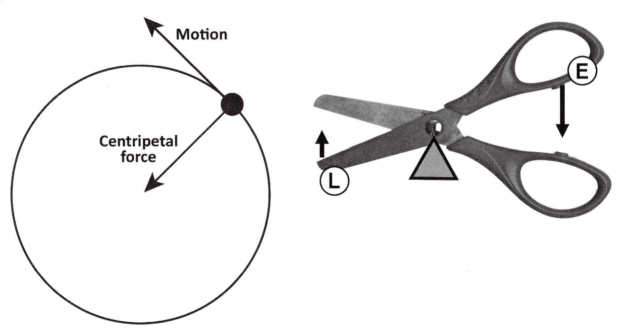

Matter and Masses

Matter is a loose scientific term that refers to an object or substance. Anything you can see or touch is considered matter. How the substance behaves is determined, to a large degree, by the type of matter.

In plain English, the term *mass* means a blob or hunk of something, as in "A giant mass fell from the sky and hit the shed." In physics, the term *mass* has a different meaning.

In this chapter, we explore matter and masses. Understanding these terms and how they relate to physics will help you understand later chapters.

Matter

There are, for the purposes of animation, three types of matter:

Solids—Anything that holds together on its own to form a particular mass or shape. Bowling balls, ice, and skin are all considered solids. Solids always retain the same volume, and don't change shape unless a force is applied to them.

Solids.

Liquids—A substance that takes the shape of its container, changes shape easily, and flows when moving. Liquids generally retain the same volume regardless of the container. Water, syrup, melted chocolate, and lava are all considered liquids.

Liquids.

Gases—A substance that expands and spreads out to take the shape of its container and fill it up as much as possible, and changes volume as the container changes volume. Examples of gases are steam, oxygen, air, and propane gas.

Gases.

COMPOSITION OF MATTER

Physics tells us that all matter, whether solid, liquid, or gas, is made up of basic units called *atoms*. An atom is, theoretically, a tiny blob of matter surrounded by other blobs of matter that float around it. All the blobs have a sort of electrical charge associated with them that binds them together and keeps them from flying apart.

Because atoms are so tiny, we can't see them the way we normally see objects, where light reflects off the object and into our eyes. Only recently have we found ways to "see" atoms by using electric current to detect their movement patterns.

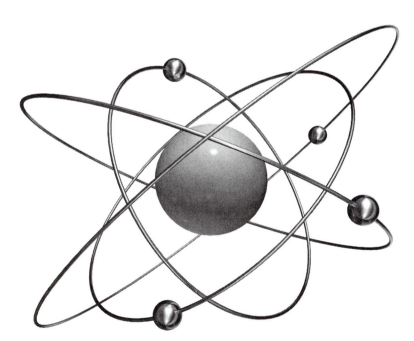

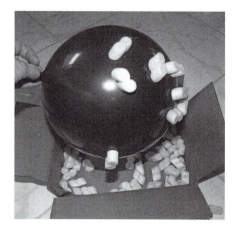

To start off understanding atoms, you can think of an atom as a balloon with foam packing peanuts stuck to it. If you rub a balloon on your clothes, you cause a little bit of electrical charge to form on the balloon. If you move the balloon near some packing peanuts, the peanuts will lightly stick to the balloon due to electrical attraction.

Each basic element on Earth has a unique blob configuration. Hydrogen, for example, has just one inner and outer blob. Oxygen has eight inner and outer blobs.

No one really understands *why* electrical attraction works the way it does. We only know that it works. While the quantum physicists are hard at work trying to figure this out, no one knows for sure. But electrical attraction explains a bunch of other stuff that scientists study, so they roll with it.

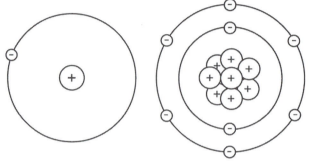

Configuration of hydrogen (left) and oxygen (right).

All substances are made up of different combinations of atoms. When the atoms get close together they share their outer blobs, which binds them together. For example, if you throw together one oxygen atom and two hydrogen atoms, you get pure liquid water, or H_2O.

When two or more atoms join together in a stable state, this is called a *molecule*. Two hydrogen *atoms* combine with an oxygen *atom* to form a water *molecule*.

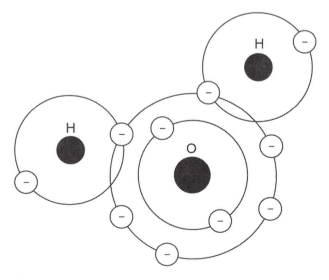

H_2 means two hydrogen atoms, single O means one oxygen.

Now for some terminology. In an atom, the central blob is called a *nucleus*. The blobs floating around it are negatively charged *electrons*. The nucleus contains of a bunch of positively charged blobs called *protons*, which attract the negatively charged electrons. The nucleus also contains *neutrons*, which have no charge at all, but which work as a sort of atomic glue to keep the protons stuck to the nucleus.

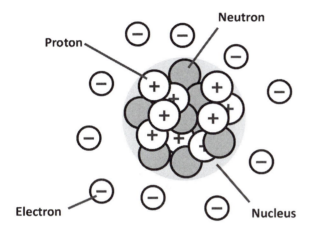

It's not vital to memorize these terms, as long as you have an overall understanding of this most basic level of matter (and you know which page in this book to come back to should you need to refresh your memory). Electrons in particular are at the root of a lot of visually interesting phenomena like lightning and electricity. In this book, we go over electrons' roles in more detail in pertinent chapters.

Atoms and Binding

Atoms like to have their electrons arranged a certain way. In the innermost ring around the nucleus, they like to have two electrons. More electrons after that are arranged in another ring or shell outside the first, with at most eight electrons. The third level has at most eight electrons. Any levels outside that like to have at most 18 electrons.

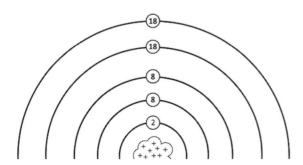

The Periodic Table of Elements organizes the elements in our universe according to how many protons each one has, and how many shells it has.

Most atoms are neutral, meaning they have the same number of protons as electrons. The number of neutrons can vary in neutral atoms, and is not always the same as the number of protons.

1 H																	2 He
3 Li	4 Be											5 B	6 C	7 N	8 O	9 F	10 Ne
11 Na	12 Mg											13 Al	14 Si	15 P	16 S	17 Cl	18 Ar
19 K	20 Ca	21 Sc	22 Ti	23 V	24 Cr	25 Mn	26 Fe	27 Co	28 Ni	29 Cu	30 Zn	31 Ga	32 Ge	33 As	34 Se	35 Br	36 Kr
37 Rb	38 Sr	39 Y	40 Zr	41 Nb	42 Mo	43 Tc	44 Ru	45 Rh	46 Pd	47 Ag	48 Cd	49 In	50 Sn	51 Sb	52 Te	53 I	54 Xe
55 Cs	56 Ba	*	72 Hf	73 Ta	74 W	75 Re	76 Os	77 Ir	78 Pt	79 Au	80 Hg	81 Tl	82 Pb	83 Bi	84 Po	85 At	86 Rn
87 Fr	88 Ra	**	104 Rf	105 Db	106 Sg	107 Bh	108 Hs	109 Mt	110 Ds	111 Rg	112 Cn	113 Uut	114 Fl	115 Uup	116 Lv	117 Uus	118 Uuo

*	57 La	58 Ce	59 Pr	60 Nd	61 Pm	62 Sm	63 Eu	64 Gd	65 Tb	66 Dy	67 Ho	68 Er	69 Tm	70 Yb	71 Lu
**	89 Ac	90 Th	91 Pa	92 U	93 Np	94 Pu	95 Am	96 Cm	97 Bk	98 Cf	99 Es	100 Fm	101 Md	102 No	103 Lr

Periodic Table of Elements.

If an atom's outermost shell isn't filled with the number of electrons it likes to have, it likes to find other atoms and hook up with them in such a way that the shell gets filled. This is why hydrogen, with its single electron, is reactive all by itself; it desperately wants another electron to fill its outer shell to capacity with two electrons. So two hydrogen atoms will often hang out together and share their single electrons, giving them each the feeling of being complete.

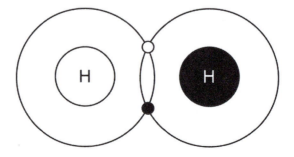

Two hydrogen atoms, each sharing an electron, makes H_2.

Atoms also like to have the same number of electrons as protons, but this isn't always the case. When the number of electrons no longer matches the number of protons, such an atom is called an *ion*. Ions are inherently reactive and are always looking for a fix to become less reactive.

In short, atoms are always looking to stabilize themselves by filling their shells with electrons. This quest accounts for much that happens structurally in our universe.

Nuclear Fusion

You might wonder why the two hydrogen atoms hanging out together don't just spontaneously become helium, the next element on the Periodic Table of Elements, which has two protons and two electrons. But such a reaction isn't likely to happen on its own. Sharing electrons requires very little energy, so atoms do it all the time. However, rearranging protons and neutrons requires a huge amount of heat or pressure.

The most common form of hydrogen actually doesn't even have a neutron, and helium has two neutrons. To turn into helium, first the hydrogen has to acquire a neutron from somewhere, which takes energy. Then there's the process of fusing everything together, which takes more energy. Hydrogen atoms either need to be shoved together very hard or heated to high temperatures to shake things up enough to regroup into a single nucleus with two protons and two neutrons (helium).

But if two hydrogen atoms do finally make it into becoming helium, the fact that they are now in a cozy, non-reactive state causes the atoms to release all that pent-up energy that they had been using to hold things together before. The energy release can be quite enormous. This process, called *nuclear fusion*, is the basis for the formation of stars in the galaxy (and nuclear bombs).

An element whose outermost shell is not completely filled, meaning it is constantly seeking other atoms to hook up with and complete its shell, is called *reactive.* An atom whose outermost shell is filled is called *non-reactive*. The elements down the right side of the Periodic Table have full shells, making them non-reactive.

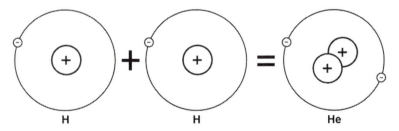

| H | H | He |

Two hydrogen atoms jam together to become helium.

You can learn more about atomic fusion and its role in the formation of the universe in the Outer Space chapter.

That's atomic theory in a nutshell, and about all you need to know about atoms to use physics in your animation. You'll need this general understanding of atoms, electrons, and elements when you read the Electricity and Magnetism section of the Forces chapter, and the chapters Environment and Earth and Outer Space.

Masses

The more an object weighs, the more force it takes to lift it, regardless of its size or what it's made of. It takes more force to lift a pool ball than a beach ball because the pool ball weighs more. In physics, we could also say that the pool ball has more *mass*. In physics, mass is the measurement of a solid object's resistance to force, which has to do with how densely its atoms are packed within its size.

MASS VS. WEIGHT

In physics, weight isn't the same as mass. When you get on an ordinary bathroom scale, it shows you a number that you consider to be your weight. If the scale is in kilograms then the number is actually an *estimate* of your mass based on weight, which the scale calculates from the force you exert on the scale at that moment.

To illustrate the difference between mass and weight, consider what happens if you jump up and down on the scale. When you land on the scale at the end of the jump, after acceleration due to gravity has given your body a little bit of falling speed, your body exerts more force than it does when you're standing still, causing the scale to register a higher number. If you stand on the scale in an elevator accelerating upward, the scale would also register a higher number. Conversely, in an environment with lower gravity, such as the moon's surface, the scale would register a lower number. In a zero-gravity space capsule, the number would register as zero (provided you could get on a scale at all in a zero-gravity environment, but that's beside the point). In each of these scenarios, the registered weight is different even though the body mass hasn't changed.

We are accustomed to measuring weight in kilograms or pounds, but technically, *kilograms* is a unit of mass and *pounds* is a unit of force. In physics, mass is measured in kilograms while weight is measured in different units that take gravity into account. In other words, it is technically incorrect to say "I weigh 75 kg" because weight is not measured in kilograms. But after a lifetime of talking about how much things weigh, we don't expect you to start saying *mass* instead of *weight* when you talk about how heavy or light an object or character is.

Under everyday conditions on Earth, where gravity is the pretty much the same everywhere, the terms *weight* (as measured in kilograms or pounds, when an object is sitting still on a scale) and *mass* can be considered synonymous.

WEIGHT is interchangeable with MASS
(for most practical purposes)

WEIGHT = MASS * ACCELERATION of GRAVITY
(in physics)

Because *mass* and *weight* imply the same thing almost all the time, we're going to keep things simple. In this book, we use the term *weight* whenever possible to discuss heaviness or lightness of mass, as this is the most familiar

term in everyday language. However, some physics terms themselves include the word *mass*, so we use that term when appropriate. There are also some physics formulas that require you to think in terms of mass rather than weight, and we discuss these as they come up. But in general, unless otherwise noted, *mass* and *weight* are used interchangeably in this book.

CENTER OF MASS

The *center of mass* is the average position of an object's weight distribution. For simple, uniform objects, the center of mass is located at the geometric center. The center of mass can also be located outside an object.

The terms *center of mass* and *center of gravity* are interchangeable except when talking about large masses in space, such as planets.

The center of mass, or center of gravity, is a key concept in working with balance and gravity in characters and objects. You'll learn more about this concept in the Weight Distribution section of the Character Design chapter, and the Center of Gravity section of the Forces chapter.

Motion and Timing

When animating a scene, there are several types of motion to consider. These are the most common types of motion:

- Linear
- Parabolic
- Circular
- Wave

Motion and timing go hand in hand in animation.

Motion Lines and Paths

Individual drawings or poses have a line of action, which indicates the visual flow of action at that single image. Motion has a path of action, which indicates the path along which the object or character moves.

Line of action.

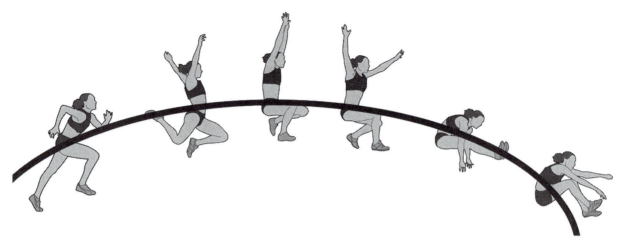

Path of action.

In physics, an object's path of action is called its *trajectory*.

The path of action refers to the object's motion in *space*. While it can help show timing, its primary function is to see the direction and path of the motion, and not necessarily its timing.

Your software's motion graph shows the object's motion in *time*. The path of action and the motion graph can look very different.

Path of action and motion graph.

Linear Motion

Linear motion refers to motion in a straight line, always in the same direction. A heavy ball rolling on a table is an example of linear motion.

Uniform motion is a type of linear motion with constant speed and no acceleration or deceleration. The distance the object moves between frames is the same over a period of time. The longer the distance between frames, the higher the speed.

If the object is moving toward or away from the camera, it can appear to be moving faster or slower even if it's moving uniformly.

Linear motion.

Faster linear motion.

Newton's First Law tells us that an object in motion will keep doing what it's doing unless a force comes along to affect it. In this way, linear motion is the default state of all moving objects in the universe. When considering how objects in your animation will move, you can consider that linear motion is *what the object will do unless something makes it do something else*. This consideration will help you visualize motion and timing due to forces such as changed timing due to gravity, or circular motion due to forces acting on the object.

Circular Motion

In life, objects and people never move in a perfectly straight line. If they did, how boring life would be! Circular motion and its components can add a lot of zing to your animation.

TYPES OF CIRCULAR MOTION

Circular motion, by nature, has to do with a circle. One form of circular motion is rotation, where an object simply spins around an axis.

An object moving along a circular path gives us another form of circular motion. The forces involved in this type of motion are more complex (and more interesting, especially from an animation point of view) and are discussed at length in this chapter.

When a person or object moves in an arc, this is also circular motion. In this case, the person or object is simply moving along a very small part of a large circle. A batter swinging a baseball bat moves with circular motion.

Other types of circular motion are wobbling and tumbling, which are explored later in this chapter.

For the purposes of looking at how these different types of motion work, we separate rotation (spinning) from moving around the edge of a circle, and

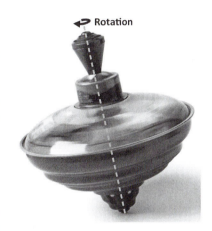

Rotation

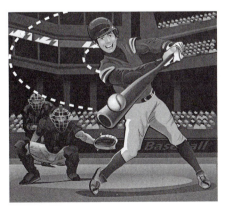

Arcs are one of the Twelve Principles of Animation.

from other types of motion like linear movement. Rotation, or spinning, can be looked at as "turning around on a stationary axis", but in reality nothing really stays put while rotating—as the top spins it moves around the surface it's spinning on, taking the center axis along with it; a rotating wheel on a car moves forward linearly as the car drives along; and so on. But if we're going to make useful decisions about circular motion in animation, we can't consider these motions all at once. When figuring out the forces and motion for movement on a circular path, it helps to consider these separately from all the other types of motion, even if the object (like a car's wheel) is also moving on a linear path at the same time.

ROTATIONAL MOTION

Rotational motion is probably the most familiar type of circular motion. CG software usually includes tools for animating a rotating object, making it easy to animate spinning wheels and tops.

Here, we'll explore some of the finer points of rotational motion, and discuss how to figure out how many rotations an object should have.

Rotation and Distance

When trying to figure out how much an object should rotate, you'll sometimes need to know the distance the outer edge of the object travels as it rotates. To learn the distance, you will need to calculate the distance around the circle that defines the motion.

The distance around a circle is called its *circumference*, which can be calculated with a simple formula:

$$C = 2\pi R$$

Where C is the circumference, π is pi or roughly 3.14, and R is the radius of the circle. The diameter of a circle is 2 times the radius, so you can also use the calculation C = pi times diameter.

LIFE OF PI

Early mathematicians wanted to figure out how to relate circles to squares in order to make calculations with circles easier. So they took a square and laid its edges out flat, and then wrapped them around a circle with the same diameter as a single square edge.

They found that you need just over three of these edges to form the circle. This is true no matter the size of the square and circle, so long as the circle's diameter equals one side of the square.

The exact number of edges is actually 3.14159265358979323846264338332 795. . . with decimal places that go on infinitely. This number is too long to be useful, and you can get by just fine using 3.14. We call this number pi, usually represented by the Greek letter pi (π).

Calculating the Number of Times a Wheel Turns

Suppose you're working on an animation sequence that includes a car moving at a steady speed. You know the radius of the wheels and the distance the car travels. How many times should you spin the wheels over the course of the sequence?

To figure this out, let's first figure out how far one rotation of the tire goes. Pretend that the tire has just gotten a coat of red paint. When we move the car forward just enough to make the wheel rotate exactly one time, the tire leaves a streak of red paint on the road. How long is the streak? The length of the streak is equal to exactly the wheel's circumference.

To find out how many times the wheel would turn, you just have to divide the total distance the car travels by the circumference (length of one wheel turn).

Number of Turns = Total Distance/Circumference

You know what pi (π) is, you know the radius R, so you can always calculate the circumference by multiplying it all together.

Let's try out this formula with an example. You have a car with wheels of radius 0.25m. If the car travels 24m at a steady speed, how many times do the wheels turn?

Calculate circumference (one turn of the wheel):

$$C = 2\pi R$$

C = 2 * pi * 0.25m

C = 1.6m = One Turn of the Wheel

Calculate number of turns:

Number of Turns = Total Distance/Circumference

24/1.6 = 15 turns

In mathematical notation, you don't use an x or * to indicate multiplication. You just jam it all together, one number after the other. So **2πR** means **2** times **pi** times **R**. You might also see it with dots in between, like **2 ● π ● R**.

Spinning, Tumbling, and Wobbling

Objects can rotate around one or more axes as they fall or fly through the air. These axes always pass through the object's center of gravity. There are three distinct types of motion related to turning around axes: spinning, tumbling, and wobbling.

Spinning—Turning around an axis that doesn't change direction. A hammer, when thrown, spins around an unchanging axis throughout its flight. In the image shown, the spin axis points straight out from this page on each frame.

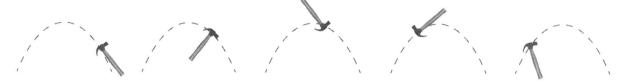

Spinning.

Wobbling—A slight effect from another axis while spinning around a single axis. Footballs often wobble when thrown.

Tumbling—Rotating with an axis of rotation that's constantly changing direction. A falling brick can turn by a complicated motion where the brick's center of gravity follows the same path of any falling object, but where the axis of rotation is constantly changing. Tumbling is not cyclic, and there's no simple way to describe the motion.

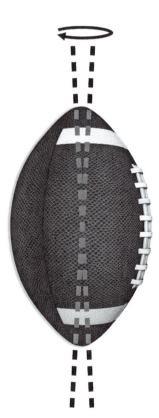

Wobbling.

Tumbling.

Tennis Racquet Theorem

If you take any object and imagine three perpendicular axes going through its center of gravity, you can make predictions about whether the object will spin, wobble, or tumble when thrown in the air. This is called the Tennis Racquet Theorem because it most commonly uses a tennis racquet to explain how it works.

With the Tennis Racquet Theorem, each axis has different properties, and different parts of the racquet behave differently depending on which axis they lie upon. On the tennis racquet, the axis that runs vertically down through the racquet's face and handle is called the *long axis*. This is the axis that is closest to the most of the object's mass. In objects where the mass is distributed more or less evenly throughout the object, the long axis runs through the longest part of the object.

The axis that runs from the front to back is the *short axis*. Here, there's no other straight line through the center of gravity for which the averaged mass is farther away—a tennis racquet is very narrow at this point, less than an inch wide, and has little or no mass near that point.

Once the long and short axes are determined, the axis that's perpendicular to both of them is the *intermediate axis*.

Axes and Rotational Inertia

Inertia, in general, is resistance to motion, while rotational inertia is specifically resistance to turning. This topic is covered in more detail in the Torque chapter, but to understand spinning, tumbling, and wobbling, we need to talk about it a little bit here.

Rotational inertia increases by squares as the distance from the turning axis increases. This means that distance from an axis plays a big part in rotational inertia. The farther a point on an object is from an axis, the more rotational inertia it will have. For instance, doubling the distance increases the inertia by a factor of four.

Back to the tennis racquet. The long axis is, by definition, the axis that is closest to most of the object's mass. This means the distance to the axis is less than for other axes, giving this axis a lower rotational inertia than other axes. This makes it easier to start the racquet spinning around the long axis than around others. It also means that when spinning on this axis, due to the low rotational inertia, it's easier for the racquet to just keep on spinning about that axis.

The short axis has a higher rotational inertia than the other axes, making it hard to start spinning the racquet around that axis. However, once it starts, the rotational inertia of this axis resists change, and thus is not prone to tumbling.

Because the rotational inertia of the intermediate axis is between the other two, along this axis the racquet doesn't strongly resist spinning, but neither

A *theorem* is a math or physics theory that seems true based on observation, and which no one has ever disproved. A theorem might one day grow up and join other theorems to form a *law*, a generalized statement about many theorems and observations that have not been disproved for a long period of time. For the purposes of animation, you can consider theorems to be as true as laws.

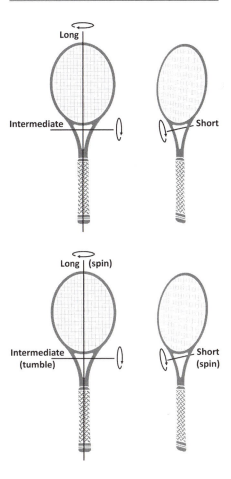

Rotational inertia is covered in more detail in the Torque chapter.

does it tend to keep spinning once it starts. Around this axis, the motion can be quite random. Any spinning around this axis is unstable, and will eventually turn into tumbling.

If you throw a symmetric object with a spin, it won't tumble but will wobble. The more the object spins, the more it will wobble.

JUGGLING

Jugglers use the Tennis Racquet Theorem when choosing what to juggle and how to spin it.

Juggling balls are spherical, so all axes are the same and there is no axis better than another for spinning. Juggling pins are cylindrical in shape, which means the short and intermediate axes are the same. In effect, juggling pins have a long axis, two stable short axes, and no unstable intermediate axis. The pins are weighted at one end so the center of gravity is closer to the end of the pin.

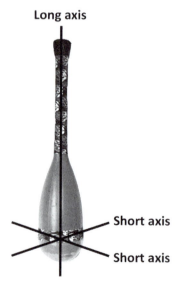

Spinning on the short axis makes an object spin relatively slowly and evenly. With the entire end of the pin consisting of short axes, a juggler can throw a pin with a controlled spin and predict where the pin's handle will land during the catch.

CENTRIPETAL MOTION
Newton's First Law (the Law of Inertia), as discussed in the Linear Motion chapter, tells us that unless a force acts on a moving object it will keep

traveling in a straight line. This means that in order to have circular motion, forces need to be continually acting on the object to keep it moving around in a circle.

Circular motion is achieved by applying force in a direction perpendicular to the linear motion, toward the center of the circle.

An unbalanced force toward the center of the circle that causes circular motion is called a *centripetal force*. Faster motion around a circle of the same radius would require a proportionally greater centripetal force. To keep the same speed around a circle with a smaller radius would also require a greater centripetal force.

When considering this rule, think of the forces you use to spin a ball on the end of a string. To keep the ball moving in a circle, you have to continually pull the string toward the center of the circle.

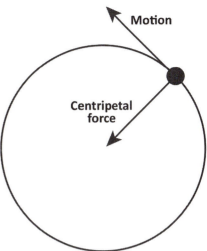

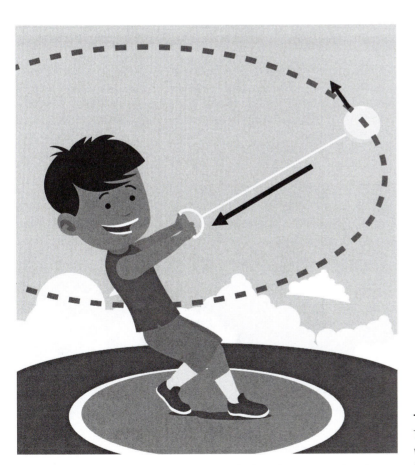

The arrow pointing toward the boy represents the force being exerted on the string to make the ball move along a circular path.

The term *centripetal* comes from the Latin words *centrum* (center) and *petere* (to seek).

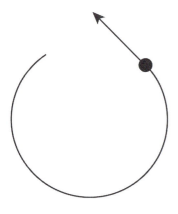

Properties of liquids and how they affect liquid movement are covered in more detail in the Liquid Effects chapter.

When Centripetal Force Stops

When an object is no longer being pulled toward the center, it is once again free of unbalanced forces and will move with linear motion again. For example, if you are swinging a ball on a string above your head and the string breaks, the ball will fly off in a straight line.

A common misconception is that the ball will fly off on a curved path. Even though this motion is not technically accurate, the idea is common enough that you might be able to animate a scene in this way without jarring your viewers.

On the other hand, if you are swinging a ball on a string in front of you in a circle that goes around from your head to your toes, and you release the string while the ball is near the top of the arc, it will travel in a curved path because of gravity acting on the released ball.

When a solid object is rotating, its mass is subject to centripetal forces. The outsides of the object are held to the center by molecular adhesion, nails and screws, nuts and bolts, glue, or whatever it is that makes the object move as one piece. If a piece of a solid object comes loose while the object is rotating, the loose piece is subject to the same rules of centripetal force—it will go flying off in a linear path.

This is the principle behind a wet dog shaking water off its head, which rotates back and forth at a rate of about five shakes per second. Before the dog shakes, water droplets are held to a dog's fur by a not-so-strong molecular bond. When the dog shakes its head back and forth in an arc, the motion is enough to break the bond. The loose droplets, being no longer attached to the dog's fur, are flung off on linear paths.

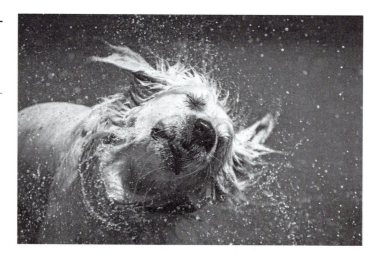

Circular Speed

Speed around a circle is expressed the same way linear speed is expressed: in distance per time. For example, a race car traveling at 100mph around a

circular track still goes 100 miles in an hour, even though the distance traveled is around a circle.

Such speeds are easy enough to calculate if you know the radius of the track and how long it takes to make one lap. Suppose the track has a radius of 0.15 miles and it takes the car one minute to make a lap. You can use the circumference formula to calculate the length of the track.

$$\text{Circumference} = 2\pi R = 2 * 3.14 * 0.15\text{mi} = 1\text{mi}$$

Since it takes the car one minute to travel the 1-mile track, the car's speed is 1 mile per minute, or 60 miles per hour.

You can also use this formula to calculate the speed of an object that's being flung off a rotating object. When an object is released from centripetal force and goes off in a straight line, it travels at the same speed at which it was traveling when it was released.

Radius, Speed, and Centripetal Force

When two objects are traveling side by side on the same circular path, they will experience different speeds and/or centripetal forces.

Suppose there are two cars going around a track. If both cars drive with the same turning radius but one goes faster than the other, the faster car is under a greater centripetal force.

If both cars move at the same speed but one is heavier than the other, the heavier car will be under a greater centripetal force.

Comparing Centripetal Forces

Suppose two similar cars are traveling at different speeds on different-sized tracks. Which one is under more centripetal force? With the formula for centripetal force, you can predict which of two cars will experience the most of this force.

The formula for centripetal force is:

$$\text{Centripetal force} = m(v^2/r)$$

With m as mass, v as velocity (speed), and r as the turning radius.

From this formula you can see that as you increase speed, the centripetal force increases. As you increase radius, the centripetal force decreases. Because the velocity is squared in the equation, differences in speed influence differences in centripetal force much more than differences in radius do.

You can use this formula to predict whether one centripetal force will be greater than another. Back on the race track, suppose both cars are moving at the same speed, and the outside track has twice the radius of the inside track. By looking at the formula, we can see the reduced radius reduces the centripetal force on the outside car to half the force on the inside car.

But if the two cars stay together all the way around the track, the outside car will be traveling at twice the velocity of the inside car. By looking at the formula, we can see that the centripetal force increases by squares when the velocity

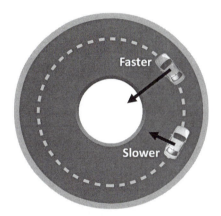

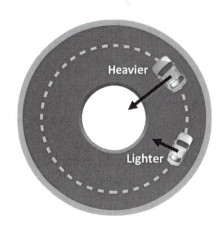

The term *radii*, pronounced RAY-dee-eye, is the plural form of *radius*. One radius, two radii.

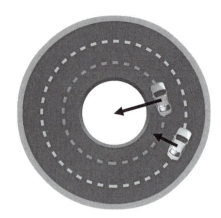

Cars at same speed. Centripetal force on inside car is greater.

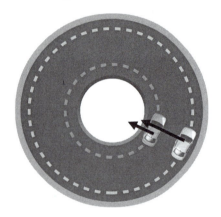

Outside car moving at double the speed of inside car. Centripetal force on outside car is greater.

Outside of wheel is under greater centripetal force due to increased radius.

increases. This means the outside car will be under a greater centripetal force than the inside car. The increase in centripetal force by squares due to increased velocity trumps the decrease due to the larger radius.

Knowing this, you can see how the centripetal force on a point near the outside of a wheel is greater than the force on a point closer to its center. The radius at the outside of the wheel is greater, which reduces centripetal force, but the velocity is also greater, which increases the centripetal force by squares.

Centrifugal Force

When an object is turning, the entire body of the object turns due to centripetal forces. But other things contained within that object, which aren't nailed down, such as people, clothing, bags in the back seat of your car, etc., aren't under the same forces. They just happen to be there, contained within the turning object.

Newton's First Law tells us that a body in motion tends to stay in motion unless acted on by a force. This means that anything that isn't firmly nailed down to a turning object is going to try and keep going in a straight line (uniform motion). As it does so, it crashes into the turning object, which exerts force on it and pushes it into following a circular path.

This is why your washing machine's spin cycle removes water from your clothes, and leaves the clothes themselves stuck to the sides of the tub. The clothes (and the water in them) keep trying to move in a straight line as the tub turns. But the clothes keep hitting the sides of the tub, which exerts a force back on them to keep them inside. The water moves in a straight line and falls through the holes on the sides of the tub to drain away, while the clothes just keep banging into the sides of the tub.

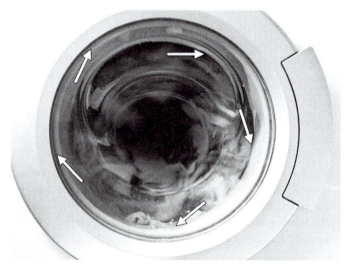

During the spin cycle, clothes are continually banging into the sides of the tub as they try to move in a straight line.

This is also why taking a sharp turn with your car makes your body feel as though it's being thrown in the direction opposite the turn. This happens not because of a mysterious force, but because your body expects to keep going straight and is prevented from doing so by the door of the turning car.

So what's the force that keeps the clothes in the tub and you in the car? When your body hits the car door, the door exerts a simple, straight-line action–reaction force to keep you inside. However, because the force keeps being exerted moment after moment as the car turns, it feels like a force is pushing your body away from the center of the circular path and into the car door.

The feeling of this force is so common that even though the force itself doesn't exist, it has its own name: *centrifugal force.*

Anything sitting on, or riding on, or only partially attached to a turning object will fall off if it doesn't hang on, due to the same tendency to keep going in a straight line. If you've ever played on a roundabout on a playground, you know this feeling. Once it gets going, if you don't hang on tight you'll fall off. Here, where you exert force through your hands toward the center, you actually become part of the mass the centripetal force is acting on.

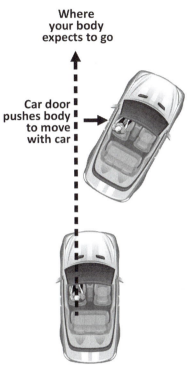

Where your body expects to go

Car door pushes body to move with car

The term centrifugal comes from the Latin *centrum* and *fugere* (to flee). The fictitious force makes you feel as though you are continually "fleeing" the center of the circle.

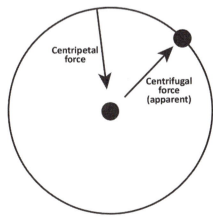

Centripetal force

Centrifugal force (apparent)

In general, the object doing the turning gets the centripetal force, while anything that's just along for the ride feels a centrifugal force.

Perhaps you have seen the trick where a person swings a bucket full of water overhead, and no water drops out. This is another example of the apparency of centrifugal force, which seems to be pushing the water into the bucket as it moves around the circle.

Actually, at each moment the water is trying to move in a straight line perpendicular to the center of the circle, but is prevented from doing so by the bucket. If the swing is fast enough, the water's tendency to try and follow the straight line is greater than the effects of gravity, and the water won't fall out of the bucket.

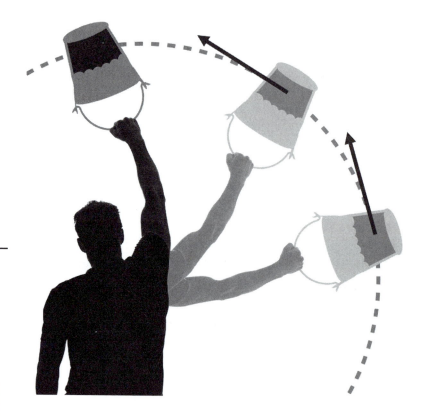

The concept of centrifugal force can be used to simulate gravity in a rotating space station with a large radius. With the right rotation, a person standing on the outer rim with his/her head pointing toward the center would feel as if they were walking in Earth gravity.

Early space station design. Image courtesy of NASA.

If you say the words "centrifugal force" to a physicist, you're likely to get an earful about how this force doesn't exist. But in animation, it can be helpful to use the concept of centrifugal force to plan characters' and objects' reactions to being inside or attached to rotating or turning objects.

Centripetal Force and Vehicles

When you swing an object on the end of a string, you provide the centripetal force through tension on the string. However, a turning car has no such string to keep it going around. With a car, the centripetal force comes from the wheels' contact with the ground. You can think of the wheels as "gripping" the ground and pulling the car toward the center of the turn to provide the centripetal force.

The concept of centripetal force coming from tire grip is key to understanding how cars respond and react to turning. On a tight turn, because the radius of the circle is smaller, the tires need to grip harder to generate enough centripetal force. This is why cars skid on wet pavement, or when they're going too fast around a tight turn—the tires can't get enough of a grip to create the centripetal force necessary to make the turn.

Race car drivers sometimes use this principle intentionally to reduce the time it takes to make a turn. Instead of slowing down on a sharp bend, the driver makes a sharp turn just before the bend from the outside of the track to the inside, quickly reducing the radius of the turn to the point where the wheels can't provide the necessary centripetal force for that tighter radius. This sends the car into a skid in the desired direction of movement. At the end of the skid, the driver resumes normal driving along the outside track. The overall time for such a turn is less than if the driver had stuck to the larger radius. Such a move is dangerous and prone to miscalculations, which is why only trained drivers (or animated drivers) should attempt this.

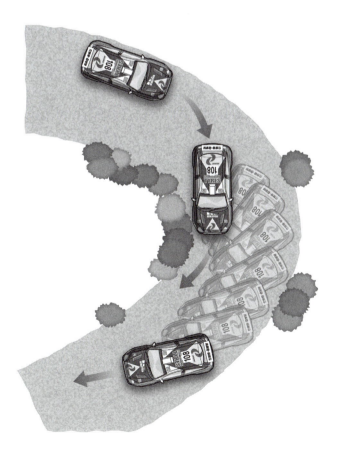

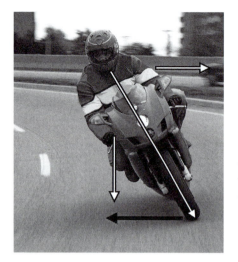

A car driver or passenger isn't in danger during ordinary driving and turn speeds—there's a big metal box to keep them from flying off during a turn. With a motorcycle or bicycle, however, there is no such safety. With these vehicles, if the rider doesn't do something to counteract the centripetal force, he will be flung off the bike in the direction away from the center. To prevent this from happening, the rider leans in toward the center of the turn, tilting his center of gravity toward the center of the turn. This balances the forces in such a way that he can stay on the bike.

Another way to look at this is to consider that a rider leaning in such a way while the bike is not moving would tip over in response to gravity. If he doesn't tip over, it's as if there is another force pulling in the opposite direction.

These visible signs of centripetal force can be used in animation to communicate speed and turning radius, especially in visual effects. You can also exaggerate them for comic effect.

PENDULUM MOTION

Any back-and-forth swinging motion in your animation follows the arc of pendulum motion. A pendulum slows in and out as it swings back and forth, like a ball in a half-pipe. The centripetal force is provided by the tension in the string, which continually "pulls" the ball toward the apex to counteract gravity.

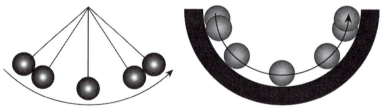

The timing around the center is somewhat uniform, with a strong slow-in and slow-out at the apexes.

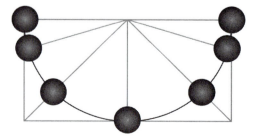

The time required to make one round trip back and forth is called the *period*. The period of a pendulum depends only on its length, not on its weight or other factors. The greater the length, the longer the period.

The motion curve for a pendulum is an S-curve, with a strong slow at each end.

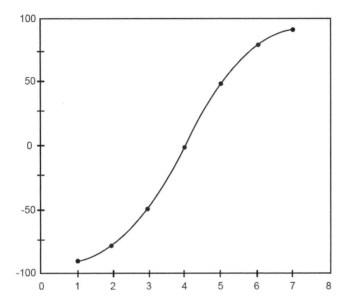

You can approximate the speed of the ball at the bottom of the swing by figuring out how far the ball drops vertically from the start of the swing to the lowest part of the swing. The combination of centripetal force from the string and vertical force from gravity causes a horizontal speed that's around the same as the vertical speed the ball would reach if it was dropped vertically without a string. See the Gravity section in the Forces chapter for how to figure out the speed of a falling object based on the distance it falls.

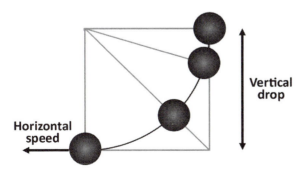

Wave Motion

Waves are a common natural phenomenon. We see wave motion in the open seas, and even in everyday flexible objects. In character animation, wave motion appears in hair, fabric, and soft flesh when they react to wind or motion.

WHAT WAVES DO

A medium is a substance capable of transferring energy over a distance. Air is a great medium for sound, while the vacuum of outer space is not.

A wave can be defined as a repetitive disturbance that travels through a medium like air, water, or a flexible object like a rope. The disturbance can travel long distances, but the medium itself doesn't travel—it just moves back and forth a little bit as part of the wave motion.

As an example, consider a long rope. You grab one end and start moving it up and down. A few minutes later you are still holding the end of the rope; the rope itself has only moved up and down, up and down. But the wave itself has traveled a long way down the rope, transferring the energy from your movements over a long distance.

VISIBILITY OF WAVES

A wave itself can be visible or invisible, but at some point matter is affected in a visible way.

Some waves, like water waves, a rippling flag, and the rope example above, are visible as themselves. Waves like sound waves are invisible, but the object that creates them (such as a speaker) might have visible motion. In addition, the invisible waves pass along energy that can affect other matter. Sound waves, for example, pass sound to you via your eardrums, which vibrate when a sound wave hits them.

TYPES OF WAVES

A helical object is shaped like a helix, a continuous coil or spring.

There are two types of waves: transverse and longitudinal. To understand the difference between the two, consider the types of motions you can make with a Slinky®, a helical spring toy. Both types of waves can travel down a Slinky.

Transverse wave (top) and longitudinal wave (bottom) with a Slinky.

If you lay the Slinky down, hold one end, and shake it up and down, you'll create a transverse wave, where the wave travels along the medium in an S-curve shape. If you repeatedly push the Slinky away from you and release it, you'll create a longitudinal wave traveling in a straight line, bunching up and expanding the material to create a pulse that travels along the medium.

Transverse Waves

With a transverse wave, the medium moves perpendicular to the wave, up and down or side to side.

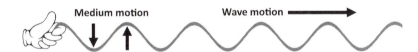

An example is a stadium wave, a synchronized standing and sitting by a crowd—the crowd doesn't move down the wave. Ripples in cloth are also transverse waves—the cloth doesn't move down the wave, but the ripple does.

Transverse waves have a cyclic back-and-forth vibration to them. A transverse wave can be represented by a cyclic graph.

Transverse wave cyclic graph.

Longitudinal Waves

With a longitudinal wave, the wave motion and material motion are parallel, and the material itself clumps together and moves apart to create a pulse.

Sound waves are longitudinal waves. A speaker head or drum head vibrates back and forth, pushing the atoms of the air so they clump together and move apart. Those atoms push other atoms in the same pattern, creating a pulse. The pulse reaches your eardrums, vibrating them and giving your brain a signal telling it that a sound has arrived. This type of wave is also called a *pressure wave*.

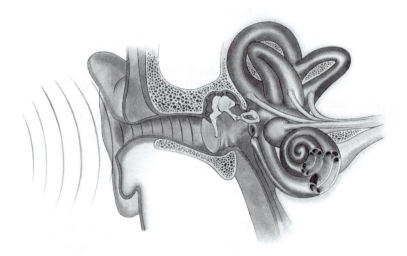

Pressure waves impacting eardrum.

A longitudinal wave doesn't have the up-and-down cycles of a transverse wave, but we often visualize longitudinal waves with peaks and valleys to make them easier to understand and work with.

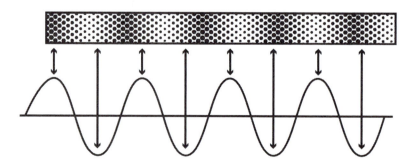

A common use for this type of representation is in sound-editing software. Even though sound is a pressure wave, the software displays the sound as cyclic waveforms.

WAVE VS. FLOW

Waves flow through a medium such as air or water. With a wave, the wave shape itself moves through the air, but the air at the originating point moves very little. With a flow, the air moves.

You can get a good idea of the difference between a wave and a flow by considering the difference between talking and blowing air out of your mouth. When you speak, the air coming out of your mouth doesn't actually get to the other person's ears; the air traveling out of your mouth merely creates a pulse (pressure wave) in the air. Conversely, when you blow out a candle the air coming out of your mouth actually reaches the candle, making a flow.

Blowing air is a flow.

WAVE PROPERTIES

All waves have these properties:

- Amplitude
- Wavelength
- Frequency
- Wave velocity (speed)

The last three properties are closely related.

Amplitude

The magnitude of a wave is called its *amplitude*. For transverse waves, the amplitude is easy to measure as the height of the waveform.

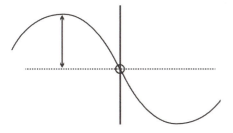

Amplitude for transverse wave.

The top of the wave is called the *crest*, while the bottom is called the *trough*.

Amplitude for a longitudinal wave.

The decibel (dB) is the unit used to measure the intensity or power of a sound, which translates in human experience to how loud the sound seems to us. Because the human ear is so sensitive, decibels are measured on a logarithmic scale, where values increase by multiples rather than linearly: 0dB is near silence, 10dB is 10 times louder than 0dB, 20dB is 100 times louder than 0dB, and so on. This allows us to measure sounds from a whisper (15dB) to a firecracker (140dB) on a single scale. 140dB is 10^{14} more powerful than 0dB.

A longitudinal wave's amplitude is the average distance that particles move from their normal, middle position. If you visualize a longitudinal wave as a waveform, you can more easily get the idea of the amplitude for a longitudinal wave.

Loudness of a sound wave depends on the degree of "clumping" that takes place due to pressure variations. Tighter clumps mean louder sound, which is represented visually in sound-editing software as a high peak. The measurement of *decibels* indicates the amplitude level.

Wavelength

Wavelength is the distance between two consecutive wave crests or troughs, which gives you the length of one single wave. With a longitudinal wave, the areas of clumping are the crests.

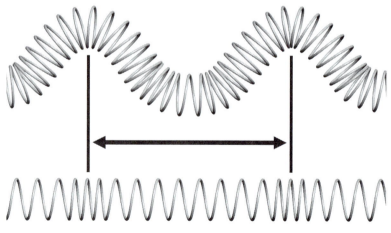

Wavelength.

Wavelength is measured in distance. Light waves have tiny wavelengths measured in nanometers (nm) or one one-billionth of a meter. Compare

with the width of a human hair, which is about 100,000 nanometers. Sound waves have much longer wavelengths, ranging within our audible range from centimeters for high-pitched sounds to meters for low-pitched sounds.

Frequency

Frequency is the number of times a single wavelength moves by one full cycle within a second. It is often expressed as "cycles per second." Frequency is closely related to wavelength; if two waves are traveling at the same speed, the one with a shorter wavelength naturally means the wave completes its cycles more frequently.

With sound waves, different musical notes have different frequencies. We detect these differences as various musical pitches. The higher the frequency, the higher the pitch. Two notes are one octave apart when one note is twice the frequency of the other.

The strings on a guitar are tightened to make them vibrate at a rate that will produce the frequency for the desired pitch. By placing a finger on a string, the string is effectively shortened, thus increasing the frequency and pitch.

A movement of one full wavelength is called a *cycle*.

The *Hertz* unit expresses cycles per second. For example, a wave with a frequency of 3 Hertz makes three full cycles in one second. The abbreviation for Hertz is Hz.

A tuning fork always vibrates at a specific frequency, making it useful for tuning musical instruments.

The sound coming from a guitar is actually made up of several waves with different frequencies. The string vibrates at a single frequency which excites

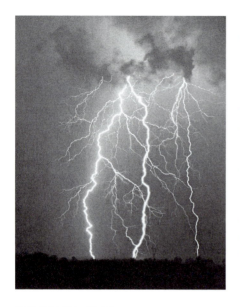

In physics, wavelength is often expressed in equations as the Greek letter lambda (λ), so you might see this equation expressed as $v = f * \lambda$.

various frequencies within the guitar's body, combining to give the guitar its distinctive sound.

Wave Velocity

The velocity, or speed, of a wave is measured by how long it takes a single cycle to move a certain distance.

- The wave speed of ocean waves near the beach is a few miles per hour.
- Sound waves move at 0.2 miles (343 meters) per second.
- Light waves move at 186,000 miles (300,000 km) per second.

The difference in speed between sound and light waves is why you see distant lightning before you hear the thunder that goes with it. Light waves travel so fast that we can consider any light that occurs on Earth to reach us instantaneously. Sound waves from a distance actually take a noticeable time to get to you.

Wave Relations

There is a mathematical relationship between the speed, frequency, and wavelength of a wave. This relationship is expressed by the wave equation

$$\text{Wave speed} = \text{Frequency} * \text{Wavelength}$$
$$v = f * w$$

Knowing one of the values means you can calculate the other two. Even if you don't know the exact number, you can use this equation to figure out what happens to the other values when one value goes up or down.

Hold Fixed	Change	Result
Wave speed	Frequency ↑	Wavelength ↓
Wave speed	Wavelength ↑	Frequency ↓
Wavelength	Wave speed ↑	Frequency ↑
Frequency	Wave speed ↑	Wavelength ↑

Table of relationships between wavelength, wave speed, and frequency. All Change directions are up (increasing). For Change in the opposite direction, flip the Result direction.

This equation is less important than consequences: basically how do wave speed, length, and frequency change if we change one or the other?

Wave Phase

As a wave passes through a single cycle, its progress through the cycle can be measured. This measurement can be expressed as a number from 0.0 to 1.0, or as a range of degrees from 0 to 360.

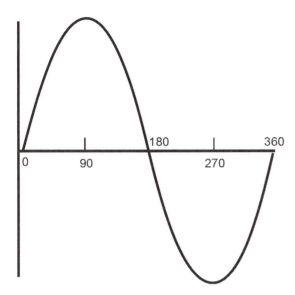

Two waves with corresponding phases are said to be "in phase." If you shift one of the waves, the waves are "out of phase."

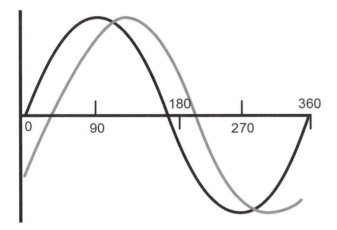

Animation software often gives you an option to set a Phase value from 0.0 to 1.0 for wave-based animation. The value of 1.0 corresponds to 360 degrees, so adding 0.5 to a Phase value shifts the wave by 180 degrees.

Wave Addition and Cancellation

When two waves meet, their amplitudes add up to produce a higher or lower amplitude. The amplitude below the middle line is a negative amplitude, which negates or reduces any positive amplitude on the other wave.

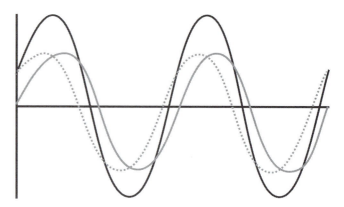

The two gray waves add up to form the black wave.

Waves can also cancel each other out completely. Two waves that are out of phase with each other by 0.5 (180 degrees, or half a wavelength) will "add up" to a zero amplitude, which is essentially no wave at all.

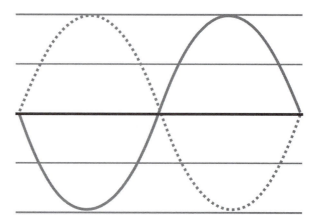

This principle is used in the design of noise-canceling headphones. A small microphone in the ear cup catches external sounds, and the electronics generate a wave exactly 180 degrees out of phase to effectively silence the external sound waves.

Standing Waves

Two waves moving in opposite directions can sometimes affect each other with more than simple addition. If the waves are of exactly equal amplitude and wavelength, the net addition will cause standing wave. With this type of wave, the crests and troughs move up and down but the points where the wave crosses the center line stay in the same location.

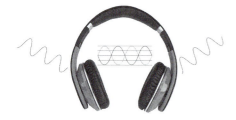

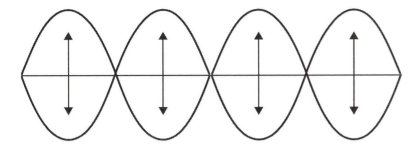

Standing waves occur when waves moving in one direction are deflected back in the opposite direction. You can create a standing wave by tying one end of a rope to a stationary object. Hold the other end of the rope, and send waves down the rope by moving your arm up and down. The waves will deflect back down the rope at the point where it's tied up. At the right frequency, you will create standing waves in the rope.

Standing waves are also called *stationary waves*.

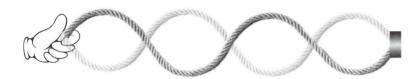

COMMON SOUND EFFECTS

When sound waves add up, interesting things can happen. Here are a few notable effects that sound can cause with its wave properties.

Resonance

Every object has a natural frequency, a speed at which it likes to vibrate. You can hear this for yourself when you drop an object on a hard surface, where it will vibrate with its natural frequency and thus make a sound specific to that object's material and shape. For example, the sounds made by wooden and aluminum baseball bats dropped on a hard surface are quite distinct from one another because they have different frequencies.

Within the object, there is always a small degree of vibration going on, even when the object appears to be sitting still. When external forces vibrate the object at its natural frequency, the result is an addition of amplitude to the existing vibration wave within the object. More vibration causes an even higher amplitude, magnifying each time the object is vibrated at its natural frequency.

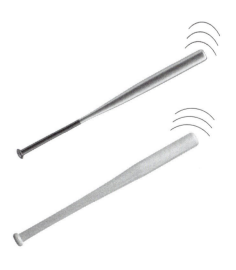

When the pattern of external vibrations is in sync with an object's natural frequency, it's called *resonance*. A sound wave with a frequency that's a multiple of an object's natural frequency will cause resonance.

Smaller waves at resonant frequencies, adding up to the larger wave.

A vibrating object usually makes a noticeable noise only if it's vibrating very fast. If you want to make something in your animation appear to vibrate very fast, give it a sound! The faster the motion, the higher the pitch.

An example is acoustic resonance, where resonant sound waves can shatter a wine glass. Another is mechanical resonance, where physical vibrations resonate with the object's natural frequency. For example, bridges have been known to shake and even collapse when the frequency of strong external vibrations, such as hundreds of soldiers marching in step, resonates with the bridge's construction material.

Doppler Effect

A moving object making a particular sound, such as an ambulance with a blaring siren, can seem to be making sounds with two different pitches. If the ambulance is approaching you, the sound of the ambulance siren has a higher pitch than if the ambulance is moving away from you.

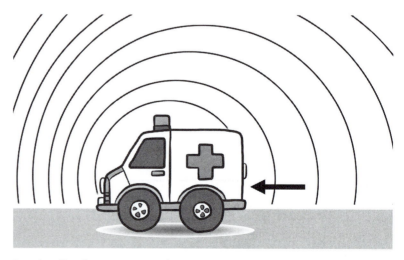

Doppler effect from a passing ambulance. Arrow shows direction of ambulance motion.

As the ambulance drives forward and emits more sound waves, the waves compress in front of the ambulance, producing waves with a shorter wavelength and higher frequency (higher pitched). Conversely, as the ambulance moves away from you, the sound waves are stretched out and have a longer wavelength and lower frequency (lower pitched). This effect of seemingly higher and lower pitches from the same sound is called the *Doppler Effect*.

Sonic Boom

When the sound source travels at the speed of sound, the wavelength goes to zero and the waves pile up to the point where a shockwave is formed. This situation produces a sonic boom, basically all the sound waves compressed into one very loud sound. Airplanes are the most common source of sonic booms. Commercial airlines don't exceed the speed of sound, but military aircraft sometimes do.

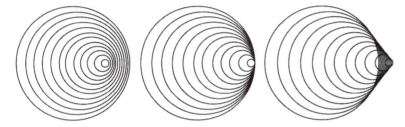

Diagram of sound waves emitted from an object moving to the right. If the speed is fast enough, sound waves pile up at the tip of the cone shape and produce a sonic boom.

Another example of a sonic boom is the sharp sound when a whip is cracked. The tip of the whip can exceed the speed of sound, creating a mini sonic boom.

The crack of the whip is a sonic boom.

Timing

Dictionary definitions of timing say things like "the choice of when something should be done; the regulation of occurrence and pace to achieve a desired effect." As animators, we have the ability to move forward and backward in time to place objects when and where we want them to be.

Everyone, even people who have never done animation, has a sense of what realistic timing should look like, in the sense that they can tell when it's wrong. However, actually knowing what the timing should be is another matter altogether.

Timing is one of the Twelve Basic Principles of Animation.

Timing in animation is measured in different ways:
- Frames (intervals of 1/24, 1/25, or 1/30 of a second)
- Keys (number of frames between poses)
- Clocks (seconds)

In certain animation software it's possible to measure time in *ticks*, which are intervals shorter than a frame. With software set up for 160 ticks per frame, for example, you could break down the motion into increments of 1/160 of a frame. The number of ticks per frame can vary depending on the software, frame rate, or method being used.

Fortunately, physics has some tried-and-true laws that can help us figure out accurate timing. Even if you plan to exaggerate your motion for effect, it helps to start with reality and work from there.

This chapter discusses timing for motion in general. For timing of specific types of motion discussed in this book, see that chapter. For example, timing for falling due to gravity is discussed in the Gravity section of the Forces chapter.

TIMING TOOLS

In animation, timing of action consists of placing objects or characters in particular locations at specific frames to give the illusion of motion. We work with very small intervals of time; most motion sequences can be measured in seconds or fractions of seconds. Frame intervals between keys are usually smaller than one second. For VFX work that needs to closely match live action, VFX artists work at the sub-frame level.

Timing is such an integral part of motion that it's impossible to completely separate the two. However, when planning your animation it can be helpful to try and work with motion and timing separately. It is a common practice, for example, to set up key poses and set timing for them afterward. Others like to nail down the timing first and animate the motion afterward.

UNIFORM MOTION TIMING

Linear motion refers to motion in a straight line, always in the same direction. An object moving with linear motion might speed up or slow down as it follows a linear path.

A heavy ball rolling on a table or incline is an example of linear motion. The ball is rotating, but its center of gravity follows a linear path.

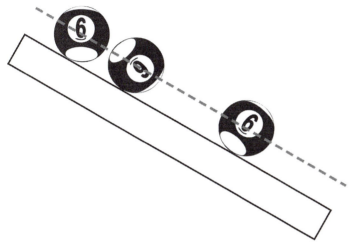

Linear motion.

Uniform motion is a type of linear motion with constant speed and no acceleration or deceleration. The object moves the same distance between consecutive frames. The longer the distance between frames, the higher the speed.

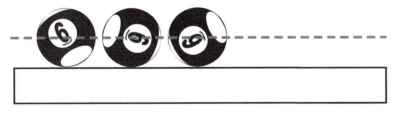

Uniform motion.

Physicists don't use the term *deceleration* when they talk about things slowing down; they use the direction and magnitude of acceleration. For example, if an object is moving uniformly and the direction of acceleration is *opposite* the direction of its movement, the object will slow down. If we used this convention in this book, things could get very complicated, so instead we use the terms *acceleration* for "speeding up" and *deceleration* for "slowing down."

Linear motion is not always uniform; an object can speed up or slow down as it moves in a straight line. Uniform motion, on the other hand, is always linear.

When uniform motion occurs, the net force on the object is zero. Net force is the total of all forces added up. There might be several forces acting on the object, but when both the magnitude and direction of the forces are added up, they add up to zero.

Uniform motion is the easiest to animate because the distance the object travels between frames is always the same.

SLOW IN AND SLOW OUT

"Slow In and Slow Out" is one of the Twelve Basic Principles of Animation.

When motion is accelerating or decelerating, we refer to this type of motion as a *slow in* or *slow out*. This type of motion is sometimes called *ease in* or *ease out*. In this book, we use the hyphenated forms *slow-in* and *slow-out* for easier understanding.

- Slow in, ease in—The object is slowing down, often in preparation for stopping.
- Slow out, ease out—The object is speeding up, often from a still position.

The term *slow out* can be confusing, since it essentially means "speed up." You can think of *slow out* as the same as *ease out*, as in easing out of a still position and speeding up to full speed.

For example, a ball rolling down an incline or dropping straight down is slowing out, as it goes from a still position or slow speed to a fast speed. A ball rolling up an incline is slowing in.

Slowing out: speeding up.

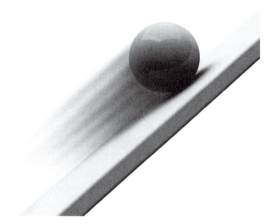

Slowing in: slowing down.

ACCELERATION TIMING

Timing for acceleration can be calculated very accurately when the net force being exerted is constant. Let's take a look at these forces and how you can use them to calculate your animation's timing.

Constant Forces

A constant force is a force that doesn't vary over time. Examples of constant forces include:

- Gravity pulling an object to the ground
- Friction bringing an object to a stop

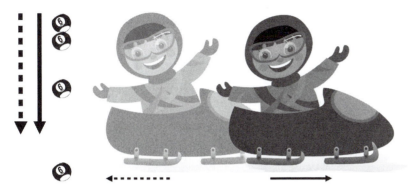

Directions of net force (dotted arrow) and motion (solid arrow).

Forces Exerted by Characters

Forces exerted by people's bodies are rarely constant throughout an entire motion. For the purposes of animation, however, you can break the character motion into short time segments and consider each of these segments to be responding to constant net force. This will make it easier for you to calculate the timing for each individual segment.

As an example, let's look at the push for a jump. The force a character exerts during the push is somewhat constant, and the timing is very short (less than half a second). In such a case the timing for a constant force is an excellent starting point, and in most cases will do the job as is.

A character walking and pushing a rock is not exerting a constant force throughout the entire sequence, but during each short part of the walk cycle the net force could be considered to be a different constant value.

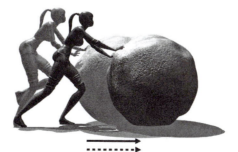

Arrows show relative force and speed between different parts of walk cycle.

Constant Force and Acceleration

Constant forces result in constant acceleration. Because the acceleration is constant, we can figure out the timing for such sequences using a few principles of physics.

The resulting acceleration depends on the direction of the force and motion, if there is any motion at all to begin with.

- When constant net force is applied to an unmoving object, the result is acceleration.

- When constant net force is applied to a moving object in the same direction as the motion, the result is acceleration.

- When constant net force is applied in the direction opposite the existing motion, the result is deceleration (acceleration in the opposite direction).

Note that constant acceleration doesn't mean constant speed. It's quite the opposite! Constant acceleration means the object is changing speed constantly.

Because gravity is a constant force, the Odd Rule can be used to animate falling due to gravity. This use is described in greater detail in the Gravity section of the Forces chapter.

THE ODD RULE

When acceleration is constant, you can use the Odd Rule to time your frames. With this method, you calculate the distance the object moves between frames using a simple pattern of odd numbers.

Between consecutive frames, the distance the object moves is a multiple of an odd number. For acceleration, the distance between frames increases by multiples of 1, 3, 5, 7, etc.

1 3 5 7

Rocket speeding up using the Odd Rule.

For deceleration, the multiples start at a higher odd number and decrease, for example 7, 5, 3, 1.

7 5 3 1

Sled coming to a stop using the Odd Rule.

The Odd Rule is a multiplying system based on the smallest distance traveled between two frames in the sequence. For a slow-out, this is the distance between the first two frames; for a slow-in, it's the distance between the last two frames. This distance, the *base distance*, is used in all Odd Rule calculations.

Odd Rule Multipliers

The Odd Rule in its simplest form, as described above, is just one way to use it. For example, you can instead calculate the distance from the first frame to the current frame and use these distances to place your object on specific frames.

	Multiply by base distance to get distance between:	
Frame #	Consecutive frames	First frame and this frame
1	n/a	0
2	1	1
3	3	4
4	5	9
5	7	16
6	9	25
7	11	36
8	13	49
9	15	64
10	17	81

If you add up all the consecutive frame multipliers up to a particular frame, you get the multiple for the entire distance. For example, on frame 4, the consecutive multiples thus far are 1, 3, and 5. If you add up these numbers you get 9, which is the multiplier for the entire distance up to frame 4.

	Multiply by base distance to get distance between:	
Frame #	Consecutive frames	First frame and this frame
1	n/a	0
2	1	1
3	3	4
4	5	9
5	7	16
6	9	25
7	11	36

Because the last column shows squared numbers, we will refer to these numbers as the "squares" when talking about methods for calculation later in this chapter.

If you're calculating the distance for a large number of frames and a chart like this isn't practical, you can figure out the odd number multiplier for consecutive frames with this formula:

Odd number multiplier for consecutive frames = ((frame # − 1) * 2) − 1

In the charts above, note that the distances in the last column are squared numbers: $4 = 2^2$, $9 = 3^2$, $16 = 4^2$, and so on. One of the benefits of the Odd Rule is you can calculate the total distance traveled from the start point to the current frame with the following formula:

Multiplier for distance from first frame to current frame = (current frame # − 1)2

When setting your keys, you can use either the consecutive key multipliers or total distance multipliers. Choose the one that's easiest for you to use for your animated sequence.

Odd Rule Scenarios

Here are a few different scenarios for calculating the distance an object travels between keys in a slow-in or slow-out.

Base Distance Known, Speeding Up

If the object is speeding up, the first frame distance is the base distance. If you know the base distance, figuring out the distance the object travels at each frame is pretty straightforward. Just multiply the base distance by 3, 5, 7, etc. to get the distances between consecutive frames, or use squares to multiply the base distance to get the total distance traveled on each frame.

Base Distance Known, Slowing Down

Suppose you want an object to slow down, and you know the distance between the last two frames before it stops. For slow-ins, the base distance is the distance between the last two frames. The solution is to work backward, as if the object were speeding up in the opposite direction. Working backward, multiply the base distance by 3, 5, 7, etc. to get the distances between each previous frame in the sequence.

Jump takeoffs and landings involve constant acceleration or deceleration, so animation of these actions can use the Odd Rule. When using the method described in the Jumping section of the Character Animation chapter, you will know the number of frames and total distance but not the base distance.

Total Distance and Number of Frames Known, Speeding Up

If you know the total distance and the total number of frames, you can find the base distance with this formula:

Base distance = Total distance/(Last frame number − 1)2

Suppose you have a jump push (takeoff) with constant acceleration over 5 frames, and the total distance traveled is 0.4m. Using the formula above, we find the base distance.

Base distance = 0.4m/(5 − 1) 2 = 0.4m/16 = 0.025m

0.4m

Using the base distance, you can calculate the distances between each frame.

Frame #	Consecutive frame multiplier	Distance from previous frame
1	n/a	0
2	1	1 * 0.025m = 0.025m
3	3	3 * 0.025m = 0.075m
4	5	5 * 0.025m = 0.125m
5	7	7 * 0.025m = 0.175m

If you add up the distances traveled, you will find that they add up to exactly 0.4m.

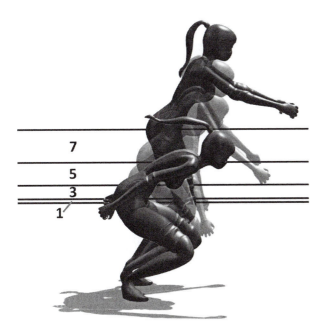

First Key Distance Known, Slowing Down

Suppose you have a moving object that you want to slow down, and you've set the first frame of the slow-in to give an idea of the pacing for the sequence. In this case, you can consider that the distance the object moved between the last two frames before the slow-in is part of the calculation—the distance between them becomes the first frame distance, and your first slow-in frame becomes the second frame in the sequence.

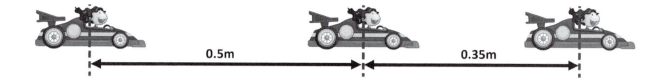

One feature of the Odd Rule is that the base distance is always half the difference between any two adjacent distances. To find the base distance, you can simply calculate:

$$(0.5m - 0.35m)/2 = 0.07m$$

To figure out how many frames are in the slow-in, divide the first distance by the base distance to find out which odd number it corresponds to.

$$0.5/0.07 = 7$$

This means the first distance corresponds to 7 in the 7, 5, 3, 1 sequence, making the sequence four frames long. Now you can work back the other way, multiplying your base distance by odd numbers to get the distances for the rest of the slow-in frames.

Frame #	Consecutive frame multiplier	Distance from previous frame
1	7	7 * 0.07m = 0.5m
2	5	5 * 0.07m = 0.35m
3	3	3 * 0.07m = 0.21m
4	1	1 * 0.07m = 0.07m

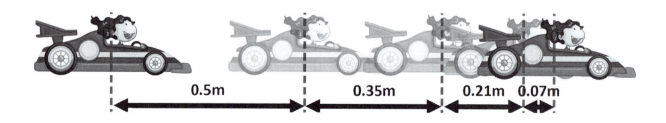

MOTION GRAPHS

A motion graph plots an object's position against time. If you're using animation software, understanding and using motion graphs is a key skill in animating anything beyond the simplest of motions. If you're drawing your animation, drawing motion graphs before animating can help you visualize the motion.

On a motion graph, the time goes from left to right across the bottom of the graph, while the object's position is plotted vertically against the time. Each axis in 3D space (X, Y, Z) has its own line showing the object's position along that axis.

At the very least, you will need to understand the types of lines in a motion graph and what they represent in terms of visible motion. You can also look at motion graphs to get a better understanding of any difficulties you're having with your timing or action.

Constant Speed

With constant speed on any axis, the motion graph is always a straight line. The greater the speed, the greater the slope of the line.

Typical motion graph in CG software.

Constant speed graph, with distance (vertical) plotted against time (horizontal).

Acceleration

Graphs of accelerating motion always show a curve. The more the curve bends, the more the object is accelerating.

Acceleration graph, with distance (vertical) plotted against time (horizontal).

Acceleration of Gravity

The motion graph for the Z axis of an object thrown in the air shows a parabola, a U-shaped curve.

Swinging

For swinging back and forth, as with a pendulum, the repetitive motion curve follows a wave pattern. Each part of the wave has a shape similar to the curve for falling due to gravity. The object goes up and down repeatedly against and with gravity.

Note that the Z-axis motion graph is not the arc of the object's motion. Even if the object is thrown straight up in the air and comes straight down, the motion graph still shows a parabola.

CHAPTER 3

Forces

As an animator, you probably already think about motion a great deal. "The character moves to the left," or "The boulder falls off the cliff and hits the ground," are the types of notes you might find in a storyboard or script, and then it's up to you to make the motion happen visually.

Storyboard with lots of motion. Where does the force come from?

Animators and filmmakers are accustomed to planning motion without thinking too much about the forces behind the motions. A film director instructing an actor to jump up and down isn't thinking about gravity; he just wants to see the motion. A scene might call for an old, noisy factory machine to be modeled and rendered, which the director simply hands off to the CG Supervisor to make happen. The director might have a strong idea of what the final result should look like, but isn't necessarily thinking in terms of forces when he describes his vision.

But without forces all motion would be uniform, with no change of speed or direction (and pretty boring to watch). While many forces in life are barely visible, or even invisible, some aspect of forces is present whenever something changes speed or direction. A few examples:

- Gravity is an invisible force that causes objects to accelerate as they fall, or decelerate when they are thrown into the air.

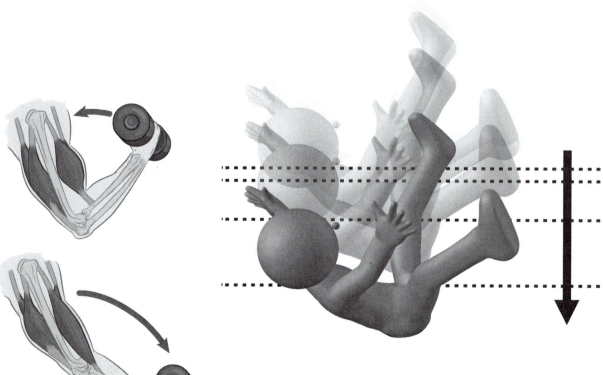

- When a person or animal moves in real life, muscles contract under the skin to create forces that move the body and limbs. Even in traditional animation of loose or lithe characters, these forces can become visible as anticipatory motion, slow-ins and slow-outs, or squash and stretch.

- With heavy machinery, a motor provides the force. The motor is most likely hidden inside the machine, but even though the forces aren't visible you can see the results. The parts don't start up all at once—there's an initial jerk of motion, a lot of noise as pieces grind against each other, and even dust and smoke.

- Forces within clouds can cause a lightning flash, which itself causes a force that can damage or burn.

Even with situations with no visible motion, the staging involves forces:

- A heavy bag hangs from a chain, causing tension on the chain. Even though there's no motion, forces cause the tension.

- A character is sitting or standing still. Gravity is acting on the character, and he's exerting a force with his muscles to stay upright. If he leans too far to one side, gravity will cause him to tip over.

Motion as simple as a character pushing a boulder involves multiple forces. The speed and direction in which the character can move the boulder (and even whether she can move it at all) are directly related to the strength of the character's muscles, friction between her feet and the ground, gravity acting on the boulder, and so on.

As an animator, you have control over how much the boulder weighs, whether the character can actually stand up, how heavy that hanging bag is, and how old and creaky that factory machine is. Understanding the forces behind the motion and staging will help you make a more compelling and believable animated sequence that represents the decisions you've made.

Components of Force

Every force has a *direction* that affects the object's direction of motion, and a *magnitude* that affects the motion's timing. Gravity, for example, has a direction toward the center of the Earth. Its magnitude is visible as a specific degree of acceleration, where it causes an object to speed up as it falls.

Pretty much all motion results from multiple forces. To illustrate this, let's look at an example of a cat falling through the air on a windy day.

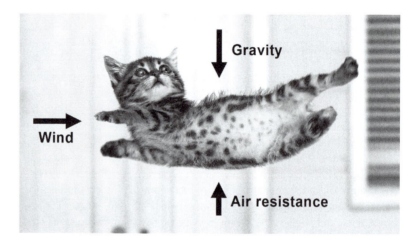

Several forces are acting on the cat:

- Gravity pulls the cat toward the ground, increasing its speed with each frame.
- Air resistance pushes up at the cat, but with not nearly as much force as gravity pulls down on it.
- The wind pushes the cat in the direction of the wind.

Adding up these forces, you can make an accurate prediction of the cat's motion and timing during the fall. All these forces are described and discussed in this chapter.

This is a very simple scenario, not even taking into account the cat's takeoff from wherever it came from, its landing on the ground, or the contortions a cat goes through while falling to enable it to land on its feet. Each portion of such an animated sequence involves a different set of forces, and thus requires its own consideration for motion and timing.

FAMILIAR AND UNFAMILIAR FORCES

Many forces you represent in your animation will be familiar to your audience, while others won't be. Some forces, like wind, create random,

variable effects, while other forces (like gravity) affect objects in the same way all the time.

With all the types of forces that will be going on in your animation, you will need to understand the underlying forces. This will enable you to animate the motion well enough to convey the underlying forces to your audience.

Familiar, Non-Random Forces

Earth's gravity is fixed, predictable, and familiar. Your audience have been living with gravity all their lives, and they have an idea of what its effects should look like. Centuries of research into gravity have given us the tools to accurately calculate motion and timing due to gravity.

Everyday human-touch forces like those for turning a wrench, pushing a car, and kicking a ball are also familiar to audiences. Your viewers will have an idea of the amount of force they themselves have had to exert under similar circumstances. While the forces involved can vary according to the person's strength, size, ability to balance, etc. these forces always fall within a certain range as limited by the human body.

Unfamiliar Forces

Some forces are completely unfamiliar, opening up their effects to artistic interpretation. Outer space forces fall into this category. While scientists do know a fair bit about how motion (including sound) occurs in outer space, anything the average viewer thinks he knows about such motion generally comes from scientifically inaccurate movies.

We forgive filmmakers for messing up the physics of outer space, because the truth is usually very dull; outer space is a big, quiet place with pockets of violent activity like stars and galaxies forming over millions of years. Getting some entertaining action to happen in outer space usually requires the bending of a few laws of physics.

Straddling the line between "technically correct" and "entertaining" has been a challenge for VFX artists since space operas were invented. The most entertaining films include enough accurate physics to keep the audience from losing their suspension of belief while keeping the action going with a few violations of the laws of physics that the average viewer won't catch.

If the climactic explosion of the Death Star at the end of the original *Star Wars* movie were technically accurate, Luke Skywalker's valiant efforts would have produced a silent explosion without any huge fireballs. But that wouldn't have been much fun, would it? In the more recent film *Gravity*, huge hunks of space junk hurtle around Earth every 90 minutes in exactly the same orbit as a working space station, and so much of this junk hits the station that it smashes it up. This premise is impossible—satellites and space stations don't use the same orbits, for one thing—but who cares? The filmmakers got enough stuff right that the movie is convincing, compelling, and very entertaining.

Variable Forces

A lot of forces are familiar but highly variable. Environmental and exterior effects fall into this category. Most likely you've seen ocean waves, lightning, and fireworks, and maybe you've seen a tornado on the news. Or maybe the only tornado you've ever seen is in *The Wizard of Oz*. In any case, you have an idea of the motion such forces can produce, even though the results are somewhat random and variable.

While there is scientific data available on the types of forces involved in these effects, there is such a broad range of possibilities that you can pick and choose, exaggerate, extend, lessen, or otherwise mess with the forces to make it look the way you want it to. Knowing about the forces behind such things will help you make them recognizable to your audience despite these variations.

Gravity

The most common force you'll need to represent in animation is gravity. We all interact with gravity daily and have an intuitive sense of how it affects objects, so your audience will know if your visual effects don't look realistic. And while the effects of gravity can be warped for entertainment value, you should know how to do it right so you can use it as it is, or alter it intelligently when needed.

GRAVITATIONAL ACCELERATION

Acceleration is expressed as distance per time per time, or distance/time2.

Gravity causes acceleration toward the center of the Earth. You can see this in action when you drop an object from a height. The object speeds up as it falls.

Gravity on Earth is about 9.8m/sec^2 or 32ft/sec^2. Rounding 9.8m to 10m gives us accurate enough calculations for most animation. Since 10 is a lot easier to calculate with than 32, we use 10m/sec^2 in this book.

COMMON MISCONCEPTIONS ABOUT GRAVITY

Take a look at these statements. They are all true!

- Close to the Earth's surface, acceleration due to gravity is always the same.

- Acceleration due to gravity does not depend on the object's size or how much it weighs.

- Effects of gravity do not depend on the height from which the object is dropped.

Misconceptions about gravity can come from observations of falling objects being affected by air resistance. As an object falls, air resistance develops and pushes in the direction opposite the motion. The falling speed of a relatively wide, lightweight object can be affected a great deal by air resistance.

Acceleration due to gravity actually varies slightly at different altitudes, with higher altitudes experiencing less acceleration. But the difference is so slight that it's usually not worth considering for the purposes of animation.

A common example is a beach ball, which is very light. The beach ball, after being tossed in the air, falls at a slower speed than a heavier ball would. This slower falling speed isn't due to lower effects of gravity on the ball—it is entirely due to air resistance.

Another example is a sky diver with an open parachute. A parachute is able to "catch" more air resistance than a sky diver alone, slowing down the sky diver to the point where landing on the ground is safe.

Air resistance is covered in more detail in the Pressure section of this chapter.

When talking about animation keys for falling animation, the point from which the object is dropped is referred to as the *apex* of the motion. Apex means "the top or highest part of something." If the object is thrown in the air, the apex is the highest point the object reaches before beginning to fall.

TIMING FOR GRAVITY

There are a few different methods you can use to calculate timing for a fall. Some are based on physics, while others are more a shorthand developed over the years to assist artists drawing frames by hand. These same principles can be used for keyframing the motion in animation software.

CALCULATING TOTAL TIME AND DISTANCE

In order to figure out the timing and keyframing for a fall, you first need to determine the following:

- Frame rate of your animation (30, 25, or 24 frames per second)
- Size of the falling object in your unit scale
- How long the object will take to fall, *or* the distance the object will fall in terms of your unit scale

PHYSICS-BASED CALCULATIONS

If you know either how long the object will fall or the distance it will fall, you can calculate the other value with the tables below. You can also use these tables to rough out the animation for a fall.

Frame Rate 24fps			
Time (seconds)	Frame #	Distance fallen from apex	
1/24	1	0.33in	0.85cm
1/12	2	1.33in	3.4cm
1/8	3	3in	7.6cm
1/6	4	5.4in	13.6cm
1/4	6	12in	30.6cm
1/3	8	21in	54cm
1/2	12	4ft	1.2m
2/3	16	7ft	2.2m
3/4	18	9ft	2.8m
1	24	16ft	4.9m

Frame Rate 25fps			
Time (seconds)	Frame #	Distance fallen	
1/25	1	0.3in	0.78cm
2/25	2	1.2in	3cm
3/25	3	2.8in	7cm
1/5	5	7.7in	20cm
2/5	10	2.6ft	79cm
3/5	15	5.8ft	1.8m
4/5	20	10.3ft	3.1m
1	25	16ft	4.9m

Frame Rate 30fps			
Time (seconds)	Frame #	Distance fallen	
1/30	1	0.21in	0.54cm
1/15	2	0.88in	2.2cm
1/10	3	1.9in	4.9cm
2/15	4	3.4in	8.7cm
1/6	5	5.4in	13.6cm
1/5	6	7.7in	20cm
1/3	10	21in	54cm
1/2	15	4ft	1.2m
2/3	20	7ft	2.2m
5/6	25	11ft	3.4m
1	30	16ft	4.9m

In traditional animation, falling motion is often animated as being faster than reality to make the action a little snappier. Use these values as a guide, then adjust to taste.

You can use any number of online tools to calculate distance or time for gravity falls, such as www.gravitycalc.com.

The formula used to calculate these distances uses the distance on the first frame, which is based on official physics calculations:

$$\text{Total Distance} = (\text{Distance on First Frame}) * (\text{Number of Frames})^2$$

You can use these tables to calculate the number of frames you'll need to show your object falling. If the total distance or number of frames is more than the highest number shown on the table for your frame rate, or the distance you wish to use isn't shown on the table, use the formula to calculate the total distance or number of frames.

Note that the amount of time it takes for an object to fall a particular distance is the same no matter which frame rate is used. The only thing that changes is the number of frames taken to travel that distance. For example, the distance fallen after 1/5 of a second is always 7.7in or 20cm. If your fps is 25, the object will have traveled 7.7in on frame 5; if your fps is 30, it will have traveled 7.7in on frame 6.

VISUAL CALCULATION METHODS

While you can use these physics-based calculations to work out motion and timing of falling, you can also use some of these more visually based tricks developed by traditional animators over the years.

The Odd Rule

With this method, an animator can start with the apex key's distance and animate straight ahead using a simple pattern based on odd numbers. This method is called the Odd Rule.

With the Odd Rule, the distance between keys increases in the ratios 1:3:5:7:9, etc., starting with the distance between the apex and the first key, which is considered to have a ratio of 1.

For each subsequent key, multiply the distance for the first key to get a new distance, and move the object that distance from the previous key.

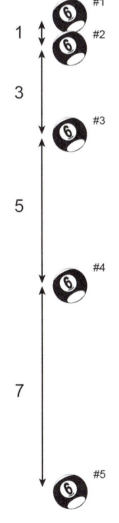

The following table shows how far to move the object from the apex if you assume the first key distance is 1 unit.

Frame #	Multiply by first key distance	Unit distance from apex
1	n/a	0
2	1	1
3	3	4
4	5	9
5	7	16
6	9	25
7	11	36

Note that the distances from the apex are squares: $4 = 2^2$, $9 = 3^2$, $16 = 4^2$, and so on. If it's easier for you to work with the total distances by recalling them as square numbers, then you can certainly do so.

The Odd Rule also works for calculating slow-ins and slow-outs for horizontal motion. This use of the Odd Rule is discussed in more detail in the Linear Motion section of the Motion and Timing chapter.

When drawing by hand a straight-on perspective of a falling object, you can also use the Odd Rule to estimate the size reduction of the object as it falls.

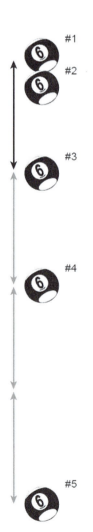

Fourth Down at Half Time

This method starts with the total distance and time of the fall, and calculates the in-betweens. A key in the middle of two other keys occurs at the halfway point in time between them, but at one fourth the distance.

The Fourth Down at Half Time rule is easy to visualize in a graph editor.

Falling à la Chai

Prof. Dave Chai developed this extension of Fourth Down at Half Time that isn't as accurate, but is a decent approximation and very easy to use.

1. Draw an interval from first and last keys.

2. Divide the interval in half. Mark a key.

3. Divide first interval in half. Mark a key.

4. Divide first interval in half. Skip.

5. Divide first interval in half. Mark a key.

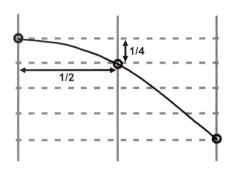

MOVING AND FALLING

Consider a ball rolling off a table. As soon as the ball leaves the table it is subject to gravity, but the ball also has some forward motion that causes it to fall away from the table.

To figure out how the ball will fall, you can combine the forward motion and the falling motion to figure out the keyframes. At the moment the ball leaves the table, its horizontal motion can be considered uniform motion.

The ball's motion due to gravity is always the same, so you can easily figure out its vertical motion. Combine the horizontal and vertical motion, and you have the correct path of action for the ball's motion.

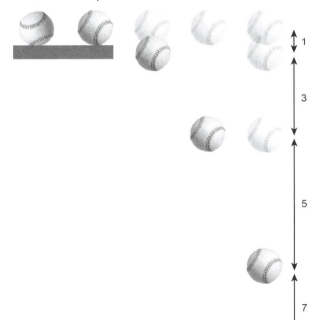

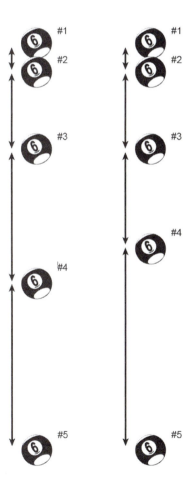

Key positions for falling ball, incorporating both vertical motion due to gravity and uniform horizontal motion.

Physically accurate falling on left, falling à la Chai on right.

A parabola, in mathematics, is a symmetric and somewhat U-shaped curve.

ASCENDING AGAINST GRAVITY

When an object is thrown or ejected up in the air, it is affected by gravity in the same way, just in reverse. The object decelerates until it reaches the apex, then descends with the exactly the same pattern of motion.

The motion of ascending against gravity then falling due to gravity follows the line of a parabola, or parabolic arc. The arc can be wide or narrow, short or tall, depending on a few different factors.

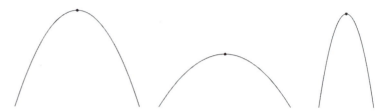

Examples of parabolas.

Water ejected from a water fountain follows a parabolic arc as it ascends against gravity and falls due to gravity.

An object on which the only force is gravity is called a *projectile* in physics.

The height and width of the arc depend on the initial horizontal and vertical velocity, which are determined by the degree of force used to get the object into the air and the angle at which the force is applied.

Projectile Velocity

For the purpose of understanding how a projectile's speed is affected by gravity, we divide the projectile's velocity into two separate parts: horizontal and vertical. The angle at which the projectile is projected into the air determines how much of the initial velocity is vertical and how much is horizontal. The vertical component of the velocity is slowed by the force of gravity until it reaches the apex, and then it speeds up as the object falls. Compare with the horizontal component, which could be considered to be unopposed by any noticeable forces. In other words, the vertical velocity changes over time while the horizontal velocity does not.

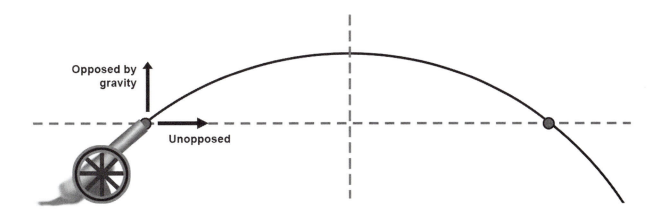

Changes in vertical velocity follow the same rules as an object thrown straight up in the air. The vertical velocity decreases due to gravity and reaches 0 at the apex of the parabola, then increases due to gravity as the projectile falls. For this motion, you would use the Odd Rule or other method for determining the vertical spacings between keys or frames.

The horizontal velocity of the projectile is unopposed by any force (except maybe a little wind or air resistance), and theoretically could keep going infinitely in the horizontal direction if gravity didn't pull the projectile to the ground.

The speed and motion on each side of the arc are symmetric. Exactly opposite where the projectile was fired, the projectile's speed is exactly the same as it was when fired.

To figure out the keyframes for any parabolic motion, you can start with the parabola and simply draw vertical lines, evenly spaced, to determine the object's location at various frames. You can also start with the timing and key positions to sketch the arc.

In your software's curve editor the horizontal motion will be a straight line, while the vertical motion will follow a parabolic arc.

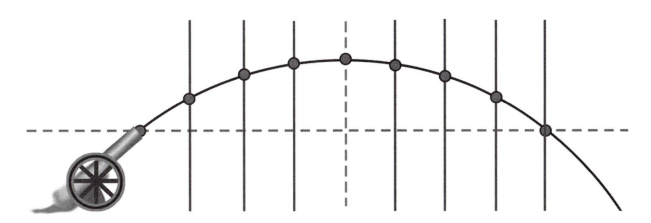

CENTER OF GRAVITY

The center of gravity is the average position of an object's weight distribution. For simple, uniform objects, the center of gravity is located at the geometric center.

For objects with more weight on one end than the other, the center of gravity will be closer to the heavier end.

Most objects are irregular, so the exact center of gravity might be hard to discern. But you can find a reasonably accurate center of gravity by considering the weight of different parts of the object.

Consider a hammer where the head is four times heavier than the handle. In this case, the center of gravity is four times closer to the head than to the center of the handle.

The center of gravity is also sometimes called the **center of mass**. Technically the center of mass and the center of gravity are different, but as long as the force of gravity is constant (as it generally is, close to the Earth's surface), the two are at the same location.

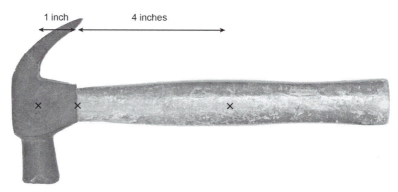

1 inch 4 inches

Such a calculation will give you a center of gravity that's close enough to be accurate to work for animation.

The center of gravity can also be located outside an object.

An object will balance if pivoted exactly above or below its center of gravity. If the center of gravity is below the pivot, the balance will be stable, meaning it can withstand a bit of shifting and still stay balanced.

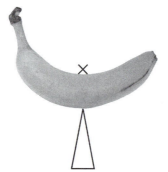

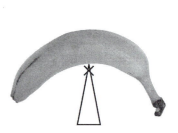

Stable and unstable balances. All are unstable except the last one, which is stable because the CG is below the pivot.

You can find an object's center of gravity by hanging it by a string a couple of different ways. Follow a line through the string each time you hang it. The place where the two lines cross is the center of gravity.

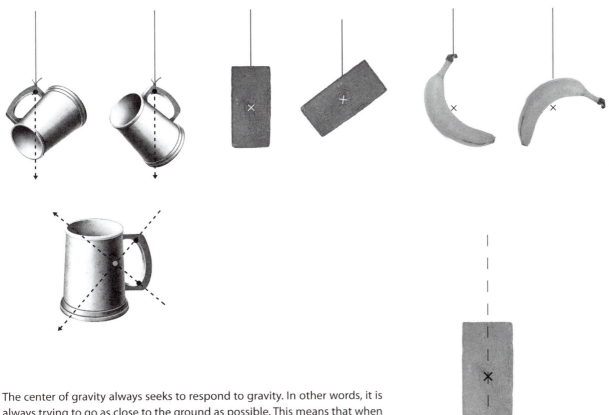

The center of gravity always seeks to respond to gravity. In other words, it is always trying to go as close to the ground as possible. This means that when you shift or move a suspended object, it will always try to settle again with the center of gravity as close to the ground as it can get.

CP

Line of Gravity

The line of gravity is an imaginary line that goes through an object's center of gravity, toward the center of the Earth.

For an object sitting on the ground, the object's *center of pressure* is the point where the line of gravity intersects the ground.

Tipping and Center of Gravity

An object's *base of support* is the area of the object that touches the ground it is sitting on. When an object has more than one area of contact, the base of support includes the area between the contact points.

In physics, the Center of Pressure is also sometimes called the Zero Moment Point (ZMP). The term *moment* can have many different meanings in physics, none of them meaning "a brief instant of time." The physics definitions have more to do with distance from a reference point.

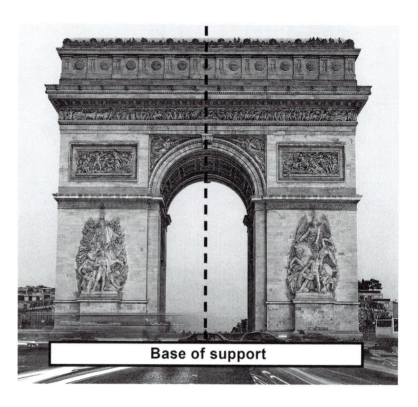

Base of support

If the center of pressure is within the base of support, the object is balanced. If the center of pressure is outside the base of support, the object will tip in the direction of the center of pressure.

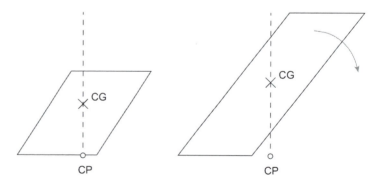

Balanced and unbalanced objects. The object on the right is unbalanced and will tip over.

When trying to work out whether an object will tip over, you can also think of it in terms of the center of gravity not wanting to shift away from the ground. If tipping would cause the center of gravity to move up away from the ground, the object will not tip on its own. If the center

of gravity doesn't have to go up in order for the object to tip over, the object will tip.

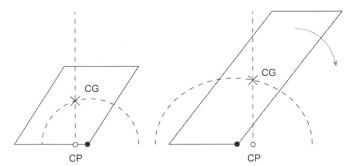

A wobbly toy with an egg-shaped bottom is a familiar example. This bottom-heavy toy wobbles but doesn't fall over because its CG is placed in such a way that the CG would rise if the toy tipped over.

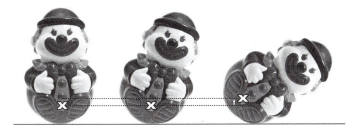

Lowering and Raising the CG

An object can be made more stable by lowering its center of gravity. This can be accomplished by placing weights in specific parts of the object.

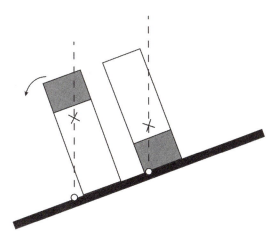

The box on the left is unstable and will tip, while the box on the right is stable due to a lower CG.

Friction

Friction is a force that resists motion when surfaces in contact move relative to one another. You experience friction every time you push or roll something across a surface.

At a molecular level, friction results from the reaction of charged particles between the two surfaces. Because there are so many surfaces that can come into contact with one another, there is a large variety of friction forces that can be generated, and exact calculations of friction are difficult to make. However, there are a few basic rules that you can use when planning your animation.

STATIC AND KINETIC FRICTION

Friction can prevent motion altogether. If you try to push something that isn't bolted down and it won't move, friction is what's keeping it in place. When you walk across the floor, it's friction that keeps your foot from sliding. Your foot pushes backward, and the friction between the floor and your shoe keeps the shoe from sliding and allows you to propel your body forward.

One way to understand the static friction is to imagine a world without it. What if everything you touched was covered in slippery oil, and the ground was made of ice? It would be hard to pick up or move objects, climb ladders and stairs, walk or ride anywhere, or even sit in a chair. Every time you shifted a little in your chair, you'd be in danger of sliding off it.

Static friction is the type of friction that keeps objects from moving altogether at the point of contact. Note that other parts of the object might be moving, but if the point of contact isn't moving, it's static friction. The friction between the floor and your shoe during walking is static friction.

Static friction is a big part of everyday life. It's the reason why stuff doesn't just slide all over the place all the time. When you're eating dinner, for example, a little bump to the table doesn't usually cause all the dishes and silverware to slide all over the place. There's enough static friction between the table and the dinnerware to keep things from moving very much.

Static friction plays an important role in action scenes. A character must push at the floor or other solid objects with his feet to jump, run, fight, push or pull other characters, etc. Without static friction, these motions wouldn't be possible.

There would be no martial arts without static friction, and without martial arts there would be no Jackie Chan movies. Let us be thankful that static friction exists on our planet.

Static friction makes it possible for wheels to roll. When force is applied to a wheel to move it forward, the part of the wheel in contact with the ground resists sliding, and the wheel "tips over" continually to produce a rolling motion.

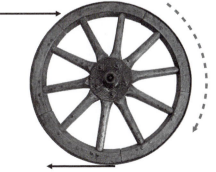

When you push a box, it might not slide but instead will tip. A tall box is more likely to tip than a flat box because it's easier to push its center of gravity off its base of support. See the Torque section for more about tipping.

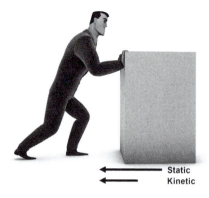

Static
Kinetic

While an object is sliding, the force resisting the sliding during motion is called *kinetic friction*. Kinetic friction is usually lower than static friction. This means that once you get that box sliding across the floor, it usually takes less force to keep it moving. Kinetic friction is sometimes called sliding friction.

FRICTION ON FLAT SURFACES

When the two contacting surfaces are relatively flat, friction is related to both the heaviness of the object and the roughness of the surface. Pushing a heavy box across a rough surface is harder than pushing a small stone across a smooth surface.

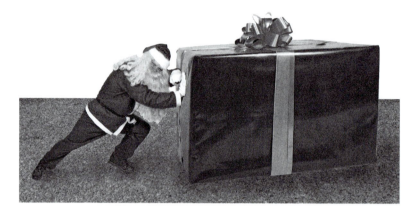

Note that the amount of friction is not related to the amount of surface contact. A tall box resists your pushing with exactly the same amount of static friction when standing up as it does when it's lying down. If surface contact is very small, the object is more likely to tip, but it still resists moving with the same amount of static friction.

FRICTIONLESS SURFACES

There is no such thing as a frictionless surface, but a few things come close. Here are some examples of object/surface pairs with very little friction between them:

- Puck on air hockey table
- Ice skates on ice

It's more likely that an animation task will involve ice than air hockey pucks. In life, there is always friction between any two objects, so objects in motion will always slow down eventually if no additional force is applied. However, the idea of ice being frictionless makes for great action in animation.

COEFFICIENT OF FRICTION

In physics, we measure the amount of friction generated between pairs of surfaces and get a number called the *coefficient of friction*. A higher coefficient of friction means more friction between the surfaces.

Material #1	Material #2	Coefficient of Friction
Aluminum	Aluminum	1.4
Copper	Cast Iron	0.29
Leather	Wood	0.5
Rubber	Dry asphalt	0.5–0.8
Rubber	Wet asphalt	0.25–0.75
Rubber	Dry concrete	0.6–0.85
Rubber	Wet concrete	0.45–0.75
Steel	Cast Iron	0.23
Steel	Lead	0.95
Hard Steel	Hard Steel	0.42
Steel	Zinc (Plated on steel)	0.45
Teflon	Steel	0.04
Wood	Wood	0.25–0.5
Wood	Wet Metal	0.2
Wood	Brick	0.6
Wood	Concrete	0.62

A coefficient is just a number you can use in multiplication to help you make calculations, or to help you understand the relative qualities of different things. In this chart, a pair of materials with a coefficient of friction of 0.25 is twice as slippery as materials with a value of 0.5. You can think of a coefficient as a fancy word for "a number you multiply by other numbers, or compare with other numbers, to help you figure stuff out."

The coefficient of friction is just a number on a scale. The number is useful mostly for comparison's sake—for different pairs of materials in your scene, you can look up the coefficient of friction for each one and compare them. The pair with the lower coefficient of friction is more slippery, and your animation should reflect this.

Note Teflon's low coefficient of friction with other materials, including itself. Also note that wet pavement is more slippery than dry pavement.

EFFECTS OF FRICTION
Another result of friction is wear and tear on an object. Each time an object comes in contact with something, bits and pieces of it wear off. After repeated encounters with another object, it will show visible wear in that spot.

A common side effect of friction is heat, sometimes a great deal of it. Rubbing two sticks together can set them on fire; tires skidding on the road can generate enough heat to melt some of the rubber off the tires.

Rolling resistance, a force related to friction, will bring any vehicle to a stop eventually. As a tire rolls, any given spot on the tire will squash slightly when it reaches the contact point between the tire and the road. Then the wheel turns and the tire recovers its volume in that spot, then the wheel goes around and the cycle begins again. Each time the tire squashes or regains its shape, energy is lost in the form of heat. If the car is coasting

and no additional force is applied, the vehicle will eventually come to a stop because of this energy loss.

The amount of rolling resistance a vehicle experiences is strongly related to how squashy the wheels or road are. Even metal and hard plastic have a degree of squashiness, albeit very small. You might have noticed that roller skates on a smooth, flat surface can go quite a way without any force, while a bicycle with a flat tire is very hard to pedal. A train with steel wheels on a steel track can coast for quite a while, but a car with low air pressure in its tires will stop of its own accord after a very short distance.

An elemental gas is a gas that appears on the Periodic Table of Elements (see the chapter on Matter and Masses). If it's not on this table, the gas is a composite of elemental gases.

Pressure and Gases

In physics, the three phases of matter are solid, liquid, and gas. If something isn't a solid or liquid, then it's a gas.

The most common gas you encounter in everyday life is air, which is actually a composite of many elemental gases such as oxygen and nitrogen. Other gases that are part of our experience are:

- Steam, which is water in gas form
- Carbon dioxide, which forms the bubbles in soda pop. Also, your body expels carbon dioxide when you breathe
- Helium inside balloons

The hallmark of a gas is that it can easily be compressed, unlike solids and liquids. An example is air in a bicycle inner tube, where air is compressed by forceful blowing of a large amount of air into a small space. The air inside the inner tube is highly compressed compared to the air outside the tube.

Gases can be compressed inside an elastic casing such as a balloon, tire, or raft, or inside a rigid casing such as an oxygen tank or helium tank. Air in the atmosphere can also be made to compress and expand. In nature, other types of gases can become compressed underground or inside plants or animals. Man-made chemical reactions can also cause gases to form and expand.

Compressed gas naturally seeks to expand. If there's a way out of the container, the gas will escape in an effort to reach the same pressure as the air on the outside of the container.

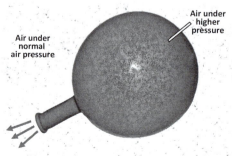

Air under normal air pressure

Air under higher pressure

When gas is under pressure inside a container that's designed to withstand a certain amount of pressure, the gas exerts a force on the container walls. The container, in turn, pushes back with an equal and opposite force, keeping the container closed and solid to keep the gas inside the container. In the case of an elastic container, the container is designed to expand but still hold the compressed gas inside.

In animation, pressurized gas just sitting around in a container or in the atmosphere isn't very exciting to watch because there's no visible action or motion. The real action happens when the gas pressure changes. A change to gas pressure can cause some pretty spectacular motion such as:

- Bomb explosion
- Rocket launch
- Strong wind
- Character sucked out of a flying airplane

Pressure is measured as force (weight) per area of the container. An example is pounds per square inch (psi), a measure commonly used to measure air pressure inside tires.

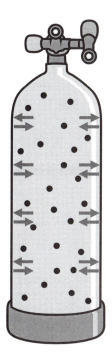

Each of these reactions is due to a sudden increase or decrease in gas pressure.

Increases in pressure are generally due to one of two causes: heat or chemical reaction.

Boyle's Law states that the pressure in a gas increases when the gas is compressed. When a gas is allowed to expand into a larger volume of space, the pressure decreases.

PRESSURE INCREASE FROM HEAT

When a gas heats up, its molecules move around a lot more, causing the gas as a whole to expand. This causes the gas's pressure to change, either increasing or decreasing in pressure depending on whether it's in a container.

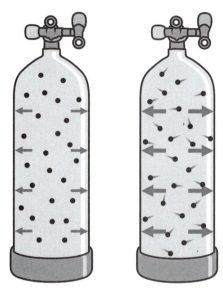

Normal pressure on container (left) and increased pressure due to increased molecular movement from heat (right).

Heated Gas in a Container

If a gas heats up when it's trapped inside a container, its volume can't change, so its pressure goes up. With enough pressure, the container can blow apart.

An example is an unbroken egg heated up in the microwave. The heat causes the embryo inside to give off steam, which puts enough pressure on the shell to blow it apart. This is one of the basic principles of explosions, which are covered in more detail in the Fire and Explosions chapter.

Egg exploding due to increased heat and pressure.

Gas expanding into a larger area, resulting in decreased pressure.

Heated Air in Atmosphere

When a heated gas isn't in a container, it has lots of room to spread out. Its volume increases, and its pressure decreases.

If a small amount of air gets heated, such as the air above your stove when cooking, the heat will simply expand and mix with the cooler air around it, and over a short time all the air in the house is again the same temperature and density. But in our atmosphere, large swaths of air can become "contained" within a region, preventing it from spreading out and mixing with other air around it. In the same way that a gas that is heated in a container increases the air pressure in that container, air in our atmosphere that is heated in a contained region can become a zone of high pressure as well.

Air in our atmosphere expands from heat, but it can only expand so much before it encounters an obstacle, such as another region of air or a mountain range, that prevents its expansion. If it can expand into enough space, its pressure goes down. But if it is contained by adjacent areas, its pressure goes up.

Another feature of heated gases is that if they expand enough, they become lighter than the gases around them and rise up. In a very simple weather

scenario, the Sun heats the ground, and then heat from the ground heats the air above it. The heated air expands enough to make it less dense. The heated air then rises, and cooler air around it moves in to replace it. The resultant difference in air pressure causes wind as the cool air rushes in.

The air in our atmosphere heats up not directly from the Sun's heat, but from heat given off by the ground below it.

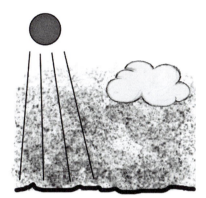

Air similar density & temperature but not all ground gets warmed

Air heated from ground expands

Hot air rises, denser air moves in

Since not all parts of the Earth heat up at the same rate, there are differences in the amount of heat coming off the ground, which leads to large regions of heated air that are trying to expand. Cooler air tends to be denser than hot, expanding air, which makes it sink toward the ground and cause additional changes in pressure and air movement.

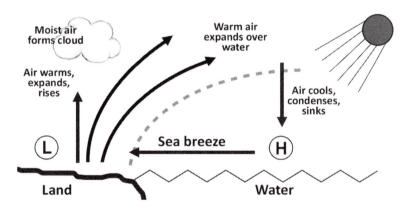

Formation of sea breeze.

Pressure changes cause a sea breeze, a light wind that often blows from the sea toward land in the late afternoon. Sea breezes happen because land heats up more than water on a sunny day. Warm air above the hot land rises and expands over the cooler water, leaving behind a low-pressure region. Because the air is moist near a body of water, a cloud is also likely to form.

The air over the water cools and sinks, creating a high-pressure region near the water's surface. Because high pressure always seeks to move into low pressure, the cool air over the water moves toward the hot air on land, creating the sea breeze.

Predicting weather is not always straightforward. Both hot and cold air pockets can develop and move in many different ways depending on time of day, temperature, lay of land, position on the Earth, time of year, behavior of regional winds, and so on. Weather moves and changes constantly; high- and low-pressure systems can move into and out of any area at any time, and there are as many variations on what can happen when air is heated and cooled as there are geographical regions.

The divisions of these areas are often shown in weather reports as "high-pressure" and "low-pressure" systems.

The variations on warm/cool and high/low pressure are many and often unpredictable, which is why the weather report isn't always accurate. Unless you're planning a career as a meteorologist, you don't need to know all these variations. The only thing you really need to know is that when a high-pressure and low-pressure system meet, with the boundary between these two systems forming either a cold front or a warm front, something is going to happen. The effects of these meetings can be quite large and can be felt not only as wind, but can cause sudden drops in temperature, intense precipitation, thunderstorms, and tornadoes.

In weather terminology, a *front* is a boundary between air masses of different temperatures.

CHEMICAL REACTION

A chemical reaction can also cause gases to form and expand. Burning wood is a chemical reaction that forms smoke; mixing baking soda and vinegar

produces carbon dioxide gas; a combustion engine works by repeatedly mixing air with a mist of fuel and sparking it up for a small explosion.

If the creation of gases takes place in open air and not inside a container, the gases expand into the air and thus are not under excessive pressure. Even so, the gases might be visible and would need to be animated in any scene that includes these types of reactions.

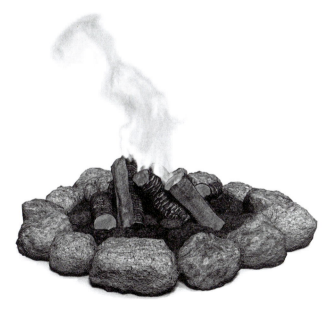

FORCE FROM PRESSURE DECREASE

If a container of pressurized gas is suddenly released, the compressed gas rushes out, creating a force in the direction opposite the rush.

Propellants work with this principle. A *propellant* is a liquid or solid that turns to gas easily and generates a large amount of gas in relation to the original volume of propellant. The gas is generated in a small space and is allowed to escape through a nozzle or other small opening. The gas, in rushing out very fast, can cause the object to move in the opposite direction. Propellants are used in rockets, guns, and aerosol sprays.

A puncture in a scuba tank creates the same effect—as the pressurized air quickly and forcefully expands out of the hole, it throws the tank in the opposite direction. This type of reaction is discussed in the Fire and Explosions chapter.

ATMOSPHERIC PRESSURE

The air around the Earth, called the atmosphere, is held to the Earth by gravity. The atmosphere fades away gradually the farther it is from the Earth's surface. Our weather is contained within an area about 50km/30 miles thick.

Aerosol spray works by using a pressurized gas to push out a fine mist of liquid particles.

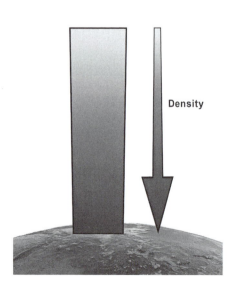

Density

The atmosphere is constantly being pulled toward the center of the Earth by the force of gravity. Because of this force, the air at the Earth's surface is under pressure from all the air all the way up to the farthest reaches of the atmosphere. This makes the air at the Earth's surface denser than air higher up. You can think of it as the air weighing more the closer you get to the Earth's surface.

Since the force from air pressure is pretty constant for objects near the surface of the Earth, it doesn't cause any visible motion to stationary objects. But if an object moves very far up in the air, it experiences a force due to changes in pressure.

A classic example is an airplane at flying altitudes, where the air pressure is much lower than on the surface of the Earth. The airplane's cabin is closed up tight before it takes off, creating a container for the normal air pressure on the ground. While the airplane is in the air, the air pressure inside the cabin is much greater than outside the cabin.

If an airplane door is opened at high altitudes, the pressurized air rushes out to equalize with the low-pressure air outside. This rush of air is short but quite violent—any loose objects close to the door, including the unfortunate person who opened it, might be pulled outside with the air. After a few moments the pressure inside and outside are equal, and the force is gone.

Air Resistance

When an object falls, it pushes the air underneath it, creating greater pressure under the falling object. This pressure then pushes back up at the object, slowing the fall. The pressure pushing back up is called *air resistance*.

A skydiver's parachute catches extra air resistance, causing the diver to slow down enough to make a safe landing.

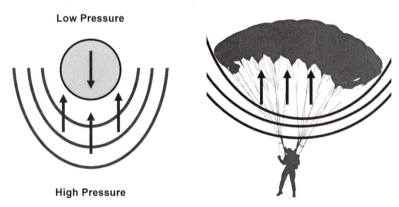

Low Pressure

High Pressure

You can read more about the Earth's atmosphere in the Earth and Outer Space chapter.

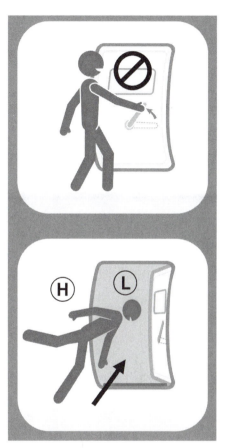

The amount of air resistance depends on the object's velocity and surface area. A skydiver can change the amount of air resistance on his or her body by assuming different positions while free falling, thus increasing or decreasing the speed of descent.

Skydiving positions for free fall.

As an object falls, air resistance builds up. At some point, the resistance reaches a level of force that keeps the object from accelerating any more. The speed at which this happens is called the **terminal velocity** for the object. Large raindrops, for example, have a terminal velocity of about 10m/sec, or 20mph.

Aerodynamic Lift

Air pressure is also why airplanes can fly. When air flows over an airplane wing, the air over the top of the wing moves faster due to the wing's shape. When air has to move faster, the pressure is less than when the air moves slower. Thus the pressure under the wing is comparatively greater, pushing up the airplane. This process is called *aerodynamic lift*.

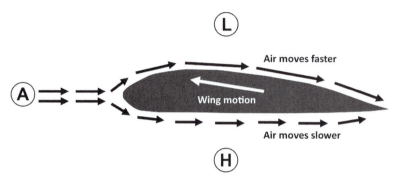

Air at atmospheric pressure approaches the wing, and separates into low and high pressure air.

An airfoil on a race car pushes it down for better friction. In this case, the "aerodynamic lift" is downward.

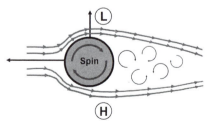

Air resistance can also affect objects thrown through the air, such as a baseball. If the baseball spins, its spin provides a force that goes against air resistance on one side, and complements air resistance on the other. This causes the ball to rise or dip depending on the direction of the spin.

Pressure Differences in Action

Differences in air pressure are responsible for forces in a variety of animation situations.

A vacuum cleaner operates from the principle of differences in air pressure. The vacuum creates a low-pressure area at one end of the hose, causing air at normal atmospheric pressure to rush toward the low pressure and suck up any objects in the air's path along with it.

With a tornado, high-speed winds create large pressure differences which cause strong forces that pull objects into the center of the tornado. Outside the tornado, air pressure is normal; inside the tornado, pressure is low. This pressure difference causes air from outside the tornado to rush to its center, pulling dust and debris with it.

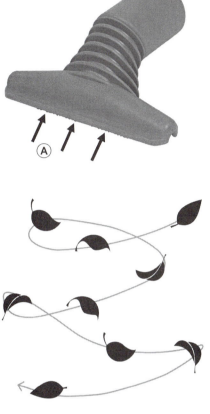

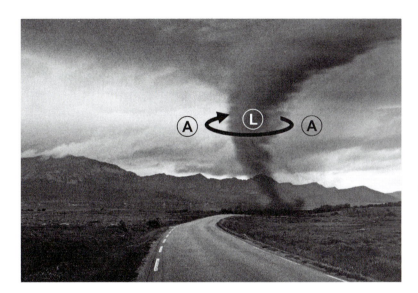

Aerodynamic lift and air resistance deflect a leaf's path of action. If there's no wind, the leaf slows when it rises and speeds up as it falls. The forces vary with the speed and angle of the moving leaf. The timing, spacing, and path of action are complex and unpredictable, but you can create a believable animation by interpreting the forces over the many instances of time.

Torque

Review:

• Classical Physics > Motion and Timing > Circular Motion

When a force on a hinged or jointed object causes rotation or a tendency to rotate, we identify this effect as *torque*.

Torque is the circular thrust or action that results when a force is applied to the object. Doors, scissors, wrenches, seesaws, crowbars, and even human limbs all operate with torque.

Motion of a door on a hinge.

Torque is the result of forces, but is not itself considered a force.

TORQUE BASICS

In the Circular Motion section in the Motion and Timing chapter, you learned that starting an object moving with circular motion requires two forces to be applied perpendicular to one another.

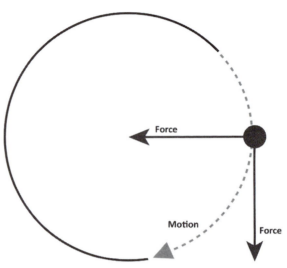

Consider a hinged door, where the hinge can be considered to be at the center of the circle and the edge of the door is at the outside of the circle. When you push the outside of the door to start it moving, the hinges exert a force to hold one end of the door while you push the other end. The resulting effect is circular motion of the door, and *torque*.

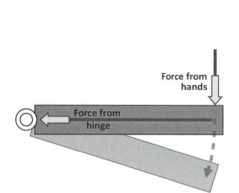

TORQUE TERMINOLOGY

Talking about torque is made easier by learning a few key terms. Here, we'll look at these terms as they apply to a hinged door.

- The hinge provides an *axis of rotation* for the object, also called the *pivot* or *fulcrum*.

- The door itself acts as a *lever*, which is defined as a rigid object connected to a pivot of some kind.

- The distance from the fulcrum to the point where the force is applied is called the *lever arm*.

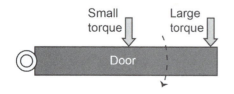

MAXIMIZING TORQUE

When learning to push open doors, you probably figured out early on that pushing the door at the edge farthest from the hinge requires less force than pushing in the middle. This is because the farther from the pivot that you push, the more torque is produced with the same amount of force.

You've also probably noticed that pushing directly perpendicular to the door produces the most motion, while an angled push doesn't work as well.

From these observations, you can see that the degree of torque depends on:

- The magnitude of the force, or how hard the lever is pushed or pulled
- The direction of the force, with a force perpendicular to the lever arm giving the most torque
- The distance from the pivot at which the force is applied, which might be less than the length of the lever itself

Pushing toward the hinge produces zero torque. In order to have torque, the force must be at an angle to the lever.

Visualizing Torque

To visualize the magnitude of the torque, you can draw a trapezoid, using the lever arm and force. The larger the trapezoid, the larger the torque.

A *lever*, by definition, is a rigid beam attached to a pivot. The beam can be any solid object that resists bending. A lever's axis of rotation is called the *fulcrum*.

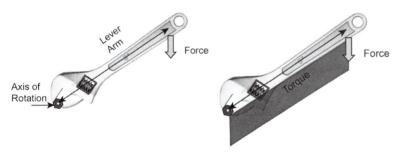

Torque is largest when the lever arm is long, the force is large, and the two are perpendicular.

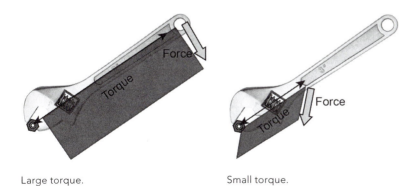

Large torque. Small torque.

Calculating Torque

When the force being applied is perpendicular to the lever, the formula for torque is expressed as the radius times the force being applied.

$$T = rF$$

Here, *radius* means the length of the arm or lever being used. It's called radius because it's actually the radius of the big circle around which the force is being applied as the object moves in a circular pattern.

From this formula, you can see that if you increase the radius, the torque goes up. This means that if you get a longer wrench, you can apply less force and get the same torque. Or, you could apply the same force with the longer wrench and get a greater torque. If you apply force closer to the center of the circle, you'll get less torque.

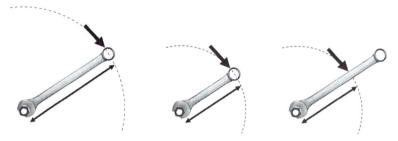

Torque is affected by radius of circle of movement. With the same force applied to all three wrenches, the torque produced on the middle and right wrenches is less than the torque produced on the left wrench.

LEVER SYSTEMS

Levers are important in engineering because they provide a way to convert a small force into a larger force in the same direction, or into a force in the opposite direction.

The force pushing on the lever is called *effort*. The object or weight being moved by the lever is the *load*. Each provides torque in opposite directions. If the effort torque is greater than the load torque, the lever will start rotating in the direction given by the effort.

The distance from the fulcrum (pivot) to the place where the force is applied is called the *lever arm* or *effort arm*. The distance from the fulcrum to the load is called the *load arm*.

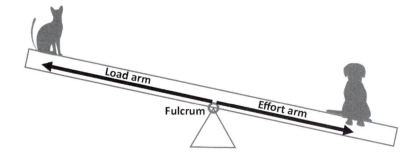

The term *lever* can mean more than just the rigid bar, beam, or board being moved. If you do additional research on levers outside this book, you will sometimes find the term *lever* being used to refer to a lever system that includes both the rigid bar and the fulcrum. In this text, to avoid confusion, we refer to the rigid bar as the lever, and the lever-and-fulcrum set as a *lever system*.

Efficiency vs. Speed

There are many ways to construct a lever system, each with unique advantages and disadvantages. In general, the farther the effort is from the fulcrum, the less force you have to apply to make the lever move.

Efficient/Slow Lever Systems

When the fulcrum is closer to the load than to the effort, the lever system is said to be efficient but slow. A small force is needed to move the lever, but the lever moves the load by a smaller distance than the effort does.

In physics, the term *simple machine* means a construction that converts a force into another force, changing the direction or magnitude of a force. A lever system is considered to be a simple machine, classified in the same grouping with wheels, pulleys, and other basic devices. Lever systems have been in use ever since our ancestors discovered they could move a heavy boulder by prying underneath it with a solid, heavy stick (lever) resting on a small rock (fulcrum).

With lever systems, the term *efficiency* refers to force efficiency. A more efficient lever requires less force to move the load than an inefficient lever.

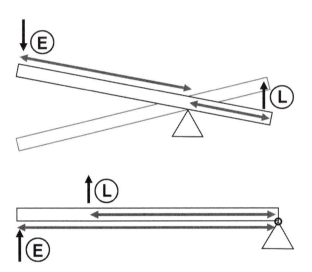

Efficient but slow lever systems.

Efficient/slow lever systems provide a larger mechanical advantage, putting out more force at the load end than is exerted at the effort end. Such lever systems are ideal for everyday tools that convert normal human force to a larger force that can perform tasks you can't do with your hands alone. A set of pliers is an example of such a lever system, converting the force from normal human strength to a big enough force to unscrew tight bolts.

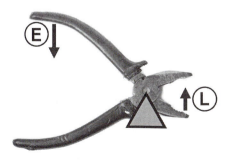

Inefficient/Fast Lever Systems

When the effort is closer to the fulcrum than the load is, the lever is said to be *inefficient* but *fast*. A large force is needed to move the lever, but the load moves very quickly relative to the movement of the effort.

The term *mechanical advantage* is used to talk about the amount of return you get on your investment of force with a lever system. A larger mechanical advantage means you can produce a bigger force on the load end than you expend on the effort end. This term is also used when talking about other types of machines like gear systems and pulleys.

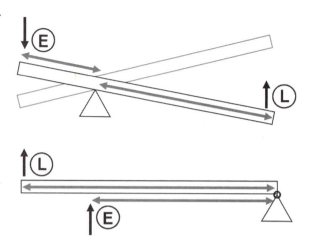

Inefficient but fast lever systems.

Inefficient/fast lever systems have a smaller mechanical advantage, where the force you get back is smaller than the force you put in. Still, such levers are useful in everyday tools where it's advantageous to sacrifice force for speed. A broom is an example of a lever system of this type. When you use a broom, you want the sweeping end of the broom to move faster than your arms. A broom doesn't weigh much, so the force required from your arms to make this happen is easy enough to provide.

Neutral Efficiency

If the load and effort arms are the same length, the lever system has neutral efficiency. A playground seesaw has neutral efficiency because the fulcrum is in the center of the lever, making the load arm and effort arm the same length.

LEVER SYSTEM CLASSES

Lever systems can also be classified according to the relative locations of the effort, load, and fulcrum.

First Class Systems

With a first class lever system, the fulcrum is between effort force and load. They can be either efficient/slow or inefficient/fast, depending on whether the fulcrum is closer to the load or the effort force.

Scissors and crowbars are examples of first class levers.

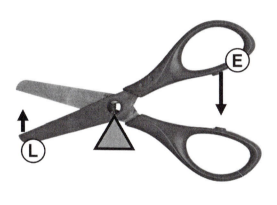

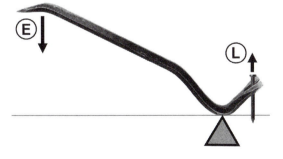

Second Class Levers

In a second class lever, the fulcrum is on one end, the effort force is on the other end, and the load is in between. Because the load always moves less than the effort force, second class levers are always efficient and slow.

Examples of second class levers are a wheelbarrow and a hole punch.

A seesaw rocks when the forces on each side alternately change. With two children of equal weight, one child temporarily lowers the force from her weight by pushing off the ground. At the same time the full weight of the other child pushes down on her end of the seesaw, causing her side to lower to the ground. Then the child on the ground pushes off, the opposite side experiences more force than the pushing side and lowers to the ground, and the cycle continues.

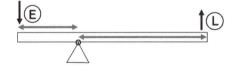

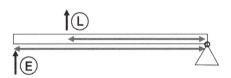

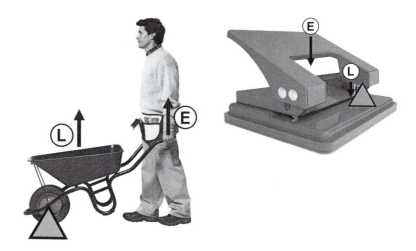

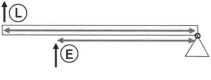

Third Class Levers

In a third class lever, the effort force is located between the load and the fulcrum. Because the load always moves more than the effort force, third class levers are always inefficient but fast.

Examples of third class lever systems are a broom, tweezers, the human elbow, and the human jaw.

In your elbow, the effort arm, which extends between your elbow and where the upper forearm attaches to the muscle, is quite small. The effort force can move the load (your forearm, wrist, and hand) a long distance. When you pick up a heavy item, you add even more to the load.

In the human jaw, strong muscles in your cheeks pull at the jawbone so you can open and close your mouth quickly. The fulcrum is located where the jawbone meets the skull.

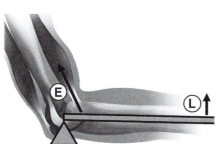

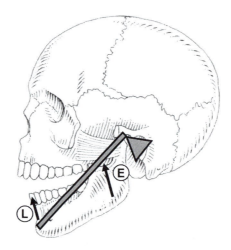

BALANCING TORQUE IN A LEVER SYSTEM

Suppose the load and effort forces are unequal, and you want the lever to balance. This means you need equal torques on both sides of the fulcrum. Recall that the formula for torque is:

$$T = rF$$

Torque = Radius * Force

Here, the radius refers to the distance from the fulcrum. In order to balance a lever system where one force is larger than the other, the radius on the larger-force side of the fulcrum needs to be cut down to a proportional fraction of the radius on the side with the smaller force.

For example, suppose you have a 10-pound cat and a 20-pound dog on a balanced seesaw. The 20-pound dog exerts twice as much force on the seesaw as the 10-pound cat. In order to have both animals create the same amount of torque and thus balance the seesaw, the dog's radius (distance from the fulcrum) would have to be half the cat's radius.

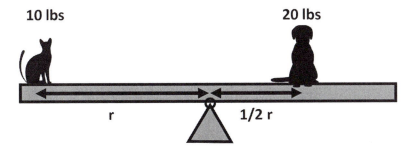

If you have characters interacting with a lever system in your animation work, keeping in mind the relationship between force (weight) and radius (distance from fulcrum) will help you convey a sense of the weight of your characters and objects.

INCREASING LEVERAGE

Leverage is defined as *the action of a lever, or the increase in force gained by using a lever*. Increasing leverage results in an increase in mechanical advantage.

You can increase leverage in a couple of different ways:

- Move the load closer to the fulcrum
- Move the effort farther from the fulcrum

An example of increasing leverage can be seen in the action of removing a nail with a crowbar. Less force is required to remove the nail if you can get the nail (the load) closer to the fulcrum.

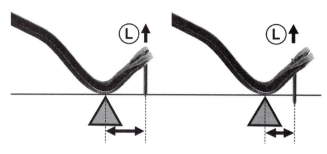

Moving the load closer to the fulcrum increases leverage.

Torque in Animation

A tipping action can be viewed as torque in action. On a tipping object, suppose the only force acting on it is gravity. As the angle changes, the amount of torque changes. At a shallow angle, there is less torque acting on the object. As the angle deepens, the torque increases and the tipping motion speeds up.

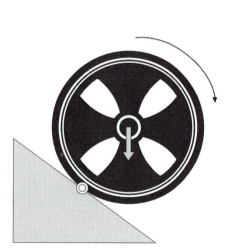

Wheels slow-out when rolling downhill (and slow-in rolling uphill) due to the torque produced by the force of gravity. Unlike tipping motion, the torque on a wheel rolling downhill is constant, so the acceleration is constant.

ROTATIONAL INERTIA

The Law of Inertia (Newton's First Law) tells us that an object tends to keep on doing what it's doing unless a force acts upon it. Rotational inertia is an object's resistance to turning. The greater an object's rotational inertia, the more it resists acceleration from torque. A heavier object has greater rotational inertia.

Rotational inertia is determined not only by an object's weight, but also by how the weight is distributed within the object. For the same torque, an object

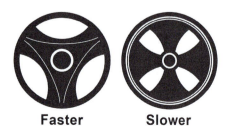

Faster **Slower**

with more weight at its center rotates faster than a similar object with its weight far from its center. For example, a wheel with most of its weight at its center rolls downhill faster than a wheel with its weight shifted to its edges.

Two metal pipes with the same overall mass can be made to have different rotational inertia by placing more of the weight at the pipe's ends. The weighted pipe will have a greater rotational inertia and will resist rotation more than the pipe with an even weight distribution.

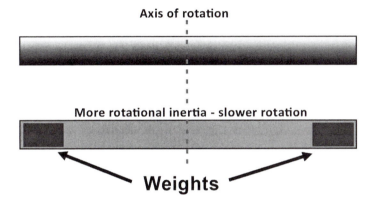

Tightrope walkers use this physics property to help them balance. A long pole with weights at the ends is more resistant to rotating, and slows the tightrope walker's rotation when he goes off balance.

Action/Reaction

Newton's Third Law states that for every action, there is an equal and opposite reaction. We can clarify Newton's Third Law a little further:

- For every action *force*, there is an equal and opposite *force*.
- Action–reaction forces always occur in pairs, with the same magnitude but opposite direction.
- The action and reaction always occur simultaneously on different objects or characters.

If you've ever punched a wall, you have a sense of action/reaction. Punching a wall hurts! The wall exerts an equal and opposite force back at your hand, causing pain and possibly injury.

ACTION/REACTION AND BALANCED FORCES

Recall that when forces are balanced, an object is either unmoving, or moving at a constant speed. A pair of forces balance when they are:

- Equal in magnitude
- Opposite in direction
- Acting on the same object

In order for acceleration to occur, unbalanced forces must be present. The two forces of an action/reaction pair never balance each other because they always act on different objects or characters. This means that an action/reaction pair of forces can cause acceleration.

ACTION/REACTION WITH TWO MOBILE OBJECTS

Suppose you have two characters who weigh about the same, standing on skateboards next to each other. They each hold up a hand and push against

In older movies, you would sometimes see people punching each other out with bare fists and walking away without any apparent injury to their hands. Modern shows and movies are getting better with this, often showing the hitter cradling his hand after a punch while exclaiming how much it hurts.

the other, causing them to roll away from one another in opposite directions. If each character pushes with the same amount of force each time, who will roll the farthest if:

1. The first character pushes while the second character holds his hand still?

2. The second character pushes while the first character holds his hand still?

3. They both push with the same force?

In the first two scenarios, the characters will roll apart by the same distance. Because of the action/reaction principle, both characters experience an equal amount of force each time. In the last scenario, they'll move twice as far apart because double the force is being applied.

ACTION/REACTION AND WEIGHT

So far, we have looked at characters with similar weight. In the last scenario, each character rolls about the same distance from the center point. The distance they roll will be different if one character is heavier than the other.

Recall that the Law of Acceleration, Newton's Second Law, states that force equals mass times acceleration.

$$F = ma$$

This means that if the same amount of force is applied to two objects with different weights, the heavier object will accelerate less.

In the example of the skateboard characters, if one character is heavier than the other, the heavier one will move slower than the lighter one. Even though the force is the same on the two characters, the acceleration is less on the heavier character.

Lighter Heavier

Fight scenes are a common example of the action/reaction with two mobile objects in both live action and animation. You can learn more about how to animate these types of scenes in the Getting Hit section of the Character Animation chapter.

ACTION/REACTION AND FIXED OBJECTS

The objects involved in a pair of action/reaction forces can include a fixed object such as the ground, a floor, or a wall. Such action/reaction forces make dynamic character motion possible. As the character pushes against the fixed object, the fixed object "pushes back" and causes the character to move.

For example, if you bend your knees and push against the ground, the equal and opposite reaction will cause your body to jump in the air.

While it might seem strange to think of a fixed object pushing back at you, thinking of it in this way will help you understand the forces at play in character motion.

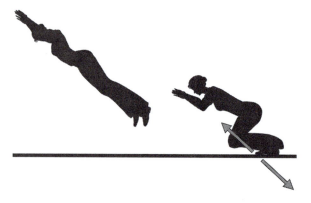

Note that an action/reaction force is not always straight up and down.

When a character walking exerts a force on the floor during a step, the immediate reaction is force exerted from the floor to the character's foot. If the character is unable to exert the force (due to a slippery floor, weak muscles, or other factors), then the character cannot walk.

If a character is going to push or pull an object with any noticeable weight, there must be a fixed object the character can brace against with enough friction, such as the floor or ground. Only then can the character get enough reaction force from the floor or ground to counteract the reaction force from the object being pushed or pulled.

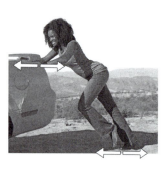

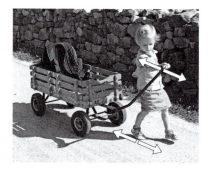

In animation, this use of action/reaction is key to animating any kind of character action. As an example, in a rescue scene where one character pulls another to safety, the character doing the pulling needs a solid surface to brace against when pulling the other character. Only then will the forces be right to allow one character to pull another.

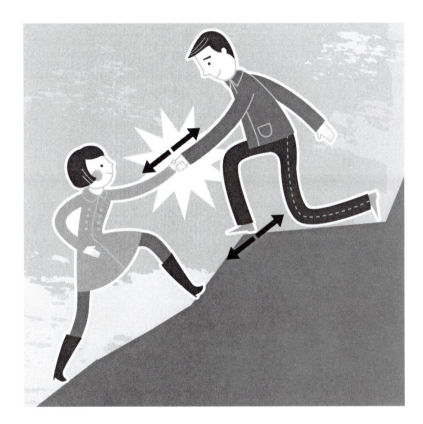

Electricity and Magnetism

Electricity and magnetism are closely related. Let's take a look at how they work, and how understanding them can help you make better visual effects and animation.

ELECTRICITY

What do you think of when you visualize electricity? Perhaps you see long, jagged streaks of light passing through the air like mini lightning flashes. Let's take a look at what electricity is really made of, so we can look at ways to represent it visually.

Electrical Charge

There are two types of electrical charges: negative and positive charges. Like charges repel, while opposite charges attract each other. In other words, two negative charges will repel each other, as will two positive charges. Conversely, negative and positive charges are attracted to one another.

Electrons carry negative charge, while protons carry positive charge. Electrons are loosely bound to atoms and have some freedom to move around, while protons are tightly locked within the nucleus. Atoms like to be neutral with an equal number of protons and electrons, but with relatively little force atoms can gain electrons to become negatively charged, or lose electrons to become positively charged. Protons, on the other hand, never go anywhere unless a huge amount of force is applied.

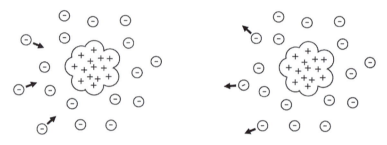

Atom becoming negatively charged (left) and positively charged (right).

Static Electricity

When an object is simply gathering electrical charge and electricity isn't flowing, this is *static electricity*. The electricity is there, waiting to do something, but nothing is happening externally (or visually). You see the effects of this electrical charge only when a positively charged object touches or comes close to a negatively charged object, making the electrons jump to the positive side. When this happens, it creates a flow of electricity. This is called a *discharge*. A discharge results in a neutralization of the negative and positive sides, and the electrical flow ceases.

You can generate static electricity on some household objects with friction. Polyester clothing tends to build up static electricity in a dryer, causing the clothes to stick to one another. You can rub a balloon on your shirt to generate enough charge on the balloon's surface to make it stick to a wall for a short time. If you shuffle across a carpet, you might get a shock when you touch a metal doorknob due to the electrical discharge.

Everyday discharges from static electricity are generally quick and weak, generating perhaps a faint spark and a light popping noise. You can sometimes see this spark in the dark, but it's so faint as to be invisible in daylight.

Flowing Electricity

Electrons flow by jumping from one atom to another within a medium. Household electricity is basically electrons being drawn or pushed through a wire in this fashion.

To understand how this works, let's look at a metal wire. Suppose there's a lot of negative charge at one end of the wire and a lot of positive charge at the other end. Since opposites attract, the electrons are attracted to the positive end, and they start to jump from one atom to the next in a flow toward the positive end.

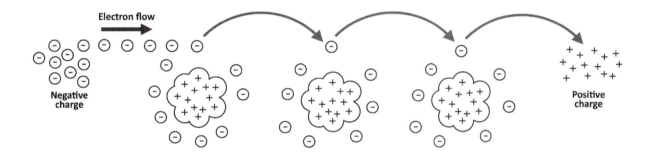

Electrical flow can also occur from positively charged atoms moving to seek electrons. Either type of flow, whether it's negatively charged electrons or positively charged atoms that are moving, creates electrical current.

In order for electricity to keep flowing, there needs to be a steady supply of positive charge at one end and negative charge at the other end. This is the principle behind a battery, which has positive charge at one end and negative at the other. As soon as some kind of circuit is set up between the positive and negative sides, electrons start to flow toward the positive end, generating electricity.

In the early days of harnessing electricity for use, it was made to flow only one way. But today, most electricity in everyday use, such as the electricity in household appliances, actually works with electricity continually being pushed and pulled back and forth. You don't have to understand the mechanism behind this to represent electricity in animation—the visual results of electricity are the pretty much the same regardless of the direction of flow, or whether it goes one way or both ways.

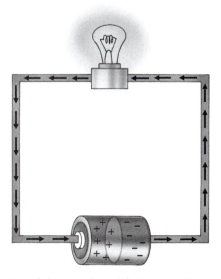

Flow of electrons through battery circuit.

Conductors vs. Insulators

Electricity moves well through some substances like metal wiring and salt water, so these substances are called *conductors*. Electricity doesn't move well through substances like rubber, paper, plastic, and styrofoam. These substances are called *insulators*.

Certain metals make good conductors because they have loose electrons. Copper atoms, for example, have an extra electron that hangs out outside the rest of the atom, only loosely attached. This electron is able to easily jump from one atom to the next.

Recall from the Matter and Masses chapter that atoms like to have a certain configuration of electrons, with different numbers of electrons arranged in a "shell" around the nucleus. Atoms like to have two electrons arranged closest to the nucleus, then eight electrons in the next one or two levels, then 18 in the outermost levels.

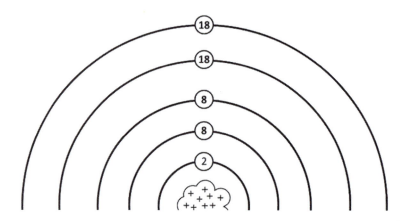

If one of the shells isn't "filled" (i.e., it doesn't have the maximum number of electrons), the electrons are a bit loose and can move easily from one atom to the next. Elements with unfilled outer shells are great candidates for conductors. (There is a lot more to this subject, such as sublevels within the shells and so on, but this basic explanation is enough for you to understand conductors and insulators.)

Copper, for example, has an atomic number of 29, so it has 29 protons and 29 electrons. If you do the electron arrangement for copper by the shells, you find that it has an outermost shell with just one electron. This electron is relatively far from the nucleus and isn't bound very tightly to it, making it easy to dislodge. It is believed that this loose electron is what makes copper such a great conductor.

Copper (Cu)
29 = 2 + 8 + 18 + 1

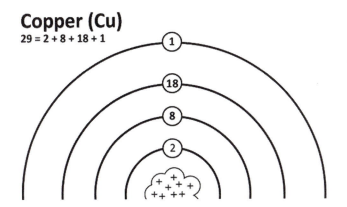

You might wonder how copper can continue to be copper while electrons are continually coming and going. Remember that an element is what it is because of its number of **protons**, not the number of electrons. An element can lose and gain electrons all day and still be what it is. If a copper atom finds itself missing its loose electron when the electricity stops flowing, it will just grab whatever electrons are around in the air and settle into its usual 29-electron state.

Knowing about this property of elements with loose electrons, you can make basic predictions about the conductivity of various elements that appear in your animation.

With a conductor, electrons not only flow along the conductor but also move quickly to the surface of the object. With an insulator, electrons transferred to the object stay stuck inside the object. If a conductive substance is used for electricity, it is common for an insulator to be wrapped around or attached to it to make it easy for human handling without electrical shock. An example is electrical wiring for a household appliance, which is usually covered with a plastic or rubbery tube.

Electric Current

Voltage is the measurement of the difference between the amount of positive and negative charge at each end of the electrical flow. You can think of voltage as the amount of "push" the electrical current gets through the conductor.

Every medium that electricity passes through offers some *resistance* to the flow. Electrons are always moving around randomly, but this doesn't make electricity. The electrons in the outer shell need a push to get moving in the direction that will cause electricity to flow, and they *resist* moving in that direction to some degree. Copper electrons resist this push very little, but there is some resistance nonetheless.

The amount of effective flow that occurs despite the resistance is measured as *current*, expressed as amperes or amps. Resistance is measured in ohms. The ohm measurement is named after George Ohm, who also came up with Ohm's Law for calculating voltage, resistance, and current:

Electrical Current = Voltage/Resistance

This formula means that you can figure out if the current, resistance, and voltage are going up or down when one of these components changes. In general, current moves in the same direction as voltage, and the opposite direction to resistance.

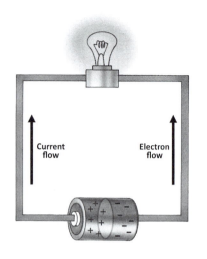

Hold Fixed	Change	Result
Voltage	Resistance ↑	Current ↓
Voltage	Resistance ↓	Current ↑
Resistance	Voltage ↑	Current ↑
Resistance	Voltage ↓	Current ↓

If electrons are flowing in one direction, the current is shown on electrical diagrams as flowing in the opposite direction. This is because in our earliest understanding of electricity, back in the Ben Franklin days, it was thought that all flow was positive to negative, and the notation has stuck. If you think about it, it still makes sense—in the same way that multiplying two negative numbers gives you a positive number, negatively charged electrons moving to the left creates a net positive result to the right. We just wanted you to know this in case you ever have to look at an electrical diagram in the course of your work.

In medicine, the term *nervous* means *having to do with nerves*, not the everyday definition of *jumpy or jittery*.

The effects of a lightning strike on the human body are covered in more detail in the Lightning section of the Environment chapter.

Electric Shock

If you touch a conductor, you can introduce electricity into your body. If the electrical current is sufficient to cause injury, this contact is called *electric shock*.

Human skin is a pretty good conductor, especially when it's sweaty. The salty water in sweat provides additional conductivity. The conductivity of our skin is the reason we can get electric shocks.

Human bodies, and most animal bodies, have nervous systems that utilize electricity to pass signals through the body. The electrical flow is generated from a chemical reaction within the body.

Electric shock can range from getting a tiny ping from a car door to being zapped by an open wire, struck by lightning, or electrocuted (death by electric shock). The electricity that moves through the body follows the path of least resistance, which unfortunately is sometimes through the nervous system's existing pathways.

The most serious damage to a body from electric shock is primarily from its effect on the nervous system, not heat from the electricity. If the electric shock disrupts the signal that contracts and relaxes the heart muscle, it stops flow of blood to the brain and causes death in minutes.

Human nervous system.

Current (amperes)	Effect
0.001	Can be felt
0.005	Painful
0.010	Involuntary muscle spasms
0.015	Loss of muscle control
0.070	Fatal if more than one second long

Effects of electric shock on human body.

Because electric shock causes muscles to contract, it can be used to fool dead muscles into moving. For example, you can zap the leg of a dead frog and make the leg muscles contract, which makes the leg itself twitch. Even though the frog is definitely dead, the nervous system still reacts to electricity.

When a storm is brewing, air pressure drops and the air has more electricity in it. These subtle changes can often be felt by animals long before human beings detect them, which is one reason why dogs get a little crazy before a storm. Dogs can also hear thunder before we do.

Sparks and Lightning

When an object is charged, the charge leaches out into the air over time. If a positively charged object is near a negatively charged one, the charge escaping from the objects can meet up somewhere between them, causing a flow of electricity through the air. This flow is visible as a jagged line of light (a spark). The air around the spark briefly heats up and expands faster than the speed of sound, making a popping or cracking sound.

In the case of everyday sparks like the one you get from putting your hand near a doorknob, the difference in charge is neutralized (discharged) and you can touch the doorknob a few seconds later without incident. But if both objects are continually being charged, sparks will continue to fly.

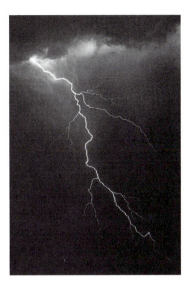

Lightning is basically a large spark going from a cloud to the ground. Lightning is covered in more detail in the Environment chapter.

MAGNETISM

A magnet is an object that attracts or repels certain other objects with an invisible force. Magnets and electricity are often found together, and can work in tandem to produce a variety of forces.

In physics, a *field* is a region or area affected by a force. For example, we are all affected by Earth's *gravitational field*.

Magnetic Fields

A magnet is surrounded by a magnetic field. A magnetic field has circular contours that indicate the directions along which objects are attracted or repelled, but it doesn't really have a "flow" associated with it in the way electric current does. It's just a region where objects can be affected by the magnetism.

With magnets, we label the ends of the flow North and South to differentiate them. Each end is called a *pole*. The North pole of an object is attracted to the South pole of another object. Conversely, the North pole of one object repels the North pole of another object.

A household magnet is often U-shaped to create a stronger magnetic force between the North and South poles. The fields generated by each pole cross and magnify one another, creating a larger force than a single end of a bar magnet.

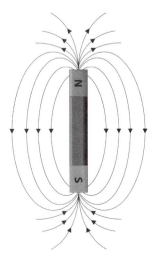

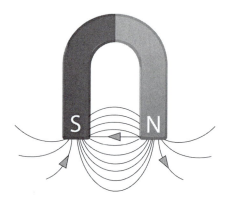

Note that an electrically charged object just sitting there without any current flowing through it does not produce a magnetic field. It's the *flowing* current that produces the magnetic field.

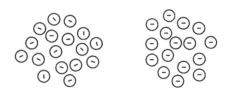

Unaligned electron grouping found in most elements (left) and aligned electron grouping in certain elements like iron (right).

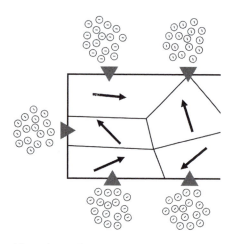

Aligned groupings.

A magnetic field can be produced by electricity. Current flowing through a wire produces a magnetic field that loops around the wire.

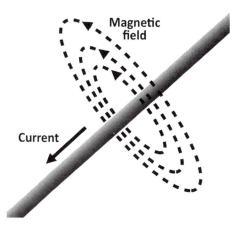

Making a Magnet

Magnetism can also be locked into an object so it continues to attract or repel other objects after the electrical current is gone. This is only possible with certain substances like iron. This is how permanent magnets are produced, and how a magnetized nail stays magnetized for a while.

At an atomic level, electrons are held close to a nucleus because of an electrical charge. In any object, these atoms spin and produce a small magnetic field, but the fields are so randomized that they cancel each other out. But in some substances like iron, the electrons like to form groupings where all the electrons point the same way, and each group produces a small magnetic field flowing in the same direction.

If all the groupings are then made to start pointing the same way, the magnetic fields produced by the alignment multiply and amplify until the field is strong enough to attract or repel entire objects. At this point, you have a magnet.

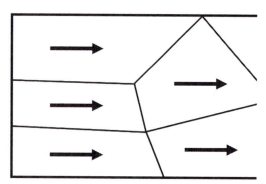

A *ferromagnetic* substance has electrons that like to form domains and thus make it possible to create a magnet. Iron, cobalt, and nickel are ferromagnetic.

You can make a ferromagnetic object into a permanent magnet by putting it close to another magnet for a long period of time. You can also create a magnet using electricity, by putting the ferromagnetic object near the magnetic field generated by the electricity.

Electromagnets

An electromagnet is a magnet that is constantly being created by a running current. Running a current through a coil creates a strong magnetic field around the coil.

For the purposes of scientific discussion, physicists call these aligned groups *domains*.

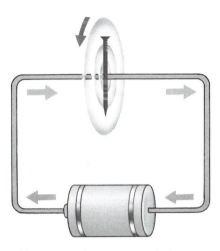

Nail being turned into a magnet by being placed close to electric current.

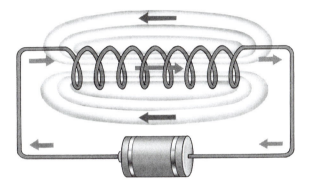

Electromagnet.

Many kitchen appliances use a combination of electricity and magnets to generate the force that runs the appliance. In one type of simple motor, a rectangular wire attached to a spindle sits between two magnets. When current runs through the wire, the magnetic field generated by each side of the wire is either attracted to or repelled by the magnet, causing the wire to turn. After the wire turns 180 degrees, the side that was being attracted is now repelled, and vice versa. In this way, the spindle is made to turn. The turning spindle can be attached to a hub with spinning blades, as in a blender or coffee grinder.

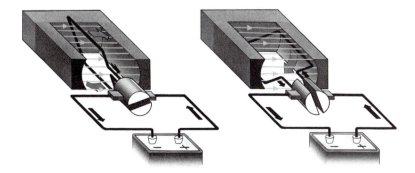

To oscillate is to move back and forth in a repeating motion. Oscillating electric and magnetic fields produce familiar electromagnetic waves such as radio waves, microwaves, and visible light.

While an electrical current can produce a magnetic field, the reverse is also true: a moving magnetic field can create an electrical current, or affect an existing current. This is called *induction*.

When a current is induced by an oscillating magnetic field, that current in turn produces another magnetic field opposite the first one. This effect is called *self-induction*.

In a power generator, a moving magnet generates electricity. This is the opposite of a motor, where electricity moves magnets.

Demagnetization

Heating a magnet randomizes the domains, reducing the magnetic field. You can also demagnetize a magnet to some degree by dropping it onto a hard floor. The shock of impact will randomize some of the aligned electrons and thus reduce the magnetic field. If you let the object sit undisturbed for a while, it will sometimes reorder its electrons and get magnetic again.

Computer hard disks store information by magnetizing (or demagnetizing) a tiny portion of the media (a byte). Each byte is a 0 or 1 ("off" or "on"). A string of many thousands or millions of bytes uniquely define a document, picture, or any other kind of file. A strong magnet near a storage device can scramble the saved data without physically affecting the drive.

Videotape also stores information with magnetization. A videotape can be erased quickly by putting it near a strong magnet.

VISUALIZING ELECTRICITY AND MAGNETISM

Electricity and magnetism remain somewhat mysterious to the general public, making them great fodder for action in animation and films.

Electric Shock

Getting a strong electric shock doesn't actually cause a person to light up or give off sparks, but this doesn't stop filmmakers and animators from representing electric shock with wild jagged lines of light and even a glowing skeleton. A more likely result from electric shock is rapid shaking or twitching and hair standing on end, but that's not nearly as interesting to watch.

Electricity is magic! It even brings the dead to life.

If you believe the Frankenstein stories, electric shock can even bring a patchwork of dead human parts to life.

Electric Current

In the film *Iron Man 3*, after 13 people are pushed out of a flying airplane, Tony Stark rescues them by having them grab onto each other and create a human chain. To keep them hanging on until they reach a safe landing, he sends electricity through them so they won't be able to open their hands.

While a current could cause a muscle contraction in a hand, in reality the exact current needed for each person would vary based on gender, skin conductivity, muscle mass, and so on. Not enough current and their hands wouldn't clench; too much current and they could suffer heart attacks, burns, and organ damage. Stark would have had to control the electrical current through 13 people at once, a feat that is highly unlikely to be successful. But since we've already bought into the idea of a man with an iron flying suit, we can certainly believe, if only for a few minutes, that Tony Stark can control electricity like this. This rescue is often cited as the best scene in the movie.

Magnetism

Since magnetism is invisible and can go through walls, it's a great tool for messing with objects locked up in police storage rooms. Evidence from crime scenes is kept under heavy guard, but if you have a strong magnet you can destroy it! Well, at least you can in Entertainment Land.

In the TV series *Breaking Bad*, the characters wish to destroy a computer hard drive being stored in an evidence storage room, so they park a truck housing a strong magnet outside the police station. As they crank up the magnet's power, small, light objects like paper clips and hanging light fixtures start to

respond. Next, entire boxes of evidence fly at the wall and stick to it. Finally, the metal shelves nearest the wall fall over. When the characters shut off the magnet, everything stuck to the wall falls to the floor. Needless to say, the mission was successful.

In the film *The Big Easy*, a magnet is used in a clever way to destroy videotape evidence. A police officer knows of a videotape in the police station's evidence room that will prove him guilty of a crime. To solve this problem, he disguises himself as a thug and throws a strong, heavy magnet through a local business's window. When the police investigate the vandalism, the magnet is stored in the evidence room next to the videotape, wiping it out.

EMPs

A strong, rapidly fluctuating magnetic pulse induces high voltage, causing strong electrical currents. An electromagnetic pulse (EMP) like this is a plot device frequently found in films. Nuclear bombs, lightning, meteors breaking up in the atmosphere, and power line surges can all cause EMPs. Less dramatic EMPs are caused by ordinary motors and engines.

CHAPTER **4**

Light and Color

Light and color, along with gravity, are perhaps the most important physics subjects for your animation toolbox. As students of art, we spend a considerable amount of time pondering how light and color can be portrayed to communicate time of day, environment, and physical temperature, and subtler concepts like depth and mood. Our lighting and color decisions develop from these factors, not from the laws of physics.

There are plenty of real-life light and color variations to choose from to communicate a mood or location artistically. Light/color that follows the laws of physics enhances a story and keeps viewers engaged, while unrealistic setups can distract your audience and keep them from following the story. Understanding the physics of light and color can help you choose the right setup that will deliver your artistic vision while still ringing true to your audience as physically possible.

The frost on the windows and the light pattern produced by the lantern on the wall tell us about time of day and environment while obeying the laws of physics.

Light and color are important in all the visual arts, from painting to cinematography. In animation, light can not only illuminate your scenes, but along with color it can be a factor in storytelling. In this chapter, we discuss the physics of light and color as they pertain to visual representation.

Light Basics

In physics, *Optics* is the study of the behavior of light, including how light works with sight. The study of optics includes these topics:

- Light sources—Things that produce light, such as the Sun or a lamp
- Shadows—Dark areas of objects that receive less light than neighboring areas
- Reflection—Light bouncing off an object. Specular reflection bounces off an object at the same angle it hits it, as with a mirror. Diffuse reflection bounces at random angles, as with a rough surface such as the Moon
- Refraction—Light changing direction when it passes through a transparent material, as through water
- Scattering—Light bouncing off an object and scattering in various directions, as with fog
- Color—Light at different wavelengths, perceived by the brain as different colors

LIGHT AS RAYS

Light acts like rays. Light bounces off a surface and into your eye. When you see an object, you are actually seeing the light reflected (bounced) off of it.

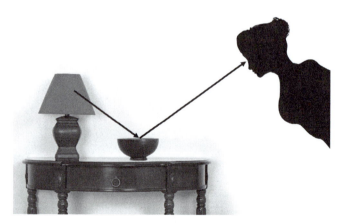

Light ray from the lamp bounces off the bowl and into the viewer's eye.

For the purpose of art and animation, thinking of light as rays helps us a great deal in figuring out where to place light sources in the scene to convey the story we want to tell. Light rays behave very predictably, giving us a solid basis for working with light in animation.

LIGHT AND REFLECTION

Many optics concepts are based on the behavior of light rays when reflecting off a smooth, shiny surface such as a mirror. The reflection of a light ray always behaves in exactly the same way when hitting a mirror, and these rules of reflection can be used to predict many other behaviors of light.

You can predict what a light ray will do when hitting a mirror with the following exercise:

1. Draw a line for the mirror surface, and draw the light ray that hits the mirror.

2. Draw a line perpendicular to the mirror where the light ray hits it.

3. Look at the angle at which the light ray hits the mirror in relationship to this line. The light ray will bounce off the mirror at exactly the same angle to the normal, on the other side of the normal.

When working with an art director or technical director, you might hear specific terminology for these angles:

- Incident ray—Light ray hitting the mirror

- Reflected ray—Light ray leaving the mirror

- Normal line—Perpendicular line dividing the rays

- Angle of incidence—Angle between normal and incident ray

- Angle of reflection—Angle between normal and reflected ray

A *normal* or *surface normal* is an imaginary line that points out perpendicular to the surface. Normals are used for calculations of light and color.

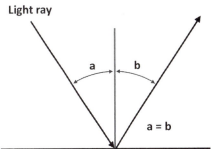

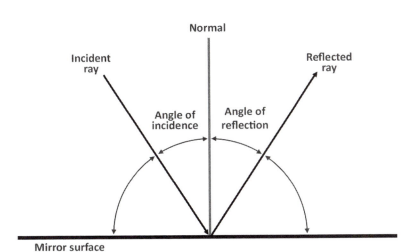

A few rules about specular reflection:

- The angle of incidence is always equal to the angle of reflection.

- The incident ray and reflected ray do not have to be the same length.

- There is no particular name for the angle between the incident ray and the mirror, but it can always be calculated as 90 degrees minus the angle of incidence. It is the same angle on both sides.

SEEING IN A MIRROR

When you look in a mirror, you are seeing reflected rays that originated from the objects you see in the mirror. The objects you view in the mirror can be much farther away from, or closer to, the mirror than you are. As long as the incident and reflection angles are the same, distance from the mirror doesn't matter.

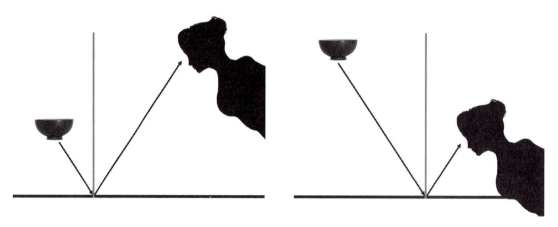

Seeing a reflection depends not on distance, but on the incident and reflection angles being the same.

Because of the way the rays are reflected back at you, the area you see in the mirror is much larger than the mirror itself. It is similar to looking through a window, where you see an area much larger than the window itself. To determine the range of the area that you can see in front of a mirror, sketch out a diagram with a line going from the eye to each edge of the mirror. Then draw a line bouncing back off the mirror at an angle that is at the same angle to the perpendicular as the line from each eye. These angles can be different for the top and bottom of the mirror. Next, extend out the original lines from the eye to the other side of the mirror.

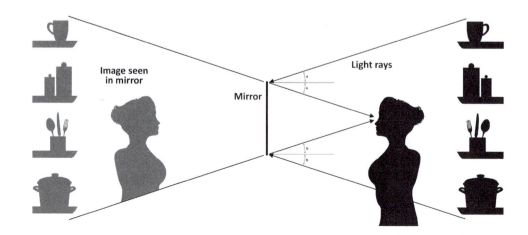

The ceiling fan blades are higher than the top of the mirror, and the floor beneath the bed is lower than the bottom of the mirror, but both are visible in the mirror's reflection. In this image, light rays from these areas bounce off the mirror and into the camera's lens.

BOUNCING LIGHT RAYS

When light rays bounce off any object, they are actually behaving exactly as they do when bouncing off a mirror. But because most objects are not as smooth and shiny as a mirror, the light rays bounce off in varying directions depending on the normal at the exact spot where the ray hits.

On any object that isn't flat and shiny, some of the rays from a light source will bounce off in another direction and away from your eyes. However, these rays will then bounce off other objects, and continue to bounce until their energy is exhausted. Some of these bounced rays reach your eyes before they peter out, allowing you to see the parts of the object not directly lit by the light source. Because these bounced rays have less

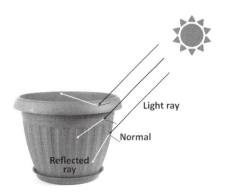

energy, the parts of the object they illuminate are not as bright as the parts lit by direct light.

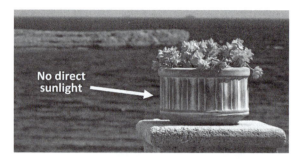

This is why, when you're outdoors on a bright, sunny day, you can usually see everything including objects not directly lit by the Sun. With the Sun as the only light source, some areas are bound to be in shadow, not receiving any direct light from the Sun. But the sunlight bounces off the ground, off water, off other objects, and even off clouds to illuminate these shadow areas to some degree.

RECIPROCITY AND RAY TRACING

The path of a light ray is always reversible—you can switch the light source and viewer and the light ray will follow exactly the same path. This symmetry for light rays is called *reciprocity*.

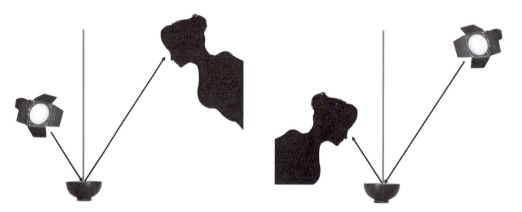

Even though all the rays in any scene are going in varying directions, reciprocity applies for each individual light ray. For this reason, reciprocity has a practical application in computer graphics. When calculating light with ray tracing, only the light rays that reach the camera need to be calculated. Because of reciprocity, the program can calculate only the light rays that go from the camera to the light source, rather than calculating every single light ray coming from the light source to see if it reaches the camera at some point.

ATTENUATION

Light rays over a particular area spread out as they get farther from the light source, which results in objects farther from the light source receiving less light than objects close to the light source. The effect of light seeming to gradually dim as it travels over a distance is called *attenuation*.

Attenuation means "reduction of strength" or "lessening."

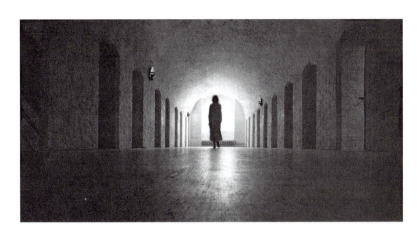

As light emanates from a particular point on a light source, its intensity reduces by squares. Suppose you consider that the light is at normal intensity 1 foot from the light source. When the light moves 2 feet away, it is 2^2 less intense (1/4 of normal intensity). When the light moves 3 feet away, it is 3^2 less intense (1/9 of normal intensity).

$$\text{Intensity} = 1/(\text{distance}^2)$$

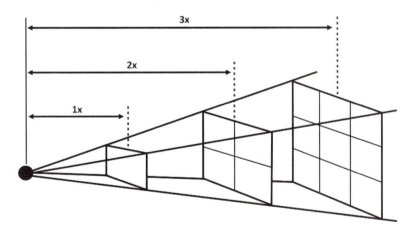

Light reduces in intensity faster when moving through fog or damp air, as the water in the air scatters and absorbs the light. Thus, the 1x distance is shorter for wet air than for dry, clear air.

Representing attenuation in animated scenes is essential to realism and appeal. Many software packages give you an automatic option for calculating light attenuation, or for manually attenuating light.

PHYSICALLY BASED LIGHTS

Software programs sometimes give you the option of using light sources based on lights in real life. Such lights are especially useful for creating photoreal renderings to match a known real-life lighting setup, as with architectural designs or live action plates.

The brightness and intensity of physically based lights are measured with a few standard terms. The definitions below are simplified and generalized, but will give you a start in understanding physically based lights.

- Candela—Measurement of the brightness of light emitted from a light source
- Lumen—Measurement of a light's brightness in relation to the angle over which the light is projected
- Lux—Measurement of light striking a surface

In life, different lights emit different light patterns. For example, a long, tubular fluorescent light emits in a pattern different from an ordinary light bulb. If you're using software to generate physically based lights, you can choose an emission shape for your light source that most accurately represents the shape of its light pattern.

Physically based lights are sometimes called *photometric lights*.

Emission patterns for different lights.

Different types of lights also shine with faint tints such as yellow or blue. You can learn more about this in the Color section.

IES FORMAT

The IES file format is used to communicate the many aspects of a physical light source such as lumens, candelas, and the shape of light emitted. Light manufacturers commonly supply IES files on their websites for engineers and architects to use when designing structures. IES files can also be represented visually to show you how the light source will behave. Between the IES file for a photometric light and a free IES viewer (of which there are several online), you can get a pretty good idea of how to represent a physically accurate light in your scene.

IES graphs and the shapes of the light emissions they produce (insets).

SHADOWS

A shadow is an area that strong, direct light can't reach due to obstruction by an object. Perhaps because we've all been looking at shadows since we were children, audiences have some degree of instinct when it comes to how shadows should look. This makes it all the more important to create reasonably accurate shadows in your scenes. By understanding the physics behind shadows, you can make sure your shadows work with your scenes and even enhance them.

CAST SHADOWS

A *cast shadow* is a shadow that appears on a surface when one object blocks light to another object's surface. In animation, we use cast shadows to give cues about the distances between objects. Shadows can also tell the viewer about the relative sizes and strengths of light sources, the distances between light sources and objects themselves.

Which ball is on the table? The distances between the ball and shadow in each image tell us the answer.

For simplicity, in this chapter we call the object casting the shadow the *caster* and the object receiving the shadow the *receiver*.

Umbra and Penumbra

The darkest part of a cast shadow, the part completely blocked by the caster, is called the *umbra*. The lighter part of the shadow is called the *penumbra*. When a single light source casts the shadow, the penumbra fades gradually from the umbra to full light. The larger the penumbra, the softer and fuzzier the edges of the shadow are.

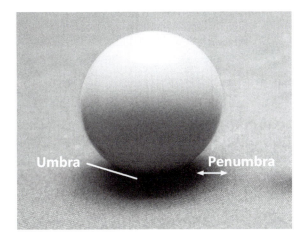

The sizes of the umbra and penumbra give strong cues about the relative sizes of the light source and object, and the distances between the light source, caster, and receiver.

To see how this works, let's take a look at a square light shining on a ball in front of a wall. For the light rays going in the direction of the ball, some light rays make it to the wall, while others are blocked by the ball. By sketching lines from each end of the light source past the caster to the receiver, we can find out where the light is blocked. The area of completely blocked light forms the umbra, while the areas that receive some light but not all form penumbras.

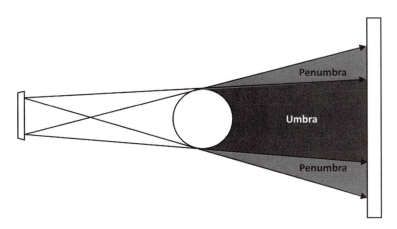

Moving the ball closer to or farther from the light source changes the sizes of the umbra and penumbra. Changing the size or position of the light source relative to the objects also changes the sizes and shapes of the shadow areas.

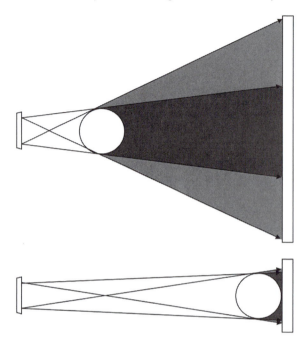

By sketching out the lines from a light source to casters and receivers, you can determine the shapes and sizes of shadows that could appear in your scene.

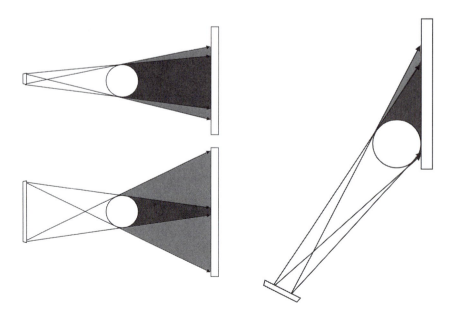

Sharp and Fuzzy Shadows

In life, all lights produce a penumbra. When the penumbra is small enough to be negligible, the shadow's edge is sharp. A sharp shadow is possible only when the caster is very close to the receiver. Differences in shadow sharpness and fuzziness can give your audience cues as to how far the caster is from the receiver.

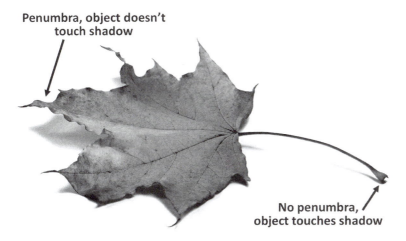

Penumbra, object doesn't touch shadow

No penumbra, object touches shadow

The leaf's stem casts a sharp shadow that touches the object, indicating that the stem is sitting on the table. The frond casts a fuzzy shadow from the same light source, indicating that the frond curls up off the table.

The size of the penumbra cast by an object can be reduced by:

- Moving the caster and receiver closer together
- Moving the light source farther away from the caster
- Reducing the size of the light source

Conversely, the penumbra can be made larger (and thus softer) by:

- Moving the caster and receiver farther apart
- Moving the light source closer to the caster
- Increasing the size of the light source

These methods can be used to convey motion in animation. For example, if a cast shadow's penumbra is becoming smaller over a number of frames, this tells the audience that the caster and receiver are moving closer together.

When a light source is very far from the objects in the scene, the light rays become almost parallel. This reduces the penumbra to nearly zero when the caster is touching the receiver.

The Sun, being very far away, delivers such near-parallel light rays to Earth and produces a negligible penumbra for objects close to the ground. The Sun does produce a visible penumbra for casters far from the ground, such as tall trees or lamp posts. The width of the penumbra for a shadow cast by the Sun equals about 1% of the distance from the object to its shadow. For example, if an object is 9 feet (108in = 2.7m) from the ground, the penumbra will be a little more than an inch wide, or around 2.7cm wide.

A complete lack of penumbra is possible only with a *point* light source, where the light rays spread out from a single point. In a light ray sketch of a point source, the umbra and penumbra lines converge and there is no penumbra. While there is no such thing as a point light source in life, a light source that is much smaller than the objects it illuminates approximates a point light source, producing a smaller penumbra than a larger light source under the same circumstances.

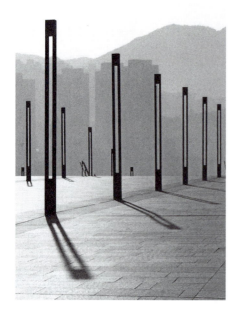

Penumbra from sunlight on the ends of shadows of tall objects.

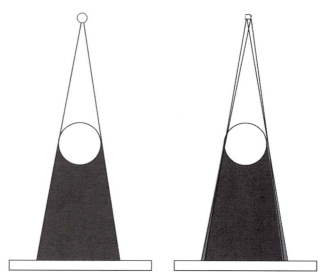

Umbra from point light source (left) and small penumbra from small light source (right).

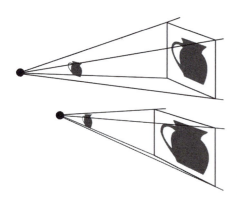

Shadows from light source smaller than caster

Shadow Angle

With a light source that is smaller in diameter than the caster, the shadow is always larger than the object.

When a light source is not very far from a sequence of like objects, the object's shadows are angled in the direction of the light. Such shadows give a subtle cue that the objects are lit by a nearby light source.

Angled shadows from a light source close to objects.

When the light source is far away, as with the Sun, the near-parallel rays cast near-parallel shadows from objects near one another.

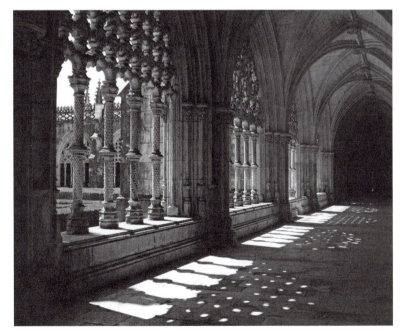

Near-parallel shadows from sunlight.

Because we have all been looking at shadows since childhood, viewers of your animation will instinctively compare the angles of shadows in your scene and deduce the approximate distance and angle of the light source. If you're creating an outdoor scene lit by sunlight or moonlight,

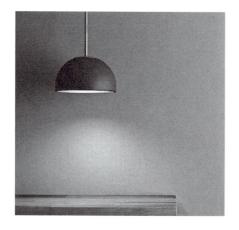

Don't confuse the umbra and penumbra from a light source with the umbra and penumbra of a cast shadow. The size of a lamp's penumbra can be very different from the size of the penumbra that it produces in a cast shadow. The size of the enclosure determines the size of the light source for the sketch you make for rays of cast shadows.

any cast shadows should be parallel or near-parallel. If the shadows are angled away from one another your audience will know, without really knowing why they know, that the light source is closer than the Sun or Moon.

Light Source Shapes

Technically speaking, every light source emanates light rays in all directions. However, an open enclosure around a light source can cause the light rays to bounce around and come only out of the opening, creating a light source that shines only in a particular direction. In such a case, the enclosure itself causes an umbra and penumbra.

The rays that have bounced before coming out of the enclosure have lost energy, so the light coming from the sides of the light source is less bright than the light directly from the light source. This means that the brightness of the light varies across the entire light source.

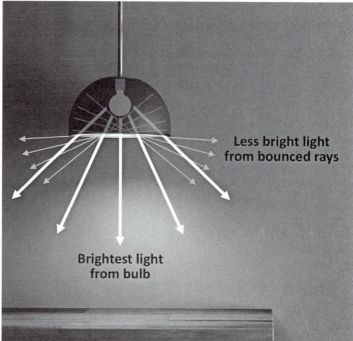

Less bright light from bounced rays

Brightest light from bulb

While a light bulb can act nearly like a point source when it illuminates large objects, a lampshade placed over such a bulb blocks the light and causes rays to bounce around inside the shade. This produces an emission pattern out of the top and bottom of the lamp, which emulates a larger light source. Very little light comes through the lampshade itself. In fact, the lampshade acts to produce an umbra and penumbra for the light source.

A *diffuser* is a translucent sheet of material that scatters light. A diffuser basically turns a small, powerful light source into a large, weak light source. The weakening of the light source reduces the intensity of the umbra, while the larger size increases the size of the penumbra for fuzzier shadows. Clouds on an overcast day act as a diffuser by turning the strong, direct light from the Sun into a sheet of softer light, lightening shadows and sometimes eliminating them altogether.

Diffuser panels are commonly used by photographers and lighting directors to "soften" the light on actors, which lightens up distracting shadows cast by noses and softens highlights on shiny foreheads.

Diffuser panels.

An overcast day often produces no visible shadows.

Shadow Intensity

Because light bounces around, a completely black umbra is unlikely to form under everyday conditions. If your scene includes bright lights and a lot of smooth surfaces, the light rays will bounce around a great deal, lightening the shadow areas. If the light is diffused over a large area, shadows can also lighten a great deal or disappear altogether.

Cast shadows from two or more lights can cross, creating interesting umbra and penumbra patterns. You can determine these patterns with the same method, by drawing lines between the light source, casters, and receivers.

Remember that a near-point light source creates a sharp shadow, with almost no penumbra. If such a light is enclosed and the opening is very small, the

umbra produced by the enclosure will be sharp and dark. Where two such sources cross, the combined umbras will be dark with a sharp edge, creating strange shapes in the scene that can distract or confuse your audience. To avoid sharp, dark crossing umbras, use larger light sources with softer penumbras.

Scene with interesting mood lighting (left) and scene with confusing lighting from the sharp overlapping umbras of two spotlights (right). What are those triangle shapes on the right? Maybe they're supposed to be bats or something. Wait, is this a vampire movie? I can't follow the plot. Let's change the channel.

FORM AND OCCLUSION SHADOWS

To make an animation scene convincing, you will likely need to include two other types of shadows in your scenes: form shadows and occlusion shadows.

A *form* shadow is a darker area on an object itself, where the darkness is due to the object's surface being angled away from the light source. The dark side of the Moon has a form shadow. Compare with a cast shadow, which is due to an object blocking light to the receiver.

Form shadow on left side of vase.

Form shadow on the Moon.

Form shadows help communicate the shape, volume, and depth of objects in the scene, the materials that make up the object, the intensity and position of various light sources, and in particular, the angles of the edges that make up the object. Sharper form shadow edges indicate a sharp object edge and a directed light, while a fuzzy form shadow edge indicates a curved surface or soft material and more ambient light.

Form shadows are perhaps the trickiest to accurately figure out and depict, but if well done they can contribute a great deal to your imagery's realism.

Illustrations of cloth bag (left) and ring box (right). Form shadows tell us about the cloth bag's overall shape and the softness of its individual folds, and about the ring box lid's shape. These illustrations can pass for photographs largely because of their careful use of form shadows.

An *occlusion* shadow is a shadow that forms anyplace where the caster and receiver are so close together that little or no light can get in.

Occlusion shadows are most obvious in cracks, crevices, or folds, but can form anyplace where light is blocked. You see occlusion shadows in cracks in the sidewalk and building materials, or where two pieces of an object have been fitted together. Occlusion shadows also appear in the interior of leafy plants, between soft objects such as cushions. Light bounces around everywhere but in these cracks and crevices, illuminating the rest of the world as comparatively bright.

Occlusion shadows are really just cast shadows and form shadows, but they're important enough to warrant their own name.

Occlusion shadows in sidewalk cracks.

Occlusion shadows where pieces of a walkie talkie fit together.

Occlusion shadows where seat cushion meets the chair.

An occlusion shadow can also occur under large objects that block light from all directions regardless of lighting conditions. For example, even though there might be no cast shadows on an overcast day, there will still be occlusion shadows in places that the light can't get to.

No cast shadows under the people, but an occlusion shadow appears under the car.

Reflection

In everyday language, we are accustomed to using the term *reflection* to refer to an image seen in a mirror or other shiny object. In physics, the term *reflection* refers to bounced light of any kind.

Recall that reflection takes place around a surface normal, where a light ray bounces off the surface at exactly the same angle to the normal of the ray that hit the object.

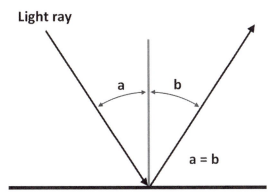

In physics (and in computer graphics), we look at all reflection as being divisible into two different types called specular and diffuse. Both types of reflection are extreme and idealized—in reality, most objects exhibit some of both types of reflection. We study these two types of reflections by considering how small groupings of light rays behave when they strike a surface.

For clarity, in this chapter we refer to the bouncing of light rays as *reflection*, and any image seen on an object's surface due to reflection as a *reflected image*.

SPECULAR REFLECTION

Specular reflection occurs on smooth surfaces where a grouping of normals follow an even or regular pattern, as on a smoothly curved surface. If a grouping of light rays bounces off a small area of a surface and directly into your eyes, you see a sharp highlight on the object's surface as a result of specular reflection.

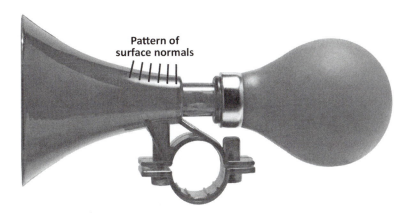

Pattern of surface normals + grouping of light rays bouncing toward camera = specular reflection.

Pure specular reflection produces a bright, sharp highlight on a surface. The highlight color is usually the color of the light source being reflected.

Specular reflection can also produce a reflected image under the right circumstances. For solid objects, a reflected image is possible only with glass and non-porous polished surfaces like metal, ceramic, and enamel. A mirror, for example, is a piece of glass or plastic covered in a thin, smooth coating of metal such as aluminum or silver. If light rays bounce from the environment to a pair of mirrored sunglasses at such an angle that they land in your eye, you can see a reflected image of the environment on the sunglasses.

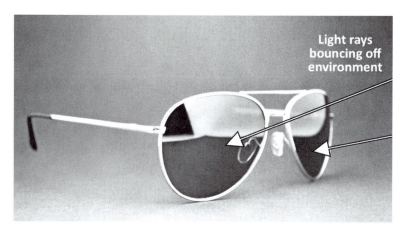

Light rays bouncing off environment

The flat surface of pressed facial powder has near-uniform color with no specular reflections.

DIFFUSE REFLECTION

Diffuse reflection occurs on a surface where the normals point in random directions, causing the light grouping to spread out or "diffuse" when it hits the surface. Visually, the surface appears to have a matte finish. Fine powder, plaster, and rough wood are surfaces that exhibit nearly perfect diffuse reflection with no specular highlights. The color and brightness of the surface doesn't change as we change our viewing angle, provided the light sources remain the same.

With diffuse reflection, light bounces off the surface at all angles. Some of these light rays reach our eyes or the camera, making it possible for us to see any illuminated spot on the object from any viewing angle.

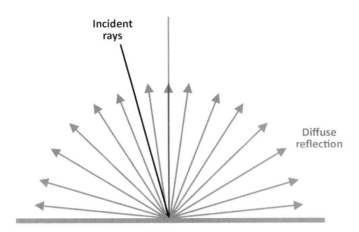

Because the light rays are reflected in all directions by the same amount, any one spot illuminated by diffuse reflection appears to be the same brightness no matter what the viewing angle is, provided the light source doesn't change. Compare with specular reflection, where you have to be looking at the object from a specific angle to see the bright reflection in a particular spot.

Diffuse Reflection and Light Intensity

With diffuse reflection, the brightness of the surface at a particular spot depends entirely on the angle at which the light rays hit it, and has nothing to do with the viewing angle. Suppose you have a single light source shining on a surface. When the light source is angled to be perpendicular to the surface, the light rays hit head-on, and the surface reflects the maximum possible amount of the light's intensity; the object appears brightest at that spot. Where the light source is angled to the surface, the light ray is spread out over more area, lessening the percentage of the light's intensity that is reflected; the object appears less bright at that spot.

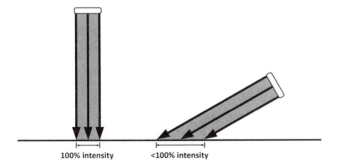

The concepts of diffuse reflection were largely brought to us by physicist Johann Heinrich Lambert, who introduced them in his 1760 book *Photometria*. The Lambert shader offered by many CG packages produces a matte surface that diffuses light evenly.

After the light rays hit the object, the rays are scattered in all directions, allowing us to see that spot on the object. The angle at which the light rays hit the object determines the intensity (brightness) of the light that reflects.

This might seem pretty obvious—we can all guess that a desk lamp pointing straight down onto your desk provides more light than a lamp pointing at a deep sideways angle. But by how much is the light reduced when it hits the surface at an angle? When the light points perpendicular to the surface (at an angle of zero degrees off the surface normal), you get the maximum intensity that can deflect off that particular surface. When the light points parallel to the surface (90 degrees off the normal) you get zero intensity. So this means that if the light is at a 45 degree angle, you get 50% of the maximum intensity, right? Nope. The percentages don't follow a simple linear formula, as you can see in the diagram.

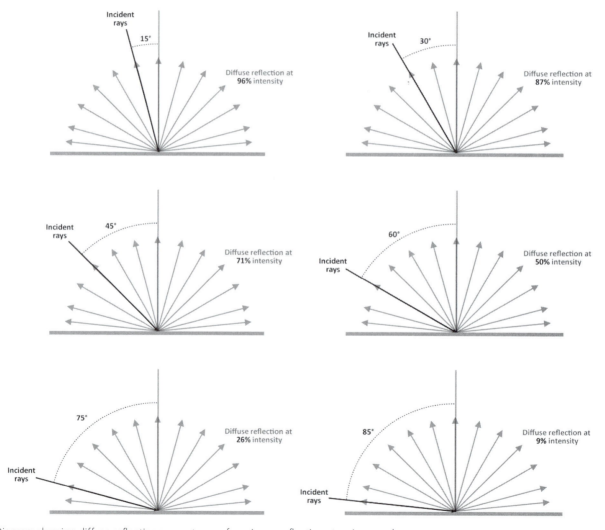

Diagram showing diffuse reflection percentages of maximum reflection at various angles.

The percentages follow a progression that has to do with the vertical component of the light ray's angle as it moves around a circle. Suppose you draw a circle, then draw a line horizontally through its center to represent the surface. Now draw a vertical line through the center of the circle to represent the surface normal. Next, we draw the radius of the circle going right down the normal line to represent a light ray. Since a light ray pointing down the normal is at zero degrees off the normal, and because the light ray is diffusely reflected at the maximum intensity possible for that surface, we label this radius zero degrees and 100%.

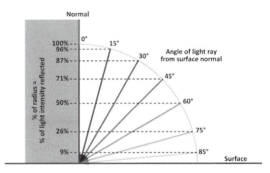

As you move the radius (light ray) around the circle at different angles off the normal, the vertical height of the radius line, calculated as a percentage of the radius along the normal, gives you the percentage of the maximum intensity that's reflected with diffuse reflection at that angle. The size of the circle doesn't matter because we're looking at percentages, which are the same no matter the size of the circle.

Detecting Shape and Color

Diffuse reflection doesn't produce a highlight—it reflects the color of the object itself. The reflected light rays carry the color with them, reflecting the color at a brightness that corresponds to the percentage for the angle.

If a diffusely reflecting object is flat, it will appear to have the same color all the way across the surface. If the object isn't flat, the directions of the normals relative to the light source change over the surface of the object, meaning that the percentage of light intensity changes. The differences in brightness give you cues about the object's shape. Areas with normals that point right at the light source appear brighter than areas with normals that point away from it.

DIFFUSE VS. SPECULAR REFLECTIONS

Diffuse reflection shows us light that has bounced off any part of the surface where light hits. Compare with specular reflection, which shows us light only where the incident and reflection angles are just right for the light to reach our eyes.

If you're familiar with trigonometry, you'll recognize the percentage of the radius as the *cosine* of the angle between the normal and light ray, giving rise to the name for this concept: *Lambert's Cosine Law*. If you're not familiar with trigonometry, you can use the diagrams here as a rough guide to light intensity percentages at different angles off the normal.

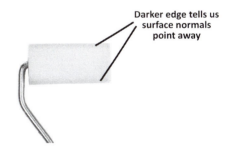

A soft paint roller is visible due to diffuse reflection. We discern the curvature of the paint roller at the top and bottom of the roller due to its darker color in those areas.

Diffuse reflection tells us about the shape and color of the object. Specular reflections tell us how smooth the surface is, and where the light source is located. Most of the objects you will represent in your animation will exhibit some of each type of reflection.

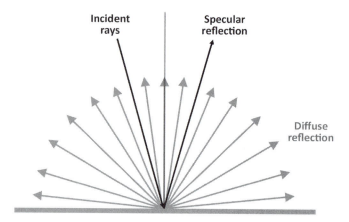

Most natural materials, and many man-made materials, are somewhat translucent or porous. In these materials light can get under the surface and bounce around, producing diffuse reflection. If the surface of the material is smooth, it will also have a specular reflection where light rays bounce into the camera.

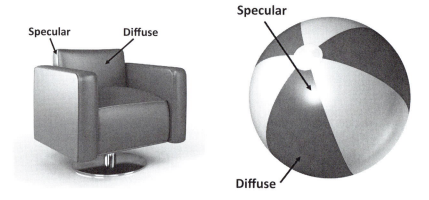

For many types of objects, the only way to tell the difference between the materials that comprise the object is to look at the highlights that form on them. On two like objects made of plastic and metal, the highlights will be very different. Metals, being opaque, can produce an almost perfect specular highlight when smooth. Compare with hard plastic, which is usually slightly translucent and thus prone to a lot of diffuse reflection.

Tea kettle with anisotropic highlights.

Metal button (left) and plastic button (right) of similar shape and size under similar lighting conditions. The color and shape of the plastic button is easy to discern due to the diffuse reflections over most of the surface.

Anisotropy is the property of something having different characteristics in different directions, such as being longer on one side than the other. Compare with *isotropy*, which implies the same characteristics in all directions. While most highlights are isotropic, highlights on metal are often anisotropic.

Specular highlights are usually in the shape of the light source, but on highly reflective surfaces like glass, metal, hard enamel, and hair, the highlights are sometimes elongated.

SHADERS

In computer graphics, the properties of a surface are collected together into a single definition called a *shader*. A shader can include information like:

- Overall color (diffuse color)
- Highlight color (color of specular reflections)
- Highlight shape
- Form shadow color (sometimes called ambient color)
- Specular or diffusion level (how shiny/diffuse the object is)
- Transparency and translucency

By setting these various parameters, you can control how much diffuse and specular reflection the surface exhibits.

DIFFUSE INTERREFLECTION

Everything you see is, to some degree, reflecting everything else around it. How well you can discern these reflections on a surface depends on how much specular reflection the surface has, and how close it is to other objects.

Because of attenuation (the lessening of light's intensity over a distance), the proximity of objects plays a big part in the visibility of reflections. If two objects placed near each other have rough surfaces, most of the bounced light rays will be lost to attenuation long before they come back again. But if the objects are placed close together, enough of the diffuse rays hit each of the objects to create a fuzzy, vague reflection of each object in the other one.

For example, if a bright red ribbon is near a white box, the box will be a little bit redder where the two are close together, and the ribbon will be whiter. These interreflective effects are most noticeable when one of the objects is white and at least a little glossy, as with a white wall in a room with a colorful lamp or statue near it. The effect is subtle, but we are accustomed to seeing this effect in life, and we unconsciously (or consciously) miss it when it's not there.

Many animation software programs come with a global illumination (GI) feature, which renders a scene using both direct illumination (from light sources) and the light that is reflected by surfaces (indirect illumination). Indirect illumination can include any and all light effects not due to direct illumination such as reflection, refraction, caustics, occlusion shadows, and diffuse interreflection, all of which are discussed in this chapter.

Spots of diffuse interreflection on a white box.

PARTIAL REFLECTIONS

Some smooth, translucent/transparent surfaces produce a less-than-perfect reflected image. An example is the screen on a cell phone or tablet. While you can use such a screen as a makeshift mirror when you can't find a real one, the reflection is quite dark and not nearly as good as a real mirror.

Every surface has a reflection coefficient that tells us what percentage of the light striking it will be reflected (as opposed to passing through it or being absorbed by it). The table below shows the reflection coefficient for common medium/surface pairs when light strikes the surface at an angle perpendicular to the surface.

Partial reflected image in tablet screen.

In physics, the substance something is traveling through is called its *medium*. For light striking a house's window, the medium is air.

Medium	Surface	Reflection coefficient
Air	Water	2%
Air	Silver	90%
Air	Glass	4%
Water	Glass	0.5%

With glass, at an angle of incidence of zero degrees (perpendicular to the surface), 4% of the light reflects while the rest (96%) passes through. While 4% is enough to form a reflected image, this doesn't mean you always see a reflected image in window glass. Let's take a look at a couple of common window scenarios to see how this works.

Suppose it's nighttime, and indoors near a window, a table lamp with a 40-watt bulb is turned on. Such a bulb produces about 400 lumens. Outside, a streetlamp some distance away provides enough light so there's about 1 lumen just outside the window. Since glass reflects 4% of the light, the intensity of the reflected light from the lamp is 16 lumens, while the remaining 384 lumens pass to the outside. In the meantime, 0.04 lumens are reflected from the outside of the window, while only 0.96 lumens pass from outdoors to indoors. For a viewer outside looking directly into the window, the 384 lumens coming from indoors is so much stronger than the 0.04 lumens of reflected light that it trumps any reflected image. Conversely, the 16 lumens of reflected light indoors is competing with only 0.96 lumens of light coming from outdoors, and thus is able to create a visible partial reflection on the glass indoors.

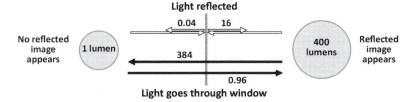

Reflected image of lamp visible in window at night.

In such a scenario, a viewer indoors who looks out a window will see mostly reflected images in the windowpane and will have a hard time making out any of the objects out on the street. If the indoor lamp is turned off, the reflected images will go away, and the viewer can see the street again.

The reflection coefficients shown in the table are for an angle of incidence of zero degrees. The reflection coefficient actually increases as the incident angle increases. This means that the farther you get from the perpendicular angle to the window glass, the more light that reaches you will have reflected from your side of the glass to show you a reflected image. However, if there's a great deal more light coming from the other side of the window, even the higher reflection coefficient won't make much of a visible difference in the amount of reflected image you can see.

Reflected images in windows are not visible from the dark outdoors when lights are on inside, even from a viewing angle several degrees off the perpendicular.

The increase in the reflection coefficient at larger angles is due to the *Fresnel Effect*, which is described in more detail in the Oceans and Lakes section of the Liquid Effects chapter.

In daylight, the situation is reversed. Viewers outside see strong reflected images in windows, while people indoors don't see reflected images on the windows if the light is strong.

Reflected images on windows in daylight.

In general, the side of the window that gets hit by the highest intensity of light will show the strongest reflected images. The stronger the reflected image, the harder it is to see through the window. If you want to see a reflected image and see through the window at the same time, you can balance the two by considering the light sources on each side of the window.

REFRACTION
When light passes through a transparent medium such as water, it bends. You can see the effects of bent light by placing an object in a glass of water. The object appears to shear or bend where it meets the water. This effect is called *refraction*.

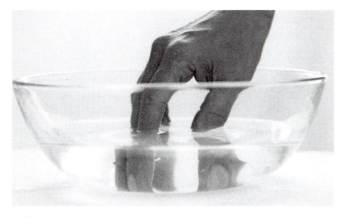

Refraction in water.

Every medium has an index of refraction (IOR), which indicates how severely it bends light. A vacuum (no air) has an index of refraction of 1.0, which is considered "no refraction." Air itself has an index of 1.00029, which for most practical purposes can be considered 1.0. The level of distortion from refraction is determined by how much the IOR differs from 1.0.

Material	IOR
Air	1.00
Ice	1.309
Water	1.333
Olive oil	1.47
Window glass	1.52
Diamond	2.42

Chart of common IOR values.

In life, it is rare to find a substance with an index of refraction below 1.0.

The amount of refraction you see is also dependent on the angle at which the light hits the object, the indices of refraction of the medium that light goes through, and how thick the medium is. For example, although window glass has a high IOR, window panes are so flat and thin that the refraction is negligible. With thicker or irregular glass, you see more refraction.

Refraction through thick, irregular glass.

Gemstones are very refractive, which accounts for their appearance and appeal.

Refraction is also responsible for rainbows. Sunlight is actually comprised of light rays with varying wavelengths in all the colors of the rainbow, which ordinarily combine to appear to us as white. The raindrops in wet air refract the strong, white light of the Sun into different colors. This happens because of *dispersion*, the tendency of some media to refract light rays of different wavelengths by different indices of refraction. A prism is another example of dispersion.

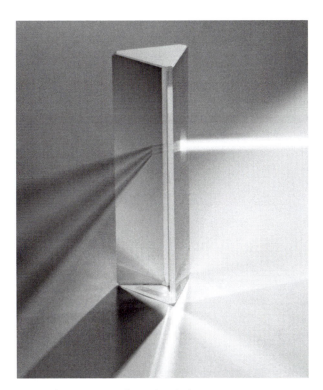

Prism refracting colors from white light.

CREATING REFRACTION WITH CG SOFTWARE

While CG software often comes with shader options for making an object appear refractive, in practice these tools are not straightforward to use. Keep in mind that software does the best it can, but doesn't always consider every factor involved in refraction, such as color shifts. In addition, calculating refraction with software can be very time consuming. As an extreme example, it would be silly to make a rainbow by trying to refract the light from a light source.

continued on the next page

Taking an IOR value from the real-life table and setting it as the IOR value in your software does not guarantee the object will look realistic. You'll need to experiment with different values, even values below 1.0, to match the result with reference images.

 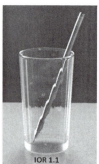 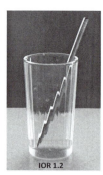 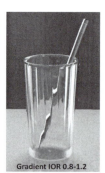

Refraction study of a pencil in a glass rendered with CG software. The first image is a photo while the rest are renderings with software-generated refraction. Even though the IOR for glass is around 1.5, the most realistic result from the software is an IOR gradient from 0.8 to 1.2 going from the top of the glass to the bottom.

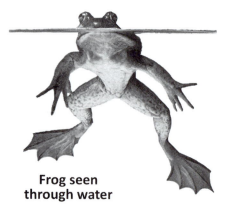

Frog seen through air

Frog seen through water

If you need to represent refraction in your animation, consider using a simpler method than calculation to set up the refraction. For a magnifying glass, consider rendering the image that the glass sees separately, then mapping it onto the surface of the glass. For an object immersed in water, consider creating a distorted copy of the object and placing it inside the water volume.

The term *caustic* comes from the Greek word for "burnt," referring to the very bright areas in caustic patterns where light is the most concentrated. These areas resemble bright sunlight, which is known to burn.

CAUSTICS

Caustics are bright, wavy patches of light due to reflection and refraction from a curved surface. Examples of caustics are light patterns cast by a glass, water, and gems. When caustics create bright spots, there are always dark areas from which the light has been deflected.

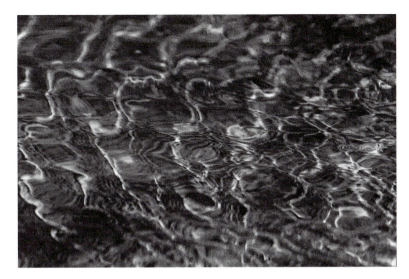

Caustics from turbulent water.

With a drinking glass, caustics occur because of varying degrees of refraction across the curved surface. The light waves bend at different angles as they pass through the object, causing them to criss-cross and add or subtract from one another. The swirling patterns produced by these caustic effects resemble the patterns of resonant and canceling waves.

In a room with an indoor pool, caustics are visible at the bottom of the pool, or as reflections on walls as bright swirl patterns.

Caustics at the bottom of a swimming pool.

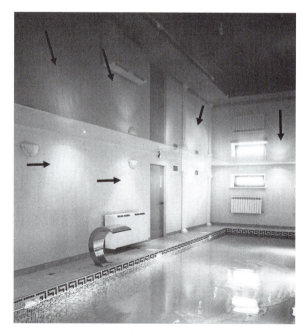

Caustic patterns on walls reflected from a swimming pool.

Under the ocean, caustics can be caused by the way light reflects off surface waves and refracts through the water. The effect is a projection of strong light

passing down through the water to produce bright wavy patterns in constant motion.

Caustics under the ocean's surface.

While your animation might include a glass of water or shiny gems, chances are you won't have to worry too much about representing caustics on a tabletop unless the glass or gem is the focus of your scene. The most common need for caustics in animation arises when you have a scene that takes place near or under the sea.

If you're using software for your animation, you're often better off finding a solution other than the "Generate Caustics" button to create convincing caustics. It's much faster to use an animated map or gobo light projected over a character. Such methods are also easier to control than software-generated solutions.

Gamma Correction

While you might think that creating realistic imagery is just a matter of "making it look real," any photoreal renderings have to take into account peculiarities in the way our eyes perceive light intensities, the way cameras capture them, the way software alters them, and the way monitors and televisions display them.

The human eye is adapted to seeing details within shadows and darker areas. This has served us well throughout the ages, where we can make out details of plants and trees for gathering food, or spot a predator hiding in the bushes. Conversely, seeing fine details in the sky has not been so important to us, and our eyes have evolved to ignore these details. The sky, even on an overcast day, contains many more variations than we are able to perceive, and is actually extremely bright—so bright, in fact, that we can't see stars during the day.

Conversely, mechanized methods of capturing and displaying light, such as cameras and monitors, treat all light intensities equally. A large part of making realistic imagery is to use *gamma correction* to make up for this difference and produce images that look more like what our own eyes would perceive. The guiding principle of gamma correction is that to our eyes, darker areas appear to have far more variations in intensity than lighter areas.

LINEAR VS. CURVED LIGHT INTENSITY

Suppose you made a chart of nine colors moving gradiently between black and white, with equal steps between each color. If black is considered to have a value of 0.0 and white has 1.0, you could assign a value between 0.0 and 1.0 to each color on the chart.

If you made a graph of these colors plotted against the numbers 0.0 to 1.0, the graph would follow a straight line because the steps between each value are equal. We call this a *linear* progression.

Now, suppose you make a second chart, this time with values that are not so evenly spaced. Let's have more dark values at the start of the chart, with just a few of the lighter values at the end. Note that the pure black and white colors at the start and end of the graph remain the same.

If you graph this new list of color values against evenly spaced values from 0.0 to 1.0, the result is a curve.

Gamma Correction for Real-World Perception

In real life, the intensity of light reflecting off of objects is like the linear progression. Any and all light intensities between pure black and pure white are present, with no particular leaning toward lighter or darker shades. When a camera takes a photo, it captures all the intensities, including fine shadings of lighter colors that the human eye can't discern.

What we perceive when looking at the real world is more like the curved progression. We discern many more fine shadings in the darker range than we do in the lighter range. To compensate for this, a digital camera maps the linear range to a curved range before displaying the image to you.

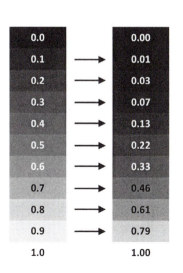

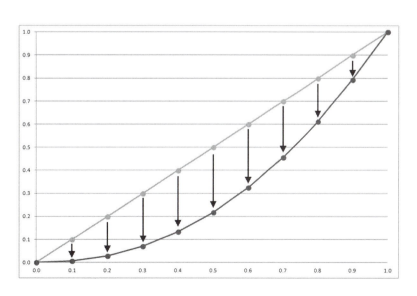

The adjusted version of the image, displayed with a wider range of darker colors than light colors, looks more "real" to us than the original image with its linear progression.

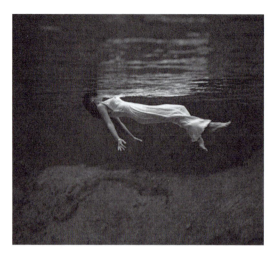

The image a camera captures, with linear light intensities.

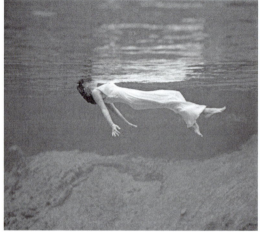

What our eyes would see, with darker areas appearing brighter and with more discernible detail. A digital camera converts linear intensities to curved intensities to show you this image.

Gamma is the Greek letter G, represented by the symbol γ. This symbol is used in the mathematical formula for corrections to the linear light intensity graph. Essentially, gamma is just a number in a formula used to give a better color range for human viewing.

Dodging is a technique for covering up an area of a photographic negative during development to decrease its exposure time, making the area lighter. *Burning* is the opposite, which increases exposure to make a darker area. These tools are mimicked in image-editing programs like Photoshop.

This process of mapping a linear progression of shades to a curved progression of shades is called *gamma correction*.

Gamma Correction and Cameras

A camera, whether digital or analog, has light sensors that respond linearly—lighter shades are just as important as darker ones, and all light intensities that go through the lens are processed in some fashion.

With traditional analog photography, light intensities are stored on film as grayscale values on the linear scale. To get a great printed image that makes use of the curved intensity graph, an analog photographer has to not only control the light coming into the camera (via exposure time, shutter opening size, etc.), but also use film development techniques like dodging and burning.

Digital cameras also capture light intensities as linear values, but don't always store all the values. As a service to the photographer, JPG and PNG images stored by a camera have been corrected by the time the image is saved. This is done to save space and make the image look better. Saving all linear intensities would make the file quite large, and would also make the photo look wrong when printed or viewed. The conversion process uses gamma correction so you get a nice image right out of the camera.

Some digital cameras have the capability to store images in the RAW file format, which stores all the light intensities linearly, keeping the same

amount of information as a traditional photographic negative. The advantage of the RAW format is that the photographer can set and control any gamma correction on the image afterward to get exactly the result wanted, rather than relying on the camera to do it for him. As a rule, any image file format being output by a camera (other than the RAW format) has been gamma-corrected by the time it's saved.

HDRI images can come close to having all the linear data stored. A series of photographs of the same scene, each taken with a different exposure, can be combined to give a wide range of intensities.

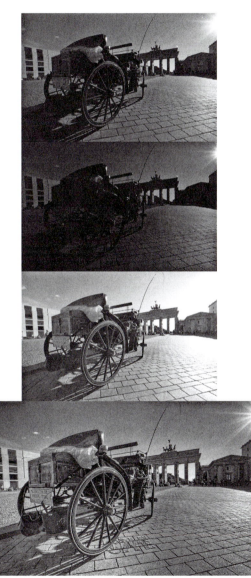

A series of photographs taken with different settings, then combined to form the final image at the bottom. Image courtesy of Klaus Hermann, HDR Cookbook.

Gamma Correction on Digital Files

In the digital world, gamma correction happens all the time. All electronic displays such as televisions and monitors perform gamma correction on images.

If your camera has an LCD screen for immediate viewing of the image, the image is gamma-corrected on its way to the display so it looks better to you. If you copy the images to your computer and display them on your screen, the images are gamma-corrected by the display before it shows them to you.

Many software renderers perform gamma correction on rendered images as it stores them.

GAMMA CALCULATIONS

To map linear intensity to gamma intensity values, you need to know the value coming in and the gamma number to calculate the value that will come out from the conversion. The formula for mapping linear intensity to gamma intensity is:

$$ValueOut = ValueIn^{gamma}$$

As an example, a digital camera that saves images in JPG format performs gamma correction on the images before saving them. Let's say the camera is using a gamma of 2.2 for correction. Let's make a chart of these values so we can get a graph of the correction curve for this gamma number.

Linear value (ValueIn)	Calculation	Gamma result (ValueOut)
0.0	$0.0^{2.2}$	0.00
0.1	$0.1^{2.2}$	0.01
0.2	$0.2^{2.2}$	0.03
0.3	$0.3^{2.2}$	0.07
0.4	$0.4^{2.2}$	0.13
0.5	$0.5^{2.2}$	0.22
0.6	$0.6^{2.2}$	0.33
0.7	$0.7^{2.2}$	0.46
0.8	$0.8^{2.2}$	0.61
0.9	$0.9^{2.2}$	0.79
1.0	$1.0^{2.2}$	1.00

A gamma value of 1.0, which produces the same set of values as the linear graph, is called a *linear gamma*.

A monitor also performs gamma correction so an image will look nice on the screen. When a monitor displays pixels, it has the capability of making each pixel on the screen as bright or dark as it wants to. A monitor wants to

start from linear gamma and map the colors to the monitor so it will look good to you, but it also assumes that images have already been gamma-corrected. So the monitor first does a reverse conversion to get the linear values back, then gamma-corrects them again based on the monitor's (or user's) setting.

A gamma value of 0.45, when used on an image that has already been gamma-corrected to 2.2, gives you back the original linear values. This allows the monitor to apply its own gamma, and for users to calibrate a monitor by adjusting its gamma value manually.

0.45 is 1/2.2. You can get the same reverse exponent for any gamma value by dividing 1 by the original gamma value.

Linear value	Calculation	Gamma result	Reverse gamma calculation	Gamma result
0.0	$0.0^{2.2}$	0.00	$0.00^{0.45}$	0.0
0.1	$0.1^{2.2}$	0.01	$0.01^{0.45}$	0.1
0.2	$0.2^{2.2}$	0.03	$0.03^{0.45}$	0.2
0.3	$0.3^{2.2}$	0.07	$0.07^{0.45}$	0.3
0.4	$0.4^{2.2}$	0.13	$0.13^{0.45}$	0.4
0.5	$0.5^{2.2}$	0.22	$0.22^{0.45}$	0.5
0.6	$0.6^{2.2}$	0.33	$0.33^{0.45}$	0.6
0.7	$0.7^{2.2}$	0.46	$0.46^{0.45}$	0.7
0.8	$0.8^{2.2}$	0.61	$0.61^{0.45}$	0.8
0.9	$0.9^{2.2}$	0.79	$0.79^{0.45}$	0.9
1.0	$1.0^{2.2}$	1.00	$1.00^{0.45}$	1.0

Note that all such back-and-forth conversions result in information loss. Large parts of the original color range are discarded during the initial gamma conversion, and additional colors are discarded during the reverse conversion, then even more is discarded for the last conversion. For casual viewing of web pages this loss isn't that important, but for photorealistic VFX work it can be problematic.

The PNG file format can store the gamma value used, but this value has limited use. Different types of displays and browsers can use it to determine how to display the image, and that's about it. Converting the image back to a linear gamma still does not get all the information back.

Monitor Gamma Adjustment

Most computer monitors have a built-in tool for visually adjusting the gamma setting. The tool displays a grouping of gray boxes or dots to be matched to a gray control color. You adjust the monitor's gamma setting until the grayish appearance of the boxes or dots approximates the brightness of the control color.

Supposedly, this adjustment gives you the "right" gamma setting for your monitor. But beware—if your animation is going to be viewed on a completely different type of monitor, it might look very different depending on that display's gamma setting, type of display, etc. If you know your animation will

Typical gamma correction tool for computer monitor.

be viewed on a specific type of monitor or television, you should test it on that type of display to be sure it looks right.

RGB Gamma Curves

So far, we've talked about gamma as if it's a single value for an entire image. Actually, there can be three different gamma values, one for each of the red, green, and blue channels of an image.

Different digital cameras use different RGB curves to correct images. A photographer might choose one camera over another based on his/her preference of RGB gamma correction.

The three curved lines in the graph represent red, green, and blue. The differences between these curves approximate the differences in the way our eyes perceive red, green, and blue. When looking at dark areas our eyes respond more to blue than to green and even less to red, and they naturally discern more detail in blue areas. For this reason, the blue curve is usually the deepest and red is the shallowest.

In many digital processes such as compositing, the fact that black is zero causes calculation problems, so a value slightly above 0.0 is used for black, and the rest of the curve follows the gamma 2.2 curve. This method of setting gamma values is called sRGB.

LINEAR WORKFLOW

So if cameras and monitors automatically do gamma correction on images, what's the big deal? Gamma correction really only becomes a concern when using several images from different sources to create your final images. You'll need to look at your pipeline to determine whether gamma correction could be a problem.

A simple example is a texture map used in a 3D scene. If a gamma-corrected texture map is used in a gamma-corrected rendering, the texture map's colors have been adjusted and reduced twice by the time you see the rendered image. While you can adjust your lighting and other settings to compensate for the texture already being gamma-corrected, you can achieve richer renderings by using texture maps with a linear gamma (1.0) and using gamma correction only on your final output.

Additionally, if various textures used within a scene have different gamma settings, you will have to spend unnecessary time adjusting the lighting and texture settings to make the scene work.

VFX compositing in particular benefits from images produced with a linear gamma. It is much easier for a compositor to work with images when as much information is present as possible, and the gamma values of all the incoming images match.

Most animation software and image-editing packages give you options for what to do with the gamma setting for various images coming in and out of the software. The safest bet is to use a linear workflow with a gamma of 1.0 on all your images except the final output (the images the audience will view). If your project consists only of photographs being composited together, as long as all the images have the same gamma setting (2.2, for example), this can also work.

The most important thing is to know the gamma settings of your images so you can make intelligent decisions about what to do with the settings, and how to proceed with your workflow.

Character Design and Animation

Character design and animation must, to some degree, use the laws of physics. While you can dream up all kinds of characters to do fantastical motion, if the character's size, weight, and motions aren't at least somewhat familiar to your audience, they won't be able to follow the story.

In this section of the book, we look at character design and animation from a physics standpoint. If there are Classical Physics subjects that pertain directly to the subject, these are listed at the start of the section. This will enable you to review any topics necessary before you dive in.

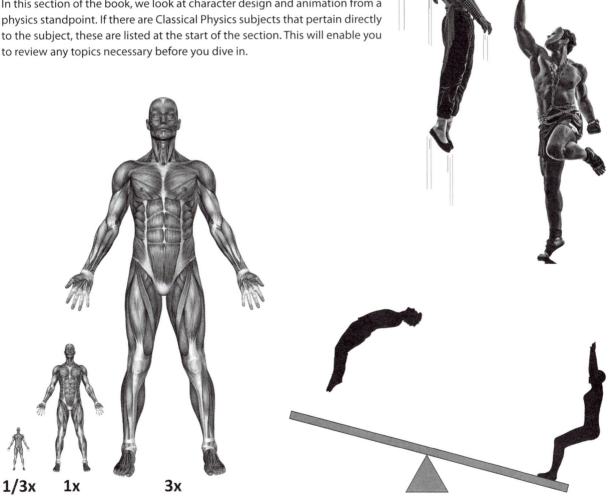

1/3x 1x 3x

CHAPTER 5

Character Design

Long before the animation process begins, character design shapes the personalities that will perform your motions. When you use physics concepts to inform your design decisions, you can increase a character's ability to perform the motions called for, and also improve its believability and appeal.

Size and Scale

The size and scale of characters often play a central role in a story's plot. What would Superman be without his height and bulging biceps? Some characters, like the Incredible Hulk, are even named after their body types.

We often equate large characters with weight and strength, and smaller characters with agility and speed. There is a reason for this. In real life, larger people and animals do have a larger capacity for strength, while smaller critters can move and maneuver faster than their large counterparts.

When designing characters, you can run into different situations having to do with size and scale, such as:

- Human or animal-based characters that are much larger than we see in our everyday experience. Superheroes, Greek gods, monsters,

ogres, and giants are traditionally represented as superhuman in both size and strength. Big prehistoric creatures like dinosaurs fall into this category, as do large mythical creatures like dragons or giant mutant cockroaches.

- Human or animal-based characters that are much smaller than we are accustomed to, such as fairies and elves.

- Characters that need to be noticeably larger, smaller, older, heavier, lighter, or more energetic than other characters.
- Characters that are child versions of older characters. An example would be an animation featuring a mother cat and her kittens. If the kittens are created and animated with the same proportions and timing as the mother cat, they won't look like kittens; they'll just look like very small adult cats.

Human and animal bodies have evolved over time to work with certain proportions between height, weight, skeletal size, heart rate, speed of movement, and so on. Messing with these proportions without considering the consequences will lead to characters that seem comical or creepy to your audience. If that's what you're going for, then great. If not, then you'll need to understand how to make your characters look like actual living beings and not just uniformly scaled versions of the real thing.

Classic example of scaling human proportions without regard for realism. We instinctively know that such a creature is impossible.

The study of the relationship of body size to shape, anatomy, physiology, and behavior is called *allometry*. Yes, there is an entire science devoted to this!

In this section, you'll learn about various cues for physical size so you can use them to design characters that will read to your audience at the size you intend them to be.

PROPORTION AND SCALE

Creating a larger or smaller character isn't just a matter of scaling everything about the character uniformly. To understand this, let's look at a simple cube. When you scale a cube, its volume changes much more dramatically than its surface area.

Let's say each edge of the cube is 1 unit tall. The area of one side of the cube is 1 square unit, and the volume of the cube is 1 cubed unit.

The term *area*, in geometry, means *the extent of a two-dimensional shape*. To figure out the surface area of a character or object, we imagine the surface to be flattened out. For the purposes of learning about scaling and proportion in character design, you can consider the terms *area* and *surface area* to be interchangeable.

If you double the size of the cube along each dimension, its height increases by 2 times, the surface area increases by 4 times, and its volume increases by 8 times.

While the area increases by squares as you scale the object, the volume changes by cubes.

Height multiple	Area in sq units multiple	Volume in cube units multiple
1	$1^2 = 1$	$1^3 = 1$
2	$2^2 = 4$	$2^3 = 8$
3	$3^2 = 9$	$3^3 = 27$
4	$4^2 = 16$	$4^3 = 64$
5	$5^2 = 25$	$5^3 = 125$
6	$6^2 = 36$	$6^3 = 216$
7	$7^2 = 49$	$7^3 = 343$
8	$8^2 = 64$	$8^3 = 512$
9	$9^2 = 81$	$9^3 = 729$
10	$10^2 = 100$	$10^3 = 1000$
11	$11^2 = 121$	$11^3 = 1331$
12	$12^2 = 144$	$12^3 = 1728$

You can also use this rule to figure out how an object will scale down.

Height multiple	Area in sq units multiple	Volume in cube units multiple
1	$1^2 = 1.00$	$1^3 = 1.000$
3/4	$0.75^2 = 0.56$	$0.75^3 = 0.422$
2/3	$0.67^2 = 0.44$	$0.67^3 = 0.296$
1/2	$0.50^2 = 0.25$	$0.50^3 = 0.125$
1/3	$0.33^2 = 0.11$	$0.33^3 = 0.037$
1/4	$0.25^2 = 0.06$	$0.25^3 = 0.016$
1/5	$0.20^2 = 0.04$	$0.20^3 = 0.008$
1/8	$0.13^2 = 0.02$	$0.13^3 = 0.002$
1/10	$0.10^2 = 0.01$	$0.10^3 = 0.001$

When you square or cube a fraction, the result is always smaller than the original fraction.

The proportions of scaled area and volume hold for any three-dimensional character or object regardless of its size or shape. When you scale a character uniformly, various aspects of its body will scale as area (squares), while other aspects will scale as volume (cubes).

Weight and Strength

Body weight is proportional to volume. The abilities of your muscles and bones, however, increase by area because their abilities depend more on cross-sectional area than volume.

In this book, the symbol √ denotes a square root.

To increase a muscle or bone's strength, you need to increase its cross-sectional area. To double a muscle's strength, for example, you would multiply its width by √2. To triple the strength, multiply the width by √3.

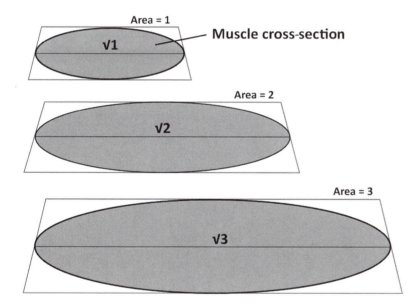

Since strength increases by squares and weight increases by cubes, the proportion of a character's weight that it can lift doesn't scale proportionally to its size. Let's look at an example of a somewhat average human man. At 6 feet tall, he weighs 180 pounds and can lift 90 pounds. In other words, he can lift half his body weight.

If you scale up the body size by a factor of 2, the weight increases by a factor of 2^3, or 8. Such a character could then lift 2^2 more weight, or 4 times more. But since he weighs more than 8 times more than he did before, he can't lift his arms and legs as easily as a normal man. Such a giant gains strength, but loses agility.

If we triple a normal man's size, he is now 18 feet tall (3 times taller), weighs 4900 pounds (3^3 or 27 times more), and can lift 810 pounds (3^2 or 9 times more than normal). He can now lift only about 17% of his body weight, which is about the weight of one of his legs.

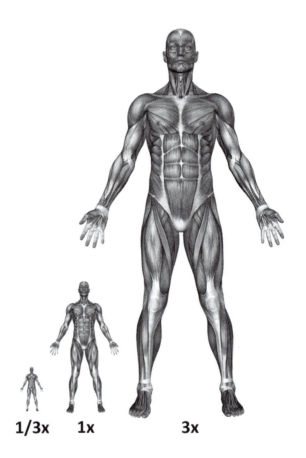

1/3x 1x 3x

Height multiplier	Height	Weight multiplier (* 180)	Weight	Lift multiplier (* 90)	Can lift	% of Body weight can lift
0.33	2ft	$(0.33)^3$	7lb	$(0.33)^2$	10lb	150%
1.0 (normal)	6ft	1	180lb	1	90lb	50%
3.0	18ft	3^3	4900lb	3^2	810lb	17%

If you want the man who's 3 times the normal height to be able to lift the same percentage of his body weight as a normal-sized man, you will have to scale up his bones and muscles to be 27 times stronger.

Recall that bones and muscles scale in strength by cross-sectional area. In order to make a man with muscles and bones 27 times stronger, you need to multiply the normal muscle and bone widths by $\sqrt{27}$, or by about 5 times. The result is 5x muscles in a 3x body.

PHYSICAL CHARACTERISTICS AND SIZE

Aside from the visible height, weight, and strength of a character, there are other physical characteristics related to size. Some are proportional to volume (cubes) while others are proportional to area (squares).

Here we'll look at some of the physical cues in nature that relate to size. These cues can be useful for subtly suggesting a character's size to your audience, for both real and imaginary creatures.

Posture

Crouching puts a strain on the bones and muscles. Animals that are low to the ground can crouch on their back legs as a normal posture without a great deal of strain. This includes small animals like mice and cats as well as low

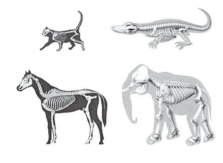

walkers like crocodiles. Taller animals like horses and elephants keep their legs relatively straight.

When designing a character, you can make it seem lower to the ground by putting it into a crouch in its rest position, or make it seem larger by making its legs straight.

Deformability

Relative stiffness is a cue for size. As an example, thread, string, and rope are made of similar materials, but have different stiffness factors due to their different volumes; thread is much stiffer than rope. Stiffness changes as a square while weight changes as a cube.

At the same time, a longer object bends more relative to its size than a short object does, due to the larger object bending under its own weight. Animal tails, hair, ears, and other body parts can bend under gravity, as can the entire body of a skinny character. Bending increases by squares as the volume increases by cubes.

Surface forces vary with area. Larger, heavier characters tend to squash more relative to their sizes than lighter, smaller characters.

A chubby bird provides more opportunity for deformation than a skinny bird.

Wing Size and Shape

Wing size and shape are physical cues for bird size. Birds that specialize in high-speed flight need longer, narrower wings. Short, stubby wings with a tapering point provide less lift but are more maneuverable, which is appropriate for smaller birds that dart around in close quarters such as trees.

Sparrows. Falcon.

Climate

Climate is a physical cue for size. In the Arctic, a small animal would freeze to death. The Arctic is populated only by medium-sized to large animals. The food sources available in a given climate also determine what kind of animals you can find there. Elephants, though large, can't survive in the Arctic because there are no plants.

Furriness is related to size. Heat production is related to an animal's volume, while heat loss is related to its surface area. Due to their small volumes, small animals can only generate so much heat before the heat is lost, so they have trouble staying warm without a coat of fur.

Large animals generate a lot of heat and need to be able to vent it, so they have less fur, if any at all. Large animals in a hot climate adapt by living in water (hippo) or venting (elephant ears).

Longevity

Longevity is related to physical size. We intuitively know that smaller animals don't live as long as larger animals. If your animation calls for an old mouse of normal size, it would have to be no more than two or three years old. If the mouse is 50 years old, this is a subtle cue that the mouse is about as big as a horse. Either that, or it's a normal-sized walking zombie mouse.

CHART OF ANIMAL CHARACTERISTICS

Here is a list of animals in order of weight, with body-related statistics for each one. The numbers here are averages or mid-range numbers for each animal. There are actually large variances within most species (such as large dogs vs. small dogs) but this chart gives an idea of the correlation between weight and other statistics for an animal of that weight.

In general, longevity is related to heart rate; smaller animals have faster heart rates. A rule of thumb is that the heart of any mammal has about 1 billion heartbeats before failure, so a faster heart gives out sooner.

Note that lifespan increases pretty uniformly with size, with the exception of monkeys and humans. There is some evidence that higher intelligence leads to a longer lifespan, which might account for this discrepancy. Modern medicine has also increased the lifespan of humans—our ancestors could expect to live until only about 30 years of age.

	Weight (kg)	Lifespan (years)	Heart rate	Blood pressure	Gestation (days)
Housefly	0.000012	0.08	300	—	1
Mouse	0.02	3	600	110	20
Frog	0.05	10	20	24	7
Snake	0.1	10	45	55	45
Duck	2	10	240	152	28
Rabbit	1	10	205	120	31
Cat (domestic)	2	15	150	129	66
Dog	5	13	90	150	60
Monkey	5	20	192	140	165
Human	90	75	60	120	270
Lion	190	12	70	190	110
Cow	800	22	65	157	275
Giraffe	900	25	65	300	430
Horse	1200	40	44	120	340
Elephant	5000	70	30	145	640
Whale	120000	85	20	25	365

Sound

The sound (pitch) an animal makes is a physical cue for size. Small animals have higher-pitched sounds; larger animals have lower-pitched voices or sounds. When the vocal cord length increases by 2 times, this changes the pitch by an octave.

Loudness is another cue for size. A small animal does not have enough volume to produce a loud sound.

Which chicken is louder?

Babyness

Babyness is a term that describes baby-like physical traits that come across as "cute." Babyness is why everyone loves kittens, puppies, and baby seals—they are not simply scaled-down versions of adult animals, but have specific characteristics that make them adorable.

Kittens, compared with adult cats, have oversized paws, and facial features clustered close together.

As compared to adult traits, babyness traits include:

- Large head
- Large eyes
- Small or large nose
- Short chin
- Eyes, nose, mouth close together, high forehead
- Small or large ears
- Soft, round body features
- Fluffy (shorter fur that sticks out straight)
- Small or large hands, feet, paws, hooves
- Ability to crouch
- Physically agile

Teenagers are something of a special case for babyness. The character might be nearly the height of an adult, but with disproportionate features in other areas. A teenaged animal or person usually has a mix of baby-sized and adult-sized features, giving an awkward appearance that can be appealing in its own way.

Teenaged cat.

Artists often exaggerate babyness even in adult characters to make them more appealing. You can, for example, give all your characters larger-than-life eyes to make them more appealing, but children should always have more babyness than the adults.

Joints

In computer animation, characters are animated much in the way you would animate a jointed toy. An animatable bone structure is called a *rig*, and the practice of setting up a bone structure is called *rigging*. Rigging includes setting up joints and limits on their movements, associating the bone structure with a character's skin, and the creation of various buttons, sliders, and other user interface controls for the rig.

Before reading about joints, you should read the Levers section in the Forces chapter.

Making a complete rig is an art and a science in itself, with several software-specific books devoted to it already. In this chapter, we discuss the joints in a rig and how they relate to real-world physics. The Character Animation chapter includes several sections on animating a character, which generally means animating the rig.

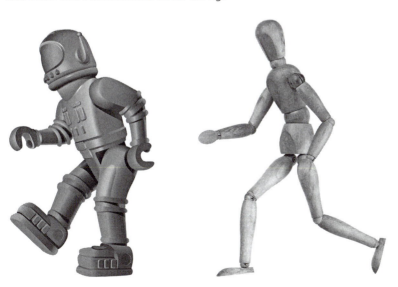

If the character consists of a smooth skin, a bone structure is defined underneath the skin, and the bone structure is animated to make the character's skin move. The skeletal structure usually doesn't look like an actual skeleton, but rather is made up of objects whose size and shape is determined by the software you're using. The "bones" in the skeleton might be box shaped or cylinder shaped, or have some other shape altogether. The bones are linked together with a hierarchical structure.

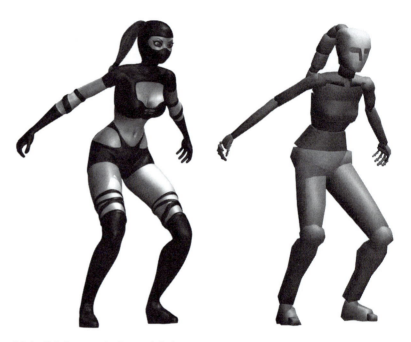

Ninja Girl character's skin and skeleton.

The challenge for animators is to move the limbs and torso so the motion looks believable. A big part of achieving believable motion is having the right kind of joints in the rig. The character designer defines the type, direction, and degree of rotation for joints, and the rigger sets up these joints as designed.

TYPES OF JOINTS

Joints in human and animal bodies are *revolute* joints. Revolute joints have either a single axis of rotation or multiple axes. The three types of revolute joints most common in the human body are hinge, pivot, and ball and socket joints.

Name	Axes of Rotation	Usage	Body parts
Hinge	Single	Bend	Elbow, knee
Pivot	Single	Swivel	Neck, forearm
Ball and socket	Multiple	Free rotation in all directions	Hip, shoulder

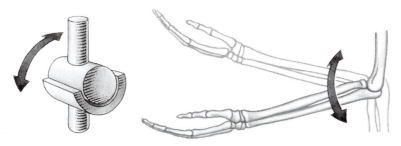

Hinge joint, elbow.

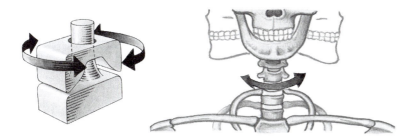

Pivot joint, neck.

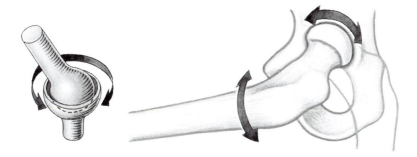

Ball and socket joint, hip.

On a robot or machine, a sliding joint that pulls or pushes a jointed part performs the same job as a muscle contraction on an animal or human being. The sliding joint that controls a backhoe arm is an example of this type of joint.

Robots and machines also have revolute joints, but might also have sliding joints. A *prismatic* or *cylindrical* joint consists of one cylinder sliding inside another, as with the telescoping legs on a tripod. A prismatic joint can only slide in and out (one axis of movement), while a cylindrical joint can both slide and rotate (two axes of movement).

Sliding joints.

Legendary animator Chuck Jones used to dress his animals in ankle-high tennis shoes and knee-high striped socks as a visual assist to remembering where the ankles and knees are.

Animal Joints

Joints in mammals tend to be similar, but have different lengths and degrees of rotation. Joints that look like knees on a dog or cat actually work more like an elbow or an ankle. The actual knee of many quadrupeds, such as cats and dogs, is up inside the skin of the hip area.

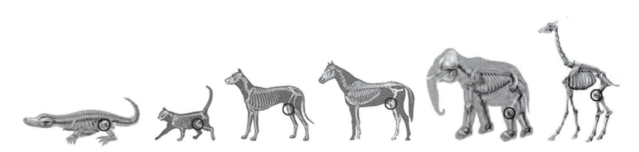

Location of knee joint in crocodile, cat, dog, horse, elephant, giraffe.

JOINTS AS LEVERS

All joints in human and animal bodies operate as part of a lever system. The effort is provided by muscle contractions. In general, the levers in human and animal bodies sacrifice efficiency for speed.

Elbow

An elbow rotates due to contraction of the bicep and tricep muscles. The forearm limb acts as a lever, with the force exerted by the muscle as an effort force and the joint as the fulcrum. The force is not applied right at the joint, but at a point on the forearm very near the joint.

This muscle/joint combination is a third class lever, where the effort arm is shorter than the load arm.

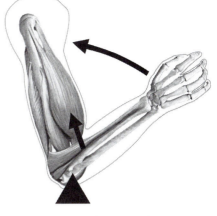

Elbow rotation with fulcrum at the joint, force applied near the joint, and direction of motion.

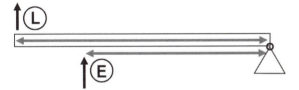

Third class lever.

The effort and load arm lengths of a lever are always measured from the fulcrum. You might think that the effort arm is the length of the entire bicep muscle, but it is actually the distance between the elbow joint (fulcrum) and the place where the bicep pulls on the forearm.

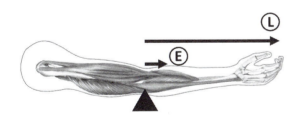

The load arm is the distance from the fulcrum to the center of gravity of the forearm. If the hand is holding an object, then the load arm is from the fulcrum to the combined center of gravity of the forearm and the object, which could be close to the hand if the object is heavy. In this case, the effort arm is quite a great deal shorter than the load arm. Recall that third class levers are always inefficient but fast. This means human beings can make quick movements with their arms.

The tricep is also a third class lever, but it pulls in the opposite direction.

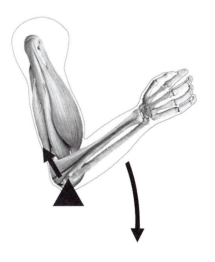

Because muscles can only contract, they are often found in pairs so the limbs can move back and forth. The bicep and tricep muscles are one such pair.

The gastrocnemius (upper calf muscle) is one of the strongest in the body because it lifts the entire body.

Foot

To raise your foot off the ground, you use a number of muscles. The bulk of the work is done by the calf muscle, which contracts to lift the heel.

The fulcrum of the foot lever is at the ball of the foot. The calf muscle provides the effort, while the load is the body's entire weight along the center of gravity line.

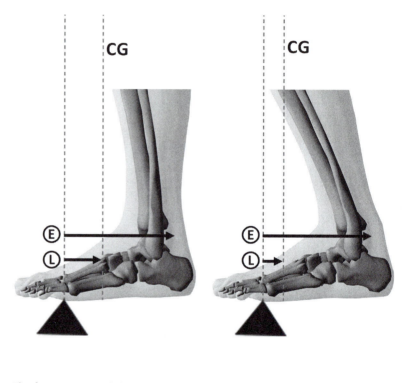

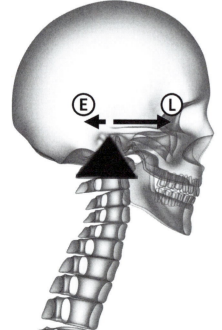

The foot is a second class lever, where the load arm is shorter than the effort arm. Leaning forward shortens the load arm, reducing the effort required to raise the heel.

Neck

The neck is the body's only first class lever, where the effort and load are on different sides of the fulcrum. The effort arm is shorter than the load arm, making the lever inefficient.

Muscles for Joints

It's helpful for an animator to know the locations and names of the major muscles that control the joints. Knowing about these muscles will make it easier for you to study animals and locate corresponding muscles on their bodies.

Splenius capitis
Trapezius
Deltoid
Infraspinatus
Triceps
Latissimus dorsi
Extensor carpi
radialus lungus
Extensor
carpi ulnaris
Flexor
carpi ulnaris
Gluteus
maximus
Hamstrings
Biceps femoris
Semimembranosus
Gastrocnemius
Soleus

Weight Distribution

Review:

- Classical Physics > Forces > Gravity > Center of Gravity

Part of character design is making sure the character can perform the movements called for in the animation without jarring departures from the laws of physics. While the animator is responsible for giving props and characters a consistent sense of weight during the motion, this is possible only with a character designed to do the movements without appearing to suddenly gain or lose weight in various parts of its body.

This doesn't mean you can't design characters with abnormally heavy or light body parts—with animation, anything is possible!—but the character's weight distribution should stay the same throughout.

Understanding weight distribution and balance is essential for creating character design, poses, and movement that work together consistently throughout the animation.

CHARACTER CENTER OF GRAVITY

Balance is based on the location of the center of gravity (CG), which is the average position of an object's weight distribution. Figuring out your character's CG is essential to setting up poses and motion that don't distract your audience by violating the laws of physics.

For any two-legged character, a good starting point is the human center of gravity. When a human being is standing up straight on both legs, the human CG is at about 55% of the person's height, in the vicinity of the belly button.

The CG can move around as the body changes poses. For example, when you bend backward or forward, the CG also moves and can even shift outside your body. The CG moves up when you raise one or both arms, since more of your weight is distributed up higher.

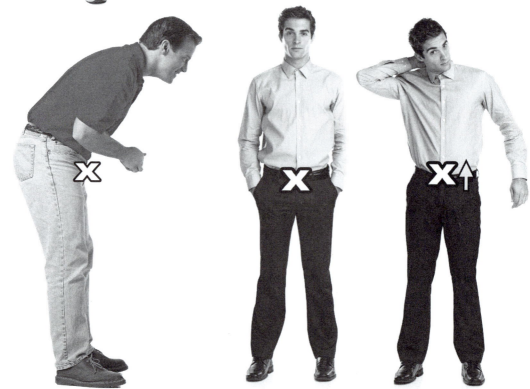

The CG for a bottom-heavy character will be lower to the ground, while a top-heavy character's CG will be higher.

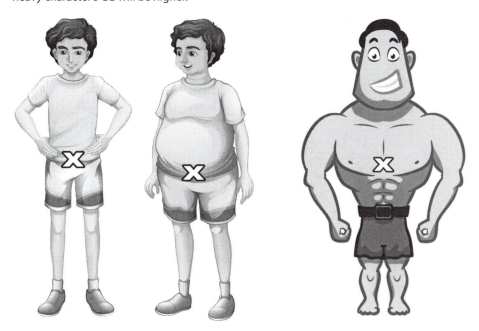

BALANCE

After you figure out the character's CG, you will need to check that the character can actually balance in all the poses called for in the animation with such a CG.

For any given pose, the character's line of gravity goes through the CG to the floor, and hits the floor at the center of pressure. A pose is in balance when the character's center of pressure is within its base of support. Otherwise, the character will tip over. Drawing lines of gravity for a character in various poses will help you determine whether the character can actually balance in that pose.

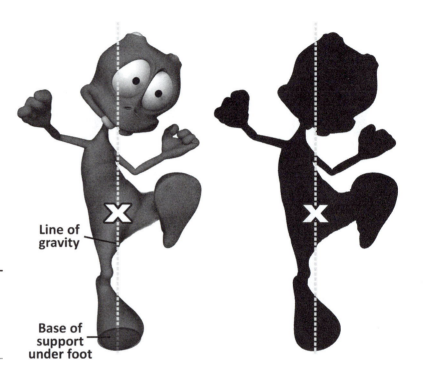

Line of gravity

Base of support under foot

To figure out your character's center of gravity, line of gravity, and center of pressure, it can be helpful to work with the character's poses in silhouette.

For a quadruped the base of support is quite large, making it easier for it to balance than a biped can. If the character has a cane or places a hand on the ground, this acts as an extra leg or two to create a larger base of support.

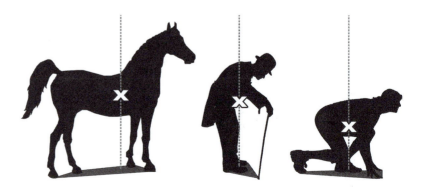

When two people are leaning or holding on to one another, the CG is at the point of average distribution for their total weight, and the base of support spans the area between the contact each of them has with the ground or floor.

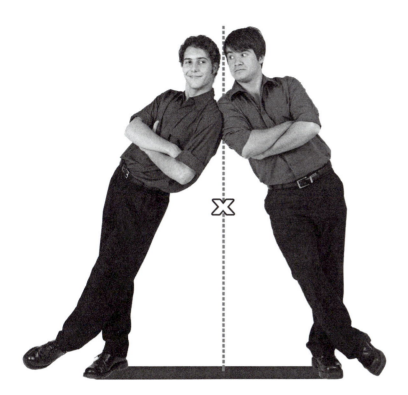

Utilizing the CG, line of gravity, and base of support when designing your poses will help you determine whether a character is in balance for any kind of pose. These tools will also help you keep the weight distribution consistent in poses and animation. If you draw a character as balanced when its CG isn't over the base of support, the character will appear to gain and lose weight in various parts of its body as it moves.

Improving Balance

If your character's CG isn't over the base of support in poses where it's supposed to be balanced, as an animator or character designer you have the freedom to alter the CG or base of support to improve the situation.

A top-heavy character generally has no trouble balancing when standing upright, but is easily thrown off balance by a small shift to the side, such as normal bending movements. While it's fairly common to see an animated

character with an oversized head, the CG in such characters is usually placed lower than is really physically accurate, as if the character's head were light for its size. This puts the CG near the belly button, allowing the character to do normal movements without tipping over.

Character with large head and two CGs for each pose: CG for head of proportionate weight (gray) and CG placed in humanoid location near belly button (white). While the difference in CG placement isn't a problem for the character while standing upright, the CG and line of gravity for the heavy-headed version falls outside the base of support when the character bends down, which would make him tip over.

A character standing on one leg can stretch out his arms and legs to move the CG over the standing leg and help maintain balance.

Toddlers walk with their legs wide apart to increase the base of support and decrease their chances of falling over.

To increase the base of support, you can place a character's feet farther apart. The larger the base of support, the easier it is to keep the character's center of pressure inside it.

In a defensive pose, where the character is preparing for attack, the feet are often spread wide to increase the base of support. Crouching lowers the CG, and holding the arms out allows for rapid shifts of the CG. These elements add stability to the stance.

CHAPTER 6

Character Animation

Believable movement of characters has very likely been a big part of your animation studies. While you can learn a lot by observing real life and studying others' work, your character animation skills can get a big boost by learning a few key physics concepts.

Jumping

A jump is an action where the character's entire body is in the air, and both the character's feet leave the ground at roughly the same time. A jump action includes a takeoff, free movement through the air, and a landing.

Crouch.

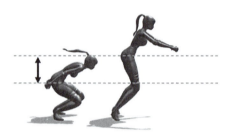

Push height.

The action of going from a standing position to a crouch isn't discussed in this chapter. Technically speaking, the crouch isn't part of the jump. It might take a character a long time to settle into a crouch, or the motion could be very quick; the crouch timing is informed more by the story than by physics. The only consideration is that the time for the crouch should be at least as long as the push time.

Review:

- Classical Physics > Motion and Timing > Timing
- Classical Physics > Forces > Gravity
- Classical Physics > Forces > Action/Reaction

Other topics that pertain to animating a jump:

- Character Design and Animation > Character Design > Weight Distribution > Balance
- Character Design and Animation > Character Design > Size and Scale > Proportion and Scale > Weight and Strength
- Classical Physics > Forces > Friction
- Classical Physics > Motion and Timing > Motion Lines and Paths

PARTS OF A JUMP

A jump can be divided into several distinct parts:

Crouch—A squatting pose taken as preparation for jumping.

Takeoff—Character pushes up fast and straightens legs with feet still on the ground. The distance from the character's center of gravity (CG) in the crouch to the CG when the character's feet are just about to leave the ground is called the *push height*. The amount of time (or number of frames) needed for the push is called the *push time*.

In the air—Both the character's feet are off the ground, and the character's center of gravity (CG) moves in a parabolic arc as any free-falling body would. First it reaches an apex, and then falls back to the ground at the same rate at which it rose. The height to which the character jumps, called the *jump height*, is measured from the CG at takeoff to the CG at the apex of the jump. The amount of time the character is in the air from takeoff to apex is called the

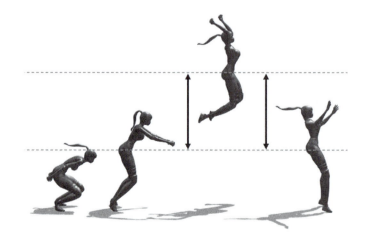

Jump height.

jump time. If the takeoff pose and the landing pose are similar, then the jump height and jump time are about the same going up as they are going down.

Landing—Character touches the ground and bends knees to return to a crouch. The distance from the character's CG when her feet hit to the ground to the point where the character stops crouching is called the *stop height*. The stop height is not always exactly the same as the push height.

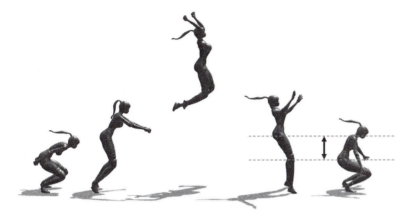

Stop height.

Path of action—The trajectory along which the character jumps, which can be straight up in the air or over a horizontal distance.

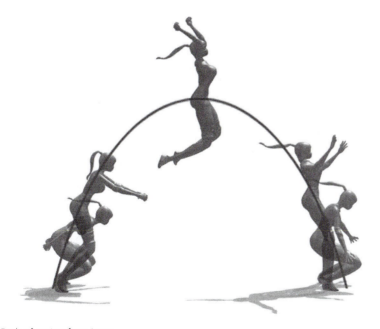

Path of action for a jump.

CALCULATING JUMP ACTIONS

When working out the timing for a jump, you will need to first decide on:

- Jump height or jump time
- Push height
- Stop height
- Horizontal distance the character will travel during the jump

From these factors, you can calculate the timing for the jump sequence.

CALCULATING JUMP TIMING

When planning your jump animation, the most likely scenario is that you know the jump height, expressed in the units you are using for your animation (e.g., inches or cm).

Placement and timing for frames while the character is in the air follow the same rules as any object thrown into the air against gravity. Using the tables in the Gravity chapter (or an online calculator), you can figure out the jump time for each frame. Look up the amount of time it takes an object to fall that distance due to gravity, and express the jump time in frames based on the fps you're using.

Example:

$$\text{Jump height} = 1.2\text{m}$$
$$\text{Jump time for 1.2m} = 0.5 \text{ seconds}$$
$$\text{Jump time at 30fps} = 0.5 * 30 = 15 \text{ frames}$$

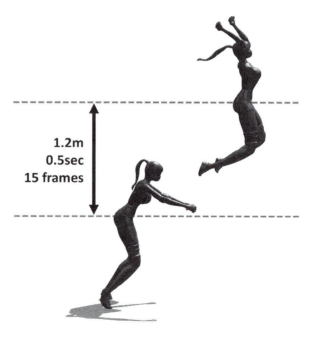

1.2m
0.5sec
15 frames

It's certainly possible for you to decide on the jump time first, and then use that to figure out the jump height. In any case, before proceeding, you will need to have both jump height and jump time in hand.

Jump Magnification

When calculating the remainder of the timing for the entire jump action, you can use a factor called *jump magnification* (JM). The JM can be used to calculate the push timing and stop timing.

The JM is the ratio of the jump height to the push height.

$$JM = Jump\ Height/Push\ Height$$

Since you already know the jump height and push height, you can calculate the JM. Then you can use the JM to calculate other aspects of the jump.

Example:

$$Jump\ Height = 1m$$
$$Push\ Height = 0.33m$$
$$JM = Jump\ Height/Push\ Height = 3$$

In life, a normal human being has a JM of about 0.5. In general, the JM increases for smaller animals and decreases for larger animals. A cat can easily have a JM of 4.0, while a cow would be lucky to have a JM of 0.1.

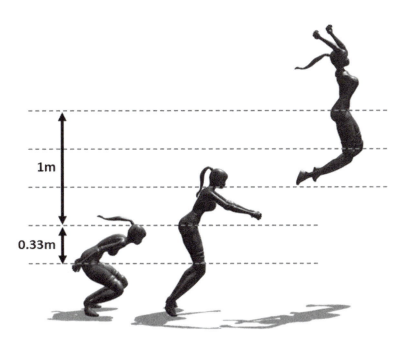

A jump height of 1.2m is higher than any human being can jump without the assistance of a trampoline or springboard. For a ninja, though, it's just another day at work.

JUMP MAGNIFICATION AND ACCELERATION

You might think that jump magnification is just a trick for estimating push timing. In fact, it's an exact ratio that tells you how much the character has to accelerate against gravity to get into the air.

The JM, besides being the ratio of jump-to-push vertical height and time, is also the ratio of push-to-jump vertical acceleration. Note that this is

continued on the next page

opposite the other ratios: while a longer jump time means a shorter push time, a higher jump acceleration means a much, much higher push acceleration.

Knowing about this can help you make more informed decisions about your push timing. To see how this works, let's look at the formula for JM and relate it to acceleration:

$$JM = \frac{\text{Jump Time}}{\text{Push Time}} = \frac{\text{Jump Height}}{\text{Push Height}} = \frac{\text{Push Acceleration}}{\text{Jump Acceleration}}$$

The magnitude of jump acceleration is always equal to gravitational acceleration, with deceleration as the character rises and acceleration as it falls.

$$JH = \frac{\text{Push Acceleration}}{\text{Jump Acceleration}} = \frac{\text{Push Acceleration}}{\text{Gravitational Acceleration}}$$

To get a closer look, let's look at a jump straight up in the air, with no horizontal motion. When you push out of a crouch into a takeoff position, you accelerate your body to a certain speed and then you leave the ground. After that, this speed is slowed by gravity until it reaches a stop at the apex, and then you accelerate as you come back to the ground.

Provided you land on even ground at the same height at which you took off, the landing speed (the speed you're traveling when you reach the ground) is the same as your takeoff speed.

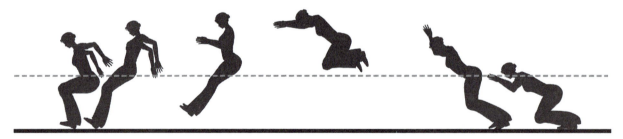

When takeoff and landing height are the same, velocity at those times is the same.

Your landing speed is the same as the velocity of any falling object, which you can easily calculate from the freefall time. Since acceleration due to gravity is 10m/sec², this means that after one second a falling object is traveling at 10m/sec, after two seconds at 20m/sec, after three seconds at 30m/sec, and so on.

Since takeoff speed is the same as landing speed, you need to get up to that same speed when taking off for a jump. If your landing speed is 10m/sec, then during your takeoff you need to get up to a speed of 10m/sec in that little bit of push time.

The general formula for calculating the velocity of an accelerating object is:

$$\text{Velocity} = \text{Acceleration} * \text{Time}$$

Physics shorthand:

$$v = at$$

Let's relate this back to our jump. If the landing velocity is the same as the push velocity, we know that:

$$v = \text{Jump Acceleration} * \text{Jump Time}$$

So . . .

$$\text{Jump Acceleration} * \text{Jump Time} = \text{Push Acceleration} * \text{Push Time}$$

Moving things around with a bit of algebra, we arrive at this equation:

$$\frac{\text{Jump Time}}{\text{Push Time}} = \frac{\text{Push Acceleration}}{\text{Jump Acceleration (Gravity)}}$$

Look, it's the JM! And it's equal to the ratio of the push acceleration to gravity. Increase your jump time, and the push acceleration goes up. Decrease your push time, and the push acceleration goes up.

Distance (or in this case, jump or push height) is also related to velocity:

$$\text{Distance} = \text{Average Velocity} * \text{Time}$$

Physics shorthand:

$$d = vt$$

With some algebra, we make this into yet another formula for the average velocity:

$$v = d/t$$

Because the average velocity is the same for both the push and jump, we can say that d/t is the same for both jump and push:

$$\text{Jump Height/Jump Time} = \text{Push Height/Push Time}$$

And with a little more algebra:

$$\frac{\text{Jump Height}}{\text{Jump Time}} = \frac{\text{Push Height}}{\text{Push Time}}$$

And once again, we have the JM.

Rather than make you go through all these calculations, we just provided you with an easy way to find the JM. Use it to calculate the heights and times for the jump and push with full confidence that it's scientifically accurate.

PUSH TIME

The JM also gives you the ratio of the jump time to the push time.

$$\text{JM} = \text{Jump Time/Push Time}$$

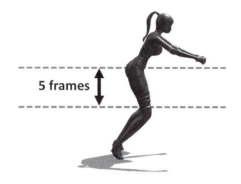

5 frames

Working a little algebra, we can express the equation in a way that directly calculates the push time:

$$\text{Push Time} = \text{Jump Time}/\text{JM}$$

Example:

$$\text{JM} = 3$$
$$\text{Jump Time: 15 frames}$$
$$\text{Push Time} = 15/3 = 5 \text{ frames}$$

PUSH KEY SPACING

During the push, the character accelerates upward from a zero velocity (in the crouch) to a velocity sufficient to throw herself into the air. This means that the keys for the push are not evenly spaced throughout the push, but rather are closer together at the start of the push (for slower motion) and spaced wider apart toward the end of the push (for faster motion).

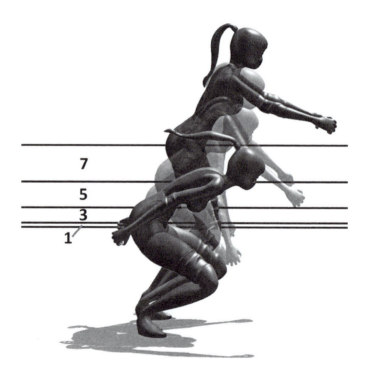

For the purpose of setting the push timing, start by assuming the character is exerting a constant force during the push (rather than a variable force) which results in a constant acceleration. To space the keys for constant acceleration, use the Odd Rule described in the Motion and Timing chapter.

From this basis you can vary the key spacing for emphasis or comic effect, keeping in mind that the end of the push is always faster than the start.

MOTION ARC AND JUMP TIMING

A fundamental part of a good jump is having a correct or believable path of action. When rising and falling due to gravity, the path of action for the center of gravity is always a parabolic arc.

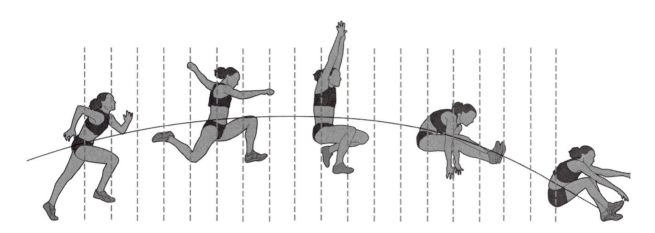

While the CG always follows this arc, a jumping character can appear to defy this rule by raising the arms or legs while jumping. Raising these limbs shifts the CG higher in the body, causing the torso to follow a more flattened arc.

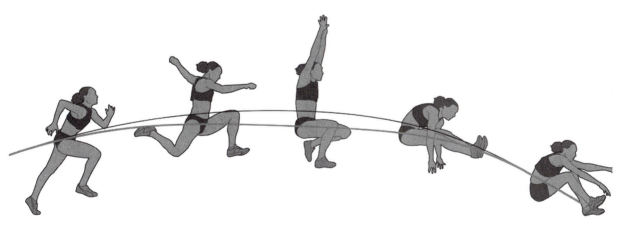

Arc for CG differs from arc for pelvis.

When a character jumps like this, if you follow the arc for a specific area of the torso such as the pelvis, you will find that its arc flattens at the top. This gives the character the appearance of floating for an instant at the apex of the jump.

The vertical timing for the jump is determined by the distance between frames due to gravity, which you can calculate using the tables in the Gravity section of the Forces chapter. The horizontal motion of the character's CG is uniform; the character's CG will move the same distance horizontally on each frame, provided there are no other forces at play, like wind and air pressure. The head and limbs will most likely not move uniformly, but the CG itself does. In other words, the motion of the CG is unaffected by flailing limbs and any other motions your character might perform while in the air.

Ballet dancers raise their arms and legs while jumping to raise the CG and cause the pelvis to float, giving the impression of graceful floating.

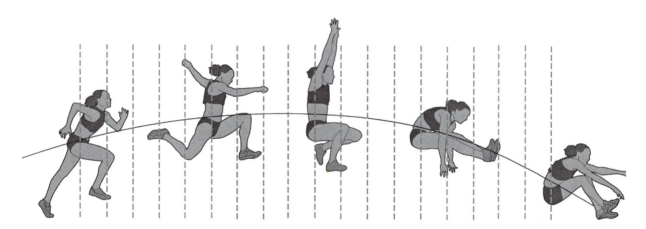

LANDING

The forces on landing are similar to takeoff. If the landing has faster timing, the forces will be larger than for a longer timing.

STOP TIME

The stop height is often a bit larger than the push height, but the timing of the push and stop are the same in the sense that the CG moves the same distance per frame in the push and stop. If the stop height is larger than the push height, you'll just need more frames for the stop than the push.

Push Height/Push Frames = Stop Height/Stop Frames

This can also be expressed as:

Push Height/Push Time = Stop Distance/Stop Time

You can also flip everything over and express it as:

Push Time/Push Height = Stop Time/Stop Distance

Using algebra, we can get the following equation for stop time:

Stop Time = (Push Time * Stop Distance)/Push Height

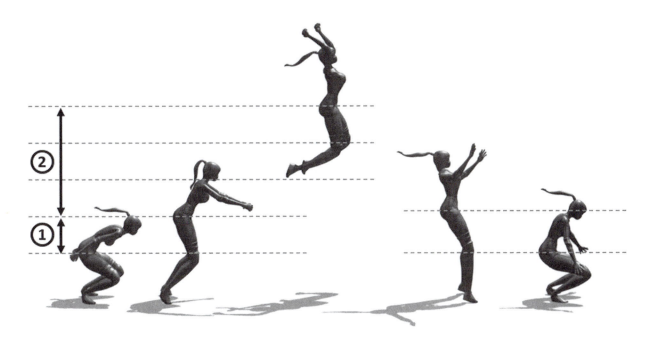

Stop height.

Example:

Push Time: 5 frames

Push Height: 0.4m

Stop Height: 0.5m

Stop Time = (5 * 0.5) / 0.4 = 6 frames

VERY HIGH JUMPS

Some jumps you animate might be very high, resulting in a large JM and a very short push time or a very long push height. Examples of such motion include:

- Being blown out from a cannon
- Bouncing off a gymnastics springboard
- Bouncing on a trampoline
- Superhero leaping over tall buildings

In the case of a character being pushed by some other mechanism such as a cannon or trampoline, the push height is the height the mechanism moves to push the character. The same rules apply for push time and key spacing.

Use whichever equation works best for you. In any case, if the stop height is larger than the push height, the stop time will be longer than the push height; if the stop height is smaller than the push height, the stop time will be shorter.

Push height for seesaw jump.

For fast pushes on exceptional jumps, use motion blur to suggest the degree of speed and acceleration.

While you might be tempted to use a longer push time so your audience can really see the action, this will be unrealistic to the point of distracting your audience. Instead of being amazed at your superhero's skills, they'll make pinched-lemon faces because "something just looks wrong." Don't be that guy who causes pinched-lemon faces! Use realistic push times on your superhero jumps.

For a superhero leap to a very high height, the push height is the same as for any jumping character. Because the height is large, the JM is very large, which means the push time is extremely short.

Let's suppose you're calculating a jump for a superhero, and his time in the air is four seconds; two seconds to go up, and two to come down. Using an online calculator for the freefall height for two seconds, we find that a physically accurate jump with this timing would have to be to a height of about 20m.

Let's assume the superhero is around human sized. Let's use the normal push height for a human being, which is around 0.4m.

Jump Height: 20m

Push Height: 0.4m

JM = Jump Height/Push Height = 50

Now we can calculate the push time.

$$\text{Push Time} = \text{Jump Time/JM}$$

$$\text{Push Time} = 2\text{sec}/50 = 0.04\text{sec}$$

No matter what fps you're using, this timing translates to about one frame. Even if your character is very large and has a push height of 1m, the push time will be only two frames or so.

Walking

Walks feature all the basics of mechanics while including personality. The ability to animate walk cycles is one of the most important skills a character animator needs to master.

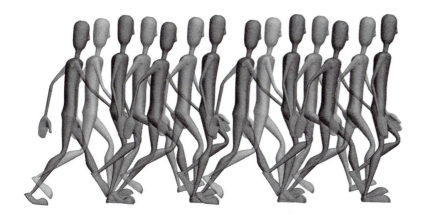

Much about walk cycles has been rigorously documented in other texts. In this book, we will study the mechanics of walking as they relate to physics, and how you can use these concepts to improve your walk cycles.

POSES

Walking consists of a series of poses. The four basic poses for a single step are *passing*, *step*, *contact*, and *lift*. In the passing pose, the free foot is passing by the opposite leg, and the body is at its most upright. In the contact pose, the free foot has come forward just enough to make contact with the ground.

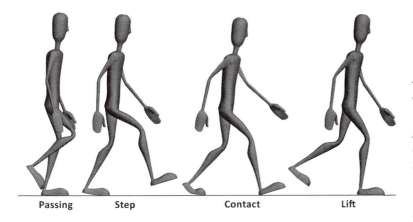

| Passing | Step | Contact | Lift |

Passing and contact are the two that are the most important to get right, as these poses include the most dynamic shifts for center of gravity, limbs, and secondary motion.

Various animation texts use different names for poses in walking. In *The Animator's Survival Kit*, Richard Williams calls the poses *contact, down, pass*, and *up*. Williams uses the term *up* where we use *step*, and draws the *up* pose with the body at its straightest and the head rising above all other poses. In a realistic walk, the body is usually straightest and the head highest in the passing position.

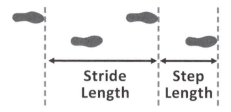

Stride Length **Step Length**

Strides and Steps

A step is one step with one foot. A stride is two steps, one with each foot. Stride length is the distance the character travels in a stride, measured from the same part of the foot. Step and stride length indicate lengthwise spacing for the feet during a walk.

Gait is the timing of the motion for each foot, including how long each foot is on the ground or in the air. During a walk, the number of feet the character has on the ground changes from one foot (single support) to two feet (double support) and then back to one foot. You can plot the time each foot is on the ground to see the single and double support times over time.

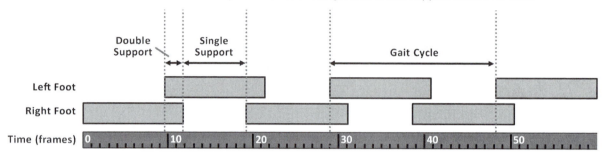

Double Support Single Support Gait Cycle

Left Foot
Right Foot
Time (frames) 0 10 20 30 40 50

Parade march music is set to 120 beats per minute, giving a beat every $\frac{1}{2}$ second.

In a normal walk, each foot is on the ground about 60% of the time. Both feet are on the ground about 20% of the time. In the contact pose, both feet are in contact with the ground.

A normal walking gait ranges from $\frac{1}{3}$ to $\frac{2}{3}$ of a second per step, with $\frac{1}{2}$ second being average.

Walk Timing

Walking is sometimes called "controlled falling." Right after you move past the passing position, your body's center of gravity is no longer over your base of support, and you begin to tip. Your passing leg moves forward to stop the fall, creating your next step. Then the cycle begins again.

The horizontal timing for between the four walk poses is not uniform. The CG slows in going from the contact to passing position, then slows out from passing to contact. The CG also rises and falls, rising to the highest position during passing and the lowest during contact. The head is in the highest position during passing.

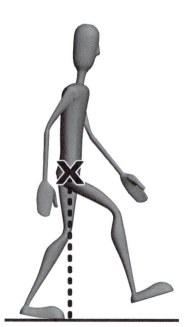

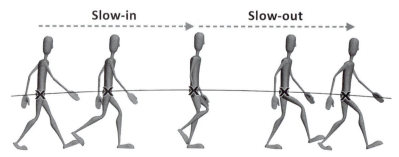

Slow-in Slow-out

To walk faster, you naturally increase both stride length and rate, and decrease the time of double support. A fast walk has a stride rate of about 4 feet/sec. At 6–7 feet per second, the movement transitions into a run.

Walking and Energy Efficiency

When walking, we naturally use the motions that expend the least amount of energy. It takes energy to shift the center of gravity, so we tend toward motions that keep the CG as stable as possible.

Horizontal CG Shift

During passing, the base of support is just one foot. To keep from tipping over, the hips shift to the side to keep your CG over the leg.

A slow walk played fast doesn't look natural because it has a different rhythm than a fast walk.

Try walking in a funny way, and you will find that you use much more energy than normal walking!

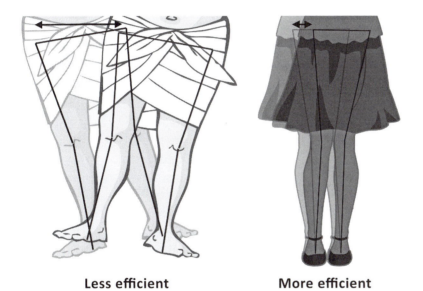

Less efficient **More efficient**

Minimizing the shift makes the walk more efficient. Naturally, with a wider or heavier character, the CG will need to shift more to keep the character from tipping over.

A character with a lot of energy doesn't necessarily need to follow the rules for saving energy while walking.

Vertical CG Shift

The larger the vertical shift in the CG during walking, the more energy needs to be expended. During a walk, the flexing of the heels, toes, and knees combine to minimize these vertical shifts.

In the contact position, you are shorter in height than in the passing position, which shifts the CG downward vertically. To minimize this shift, you naturally extend the heels and toes to make the effective leg length longer.

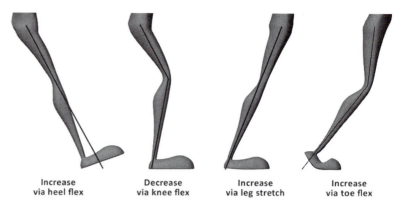

| Increase via heel flex | Decrease via knee flex | Increase via leg stretch | Increase via toe flex |

Effective increase and decrease in leg length during contact period over the course of a walk, and the cause behind the increase/decrease.

We bend both legs when walking, including the standing leg. The knee flexes about 15 degrees just after the heel strike and remains flexed until the center of gravity passes over the weight-bearing leg. This flexing minimizes the amount by which the center of gravity rises during passing.

HIP ROTATION

The hips rotate constantly during a walk, following the swinging leg. Hip rotation keeps the center of gravity as high as possible in the contact and lift poses, saving energy.

When the right leg is about to come off the ground in a lift position, the hips are rotated with the left leg extending forward as much as possible and the right leg extending back as much as possible.

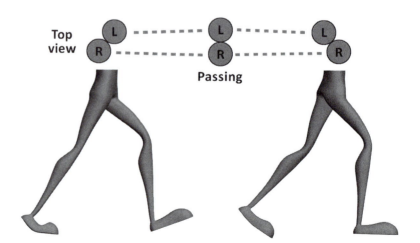

When the right leg reaches the ground in the contact position, the hips are rotated in the other direction, with the right hip rotated forward to extend the leg as much as possible.

SHOULDER ROTATION

Hip rotation requires a rotational force (torque) on your hips. It takes less effort if you balance the rotation of your lower body with the opposite rotation of the upper body. Shoulder rotation going opposite pelvis rotation helps you keep your balance. The arms swing with the shoulders.

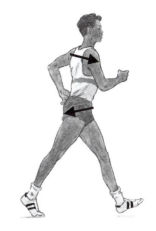

Dancing and Gymnastics

Review:

- Classical Physics > Forces > Torque
- Classical Physics > Forces > Gravity > Center of Gravity

Athletes can do motions that seem to defy the laws of physics. In reality, they're taking advantage of various laws of physics to perform feats that most of us can't do.

TORQUE AND TURNING

A character can turn in the air by generating torque before leaving the ground, pushing forward with one foot and backward with the other.

A dancer can start a turn on one leg with both feet on the ground. One leg pushes off the floor, creating a lever arm between the two feet. When the feet are farther apart, the "lever arm" is longer and it is easier to turn.

The arrows from the feet indicate the forces exerted by the person pushing on the ground; the resulting reaction forces create the torque that produces the body's rotation.

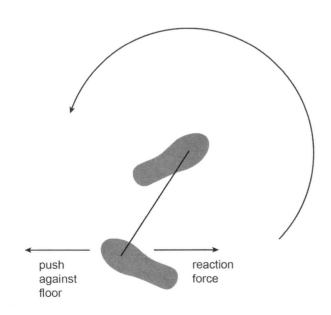

push
against
floor

reaction
force

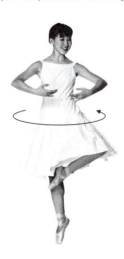

BALANCE WITH MULTIPLE CHARACTERS

When two characters are holding on to one another, the center of gravity for the entire system is somewhere between the two characters' individual CGs. If one character weighs more than the other, the line of gravity is closer to the heavier character than the lighter one. The base of support extends over the standing feet of both characters. This system allows characters to lean toward or away from each other in a way that would cause tipping if either character were standing alone.

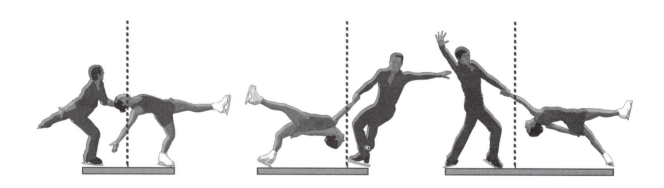

GYMNASTICS LEVER SYSTEMS

A classic gymnast trick has one gymnast jumping on to the end of a seesaw, which throws a gymnast at the other end into the air. When representing a trick like this in your animation, it can be helpful to understand the class of lever system you're using. While viewers won't necessarily know (or care) whether your physics are accurate, they will often have a concept of how the load should react to the effort in your lever system.

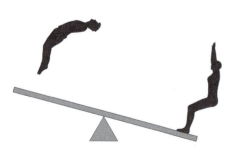

Gymnasts on seesaw-type lever.

In the gymnast–seesaw example, the effort comes from the jumping person's weight plus additional force due to momentum (mass * velocity) that the jumper acquires during the falling part of the jump. Because of the additional momentum from the fall, even a light person could presumably produce enough force to move a heavy load.

If you've ever tried experiments like this with a seesaw, you'll know that even with a heavy effort and light load, the load flies up to only a small degree, if at all. But in animation, it's a lot more fun to show the load flying off into the air.

Suppose you move the fulcrum so it's closer to the load. Now the lever system is efficient but slow, meaning the effort moves a longer distance than the load. A slow lever system isn't going to give you this fast kind of push on the load that you need to make it fly off into the air.

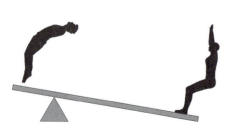

Efficient but slow seesaw lever.

If the fulcrum is closer to the effort, the system is inefficient but fast. This means that the load will move faster than the effort, making it a

more desirable choice for if you want the load to gain enough speed go flying off.

Another consideration is the load's trajectory when it flies into the air. Physics tells us that once the load leaves the lever, it will continue to move in the direction in which it was traveling at the moment it left the lever. Per the laws of physics, the load travels in a slight circular motion while sitting on the seesaw. At the time the load leaves the lever, the motion is angled slightly toward the fulcrum. When the load leaves the seesaw, the load's CG continues in a straight line in the same direction in which it was moving when it left the seesaw. Once the load is in the air, it is of course subject to the force of gravity, and the path of action is a parabolic arc.

In this type of animation we sometimes see artistic license being taken with the trajectory, with the load flying off backward away from the lever. If this is the kind of motion you want to animate, you're in luck. Springboards used by gymnasts and acrobats have served to confuse the average viewer about the direction in which a person would fly off a lever system, and how high they would fly.

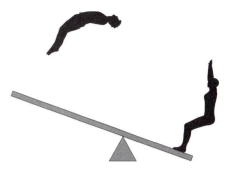

Inefficient but fast seesaw lever.

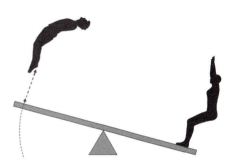

Motion path for gymnast flung from seesaw lever.

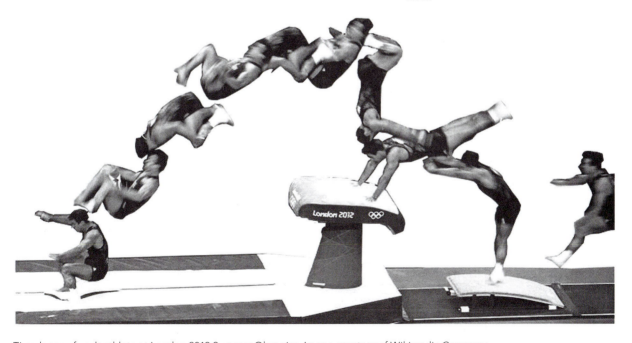

Time lapse of vault athlete at London 2012 Summer Olympics. Image courtesy of Wikimedia Commons.

A gymnast's springboard is like a third class lever, with the spring pushing back up (effort) at the gymnast (load). The gymnast flies upward because he or she converts energy from forward motion to upward motion, a trick that requires superior body strength and rigorous training. When reaching the vault, the gymnast also uses his or her body as a lever with the hands as a fulcrum, yet another feat that requires strength and training. In other words, ordinary people wouldn't bounce off a springboard and vault over that way; they would simply continue the forward motion off the springboard and smack face-first into the vault.

A springboard and seesaw are quite different, from a physics perspective, but your viewers most likely aren't thinking about this. All they know is that when a board pushes a person up fast, the person goes flying into the air. Since viewers watch gymnastics far more than they watch people jumping on seesaws, you can get away with borrowing the springboard motion for your seesaw animation.

Lifting Weight

Review:

- Classical Physics > Gravity > Center of Gravity
- Character Design and Animation > Character Design > Weight Distribution

Picking up an object requires a number of shifts in the center of gravity. When you squat to lift an object, you shift your backside backward to keep the center of pressure inside the base of support.

You can tell how heavy an object is by the shift in the center of gravity when a character holds or lifts it. The character and the object have their own combined CG, the average distribution of the character's weight and the object's weight together. In animation, the more the CG is shifted toward the carried object, the heavier it will appear.

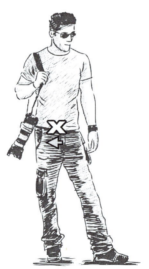

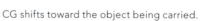

CG shifts toward the object being carried.

Carrying a heavy box.

To hold a heavy object, the character has to lean over to keep the combined CG over the base of support so the character can stay upright.

Carrying a light object shifts the overall CG to such a small degree as to be negligible, and the character's posture and CG are almost the same as if no object were being lifted or held.

SHIFTING BODY WEIGHT

A character's CG can shift in a number of ways during animation due to body shape changing. If the character bends forward, backward, or sideways, or stretches out the limbs, the CG will shift. As long as the CG stays over the base of support, the character can balance.

For example, if you reach forward, your CG shifts forward. When reaching forward while standing on one leg, you naturally put your arms and legs out to shift your CG back over your standing leg.

Knowing that a character can balance only if the CG is over the base of support, you can work out any number of poses for a character.

SITTING AND STANDING

Sitting and standing are largely a matter of shifting balance while always keeping your CG over the base of support.

To sit in a chair, you need to bend your knees and lean forward to bring your center of gravity over your feet. Then you bend over further so you can bend your knees even more and still keep your CG over your feet. Finally, your backside hits the chair and rests on the seat. The chair forms a large base of support for your body.

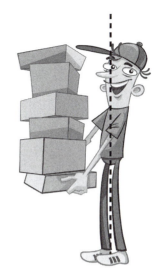

Holding lightweight boxes.

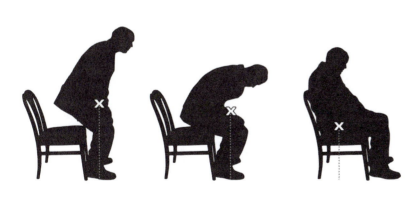

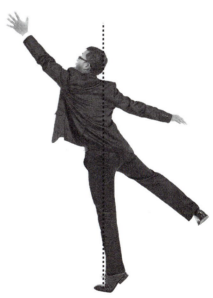

To stand, you reverse the process. You lean forward to shift the CG over your legs, and move your feet apart to increase your base of support. If the chair has arms, you can extend your base of support to include your hands.

Getting Hit

Review:

- Classical Physics > Forces > Action/Reaction

If you've ever kicked a tire, punched a wall, or otherwise hit a solid, immovable object, you know something about the forces involved in action/reaction. The object being hit experiences a force, and the person doing the hitting also experiences some pushback from whatever he's hitting. The immovable object usually wins that particular fight!

In animation that involves hitting or getting hit, action/reaction comes into play. When both objects involved are mobile, as with two characters fighting, both are visibly affected by the action/reaction forces.

FIGHT SCENES

Fight scenes are realistic when the action forces in punches and kicks have believable reaction forces. The person being hit experiences a force, and the person doing the hitting also experiences some pushback from whatever he's hitting. The rules of action/reaction with mobile objects apply because the characters can tip, fall over, or fly backward due to the action or reaction force. In other words, the characters are not fixed objects like a wall or floor.

When one character kicks another in the head, for example, there are equal and opposite forces going from the foot to the head, and from the head back to the foot.

In live action and animation, the action force in fight scenes is sometimes represented as much greater than the reaction force, to enhance the entertainment value. In traditional animation, this is done for comic effect. In martial arts films, action films, and comics, action force is exaggerated to emphasize the strength or prowess of the fighter. Plus it's just plain fun to see the villain go flying when the hero gives him a good smack.

MOMENTUM AND FORCE OF IMPACT

You're probably familiar with the term *momentum* in common language as meaning the amount of thrust or "oomph" that a moving object has. Intuitively, you know that getting hit by a lightweight, slow-moving object (like a soccer ball) is a very different experience than getting hit by a heavy, fast-moving object (like a boulder that just fell off a cliff). The momentum of these two objects is very different.

In physics, the exact definition of momentum is the mass times the velocity.

$$p = mv$$

Momentum = Mass * Velocity

From this equation, it's easy to see that a heavy moving object has more momentum than a light object moving at the same speed. In the same way, if two objects weigh the same, the one moving at higher speed has more momentum.

CHANGING MOMENTUM

Understanding momentum becomes important when animating interactions where the momentum is changed in some way. Usually this means something

In the examples in this chapter, we substitute *weight* for *mass*. Although a physicist will be quick to point out that these aren't always the same thing, they're close enough to the same thing near the surface of Planet Earth for us to use *weight* for our calculations.

is stopping the object, bringing its velocity to zero and thus changing its momentum to zero.

The degree of force involved in changing an object's momentum is directly related to the time interval, which is sometimes strongly related to the materials and surface area involved.

Suppose you toss an egg about three feet into the air and catch it gently with your hand in such a way that the eggshell doesn't break. Your fleshy hand provides a cushion to slow the fall with gentle forces, stopping the egg's fall over a fraction of a second or so. You'll also lower your hand while slowing the egg, increasing the time interval even more. You have changed the egg's velocity (and thus its momentum) to zero over this interval of time by gradually exerting an opposing force against the egg's fall.

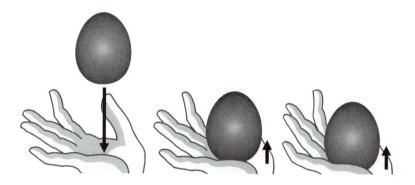

Next, hold the egg about three feet above a hard floor, and drop the egg. The egg isn't moving that much faster when it hits the floor than it was when it hit your hands, but because the time of impact is so short, the egg breaks.

The nearly instantaneous change in velocity (and thus momentum) means the force of impact on the egg is very large. The egg pushes on the floor with an equal and opposite force but that won't do much to the floor. If you drop an iron cannonball on a wooden floor, then the physics is similar but the roles are reversed; the falling cannonball can break the wood.

Force and Changing Momentum

Even though the time to slow the egg with your hands is only a fraction of a second, this time is enough to make an enormous difference in the amount of force exerted back on the eggshell at any given moment.

At each consecutive moment during the time interval where your hands are stopping the egg, the egg is exerting an opposing force on the surface of your palms, and you are pushing back. Because there's a time interval and surface area involved, the egg's momentum change is "spread out" over that time and area rather than occurring all at once in one spot at the time of impact.

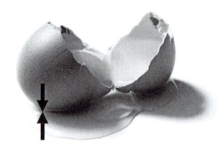

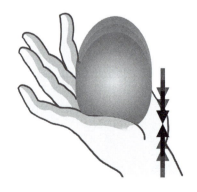

This is the idea behind seat belts and air bags in cars to prevent injury during crashes. These mechanisms cause the force of impact to be "spread out" over a fraction of a second on a larger part of your body. This creates a series of consecutive instants of spread-out pressure which your body can easily withstand, rather than one single instant of high pressure in one place.

Action/Reaction and Changing Momentum

A bullet striking a character's body is another example of changing momentum. If the bullet is stopped when it hits the character, the bullet's momentum is changed to zero. With regards to time/force/materials, let's look at a couple of different ways the bullet could be stopped by the character:

- The bullet hits soft flesh, and the flesh exerts a force that stops the bullet over a short time interval.
- The bullet hits metal armor and stops instantly.

The law of action/reaction tells us that whatever the bullet hits will exert an equal and opposite force against the bullet to stop it. If the stop is instantaneous, as with the armor, a large force is exerted at the moment of impact, causing a reaction in the armor that throws it (and thus the character) backward away from the motion of the bullet.

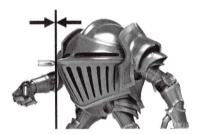

The momentum from the bullet is effectively transferred directly to the armor. But remember that momentum is mass * velocity.

So the bullet's momentum = bullet's mass * bullet's velocity = man's mass * man's velocity.

If the bullet's momentum is transferred to a character who weighs 1000 times more than a bullet, the velocity imparted to the character will be 1000 times less than the bullet's velocity. This means that the velocity imparted is quite small.

Whether the bullet is stopped by soft flesh or hard armor, the man's velocity after stopping the bullet is the same. The difference is the force of impact is larger with the armor. With the armor the acceleration of the man is large but the time interval for that acceleration is small. When the bullet is stopped by flesh, it's a lot like when you catch an egg with your hands; the force (and acceleration) is smaller but the time interval is longer.

A bullet hurts a person through damage to internal organs, bleeding, and other injury-related factors, not by throwing him backward. A character is more likely to double over in shock or pain than to be physically moved by the force of the bullet itself.

A scenario somewhere in the middle is a character being shot while wearing a bulletproof vest. The vest repels the bullet by stopping it over a short interval within the vest itself. Because of the shorter stop time the moment-by-moment force is greater than if the bullet were stopped by flesh.

Despite all these factors, audiences seem willing to accept that a bullet hitting flesh can throw a person backward. In the movies, we sometimes see a character propelled backward through a plate glass window (or other impressive obstacle) by a bullet shot into his chest, then the poor victim falls to a spectacular death 30 stories below. This backward thrust is impossible unless the person has an impervious plate embedded in his chest and the bullet is extremely heavy. It's more likely that the person would simply stumble backward in shock, but that isn't nearly as dramatic as a good shoot-smash-fall sequence.

Feel free to design the character's reaction to getting hit as you like, but with full knowledge of the actual physics involved!

Recoil

Recoil from a gun is another example of action/reaction with two mobile objects. Because the bullet and gun are both hard metal, neither absorbs the force gradually—the transfer of momentum is nearly instantaneous, and the action force that accelerates the bullet results in a matched reaction force in the opposite direction. The bullet's momentum is matched by the gun's momentum in the opposite direction, creating recoil.

$$\text{Bullet Weight} * \text{Bullet Speed} = \text{Gun Weight} * \text{Gun Recoil Speed}$$

Because the gun weighs a lot more than the bullet, the recoil speed is a lot less than the bullet's speed. The gun's momentum is then passed to the character, where the character's muscles push back in an effort to stop the gun.

If the character's muscle strength isn't great enough, the character might be thrown back. In animation, unexpectedly large recoil is sometimes used for comic effect.

Tipping Over

Review:

- Classical Physics > Forces > Gravity > Center of Gravity > Tipping and Center of Gravity
- Classical Physics > Forces > Torque > Torque in Animation
- Classical Physics > Forces > Friction

As you learned in the Gravity section, tipping occurs when the object's center of gravity moves over in such a way that the center of pressure is no longer over the base of support.

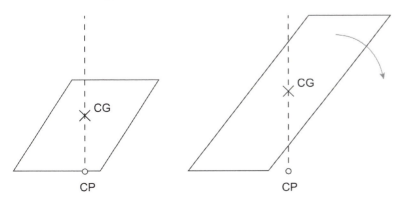

In the section on Torque, you also saw that tipping can be viewed as increasing torque as the tipping angle increases.

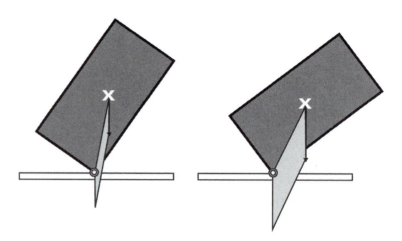

ROTATIONAL INERTIA AND TIPPING

Rotational inertia plays a part in the speed of tipping objects. If you have two objects made of the same material with different lengths, the longer object has a center of gravity that is farther from the axis of rotation. Thus the longer object has a larger rotational inertia, so it falls more slowly.

You can use these principles in character animation. For example, an adult falls slower than a child.

You can also use this principle to make a character appear top heavy. A top-heavy character will have greater rotational inertia than his bottom-heavy friend, so the top-heavy character will tip, bend, and rotate slower in animation.

TIPPING AND FRICTION

Tipping sometimes works hand-in-hand with friction. If your character is pushing a box across a floor, the box might tip rather than slide, based on a variety of factors:

- If the box is taller than it is wide, it is more likely to tip. A taller box has a longer torque arm, making it easier to move the box's center of gravity past the base of support. But since the box is tall, it will fall slower than a short box once it starts tipping.

- The lighter the box, the more likely it is to tip if it is pushed near the top. Very little torque is needed to move the center of gravity past the base of support. On the other hand, a light box has less friction than a heavy box, so it might also slide when pushed.

- The higher up the force is applied, the larger the torque arm and the more likely the box is to tip.

- The higher the center of gravity, the more likely it is to tip. Once it tips, the box will fall slower than a box with a lower center of gravity.

- On a rougher surface, static friction keeps the box from sliding, making the box more likely to tip than slide.

Drag and Follow Through

Review:

- Classical Physics > Motion and Timing > Circular Motion

Drag and *follow through* are effects that occur when something soft or jointed is attached or tied down at one end to a parent object. When the parent object starts to move, the unattached part of the child object tries to stay where it was just before the motion. This causes the child object to trail behind or in front of the parent in the direction opposite the parent's motion.

In animation, the terms *parent* and *child* refer to systems where one or more objects (children) are linked to a main object (parent). In the images here, the robot's torso/head is the parent object, and the antennae and limbs are child objects.

Hair in neutral position, and hair during acceleration.

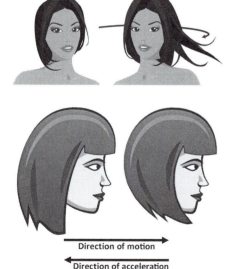

Hair in neutral position, and hair during deceleration (negative acceleration).

Drag and follow through are entirely due to the Law of Inertia. The Law of Inertia, also called Newton's First Law, states that an object at rest stays at rest and an object in motion stays in motion with the same speed and in the same direction unless acted upon by unbalanced force. The child object's center of gravity attempts to keep doing what it was doing as long as possible until forces from the parent object pull it along.

Examples of the types of objects that experience drag and follow through are:

- Hair
- Cloth
- Ribbons and streamers
- Soft flesh
- Hinged objects, including limbs

While drag and follow through can happen with any kind of object regardless of weight, the most visible effects happen with soft, light substances like hair and cloth. Because they are pliable and subject to a great deal of air resistance, hair and cloth appear to float and flow as they trail and settle.

DRAG

Drag occurs when the parent object accelerates forward. The tied-down part of the child object moves along with its parent, while the rest trails behind.

Consider a long-haired character sitting on a bus that starts moving forward. When the bus accelerates, the part of the hair attached to the head moves with the head, but parts of the hair not attached to the head flow behind the head.

Drag can also occur with circular motion, as when a character turns her head. If the parent object turns in a circular motion, the child objects will experience a centrifugal force. In reality, the child objects are just trying to continue moving in a straight line but are being pulled inward by the parent object. This is another example of inertia at work.

FOLLOW THROUGH

Follow through occurs when the parent object comes to a stop. In effect, the parent object experiences deceleration—the acceleration is in the direction opposite the motion. The child object's center of gravity keeps moving until

it is stopped by other forces, such as the head exerting a force on the hair at the point where it's attached to the head.

Overlapping Action

Review:

• Classical Physics > Motion and Timing > Circular Motion > Pendulum Motion

If a parent has more than one child object, these objects will most likely accelerate or decelerate at different speeds when the parent starts or stops. This principle is known as *overlapping action*.

LENGTH AND MOTION

Objects respond differently to follow through and drag primarily because of differences in length from the attachment point to the parent object. To illustrate these differences in motion, consider the motion experienced by a horse's mane and tail as the horse runs.

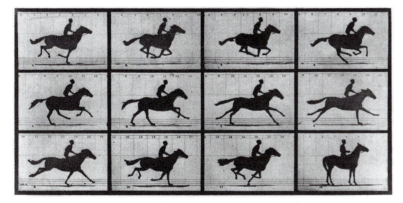

Eadweard Muybridge photography of a horse in motion. The mane repeatedly moves away from and toward the neck while the tail stays out from the body.

• The underside of a horse's tail doesn't move as much as the top because of the weight of the upper portion of the hairs bearing down on it. The upper part of the tail is more susceptible to motion.

- If two child objects are made of the same material but have different lengths (as with a horse's mane and tail), the shorter object will move from its previous position faster than the longer object does. There are two effects in play here: larger objects have more inertia since they have more mass, and longer objects have larger rotational inertia so their rotational acceleration is slower. The mane hairs, being shorter, are susceptible to more rotational acceleration than the tail.

Angular motion of tail and mane hairs from original position to drag position.

- While the ends of longer hairs move slower than shorter hairs, they travel a longer distance. You can think of this as a pendulum, where the end of a long pendulum swinging to a 30 degree angle moves farther than a short pendulum going to the same angle.

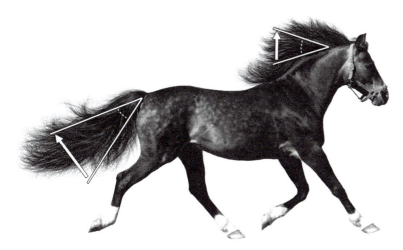

If a long tail hair rotates over the same angle as a short mane hair, the end of the long hair will travel farther than the end of the short hair.

Pony tails, kite tails, and other long, flexible objects stretch and contract similar to the way springs do. In physics, Hooke's Law tells us that the force needed to compress or stretch a spring is proportional to the change in the length of the spring—the greater the change in the length of the spring, the more force is needed. Hooke's Law can be applied to any long, thin object made of flexible material, including a tall building shaken by the wind or the string of a musical instrument being plucked.

- A running horse, or any running animal or character, doesn't have a constant horizontal velocity. The body slows down as the feet hit the ground, then speeds up as the feet push off the ground. These changes in velocity cause any trailing objects, such as a mane or tail, to contract and extend like a flexible spring. You can see this effect in the Muybridge photo series.

SURFACE AREA AND MOTION

Another difference in drag or follow through can come from the object's weight vs. surface area. Although the acceleration of gravity is the same on all objects, lighter objects with a large surface area (such as a kite) are more subject to air resistance, and thus will seem to resist gravity more than heavy objects. A kite's streamers, being child objects of the kite itself, have a lot of dynamic motion due to follow-through, drag, wind, and air resistance.

When animating overlapping motion, consider all objects in the scene which are soft or jointed, and which are not completely tied down. Then consider the length, weight, and flexibility of each object, and how long it is from the tied-down point to the end.

Although it can be hard to accurately predict the exact effects of inertia and air resistance, you can at least cause different objects in your animation to respond differently to inertia, and thus make a more dynamic, realistic, and compelling sequence.

PONYTAIL SWING

There are many online calculators to help you calculate the period or frequency of a rigid pendulum. Multiply the rigid pendulum's frequency by 1.15 to get the frequency for the flexible version. The frequency of a flexible pendulum is about 15% longer than the period of a rigid pendulum. For example, the frequency of a 14 inch rigid pendulum is 1.275 seconds, so the frequency of a 14 inch ponytail is 1.5 seconds.

The magnifying effect of resonating frequencies is called *parametric resonance*.

A ponytail is like a flexible pendulum that can swing when a character's head moves. When a character makes a repetitive up-and-down motion like running, the body's up-and-down motion makes the ponytail move up and down. Under some circumstances, the ponytail can also swing wildly from side to side when a character runs. Let's take a look at how these circumstances happen.

Recall that a pendulum of a specific length always has the same period, the length of time for a full back-and-forth swing. As long as the length of the pendulum stays the same, the period stays the same, regardless of whether the swing is tight or wide. The same is true for the frequency, which is simply 1 divided by the period.

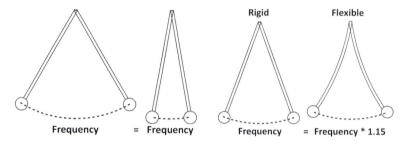

The slight left–right motion of the body while running is responsible for the ponytail moving side-to-side, but only to a small degree. A big, wide ponytail swing happens when the frequency of a character's run is twice the ponytail's pendulum period, causing the frequencies to resonate and magnify. This makes the ponytail swing much higher to the left and right than it would if the ponytail were a different length, or if the run cycle had a different frequency.

For example, suppose your character is running at a rate of 3 steps per second, which causes the entire body to move up and down at a rate (frequency) of 3 up–down cycles per second. As mentioned earlier, the frequency of a 14 inch flexible pendulum is 1.5 cycles per second. In this case, the run frequency is twice the ponytail's natural swinging frequency. This means a 14 inch ponytail will resonate and fly high on the left and right sides when the character runs at 3 cycles per second.

Visual Effects

Visual effects are any images or imagery that are created or manipulated outside a live action shot. Some visual effects are created to enhance a live scene, while others stand on their own without any live action in the scene at all. Visual effects are sometimes called VFX or SFX (short for special effects).

In general, visual effects are intended to appear to be live action, or to blend in with any live action so as to appear real. Knowing the physics concepts behind the environment, explosions, and other common VFX needs can help you make more realistic imagery. The same physics concepts can also be applied to traditional animation to enhance realism in a scene. If there are previously discussed topics that pertain directly to the subject, these are listed at the start of the section. This will enable you to review any topics necessary before you dive in.

Stealing home plate in a baseball game, with enhanced dust.

Surfing in a simple, elegant ocean.

CHAPTER **7**

Environment

In your animation work, you will very likely need to represent our external environment in some fashion. Understanding the basics of weather effects like clouds, rain, and lightning will help you make your weather-based animation effects more realistic and compelling.

Changes in air pressure cause a lot of the changes we see in our environment such as clouds and rain. To get the most from the Environment chapter, be sure to read the Pressure section of the Forces chapter.

Clouds

Clouds in the sky are part of everyone's experience from the earliest age. Many of us have memories of lying on the ground on a summer day and picking out shapes in the fluffy clouds above.

Scientists have succeeded in identifying different types of clouds and predicting their behavior to a great degree. Knowing how, why, and when clouds form will help you depict them in a more realistic way.

WHAT'S IN A CLOUD

A water droplet in a cloud is about 100 times smaller than an ordinary raindrop.

Clouds are composed of water or ice droplets clinging to microscopic dust particles. The droplets are so small that they are easily suspended in the air.

Clouds form as a result of water evaporation. Water evaporates from the Earth's surface and rises into the air above. There, it cools and condenses onto dust particles, forming water droplets or ice particles. Water and ice reflect and scatter all colors, so they appear to us as white. Large groupings of these particles appear to us as clouds.

Evaporated water usually doesn't travel straight up and form clouds, but gets blown around a bit first. Differences in temperature over adjacent regions cause differences in air pressure, which produces winds that blow from warmer to cooler regions. When the water vapor reaches the cooler region, the water condenses and clouds form.

Once clouds form they are subject to winds and changing temperatures, which cause them to move across the sky, change shape, and grow or disperse.

TYPES OF CLOUDS

In order to discuss clouds, we group them into categories with names derived from Latin.

Cumulus cloud.

- Cumulus clouds are light, fluffy clouds with distinct outlines, commonly referred to as "fair weather" clouds. This is the type of cloud most often depicted in cartoons. Cumulus clouds are dense and opaque, blocking out the Sun as they move past it. With thick cumulus clouds, areas facing

away from the Sun have shadows, making the clouds appear almost solid. Cumulus means *pile* in Latin.

- Cirrus clouds are long, wispy clouds that occur at high altitudes. Such clouds are thin and flat, and don't block the Sun to any great degree. Cirrus means *lock of hair* in Latin.

- Stratus clouds are nearly uniform sheets of cloud material. Stratus means *layer* in Latin. Fog is actually a stratus cloud at ground level.

- Nimbus clouds are any clouds that produce precipitation (rain, snow, hail). Nimbus means *cloud* in Latin.

CLOUD ALTITUDES

Different types of clouds form at different altitudes above Earth. We can divide the altitudes into three areas:

- Low—Below 6500ft/2000m

- Alto—6500–23,000ft/2000–7000m

- High—Above 23,000ft/7000m

Within these altitudes, there can be various categories of clouds. The names of clouds are combined together or with the name of the altitude range to describe the cloud.

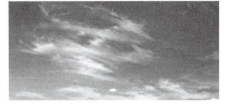
Cirrus cloud.

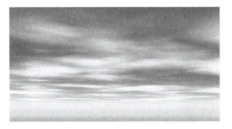
Stratus cloud.

Altitude	Name	Appearance
High	Cirrus	Long, wispy
	Cirrostratus	Transparent sheet
	Cirrocumulus	Speckle fluff
Alto	Altostratus	Translucent sheet
	Altocumulus	Dotted fluff
Low	Stratus	Opaque sheet
	Cumulus	Fluffy, individual
	Stratocumulus	Fluffy sheet
	Nimbostratus	Rain-producing sheet
All	Cumulonimbus	Tall, anvil shaped, rain producing

Cirrostratus cloud.

At high altitudes, all clouds are considered cirrus clouds of one kind or another. The air at this altitude is quite cold, so these clouds are made of ice crystals. The clouds are a brilliant white due to their icy composition, and are relatively thin and flat; they don't have shadow areas the way fluffy cumulus clouds do at lower altitudes.

Cumulus and stratus clouds can also occur at high altitudes, named with the prefix *cirro-*. Cirrocumulus clouds are dotted versions of cirrus clouds, while cirrostratus clouds at this level are transparent enough to reveal the Sun as a hazy ball.

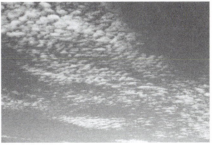
Cirrocumulus cloud.

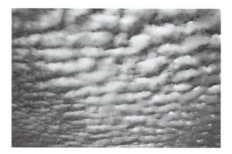

Altocumulus cloud.

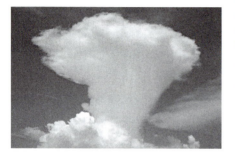

Cumulonimbus cloud.

Alto clouds can be cumulus or stratus clouds, which are made from ice crystals at higher levels and water droplets at lower levels. At this level clouds are translucent, allowing you to see the Sun through them dimly. Altocumulus clouds are puffier than cirrocumulus clouds, but not as puffy as low clouds.

Low clouds, which are made of water droplets, can be either stratus or cumulus clouds, and can also be nimbus clouds. A low stratus cloud blocks out the Sun itself and disperses the Sun's light somewhat evenly, making it difficult to tell where the Sun is. Nimbus clouds are low clouds, or clouds which start low and extend up into higher altitudes.

Most clouds aren't tall enough to extend over multiple altitudes, with one notable exception. Cumulonimbus is a tall, anvil-shaped cumulus cloud that extends from very low to very high altitudes. Such clouds can produce lightning in addition to rain.

Stratus clouds can exist at any altitude. You can sometimes estimate the altitude of a stratus cloud by how well you can see the Sun through it. Through a cirrostratus cloud, the Sun is visible as a hazy ball. With a stratus cloud at a low altitude, the Sun is barely visible or not visible at all.

Cirrostratus cloud.

INSIDE A CLOUD

You can get an idea of what a cloud looks like up close by observing fog on the ground. Fog is actually a very low stratus cloud. When there's fog on the ground, the sky is always overcast.

When approaching a cloud from the outside, as in an airplane, clouds look similar to the way they do from the ground. However, when you're actually inside a cloud, it looks a lot like fog. You can see only a short distance in front of you, and as you move, your visibility is limited to the same distance at all times.

MOVEMENT OF CLOUDS

Clouds are prone to being blown by a wind of some kind, which means they are constantly moving and changing shape. When you consider that clouds form from differences in air pressure, and that wind results from differences in air pressure, it's easy to see that clouds and wind often go together.

If you glance up at the sky for just a moment, clouds can appear motionless. But if you watch for several minutes or record a time-lapse video of the sky, you'll see the movement and changes in cloud shapes.

It's not unusual to see clouds at different altitudes moving at different speeds. Cirrus clouds can be subject to winds from a jet stream, which can blow at speeds up to 180mph/300kmh.

Clouds also change shape as they move. They are constantly condensing more water to become larger, or evaporating more water to become smaller. Clouds are extremely large and far away, so these differences are subtle. In general, wispier or smaller chunks of clouds at the outer edges of the cloud move and change shape more visibly than the main cloud mass.

A jet stream is a fast wind that occurs at 25 to 40,000 feet (6–9 miles, 10–15km) above the Earth's surface. Jet streams form when the surface temperatures of two adjacent regions are very different, which means the two areas have very different air pressures. Most jet streams flow from west to east.

CLOUD EFFECTS

Clouds can create some pretty spectacular lighting effects in life. These effects can be used in your animation to set a mood for your story.

Cloud Combinations

Combinations of clouds at different altitudes can make some of the most visually spectacular formations. For example, a thin cirrostratus cloud at high altitude coupled with low cumulus clouds create a slightly hazy sun and contrast in shadow areas of the lower clouds.

A hazy sun through altocumulus clouds coupled with mist over water gives a lot of opportunities for lighting effects. For example, if a cloud is opaque it will cast a shadow on the ground.

God Rays

Rays of light that appear to radiate out from the Sun are called *God rays*. Although the light rays are actually parallel, they appear to converge at the Sun due to a perspective effect. The light rays stream through gaps in clouds (usually stratocumulus) or between objects, creating the effect of separate rays coming down from the Sun.

God rays are also called crepuscular rays. Crepuscular means "pertaining to twilight," which is the dim light at dawn or dusk. The most spectacular crepuscular rays tend to occur at sunset, but they can actually occur at any time of day.

God rays.

Backlit clouds.

In CG software, God rays can be simulated with a volumetric light.

Backlit Clouds

Cirrus clouds are bright white and don't have shadow areas. Thick cumulus clouds, on the other hand, have shadow areas at the bottom and the front surface opposite the Sun, which can be quite dark especially at dawn or dusk. The strong contrast between the two can make a compelling image.

CG APPROACHES TO CLOUDS

In the early days of computer graphics, when solids were the only types of objects one could easily create, clouds were hard to portray realistically due to their non-solid and transparent nature. Particle systems were the first useful approach, with each particle representing a chunk of the cloud as a semi-transparent image on a small plane.

Realistic cloud simulation is really only possible with a simulator designed for the task. Such simulators, which utilize voxel-based techniques, are needed only if you need to have a lot of control over your clouds' shape or motion, or if your camera or subjects move through clouds.

The term *voxel* comes from combining the words *volume* and *pixel*. The technical definition of voxel is "a point or value on a three-dimensional grid." In CG, a voxel is one cube in a 3D grid. Such a grid moves around as a single unit, with individual voxels holding specific properties such as transparency and color which can change over time. The voxels don't move individually, but through gradual shifts of color and transparency over a series of frames, the effect can "move" across or through the voxels.

Voxels

Voxels are commonly used in a group or cluster where the grid moves around as a single unit (as with an entire cloud moving across the sky) with the addition of changes of color and transparency in individual voxels over time (as with the edge of the cloud slowly changing shape). Voxel-based techniques have allowed the field of CG rendering to move beyond solid 3D objects to wispy or changeable effects like fog and fire.

Rain

Review:

- Visual Effects > Liquid Effects
- Classical Physics > Forces > Pressure and Gases> Air Resistance

While meteorologists have a very specific definition of rain, for the purposes of this book we consider rain to be "water falling from the sky." Rain typically occurs only under certain weather conditions, and it looks and acts differently depending on those conditions, the surrounding area, and the surface it strikes.

While your audience might not be weather experts, many people have an intuitive sense of rain. In this book, we look at some of the different properties of rain so you can include both obvious and subtle cues in your own work, cues that will make the rain a believable enhancement to your animation and not a distraction.

And if you're creating a magical or fantasy world that includes rain or fog, understanding the geographical features of rain-producing areas can also help you create a more believable world.

RAIN FORMATION

In the Clouds section, you learned that clouds are collections of tiny water droplets or ice crystals that are light enough to be suspended above the Earth's surface. An ordinary cloud becomes a rain cloud when the water in the cloud becomes too heavy to be suspended any more.

Precipitation is any form of water that falls from the sky and reaches the ground, such as rain, snow, or hail.

The formation of rain is an extension of the way clouds form. In the same way that cool air condenses water vapor and forms a cloud, more cooling water vapor leads to more water droplets and a larger or heavier cloud. The water droplets become so numerous that they join together to form larger droplets, which eventually cannot stay suspended in the air. Then the droplets begin to fall out of the cloud suspension, and you get precipitation.

Types of Rain Clouds

There are two main types of rain clouds. A quick rainfall is likely to come from a tall, fluffy cumulonimbus cloud, while a rainfall of longer duration comes from a wide, blanket-like nimbostratus cloud. While these two types of clouds are formed by different weather conditions, both are a result of warm, humid air meeting up with cool air.

With a tall cumulonimbus, the area around the cloud might be a perfect blue sky, or there might be other cumulonimbus nearby to fill in your view of the sky. Conversely, a nimbostratus cloud tends to form a sheet of gray overhead.

Recall from the Clouds section that rain-producing clouds include the word "nimbus" or "nimbo" in their names.

Tall cumulonimbus cloud against blue sky.

Wide, flat nimbostratus cloud, making sky appear mostly gray.

If you look under the hood at how different types of rain clouds form, it's essentially the same for all of them: warm and cool air interact with each other, then warm air cools to form heavy water droplets. The differences in types of rain clouds come from the weather activities that precede them: evaporation leads to tall, fluffy clouds, while two pockets of cool/warm air lead to a big slab of cloud.

In addition, distinctions between clouds can be, like the clouds themselves, rather fuzzy. For example, the bottom part of a cumulonimbus cloud can flatten and spread, making it look and act a lot like a nimbostratus cloud. Realize that scientists classify these different types of clouds to make them easier to study and discuss among themselves, not to make them easier for animators to understand and represent in their work.

With that in mind, we'll look at some of the characteristics of rain and its clouds so you can use them intelligently in your own animation.

Nimbostratus: Frontal Rain

Frontal rain or *stratiform rain* comes from the meeting of two fronts, where air is pushed around in such a way to create heavy water droplets within a wide, flat nimbostratus cloud.

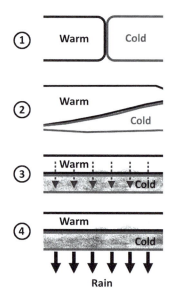

Formation of nimbostratus cloud and resulting precipitation.

Recall from the Atmospheric Pressure section in the Forces chapter that a *front* is a mass of air with a particular characteristic such as temperature, moisture level, or pressure. Your local weather report might talk about a cold front clashing with a warm front, or a high-pressure front meeting a low-pressure front. The meeting of two opposite types of fronts is, by nature, a violent event, and can cause a wide variety of weather conditions including wind and thunderstorms.

Convection is a scientific term for the movement and circulation of warm and cool air around each other.

When a large warm front meets a large cold front, the warm front rises, moves up on top of the cool air, and sits on top of it. Then, because the temperature higher in the sky is cooler, the warm air cools and its water droplets condense, producing a wide, flat nimbostratus cloud that often covers the entire sky.

Rain from such a cloud is called *frontal rain* or *stratiform rain*. This type of rain falls steadily for a period lasting from several hours to a few days.

Cumulonimbus: Convection Rain

The evaporation of moisture from land or water masses tends to form a cumulonimbus cloud, which can produce heavy rainfall for a short period of time (a few minutes to a few hours). This type of rain is called *convection rain*.

In warm climates, or in areas near large water masses, water evaporates, rises up, and cools to form a cumulus cloud. As the water keeps evaporating, the cloud becomes taller and taller. The air is cooler higher up in the atmosphere, so the water droplets at the top of the cloud cool down, condense, and become heavier, causing them to drop to the bottom of the cloud.

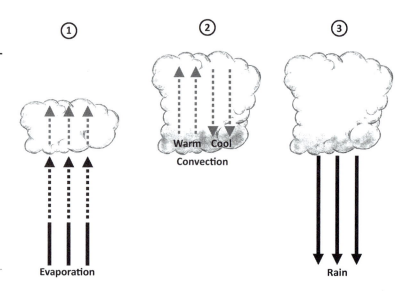

Then the air becomes warmer and moves back up to the top of the cloud, leaving some of the heavy moisture behind at the base of the cloud. More water might evaporate and join the cloud, and the cycle goes on and on with warm air moving up to the top of the cloud and cool air moving down and dumping moisture at the bottom of the cloud. Eventually the water at the bottom of the cloud is too heavy, and it falls as rain.

This movement of the cool and warm air around each other is *convection*. A cumulonimbus cloud produces heavy rain for a short time, and can also produce lightning between the ground and within itself.

Orographic Rain

In hilly regions clouds can form on just one side of a mountain, causing rainfall just on that side of the mountain. This type of rain is likely to happen where there's a lot of water available for evaporation, such as a seashore or lake near the base of a mountain.

Water from one side of the mountain evaporates into warm air. Wind pushes the warm air inland and up the mountain into high, cool air, where the water condenses and forms a nimbostratus cloud. The cloud then expels its frontal rain.

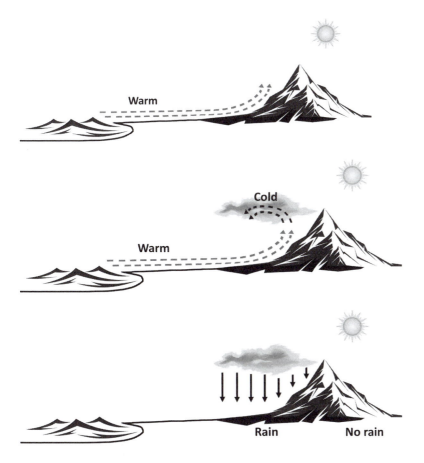

Such a cloud can expel all its rain before passing by the top of the mountain, making one side of the mountain rainy while the other side stays dry. This type of rain is referred to as *relief rain* or *orographic rain*. The dry side of the mountain is referred to as a *rain shadow*.

Orographic rain can also form as convection rain, where fluffy cumulous clouds form from the evaporation of a body of water. These clouds are then pushed up the mountainside to meet cooler air, where the clouds become heavy with rain. The clouds then expel their rain before passing over the mountaintop.

Orography is the scientific study of mountains, including their effects on weather and climate.

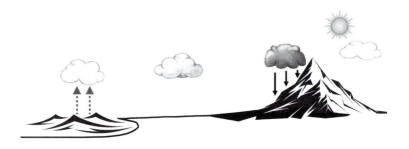

IT'S ALWAYS RAINY IN SEATTLE

By studying an area's topographical and precipitation maps side by side, you can get a clear view of the reasons behind rainfall in that area. For example, the rainiest region in the USA is the Northwest corner, which includes the city of Seattle, Washington. With a study of the area's topology and proximity to water, it's easy to see why.

The west coast of Washington borders the Pacific Ocean, and several rivers and large bays contribute to the presence of water near the coast. Water evaporating from the oceans and bays forms clouds, which are blown inland. Then the clouds get blown up against the mountains a few miles inland, forcing the clouds to rise and cool and produce rain. Typically, these clouds expel all their rain before passing by the top of the mountain.

Where relief rain continuously leaves one side of a mountain wet and the other dry, the dry area is called a *rain shadow*. On the precipitation map, you can see some areas of high precipitation right next to areas of low precipitation. Looking at the topology map of Seattle, you can see that a mountain range is present in the high-precipitation areas. Knowing that the wind near a coastal area usually blows inland, you can surmise that the eastward side of the each mountain range is a rain shadow area.

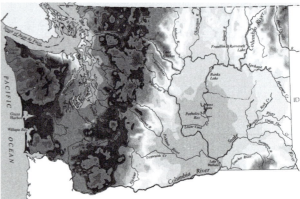

Washington's topology (left) predicts its precipitation and rain shadow (right). On the topographical map, darker regions indicate higher-elevation topology such as mountains. On the precipitation map, dark areas receive a lot of rainfall while light areas receive little to none.

More about Rain Clouds

With all clouds, when the cloud is thin it lets a lot of light through, and we see the reflective droplets that form the cloud as being white in color. But when the cloud becomes large and accumulates a lot of water, it starts to absorb and scatter the light and prevents it from filtering all the way through the cloud, making the bottom appear gray rather than white. For this reason, the bottom of a rain cloud appears to us as gray in color.

Cumulonimbus clouds can form lightning with the ground. Only cumulonimbus clouds can form lightning within themselves, as they have a sufficient height for vertical self-lightning. Cumulonimbus clouds can have strong updrafts (air blowing upward) that not only help make them taller, but can also cool the water droplets so fast that they freeze into hailstones.

Note that other types of clouds can form precipitation, too. Cirrus (high-altitude) clouds can rain ice crystals, but these crystals usually evaporate before they hit the ground.

The inside of a cumulonimbus cloud is big, busy, violent place. For an enlightening read, search online for "people stuck in cumulonimbus updrafts." A handful of parachute jumpers and paragliders have had the experience, which included being thrown about for more than half an hour in freezing-cold low-pressure air while dodging lightning and even hailstones. Not all have lived to tell the tale.

WIND AND RAIN

The meeting of two cool/warm fronts, by nature, creates wind. Frontal rain is caused by a front, so it's natural that such rain would be accompanied by wind both before and during the rainstorm.

Even though a convection rain cloud isn't caused by a front, it is often accompanied by warm/cold or moist/dry fronts. In coastal areas, for example, there are strong differences in air temperatures just above land (warm) and sea (cooler) on a warm, sunny day. The warmer land air and cooler sea air continually cause a warm/cold front where the land meets the sea, creating a sea breeze that blows inland.

WHERE RAIN FORMS

By understanding the way rain clouds form, you can figure out which geographical areas are likely to get the most rain:

- In coastal areas, where there's a lot of water to evaporate into convection rain.

- In tropical climates, where the ground is warm. Air near the ground soaks up the heat and rises, producing convection rain.

- Warm areas near mountains and hills. Relatively warm air near the ground is blown by the wind up the sides of mountains to produce orographic/relief rain.

Predicting Rain

If your animation includes a pre-rainfall sequence, including intuitive or well-known rain predictors can help make your scenes more believable.

Just in case you forgot: on Earth, the Sun always rises in the east and sets in the west. The Sun is at its highest overhead point at noon, dipping to the north or south depending on your distance from the equator and the time of year. As an animator, you should have a grasp of these sun positions; if you haven't done so already, start looking for the Sun at different times of day and noting where it is in relation to the horizon.

An old seaman's saying can help you remember which type of red sky produces which weather condition: "Red sky at night, sailor's delight. Red sky in the morning, sailor's warning."

Humans and animals know rain is coming when:

- Wind suddenly shifts direction. Remember that rain is often accompanied by the clash of two fronts, which also causes wind.

- Plants and flowers smell stronger and earthier. The wet air involved in the formation of rain clouds goes hand-in-hand with a low-pressure area, which brings out smells more strongly.

- Air becomes more humid. Hair curls a little more, and perspiration forms more readily.

- Animal behavior changes. Dogs and cats hide from thunder long before people hear it. Cows lie down when a storm is coming. Conversely, birds flying high in the sky are an indication of fine weather for some hours to come.

- The sky is red at sunrise. For an explanation, see "Weather from the West" below.

Weather from the West

Keep in mind that weather systems on Earth tend to move from west to east. This means that "a storm coming our way" is more believable when it's coming from the westerly direction. If such a scene takes place during the day, the position of the Sun will give viewers a cue to your scene's east/west orientation.

Dry/high-pressure air kicks up dust, which contributes to a red sky at sunrise or sunset. A red sunrise means dry air has moved past you to the east, and a wet/low-pressure front is coming right behind it. In other words, a red sunrise means rainfall is coming.

Conversely, a red sunset (in the west, naturally) means the dry air is coming your way, and the next day will most likely be fine, dry weather and blue skies.

RAINDROPS

Now that you've learned how rain forms, let's take a closer look at the rain itself.

When suspended in the air, rain droplets are spherical. Water droplets can join with other droplets to become larger blobs of water, which also tend to be spherical. When droplets land on a hard surface such as a table or windowpane, one side of the droplet flattens out.

Falling Raindrops

When falling, small raindrops remain spherical, but larger raindrops become hamburger-shaped due to air resistance pushing up at the droplet. The air resistance causes the center of the droplet to fall less than its outer edges. If

the drop falls long enough, air resistance becomes strong enough to split the raindrop into smaller drops, which are spherical.

Image courtesy of NASA.

Raindrop Blur

Even though raindrops are spherical or hamburger-shaped when falling, when looking at falling rain we don't perceive them that way due to their speed. Our eyes can't register more than half a second of motion at a time, so we see raindrops as long, blurry spikes. In both traditional and VFX animation, audience members are accustomed to seeing rain this way.

Raindrop Visibility and Color

Water is transparent, so raindrops are hard to see. The main reason we can see them is because they reflect and refract light. In daylight, from a moderate distance, the refraction looks like generic black/white/gray streaks. Up close, you can actually see the colors of the environment.

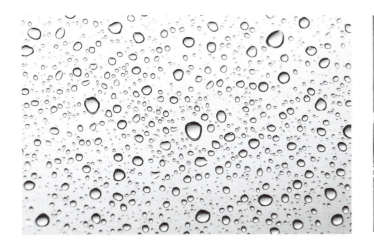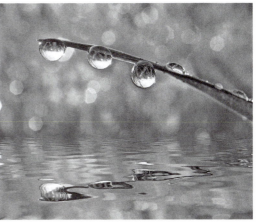

Because there's so little light at night, raindrops are nearly invisible unless illuminated by lamps or other light sources. At night, what you most often see are the effects of the rain such as puddles and splashes, as opposed to the raindrops themselves.

Enhancing Rain

When looking to represent rain in your animation, you can ease the burden of making the rain look perfect by adding visual cues in addition to the rain itself.

High winds tend to occur at the onset of a rainfall, when a hot and cold front first interact, because of the sudden instability in air pressure. This is why rain that goes on for longer periods (like days) tends to be more of a calm and constant drizzle in the middle and end of the storm, with less wind than the start of the rain period.

Wind intensity changes with the time of day as well. During sunrise and sunset, the air temperature changes suddenly while the land temperature changes gradually. The large difference in temperature between the land and air results in wind. This is most apparent at sunset (especially in coastal areas), when people notice a sudden increase in wind while the Sun is setting. The air is generally calm mid-day and mid-evening, when the land and air have similar temperatures.

Under wind conditions, rain comes down at an angle and changes direction frequently. To punch up the effect, other objects in the scene such as characters, umbrellas, flags, and debris should also be seen to react to the wind.

From a distance, rain looks like slow-moving sheets of mist under storm clouds. Heavy rain in high winds can appear as a sheet of rain, with no distinct drops visible. Such rain looks more like moving puffs than raindrops. The effects are visible on objects caught out in the rain, though.

When rain bounces, it produces mist. Light, bouncing rain breaks into smaller droplets to form the mist. Mist also results when rain hits a hot surface and evaporates. You can see this effect around the wheels of a car moving in the rain. The tires kick up rain from the pavement, causing some of it to evaporate into mist. Thus, the area around the car's tires is hidden in a mist when compared to the rest of the car.

Rain causes movement of plant life, where petals and leaves move under the impact of rain drops.

The appearance of rain can also be suggested with sound effects. Falling rain sounds like steaks sizzling on a grill, and the sounds of howling winds can be

added to enhance the feeling of a heavy storm. The sounds of wind vary with the environment as well. For example, wind in a city, flowing between closely placed buildings, will be more high-pitched than wind over an open field, which would sound lower and be more of a howl. Rain also sounds different hitting shingles than if it is hitting metal or plant life.

Invisible Raindrops: Puddle Effects

If your focus is a puddle during a rainstorm, you can skip the raindrops and just make the puddle effects. In life, when you're watching a puddle during a rainstorm, the drops move by your line of sight so fast that they don't really register.

A raindrop produces a ripple on a puddle. For light rain, creating a few ripples on a puddle is enough to suggest rain. The height and speed of the ripple depends on the height of the rainfall and size of raindrops. In general, larger raindrops produce higher and wider ripples than light ones. Since no two raindrops are exactly the same size and weight, your ripples should vary in size.

Heavy rain causes small droplet splashes. These droplet splashes make secondary ripples as they land.

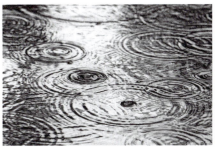

Slow-Moving Raindrops: Windowpane

A common storytelling device involves a view of raindrops on a windowpane.

Kylee Love's *Rainy Day Window*, oil paint on canvas. Image courtesy of artist.

Rendered image of coffee cup by a rainy-day window.

Raindrops stick and drip on windowpanes due to natural adhesion properties between water and glass.

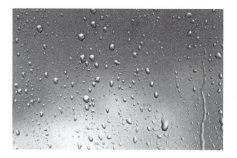

Surface tension refers to the tendency of water's surface (where it meets the air) to be tougher and more resistant to change than the main body of water. See Properties of Liquids for more information.

The shape of a raindrop on a windowpane depends on the angle and speed at which the drop hits the windowpane in the first place. A direct hit perpendicular to the window typically only occurs as a result of extreme weather such as tornado-force winds or a hurricane. During any given storm, various sizes of raindrops hit the window at all kinds of angles, creating a pattern unique to the weather conditions that day.

To Drip or Not to Drip

Smaller raindrops stick to a windowpane, while larger ones succumb to gravity and stretch out downward, creating a drip pattern.

When a raindrop hits the windowpane, it goes from being a free drop held together by surface tension to a drop adhering to a surface due to adhesion, with its outer surface (the part of the drop that touches the air) still held together by surface tension.

A rain droplet on a vertical windowpane is under constant stress. Right after the water droplet hits the pane, gravity tries to pull it toward the ground while forces from the droplet's surface tension and adhesion try to keep the droplet stuck to the windowpane exactly where it is.

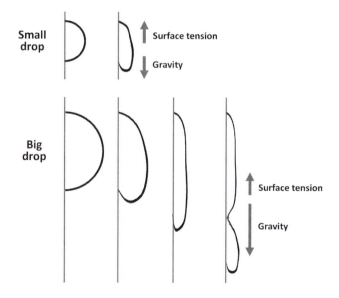

A smaller raindrop is able to resist dripping because the forces from surface tension and adhesion to the glass are enough to balance the force from gravity. But with larger drops, the force of gravity is greater than the forces from surface tension and adhesion, so the droplet drips.

For the purposes of animation, it isn't very useful to scientifically predict which droplets will drip and which won't. Just know that if some droplets are going to drip and some aren't, the bigger ones are the most likely drippers.

Drip Shape

The path and shape of the droplet's stream are mostly determined by the shape of the droplet when it first stuck to the window, before it starts dripping down the pane. This is why a droplet's stream is never straight and uniform.

The shape of the stream can also be affected by minute defects in the windowpane, dust particles stuck to the window, and the direction of blowing winds. In any case, a drip is rarely a straight line with a uniform size all the way down.

Lightning

Review:

* Classical Physics > Motion and Timing > Wave Motion (for sound waves/pressure waves)

Lightning is a fast, bright jagged line of light from a cloud, usually occurring during a storm.

Lightning consists of a primary bolt (channel) and several tendrils of less bright lightning branching out from the primary bolt and discharging in the air around them. A bolt can extend in any direction, vertically or horizontally. The entire lightning flash lasts a fraction of a second.

Lightning can form between a cloud and the ground, between two clouds, or within a single cloud (known as intra-cloud lightning).

HOW LIGHTNING FORMS

Lightning forms due to electrical charge that accumulates in clouds and on the ground. When a quantity of positive charge accumulates near a quantity of negative charge, the charges seek to equalize quickly with a bang. This fast flow of charge from one area to another is what creates visible lightning stretching from a cloud to the ground.

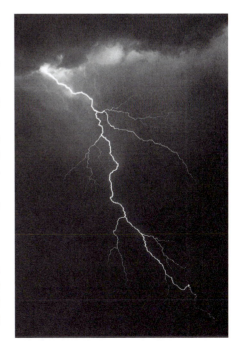

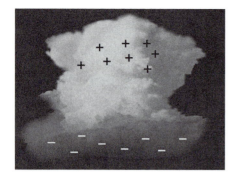

Let's look at this process in more detail.

1. Within a cloud, low-pressure (cool) and high-pressure (warm) areas butt up against each other, causing an accumulation of negative charge at the bottom of the cloud and positive charge at the top.

2. As the negative charge at the bottom of the cloud seeps into the air below the cloud, the positive charge in the ground is drawn to its surface and starts to move through the air too.

3. At some point, a sufficient accumulation of negative and positive charge meets for electricity to flow quickly and visibly down a narrow path in an attempt to discharge (balance out positive and negative charges). The electricity discharges, exciting the air directly around it and causing it to light up, making the lightning we see during a storm.

Particles separate because heavier particles accumulate negative charge as they sink downward, while positive charge accumulates in the top of the cloud.

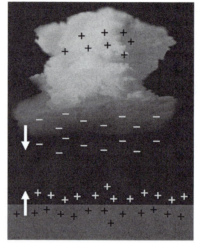 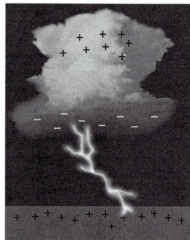

Cloud-to-Cloud Lightning

The positive charge at the top of one cloud and the negative charge at the bottom of another cloud can meet in the air and cause a lightning bolt between the clouds.

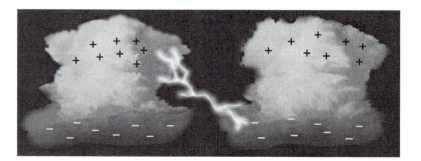

Lightning can also form within a single tall cloud, between the positive and negative charge at the top and bottom of the cloud.

Lightning Formation and Appearance

Lightning tends to form from tall convection (cumulus) clouds, as these clouds have sufficient height to house the separation of positive and negative charge required to form lightning, along with the differences in temperature between these two regions (cool on top, warm on bottom). These types of clouds are more common in tropical areas than in other parts of the world, leading to more lightning in the tropics than in cooler climates. Florida is the lightning capital of the U.S and tropical Africa (Rwanda) is the lightning capital of the world.

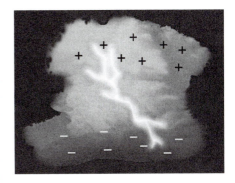

While the type of lightning we most often see from the ground occurs between a cloud and the ground, intra-cloud lightning, or lightning within a cloud, is actually the most common type of lightning.

World map of lightning strike frequency. Image courtesy of NASA.

In the U.S., the state of Florida receives the most lightning strikes. The tropical environment and the moisture in the atmosphere make for frequent growth of cumulonimbus clouds.

A lightning bolt is ordinarily several miles long and only about an inch wide. If only the one inch was visible, we wouldn't be able to see a lightning strike from miles away. We can see the lightning because the air or atmosphere around the lightning strike heats up very quickly and lights up very brightly.

When lightning strikes, it moves along the path that will allow the most discharge. This means it looks for the path with the most to offer in terms of positive–negative difference in charge. Lightning is most likely to form between the closest points between the cloud and the ground, such as tall trees or buildings.

A lightning bolt begins to form from the movement of electrons below the cloud, moving toward the ground at speeds up to 60 miles/second. The electrons follow zigzag patterns, branching out in unpredictable ways. At this point there is no bright flash yet, but there might be a purplish glow from the increased electrical activity. This movement of electrons is called a *leader*.

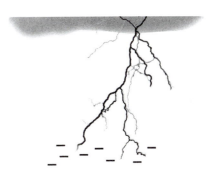

Leader.

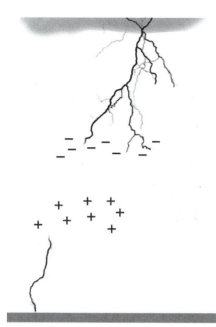

Streamer.

This activity also serves to draw positive charge even further from the ground, and up through trees, buildings, and other tall structures. This movement of charge is called a *streamer*.

The streamer meets the leader fairly close to the Earth, perhaps a few hundred feet up. At this point, electrons flow freely between the two areas and a lightning bolt occurs.

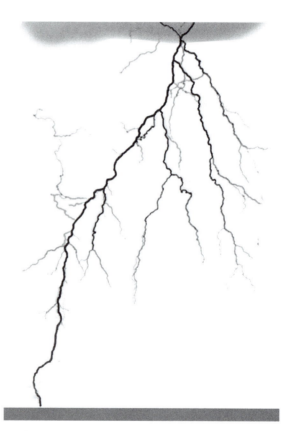

Leader meets streamer to form lightning bolt.

Multiple lightning flashes in quick succession.

This initial bolt is instantly followed by several additional surges so close together in time that they might appear to happen simultaneously.

If you view a lightning flash in slow motion, you will find that the lightning flash is brightest at the base at the moment when the streamer meets the leader. The streamer (lower part of the flash) lights up and appears to travel up the leader. In this way, lightning might appear to originate on the ground, but in reality it's a joint effort between clouds and the ground.

LICHTENBURG FIGURES

Electrical discharges, whether large or small, tend to flow in the same type of jagged pattern. An electrical discharge into a clear acrylic block, for example, creates an artistic pattern reminiscent of lightning.

Such a pattern even has its own name: the Lichtenburg Figure, also called a lightning tree. Such a figure is a lightning-like pattern created by an electrical discharge into an insulator such as a clear acrylic block (or the skin of a lightning victim).

Lichtenburg Figures are useful for plotting out realistic lightning patterns. They are also works of art in their own right. Check the Internet for numerous videos and "how-to"s on creating your own Lichtenburg Figures, or for studying existing figures as inspiration for lightning effects in your own animation design.

Image courtesy of Bert Hickman, http://www. teslamania.com, via Wikimedia Commons.

EFFECTS FROM LIGHTNING

When a living creature is struck by lightning, the most common effect is interruption of the nervous system. A person or animal getting struck by lightning is a very quick business, with the entire strike lasting a fraction of a second. The lightning goes bang and the person jolts and falls down. The end. Most of the damage is on the inside, so there's actually very little to see aside from the strike itself. Human beings and animals don't light up or glow when struck by lightning, as the electricity passes through internally and not on the surface or skin.

However, most of your audience has never seen someone actually get struck by lightning, so you can get away with punching it up a bit. If you're going for comedic effect you can make the skin light up, perhaps to the point of the character's skeleton showing through. The lighting-up can blink on and off a few times. Hair can catch on fire. The character can develop internal lightning the way a large storm cloud does. And so on.

Trees, buildings, and other structures are affected more visibly than living beings, sometimes glowing or catching fire as a result of a strike. Trees may even explode due to the rapid heating and boiling of water in the tree's sap.

Thunder

Recall that sound is essentially a pressure wave moving through the air. If the pressure waves accumulate on top of one another, the result is a loud boom.

Thunder is a pressure wave created instantaneously by the super-heated air around the lightning bolt. The pressure wave dissipates within a few miles of the original boom, which is why you only hear thunder if the lightning is relatively close by. Because light moves faster than sound, we see the lightning before we hear the thunder.

A common layman's trick for predicting when a storm will arrive is to count the seconds between a visible lightning strike and a thunder clap. Although exact predictions are complicated by wind and other atmospheric factors, you can get a decent approximation by figuring on a difference of 5 seconds per mile, or 3 seconds per kilometer.

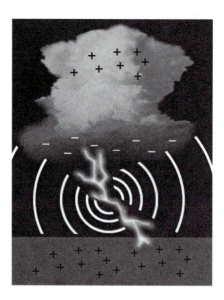

Thunder is not one single boom but several in succession. The loudest part of the thunder is generated by the primary bolt, with small cracking sounds from lightning tendrils. Thunder sounds like a boom, while lightning itself makes more of a crack or clap sound.

CHAPTER **8**

Fire and Explosions

Fire and explosions, along with breakage and flying debris, are often enhanced or created altogether in live action films. Understanding the physics behind fire and explosions can help you create convincing visual effects for both live action enhancement and traditional animation.

Fire

Fire is a rapid chemical reaction between a fuel and another substance, usually oxygen. Heat, light, and gases are released during the process. When certain types of fuel are heated up enough around an oxidizer, they will burn.

From an artist's point of view, there are a few distinct types of visible fire:

* Flames
* Smoldering solid matter
* Fireball

FLAMES
Flames come from gases being burned up. The fuel heats up and gives off gases, which then burn as flame. For example, wood contains cellulose, a

An *oxidizer* is a substance that causes fuel to burn. Oxygen gas is the most common oxidizer involved in fire, though oxygen-rich compounds and some non-oxygen oxidizers like fluorine gas can react with fuel and cause a fire.

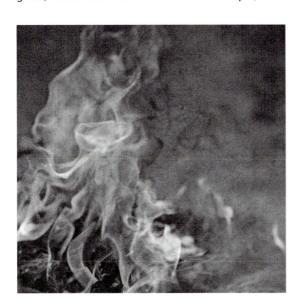

A campfire burns cooler than a candle, but gives off more heat than a candle because it's bigger.

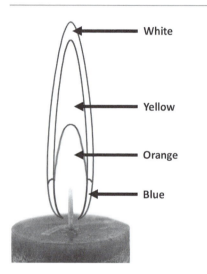

White

Yellow

Orange

Blue

Colors of a candle flame.

carbon-based substance. When you light kindling the cellulose heats up, giving off gases that catch fire. As the temperature increases from this fire, the carbon left behind from the initial reaction burns and give off more gases, which then burn and create more heat which creates more gases, and so on until all the fuel is gone. The solid fuel itself burns to ash.

A candle works the same way. Wax itself, in its solid form, is very difficult to burn, but the gases that wax emits when heated burn nicely to create a candle flame. Wax gas burns at a lower temperature than a candle wick. This is why a candle's wick needs to extend only a short way above the candle; you're not really lighting the wick, but rather you're lighting the wax gases around it. The wick itself burns only when it gets hot enough, which only happens after all the wax gas around it has burned up, and only if the wick gets hot enough from burning for a little while.

Flame Appearance

A flame is basically light emitted due to the burning of both solids and gases, which rises due to its heat. The shapes and colors of flames are complex and depend on the substance being burned.

The incandescent color of a flame is related to its temperature, with cooler flames appearing as red, hotter flames appearing orange and the hottest flames appearing to be white or blue.

Flame color	Temperature range (Fahrenheit)
Blue	2700–3000°F
White	2400–2700°F
Orange/yellow	2000–2200°F
Red	1000–1800°F

Most types of flames include a variety of colors depending on how hot the flame burns. In general the flame is hottest at the base (white or blue) and at the tip of the flame (white). The interior of the flame is red, orange, or yellow depending on how hot the flame is.

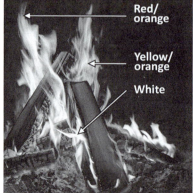

Red/orange

Yellow/orange

White

Colors of a campfire flame.

Flames are also somewhat transparent. For an artist, it's easier to make convincing flames against a plain background than it is to try and get the transparency right on a patterned or multi-colored background.

Creating Flames

Before the days of computer graphics, the pyrotechnics artist on a movie shoot was responsible for creating explosions and fires. Sometimes these fires or explosions were real, but created in a highly controlled environment to keep people and property from danger. Other times, tricks with props were used to simulate these effects.

For flames, these artists sometimes used strips of colored cellophane or fabric tied down at one end, with a fan blowing the strips upward to simulate dancing flames. These days, fake-flame decorations are available for purchase at gift shops. The effect is convincing enough from a short distance away.

If you need a controlled flame in your animation, you can use the same technique in your software to create flames. Model a few polygon strips and texture them with a varying yellow-orange color, then make them randomly dance.

Various elements and compounds that emit different colors can also change the color of a flame. For example, sodium gives off a yellow flame and copper burns as blue. The various colors of fireworks are due to these different compounds.

Cellophane "flames" are blown upward by a small fan to simulate a burning torch.

Because flames are so complex, you might find it easier to take a live-action movie of a fire and composite it into your scene. For photoreal VFX, there are software packages available specifically for making realistic fire.

SMOLDERING SOLID MATTER

There is a second component to fire beyond the flame. When the fuel becomes hot enough, the fuel glows. This effect, called smoldering or *pyrolysis*, means the fuel is changing composition in a way that is irreversible. With wood, for example, pyrolysis indicates that the wood is turning into charcoal.

Smoldering can happen even without flames. Examples are a burning cigarette, embers from a fire that has gone out, and cotton-based upholstery that smolders for hours after a small spark or burn has struck it.

FIREBALL

A *fireball* is a ball of fire from a mass of burning material. A fireball has a roughly spherical shape.

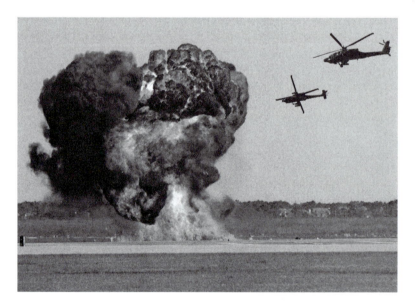

The burning material in a fireball is mostly either a gas or a solid. Examples of when a fireball occurs:

- A fuel explosion causes fuel gases to be created, or a chemical explosion creates gases via a chemical reaction. Immediately after a fuel or chemical explosion, any flammable gases burn and expand rapidly. This type of fireball burns itself out quite quickly, leaving behind smoke. See the Explosions section in this chapter.

- Immediately after a nuclear blast, intense heat burns oxygen in the air, creating a fireball with a long life relative to a fuel or chemical explosion. The fireball is just one of a series of visible nuclear blast reactions such as a wave of thermal radiation. See the Explosions section in this chapter.

- When a meteor enters the Earth's atmosphere, the compressed air in front of the meteor heats to high temperatures and causes both the meteor and atmospheric elements to burn. The meteor is effectively a fireball with a trail of burning gases and melted particles.

FIREBALLS IN SPACE

Fireballs in space have become a staple of sci-fi movies ever since the Death Star exploded in the original *Star Wars* movie in 1977. In reality, an explosion in outer space would be pretty dull—just a container breaking apart quickly and its pieces drifting away in space at the same velocity for ever.

Since there's no oxygen or gravity in space, fire can't burn and a fireball could not possibly occur, nor would a shockwave or a flaming spaceship. But VFX artists take liberties with physics when designing and animating outer space explosions to make them more visually interesting. Nowadays, every audience expects a big fireball at the end of an intergalactic showdown.

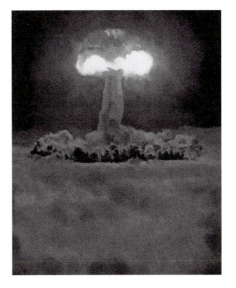

Mushroom Clouds

Most fireball-type explosions are over in a split second, but nuclear explosions and volcanoes produce fireballs that burn a little bit longer than that. Recall that a fireball is essentially a ball of hot, light air. When a fireball burns for more than a second, the fireball rises due to its buoyancy. There is a suction effect as heat and debris are drawn up through the column of hot air.

In a mushroom cloud, the column of hot air is called the *stem*.

Image courtesy of Wikimedia Commons.

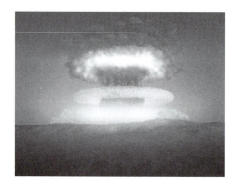

As the fireball rises, its top cools into smoke. Air pressure pushes the smoke downward and it flows to the sides of the fireball. The smoke at this point is commonly a reddish-brown due to the burning of nitrogen in the air. The smoke is then sucked back toward the hot column at the center, curling around to create the mushroom shape. This creates a flow that pulls along even more smoke to continue the mushroom shape.

The fireball will continue to rise until it burns out, at which point it is much cooler than before. After the fireball burns out, the smoke becomes mostly an ordinary cloud made up of water droplets, and it turns white. This cloud then dissipates into the air.

During the initial phase of the mushroom cloud, when the fireball is rising, short-lived rings of vapor can form around the stem. The low-pressure, hot rising air will cause a reaction of high-pressure, cooler air pushing back down (similar to the way air pressure behind a shock front works). The high-pressure cool air can condense water present in the air into a steamy vapor and form a ring around the stem. When the pressure and temperature return to normal, the ring dissipates. Imagery of real mushroom clouds shows that sometimes one or two condensation rings form in succession.

Mushroom Clouds in Animation

In life, mushroom clouds only occur with very hot fireballs burning a lot of matter, as with volcanoes and nuclear explosions. Smaller explosions (such as blowing up a car, building, or computer) do not actually create mushroom clouds. Regardless, mushroom clouds have become the standard for ordinary explosions in many films and games. A mushroom cloud helps to extend the time of the visuals and gives more opportunity for bright, spectacular effects.

In life, a mushroom cloud fireball can last several seconds, making it a great candidate for a longer animation. With a CG representation of a smaller explosion such as a car blowing up, the fireball burns out within a second, but the mushroom cloud can remain onscreen for 3-6 seconds more before dissipating.

A small-explosion mushroom cloud also gives an opportunity for burning debris on the ground to continue to fuel the cloud.

Space explosions do cause rings to form, but they're not the same as condensation rings formed by mushroom clouds on Earth. They're *accretion rings*, basically a ring of debris from an explosion being pulled by gravity into a star or a black hole.

VFX artists consider that it's more important for an explosion to read well than for it to be realistic. The explosion must also look good and be convincing, but it has to last long enough for the audience to see it.

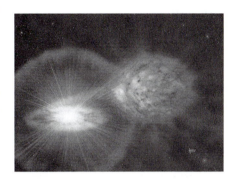

White dwarf star exploding (left). Image courtesy of NASA.

Smoke

Smoke forms from tiny solid, liquid, and gas particles from the fire being carried up by heat. Smoke is basically stuff that isn't quite burning, and which is light enough to be carried away.

It can help to think of smoke as "cool fire" that follows many of the motion principles of fire.

You get smoke from a fire when the fire isn't hot enough to burn all the gases that form. Over the life cycle of a fire, you get smoke at these times:

- Before the fire starts, when gases are forming and evaporating prior to ignition.

- While the fire is burning, if the fire isn't hot enough to burn all the carbon and other substances including water. If a fire is extremely hot, the water will vaporize and disappear quickly. If the fire isn't extremely hot, the water will evaporate and turn into smoke.

- After the fire is out, when it's cooled down enough to vaporize some of the fuel into gases but not hot enough to burn. Smoldering often produces smoke.

Smoke can happen with flames or with smoldering alone. Smoldering usually produces more smoke than flames.

Like flames, smoke is unpredictable and can be challenging to simulate accurately. In VFX, the most reliable methods for creating believable smoke are compositing live action footage of smoke against a greenscreen, or

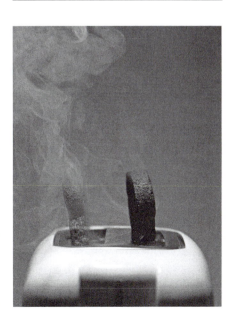

watching a lot of reference footage and recreating what you see with a particle system.

SMOKE APPEARANCE

The color and quantity of smoke depends on the fuel being burned, the temperature of the fire, and the chemicals it may contain. Hotter fires have less smoke because more of the debris and particles are burned up before they can fly off. Any smoke from hotter fires rises faster initially due to its heat.

Smoke is usually gray in color, although it can have different colors if chemicals are present. Signal flares can produce yellow, orange, or red smoke due to their chemical compositions. Very fine smoke, like that from a cigarette, has a bluish tint. When you exhale cigarette smoke it's white since the smoke particles acquire moisture in the lungs and get bigger.

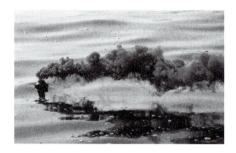

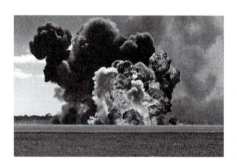

Orange signal flare in the ocean.

Heavy smoke appears opaque, while light smoke is translucent. Visually, smoke can be puffy and solid looking, or light and tendril like. In general, large quantities of smoke look puffy, while small quantities look wispy.

Smoke doesn't produce light, so it is visible only when a light source is present.

Puffy Smoke

Puffy smoke from a fireball or other large area follows the motion of flames. When the fireball cools and smoke is produced, you can animate its motion as a continuation of the flame motion.

Heavy smoke, as from a smokestack, has a solid appearance and can appear to move as a single mass with some random motion within the mass itself.

Tendril Smoke

When a small amount of smoke emanates from a single point, the smoke tends to rise in a straight column at first, then splits out to somewhat parallel lines. Then the smoke continues to rise with a slightly swirly pattern as it is affected by light air currents.

At a certain height, the smoke motion is fast enough that it becomes very chaotic; the smoke begins to dissipate, and it no longer rises.

If wind is present, the smoke still follows the same pattern but at an angle.

Campfire Smoke

When flames are present, smoke is carried up along the flames and disperses from the tops of the flames. Smoke from a campfire is usually a combination of tendrils and puffy smoke.

The hotter the fire, the less smoke there will be. Damp or green wood creates a lot of puffy smoke, while dry, dead wood burns hotter and creates light tendril smoke. A bright, hot campfire at night might seem to have no smoke at all—as your eyes adjust to see the bright fire, they lose the ability to discern the smoke.

Explosions

To *explode* means to expand rapidly with force. An explosion is a forceful, violent, rapid expansion of gases.

In entertainment, explosions are loud, bright, and visually dramatic. They get audience attention and can inspire awe, fear, and excitement. Action films often end with a spectacular and satisfying explosion where the bad guy gets incinerated.

The keynote of visible explosions is the *rapid* expansion of gases, which pushes the air around it with great force. The expanding gas or air pushes at objects around it, breaking them apart. Explosions are often accompanied by flaming fireballs and flying debris.

TYPES OF EXPLOSIONS

Explosions generally fall into one of these categories:

Pressure—Where gases already exist within a container or enclosed space, they can be heated and expanded to produce an explosion. Examples are a balloon popping when it's blown up with too much air, or a volcano spewing lava. With a volcano, rocks melt under the surface of the earth, releasing liquid magma and gases. When the gas pressure becomes too high, the gases push out of the volcano's mouth at great speed, shooting out lava with them. Such explosions are usually accidental or organic.

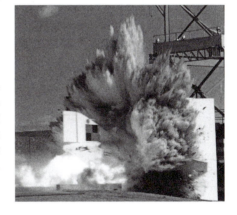

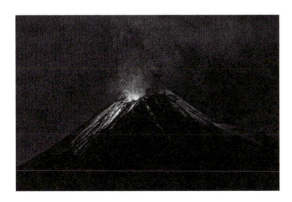

Fuel—Similar to a pressure explosion, except that fuel is involved. A fuel is any solid or liquid that can be burned. When fuel is heated, gases form and expand. If the fuel is in a container, the pressure exerted on the container can break it apart (as with a fuel tank or propane gas explosion) or the gases can escape quickly via an escape route (as with rocket fuel gases thrusting through a nozzle). The heat generated by the fast exit can cause the fuel gases to catch fire and burn after the initial force of the thrust or explosion.

Chemical—A type of explosion that involves chemical reactions, such as TNT, nitroglycerin, bombs, and other chemical mixtures that release gases very rapidly when stimulated. Heat or electrical impulse triggers rapid decomposition (rearrangement of atoms) that yields a lot of gas and heat. Chemical explosives are commonly used as a controlled way to blast away rock for mining purposes and the development of roads and railway tracks. In general, chemical explosions are more powerful than fuel explosions, and can produce vibrant colors depending on the chemicals used.

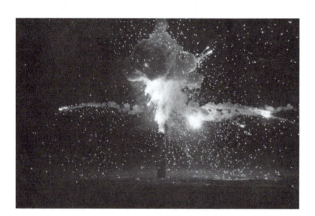

TNT exploding in a dark room.

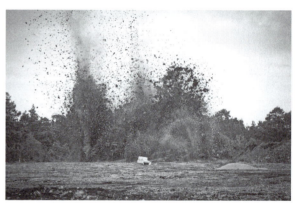

Blasting rock in a quarry.

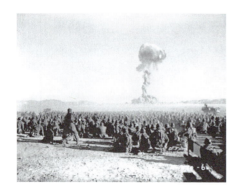

Nuclear bomb test, 1953.

Nuclear—A nuclear explosion involves the splitting or smashing of atoms in such a way that they form new types of atoms, generating a massive amount of heat in the process (as well as radiation). When the bomb explodes, the air around the bomb is heated to extremely high temperatures and expands rapidly. In this way, a nuclear reaction uses the air at the explosion point as its expanding gas. Nuclear explosions are much more powerful than chemical explosions, and usually result in a mushroom cloud.

LIFE OF AN EXPLOSION

Every explosion follows a set sequence of events that takes place over a few seconds.

1. Some gases exist already, or are created rapidly.

2. The gases are excited by heat, causing them to expand.

3. The gases exert pressure on the air or container around them.

4. A rush of gases pushes outward in an instant, generating wind, noise, and destruction to things around it.

The initial force of an explosion is usually far greater than force from gravity, so the initial motion takes place directly outward from the source of the explosion. If the explosion takes place on Earth, after the initial force the flying pieces are subject to gravity and follow the path of projectile motion.

Before the Explosion

Before step 1, the gases that start the explosion might be generated rapidly from solids or liquids experiencing heat or an electrical impulse. The electrical impulse might be triggered by a switch (as with pushing a lever to ignite TNT) or by impact with the ground (as with a bomb).

In any case, once the gases are created, it's the gases being heated that causes the fast expansion that makes up the actual explosion. Gases can form and expand so quickly that the actions of creating the gases and heating them to the point of explosion seem simultaneous.

After the Explosion

If the explosion involves a fuel, the heat from the explosion can cause the fuel to catch on fire, creating a fireball that burns until the fuel runs out. Fuel might also be thrown far from the explosion site, causing fires in those areas.

Exploding television set. Note that fragments toward the bottom are already falling to the ground within a fraction of a second after the explosion.

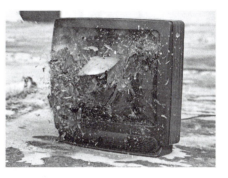

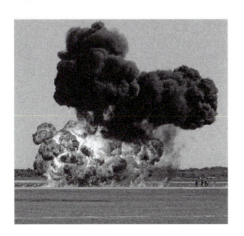

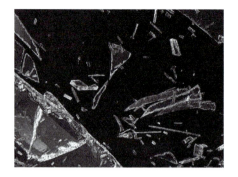

Explosions can also cause shockwaves (described later in this section) and mushroom clouds (described in the Fire section above). There also might be flying debris, which is discussed in the Breakage and Fracture section of this chapter.

ROLE OF CONTAINERS

If gases expand rapidly inside a container, when the gases rush outward the container can burst.

Whether the container's flying pieces are a significant part of the visual action depends largely on whether the explosion was intentional or unintentional.

In an intentional explosion, the container's role is to keep the explosive material intact until it's set off. Such explosive materials are chosen for their capacities to generate a huge amount of energy relative to the container size. The container can be as simple as cardboard or plastic (as for TNT) or might be a metal casing (as for a bomb). Here, the damage is not caused by the flying pieces of the container, but rather by rapidly expanding gases pushing air and knocking over objects external to the explosion, plus any resulting fires from the heat.

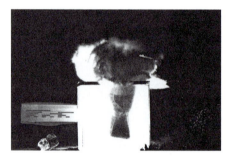

Dry ice bomb exploding.

Dry ice consists of frozen carbon dioxide. As it warms up, dry ice goes directly from a solid to a gas, emitting a foggy mist. Dry ice is commonly used to create fog and smoke effects for theater and parties.

If the container isn't meant to be exploded, it is likely to play a bigger role in the visual interest of the explosion as well as the damage. Examples are an airplane fuel tank, a pressurized oxygen tank, or a house full of propane gas. In such a case, flying pieces of the broken container are a big part of the action.

A few types of bombs are designed in such a way that the fragmenting container will cause damage. A dry ice bomb, for example, is a piece of dry ice placed in a sealed glass or metal container. As the dry ice (frozen carbon dioxide) evaporates, gas pressure builds up quickly. Most of the damage from the explosion comes from the fragmented container's glass and metal shards rather than the exploding dry ice.

TIMING FOR EXPLOSIONS

If realistic timing were used for explosions in animation, the explosion would be over in about two frames. Even with a fireball, the whole process (blast, fire, debris) is over in a few seconds. People can process only 10–12 frames per second, so many viewers wouldn't see the actual explosion at all! To give animated explosions more visual impact, artists ordinarily animate explosions over 24–30 frames. Even though this practice technically produces a slow-motion explosion, it works as a representation of a real-time explosion for most visual media. The action can also be extended by including a lot of secondary fire and damage to buildings, cars, and the ground around the explosion.

SHOCKWAVES

Some explosives are so strong that the expanding gases move faster than the speed of sound, which produces a shockwave. A *shockwave* is a wave that moves through air or the ground after a detonation.

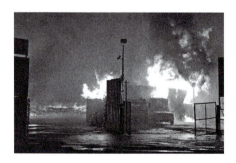

Fire after explosion.

Shockwaves through Air

When a bomb detonates, hot gases expand rapidly away from the explosion point in all directions, creating a sphere of pressure in the air. The outer edge of the sphere is called its *blast front*. To an outside observer, the blast wave through air has a spherical shape.

The air being pushed by the blast front is compressed from this rapid expansion, putting it under high pressure. At the same time, the air behind the expanding gases (inside the blast front sphere) experience low pressure.

An explosion that moves faster than the speed of sound is said to *detonate*, while an explosion moving slower than the speed of sound is said to *deflagrate*. The word *detonate* is also commonly used to mean "to explode," but in its strict physics definition, it is used only for explosions that travel faster than sound. The term *detonate* comes from a Latin word meaning *to thunder down*.

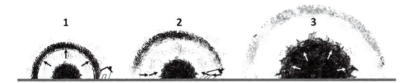

The blast front piles up air pressure in front of it. Recall that sound is simply compressed air. When this blast front reaches your ears, you hear a sonic boom and feel a rush of wind strong enough to blow out windows and even knock over buildings.

Meanwhile, air rushes into the low-pressure area behind the blast front to equalize the pressure, much like a vacuum cleaner. Objects and debris are sucked in toward the center of the blast.

Lastly, any exploding material or expanding gases with speeds below the speed of sound expand outward in a second wave.

Shockwaves through the Ground

With an explosion that occurs near the ground, part of the blast front will travel through the ground instead of the air. Pressure waves travel faster through the ground than the air, so the blast front within the ground moves outward from the center of the blast faster than the blast front in the air.

If the shockwave is strong enough, it manifests as a ripple disturbance on the ground itself, traveling in a circular pattern away from the explosion point.

Such a shockwave happens very fast. In the movies, the shockwave usually travels somewhat slowly so viewers can see it more clearly.

Breakage and Fracture

A solid, brittle object, when hit with enough force, will develop cracks and shatter. Exactly how the object breaks is a matter of physics. Understanding exactly what happens when an object fractures in real life can help you keyframe your animation to simulate real breakage.

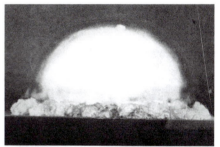

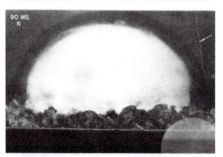

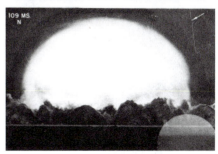

Images of Trinity nuclear weapons test in 1945. The shockwave is visible as a dark halo moving ahead of the smoke.

If you're doing CG you could use a physics engine to calculate fracture for you, but such engines can take a long time to calculate the motion, and the results are never perfect—you might have to tweak the parameters a number of times. Understanding the physics behind fracture can help you keyframe the motion yourself in both CG and traditional animation, and also get better results from a physics engine should you choose to use one.

ANATOMY OF FRACTURE

Although an object might seem to shatter in an instant, there are actually several stages the object goes through between impact and the end of the motion. Regardless of whether you're fracturing a dinner plate or a skyscraper, the object goes through the same series of events.

At the point of impact, the force from the object hitting it has to go somewhere. Initially, breakage and crumbling happen at the point of impact. If the force isn't large enough to do any more damage, that's the end of the breakage.

But if the force is strong, the stress has to go somewhere after the initial impact. The stress finds the path of least resistance through the object, through the largest internal cracks. Then the initial cracks branch out into smaller cracks along more paths of least resistance, in the general direction of the force. If the force is strong enough, the cracks go all the way to the edges of the material, breaking it into pieces.

 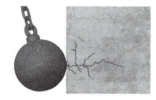

Very dense materials are less likely to fracture, as they have fewer tiny cracks to begin with. Dense materials tend to be heavy, so in general we can consider that the heavier the object or material, the more force will be needed to crack it.

An object with some elasticity will bend before cracking. Brittleness is a measure of how likely an object is to crack or break when under stress. Ceramics and glass are the most brittle substances, while metals can be quite elastic and will bend and shear before cracking.

CRACK PATTERNS

When an object is subjected to a force strong enough to crack or fracture it, cracks form randomly but are more likely along the paths of least resistance. Every solid object has points that are weaker than others. To determine crack patterns, you need to figure out where those weak points are.

Inherent Weak Points

With some materials, the weak points are easy to spot. In brick, for example, the caulk between the squares of concrete breaks before the concrete does.

Internal Cracks

Have you ever had a drinking glass break in your hands while washing it the same way you always do? This most likely happened after you'd used the glass many times over a long period. All that usage and washing and drying takes its toll after a while, causing invisible cracks from the manufacturing process to get larger and larger until one day, the glass can't even take the small stress of everyday handling without cracking.

Every object, from the table you're sitting at to the trees outside and the bones in your body, is made of some kind of material packed together. But the material isn't packed as densely as it could be—in between the material is air and sometimes or other gases or even liquid. You could say that every object on Earth has tiny, invisible cracks in it.

For man-made objects, the engineers designing the manufacturing process strive to distribute these cracks evenly or in such a way that the object will last as long as possible. But some cracks are always going to be bigger than other cracks, even if the difference is very slight.

New objects are more likely to fracture evenly, while an older material subjected to wear and tear has specific weak points. An example would be a building's roofline that consistently drips water down a specific exterior wall after a rainfall. Over time, the running water will cause weakness over its path. These areas will fail first if an earthquake, explosion, or other impact occurs.

Suppose you've had a heavy object sitting on a table for a long time. The stress of the object's weight will increase the size of the cracks in that area. Even if the heavy object is removed, the table is more likely to break where the heavy object was sitting previously.

If a table is exposed to outdoor elements for a long time, just a light touch can cause it to disintegrate. Even exposure to indoor air will increase the size of the cracks over time.

Cracks in a brick wall tend to form along the line of mortar, which is weaker than brick.

Close-up view of drinking glass reveals tiny flaws that will be the first to crack under pressure.

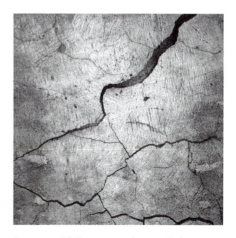

Stucco wall falling apart after cracks have formed from repeated water flow.

Close-up of cracks in an outdoor wooden table.

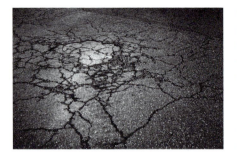

Asphalt cracked due to water damage.

In materials exposed to the outdoors, water is a frequent contributor to weak points because of the way it expands and contracts. Water can seep into a tiny crack, then freeze and expand to increase the size of the crack. When the water thaws it contracts again, but now there's more room in the crack and more water gets in. The new volume of water freezes and expands the crack, and the cycle continues.

There is an infinite number of ways an object could develop cracks and damage. When animating breakage and fracture, consider where the object's natural weak points are realistically going to be, and animate the breakage with these weak points in mind.

ANIMATING BREAKAGE

To figure out the fracture pattern for your object, the best method is to find or make slow-motion videos to see how the object is likely to break. Knowing the physics of crack patterns will help you interpret what you see in the video. If you can't find or make slow-motion video, see if you can determine the crack pattern based on the stresses the object has been likely to endure during its lifetime.

If using computer graphics, you can model the object with the cracks already in it, and animate the object breaking into pieces accordingly. There are also physics engines available that determine the most likely crack pattern for a breaking object.

Tetrahedron.

How Physics Engines Determine Fracture

To form cracks and fracture objects, CG physics engines use an automated method of determining the most likely path for cracks. The most common method uses tetrahedrons to fill out the mass of the object being struck.

The force is calculated along the direction of impact. Based on this direction, the tetrahedron edges that are most affected by the force are split to form cracks, and more tetrahedrons are formed at the tip of the crack.

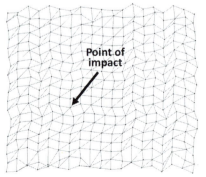
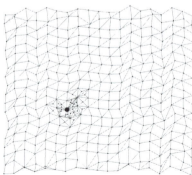
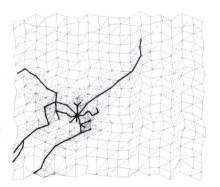

Computer-generated crack formation on a surface.

Then the mesh is split again as the stress dissipates. This continues until the stress is completely dissipated, or the cracks reach the end of the mesh.

Flying Pieces

After a fracture, how far the pieces fly is based on the force used to break the object and brittleness of the broken material. The more brittle the material, the farther the pieces fly.

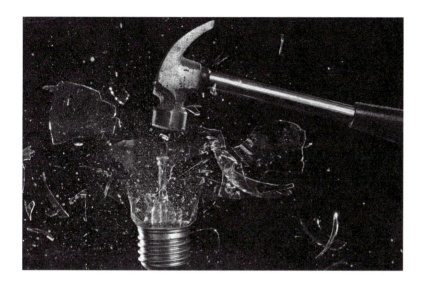

When animating broken pieces, remember the law of action/reaction. If half the broken object flies 1m to the left, the other half should fly roughly 1m to the right.

When pieces fly off after a breakage, they're subject to the usual gravitational forces and follow projectile motion. Pieces tend to fly off horizontally, and not upward unless there is a strong force pushing them upward.

Liquid Effects

Whether you're animating wine pouring into a glass, or a sailboat on the ocean, understanding the properties of liquids can help you do a better job of representing them visually in your work. In this chapter we look at properties common to all liquids, and also the specific physics behind the complex movement and appearance of ocean waves.

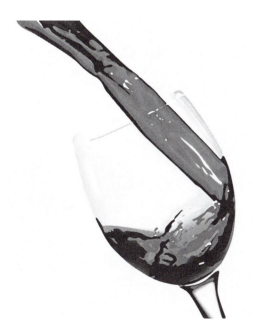

You might be accustomed to using the words *liquid* and *fluid* interchangeably. In physics, a *fluid* is any material that easily changes shape when subjected to a force. In this regard, both liquids and gases are considered fluids. A liquid is distinguished from a gas in the regard that it tends to take the shape of its container. This chapter is about liquids only.

Properties of Liquids

While there are many different types of liquids, they all have certain properties in common.

When you set out to figure out how a liquid will move, you will most likely consider its thickness. We all know that thicker liquids move slower than thinner liquids. But what does the term *thickness* really mean? In physics, this property is determined by a number of factors.

When physicists study liquids, they often compare their properties to those of water. Water is abundant and easy to study, and gives us something familiar to compare other liquids to.

COHESION

Cohesion is the tendency of a group of the same type of molecules to stick together. You can think of it in terms of how much force is needed to break something apart. A piece of cement, like all solids, has high cohesion; you need to apply a strong force (such as the force from a swinging sledge hammer) to break it up. Air, like all gases, has weak cohesion; a puff of breath causes its molecules to float away in every direction.

Liquids are somewhere in between. Liquid molecules try to stay together, but medium-strength forces like wind and gravity can cause them to move around. A puddle of water that isn't constrained by a container is an example of cohesion, where water molecules cling together unless a force stronger than their own cohesion drives them apart.

At the mouth of a dripping faucet, the water inside the faucet will try to hang on to the other water molecules as long as it can, but eventually gravity pulls off a piece and creates a separate droplet.

Liquids that we think of as "thick" have strong cohesion. For example, melted chocolate has stronger cohesion than honey. If you pour each of these substances into a spoon, you can easily see this. Both liquids try to resist gravity and stay in a clump in the spoon as long as they can, but the honey is less successful. The melted chocolate is able to clump together in a pile and resist falling out of the spoon for a longer time.

ADHESION

Adhesion is the tendency of one type of substance to stick to another type of substance (like a solid object) despite forces like gravity acting on it. An example is a raindrop sticking to a windowpane, or that last bit of shampoo that sticks to the bottom of the bottle no matter how much you shake it. If it weren't for adhesion, liquids would immediately slide off any tilted surface due to the force of gravity.

In figuring out how a liquid interacts due to gravity or other forces, the level of adhesion is important only where the liquid meets a solid surface. Away from the solid surface, cohesion determines how the liquid behaves.

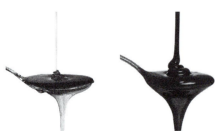

Pouring honey into a spoon (left) vs. melted chocolate (right).

Adhesion **Cohesion**

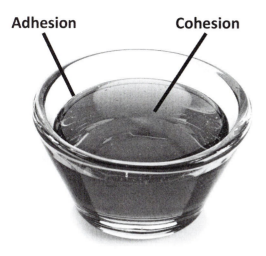

Adhesion between glass and water; cohesion within water itself.

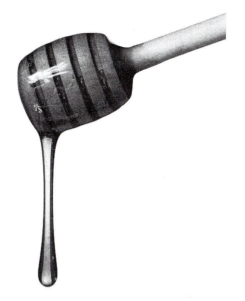

Adhesion properties are different between different liquid/solid pairs, and at different temperatures. For example, adhesion between oil and plastic or glass is weaker than adhesion between oil and metal.

How a liquid moves over a solid surface is determined by both adhesion and cohesion. The liquid's level of cohesion determines how well the mass of liquid stays globbed together, while the level of adhesion determines how quickly or slowly this glob separates from the other surface.

A honey dipper, a common household implement used for dispensing honey into coffee or tea, can be made of either wood or metal. The advantage of a wooden honey dipper is that honey adheres more to wood, allowing you to pick up more honey. The advantage of a metal honey dipper is that honey adheres less to metal, making the honey dipper easier to clean.

Some solid substances have low adhesion with just about every liquid. Materials used for kitchen countertops and floors are created specifically to have low adhesion with liquids, making any liquid mess easy to wipe away.

VISCOSITY

The term *viscosity* refers to how much a liquid resists changing shape when it is moving, as when a liquid is poured. Viscosity is the scientific term that corresponds most closely to what we call "thickness". Thicker liquids like olive oil, syrup, and paint are more viscous than water.

In the liquids we use in our everyday lives, viscosity is directly related to cohesion—the higher the cohesion, the more viscous the liquid. It is also related to adhesion, where high adhesion to the container it's in can increase the liquid's viscosity. If a bucket is full of some liquid, cohesion will play a bigger part in the viscosity level than adhesion because more of the liquid is sticking to itself than to the sides of the bucket. If the bucket is

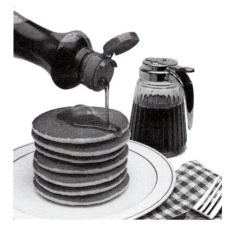

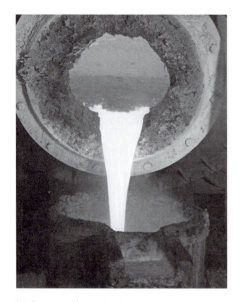

Molten metal pouring into a cast.

The centipoise measurement is named after physicist Jean Léonard Marie Poiseuille.

nearly empty, adhesion will play a bigger part in determining how readily the liquid flows.

Oil and water are both less viscous at higher temperatures. The difference for oil is visually noticeable, where warm or hot cooking oil (as when heated up in a pan) flows much more easily than room-temperature oil, making it easier to spread around in the pan.

Molten lava is a strong example of a liquid changing viscosity with temperature. After the lava comes up through the Earth's surface and cools, it turns to rock. Metals show a similar attribute, where high temperatures in a foundry are used to make the metal flow into the desired forms, where it then cools into hard shapes.

Viscosity is measured by a factor called a *centipoise* (cP). Water at room temperature has a viscosity of about 1cP. A higher centipoise means the substance is thicker and has a higher viscosity. The numbers in the following chart are rough values, mostly for comparison to the viscosity of water. The actual value can be higher or lower based on temperature, air pressure, and other factors.

Substance	Viscosity in cP
Water	1
Mercury	1.5
Isopropyl alcohol	2
Turpentine	2
Blood, milk	3
Gasoline	8
Beer	18
Olive oil	80
Motor oil SAE 10	90
Motor oil SAE 40	320
Nail polish	450
Latex paint	750
Corn syrup	1400
Water-based paint	2400
Honey	5000
Chocolate syrup	18,000
Ketchup	75,000

Molten lava	80,000
Melted chocolate	80,000
Peanut butter	250,000

By comparing the viscosity of a substance in your animation to the viscosity of water or another substance, you can work out how to visually represent pouring and flow for that liquid. For example, molten lava and melted chocolate have similar viscosity levels, so looking at flowing chocolate can give you a reasonable reference for the speed and movement of molten lava. If you do so, keep in mind the relative weights of the liquids. Mercury, for example, is more than 13 times heavier than water, so it pours more easily than water.

Newtonian and Non-Newtonian Fluids

Most of the less viscous liquids retain the same viscosity regardless of the degree of force applied to them or the amount of time the force is applied. Water, for example, retains the same viscosity whether it's shot out of a high-pressure hose, dripping from a faucet, or sloshing around in a water bottle. The time it flows doesn't matter either—water keeps the same viscosity whether it's pushed along for a fraction of a second or several hours.

But some higher-viscosity liquids can increase or decrease in viscosity to a marked degree depending on the degree of force being applied, and/or how long the force is applied. There are several examples of this in everyday liquids.

Dairy cream, for example, will thicken if you apply force in the form of stirring it vigorously, and will eventually become whipped cream. Honey, on the other hand, becomes less viscous when stirred. Many cosmetics also work in this way—nail polish and cosmetic gels become less viscous when shaken for a short time. Unlike whipped cream, these liquids will eventually return to their previous viscosity states if left to sit for a while.

Latex paint is designed to work with changing viscosity. When you gently dip the brush into the paint, there is little force and the paint has a somewhat high viscosity, thick enough to make a good volume of paint stick to the brush. When you then move the brush across a surface, this strong force makes the paint less viscous so it spreads easily. After the paint is laid down on the surface, it goes back to its original higher viscosity so it will avoid dripping before it dries.

Fluids that retain the same viscosity regardless of forces are called *Newtonian*, while the ones with changeable viscosity are called *non-Newtonian*. Newtonian fluids pour evenly and steadily, while non-Newtonian fluids tend to change speed as they pour. Water and beer are Newtonian, while thicker substances like lava, blood, paints, and many food products (yogurt, ketchup, honey, chocolate syrup) are non-Newtonian.

Cream thickening when vigorously stirred.

Higher viscosity **Lower viscosity**

Newtonian fluids are named for Isaac Newton, who first explored such fluid properties.

Type of fluid	Substance
Newtonian	Water
	Milk
	Blood plasma
	Oil
	Beer
Non-Newtonian	Printer ink
	Yogurt
	Gels
	Cream
	Honey
	Nail polish
	Ketchup
	Molasses
	Maple syrup
	Latex paint
	Blood
	Toothpaste

Solid/Liquid Behavior of Non-Newtonian Fluids

Another feature of thick non-Newtonian fluids is that they can act like solids. When no force is being applied, the fluid acts nearly like a solid, pooling in a pile with high viscosity. A slow, gentle force causes the fluid to act like a liquid with lower viscosity, but a hard, fast force causes it to act like a solid again, with higher viscosity.

When you apply . . .	It acts like a . . .	Viscosity
No force	Solid	Higher
Slow, gentle force	Liquid	Lower
Hard, fast force	Solid	Higher

Liquid/solid behavior of thick non-Newtonian fluids.

When we say a "hard/fast force," we're not talking about extreme force like that from an earthquake or falling meteorite. You can create a sufficient hard, fast force on a household liquid with your own two hands and see this behavior for yourself. Most liquid foods that come in squeezable bottles—ketchup, mayonnaise, mustard, just to name a few—will exhibit this behavior.

When you turn a squeezable ketchup bottle upside down and shake it, this fast, hard force dislodges the ketchup as a solid mass and moves it near the squeeze hole. If you then squeeze very fast and hard, you don't get much ketchup; the force causes the ketchup to act like a solid, and the squeezed air simply blows a hole through the middle of the mass. But if you squeeze

gently, the ketchup starts to behave like a liquid and flows out of the hole. When the ketchup lands on the plate, it acts like a solid again, pooling in a peaked puddle.

Compare this with a water bottle that has a nozzle, where you'll get a stream of water no matter how hard and fast you squeeze. When the water hits a surface, it makes a flat, thin puddle or breaks into droplets. The water acts like a liquid under no force, under a slow/gentle force, and under a hard/fast force.

While cohesion plays a part in making non-Newtonian fluids behave the way they do, the laws of cohesion don't account for these changes in viscosity due to force. Non-Newtonian fluids simply operate under their own rules.

Because they're called non-Newtonian *fluids*, and fluids can include both gases and liquids, you might assume that there are some gases that exhibit non-Newtonian behavior. There are, but such gases are extremely rare and unlikely to be found in your kitchen.

FOOD SCIENCE: KETCHUP

Non-Newtonian liquids remain a subject of much study, especially as a part of food science. It wasn't so long ago that all ketchup from the supermarket came in glass bottles—you had to smack the bottom of the bottle to dislodge the ketchup, then wait a minute or more for the ketchup to flow. While restaurants have had squeezable ketchup bottles for a long time, the plastic, squeezable, resealable, upside-down ketchup bottle for the home is a relatively new innovation that resulted from the study of non-Newtonian fluids.

While the squeezable bottle is faster than the glass bottle, hitting the bottle used to be part of the fun of using ketchup. It's not unreasonable to assume that somewhere out there is an enterprising engineer inventing a ketchup bottle that limits squeezing to a gentle pressure that will be sure to move the ketchup out of the nozzle. This will, unfortunately, take the last of the fun out of ketchup.

SURFACE TENSION

When a liquid meets air, as when pooled in a puddle or sitting in a container, the part of the surface exposed to air is pulled a little tighter than the rest of the liquid, like the head of a drum. This property of liquids is called *surface tension*.

The level of surface tension has to do with how strongly the liquid's molecules bind together (cohesion). Because of cohesion, all molecules in the liquid pull at their neighboring molecules with equal force in all directions. However, on the surface there are no liquid molecules to adhere to. The pulling force has to go somewhere, so the molecules at the surface pull even tighter on their neighbors, effectively contracting the surface and making it harder to penetrate.

At the surface (shown as gray), the force that would ordinarily bind molecules from above (dotted arrows) has nothing to bind to, so the force goes into the horizontal binding force instead.

Surface tension is expressed as force per area, either as Newtons per meters squared (N/m^2) or dynes per cm^2. One N/m^2 = 1000 dyne/cm^2.

Surface tension is the reason why small creatures can walk across the water's surface. After a liquid surface has been indented, it has a natural tendency to pull itself taut again and restore its flat surface. This is why an insect's "footprints" on water disappear almost immediately.

The chart shown is a guide to surface tension values for various substances. The values are for liquids at room temperature unless otherwise specified.

Substance	Surface tension (dyne/cm^2)
Water	73
Honey	66
Water—boiling	59
Latex paint	45
Soapy water	37
Olive oil	32

Surface tension is not directly related to viscosity. Honey, for example, has a higher viscosity than water at room temperature, but a lower surface tension. Overall, household liquids (water, cleansers, oils, honey, syrup) have surface tension values in the 30–70 range.

When animating a high-viscosity liquid, you don't need to concern yourself much with surface tension. With high-viscosity liquids like melted chocolate or molten lava, surface tension doesn't affect the flow nearly as much as the viscosity itself. But for low-viscosity liquids, surface tension plays a role in how the liquid splashes and puddles.

An object can appear to float when its weight distribution allows it to sit on the surface due to surface tension. A paper clip, when laid on a water surface, will either sink or stay on the surface depending on how you place it on the water. If you lay it gently on the water's surface, it won't break the surface tension and will sit on the surface. However, if you dip it vertically into the water past the surface tension, it will sink because it weighs more than the water it displaces.

BUOYANCY

An object sitting on the surface due to surface tension is not the same as a large object like a boat floating. Floating follows different rules.

An object can float when it weighs less than the water it displaces. A boat floats because it displaces a large amount of water, enough to support a heavy object that is mostly hollow on top.

Some substances alter surface tension when added to a liquid. An example would be paint thinner added to paint, which lowers both viscosity and surface tension. Soap added to water reduces surface tension without affecting viscosity. A substance that reduces surface tension is called a *surfactant*.

If the water is soapy, this makes the surface tension too low and the paper clip will sink no matter how you place it in the water.

Like any other object, a boat has a center of gravity. A boat in water also has another spot called the *center of buoyancy* (CB), which is located at the center of the distributed weight of the displaced water. As the boat's weight pushes down along the line of gravity, pressure from the water

underneath pushes the boat upward along the line on which the center of buoyancy lies.

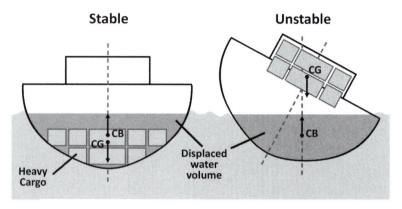

Stable and unstable centers of gravity in a boat of the same size and weight.

If the center of buoyancy is above the center of gravity, the boat is stable; it will tend to right itself after being slightly tipped by waves or wind. A stable boat has the majority of its weight under water and below the center of buoyancy to prevent tipping.

Conversely, a top-heavy boat, where the center of gravity is higher than the center of buoyancy, is unstable and prone to tipping. If wind or waves push the center of gravity off the line of the center of buoyancy, the boat is likely to keep tipping, at which point it will take on water and become so heavy that it sinks.

Stability is also affected by the shape of the hull. As the boat is lightly tossed in even the calmest water, the position of the CB shifts around, based on the water that's displaced by the hull at any given moment. A good boat design includes a hull shape with enough room to keep the CB well above the CG.

Liquid Appearance

You can determine a lot about liquid appearance from its viscosity, surface tension, adhesion and cohesion properties.

MENISCUS

When a liquid sits in a container, there is some adhesion between the liquid and the substance that makes up the container. At the top of the liquid, where it meets both the air and the container, both adhesion and surface tension act on the liquid to give the top surface a curved shape at the edges. This part of the surface is called a *meniscus*.

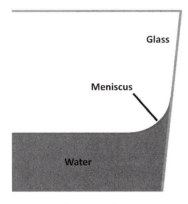
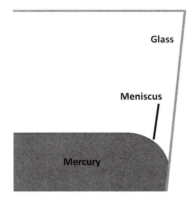

Meniscus of water and mercury.

If surface tension is stronger than adhesion, the meniscus falls below the surface and creates a convex (up-curve) shape. If adhesion is stronger than surface tension, the meniscus is above the top surface of the liquid, making a concave (down-curve) shape.

Different types of containers and liquids produce different meniscus shapes. Water in glass produces a concave meniscus, while mercury in glass produces a convex meniscus.

The meniscus curve affects the appearance of liquids. Visually, a glass of water has a noticeable line at the water's surface due to light reflecting off the meniscus. If the meniscus isn't there, audiences instinctively know that the container isn't glass, or the liquid isn't water. Water has lower adhesion to plastic than to glass, so the meniscus on a plastic cup is less pronounced than the one on a drinking glass.

By learning the adhesion properties and the meniscus size and shape for the liquid and the container it's in, you will be better able to represent the size of the refraction at the top of the liquid.

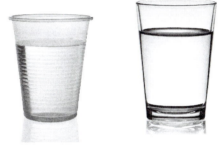

Small meniscus of water in plastic cup (left) refracts less light than larger meniscus of water in glass (right).

POURING SHAPES

A highly viscous liquid pours with a shape that can appear almost solid. With a low-viscosity liquid, the pouring shape is more irregular due to low cohesion; the molecules don't hold together as well during the fall.

Liquids tend to be smooth and shiny when pouring unless they are full of chunky material, as with peanut butter or lava. If the liquid is translucent or transparent, it will refract the colors around it. Most natural liquids like oil, honey, and natural gas are translucent or transparent. Man-made liquids like glue and paint can be translucent or opaque, depending on how they're made.

During pouring, a low-viscosity translucent liquid will reflect and refract more than a high-viscosity liquid with the same translucency, due to its irregular shape.

Coffee (left) pours translucent with an irregular shape, while paint appears more solid.

Oceans and Lakes

Review:

- Classical Physics > Motion and Timing > Wave Motion
- Classical Physics > Forces > Pressure and Gases

Representing the ocean or any large body of water is a common need for animation projects. Knowing the physics behind such bodies of water will help you make more realistic and convincing scenes. Whether you're making traditional animation drawings or creating realistic visual effects, the same laws of physics apply.

WAVES

Any section of an ocean or large lake can have numerous small and large waves moving at the same time. In this chapter, we'll look at the basics behind wave formation and movement.

Wave Terminology

All ocean and lake waves follow a similar pattern as transverse waves. Recall that with transverse waves, the material itself doesn't move down the wave. With ocean and lake waves, the water droplets themselves don't move much. However, the wave pattern itself can move hundreds or even thousands of miles.

When discussing ocean waves, we use the same terminology we use to discuss any kind of transverse wave. The top of the wave is called the crest, while the dip between crests is called the trough.

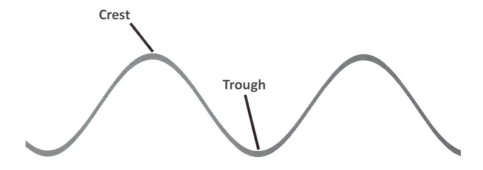

An ocean wave has a wavelength and amplitude. The amplitude, or wave height, is measured from halfway between the trough and the crest.

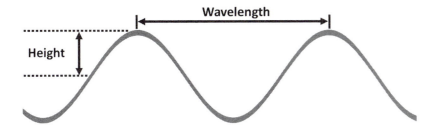

How Ocean Waves Form

In the ocean or other large body of water, waves form from a disturbance in or over the water. The most common disturbance to cause waves is wind, but disturbances can also be caused by marine life, boats, shifting of tectonic plates, falling meteors, and anything else that moves water around.

In this section, we look at how wind forms waves out in the ocean. The end result, waves moving across the ocean's surface, is the same regardless of whether it's caused by wind or some other disturbance.

Capillary Waves

When wind starts to blow over a still body of water, ripples and small waves form on the water's surface due to friction between air and water. The wind just above the water's surface moves slower than the wind above it because it is more affected by this friction. The faster-moving wind just above it topples in front of the slower-moving wind, creating a small trough and displacing water to form a small crest. These small ripples and waves, less than an inch in wavelength, are called *capillary waves*. Capillary waves tend to have sharper, more V-shaped troughs than larger ocean waves.

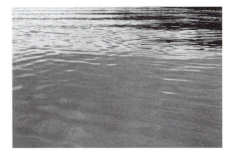

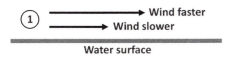

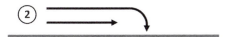

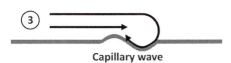

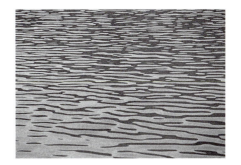

A capillary wave, once formed, radiates out in all directions from its source. If a surface consists of numerous capillary waves formed by wind, they will appear to move in the general direction of the wind but with a good degree of randomness.

Right after a capillary wave is formed, the water's surface tension tries to pull the surface taut to flatten it out. If the disturbance that caused the capillary waves isn't continuous but rather a one-shot deal, as with a stone being dropped in the water, the ripples radiate out and dissipate, and the surface goes back to its previous shape rather quickly. But capillary waves from wind will continue to form if the wind continues to blow, and if the wind is strong enough the waves will eventually get larger.

Gravity Waves

As the wind continues to blow, the air moves faster over the crests of the capillary waves. This higher speed causes the air to have lower pressure over the crests and higher pressure in the troughs. Water, being a liquid that's easy to push around, responds to the higher pressure in the troughs by pushing down and making the trough wider and deeper, and responds to the lower pressure on the crests by drawing the water forward. This process can be likened to the wind gripping or grabbing the crest of the wave, pulling it forward. When its wavelength reaches more than 0.7in (1.74cm), the wave graduates from a capillary wave to a *gravity wave*.

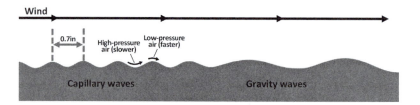

During the process of gravity waves forming due to steady wind, the change in wavelength is not proportional to change in wave height—the length of the wave increases a lot more than the wave height increases. In other words, the troughs widen a lot more than the height increases.

Movement of Waves

Once the waves start going in an ocean, individual water droplets move around in a circular pattern.

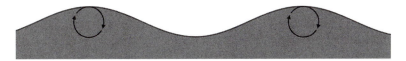

Pattern for traveling waves in ocean, going left to right.

The water droplets at a crest then roll downward and form a trough, then roll back up again to form a crest. While an individual water wave can appear to move a great distance, the individual droplets themselves are just rolling around and around within the same area. The droplets' overall motion follows a wave pattern, with a wavelength and amplitude.

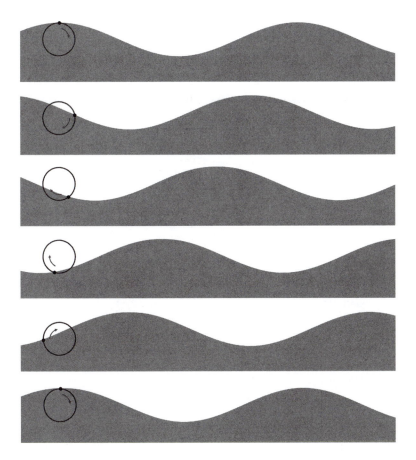

Breaking Waves

Wind and other factors can push a wave around and shorten its wavelength. When wavelength decreases, the wave height increases and crests become

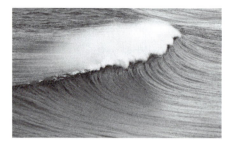

Wave breaking in the ocean.

pointier, and at some point the peak can no longer hold together. When this happens, the wave *breaks* and the peak falls over.

The ratio of a wave's height to its wavelength is called its *steepness*. As steepness increases, the wave becomes pointier at the crest. When steepness is less than 1:7, the wave breaks. In other words, the wave breaks when the wavelength becomes so short that it's less than 7 times the wave height.

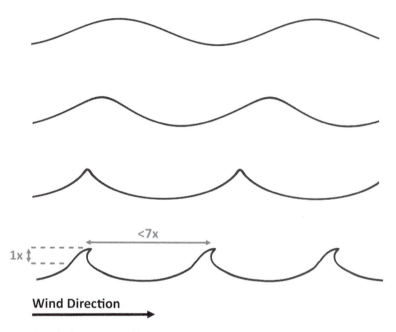

Wavelength shortening and height increasing until wavelength is less than 7 times the wave height, causing a break.

The falling peak of a breaking wave is infused with air as it falls, forming foam and bubbles that appear to us as white in color.

Shoreline Breaks

Ocean waves commonly break as they run into shallow water at a shoreline. To understand why this happens, we need to look at the water underneath the visible wave. In the deep ocean, the circular motion of water droplets that make up a wave actually extends far below the surface. The circles around which the droplets travel get smaller and smaller farther down, and at a certain level the circular motion is negligible. This level, called the *wave base*, is about half a wavelength down in the water.

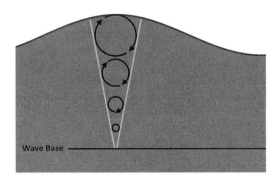

When waves move into shallow water near the shoreline, the water near the wave base is held back, holding the entire wave back. This causes the waves to slow down and crowd together, with a shortened wavelength and pointier crests. When a wave's length reaches the point where it's less than 7 times the wave height, it breaks. The water at the top of the break, in attempting to continue its circular motion, topples down in front of the wave.

A wave that's being held back on the bottom is said to "feel bottom."

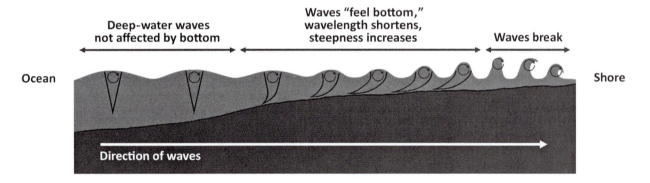

Any obstruction not far below the water's surface, such as rocks and reefs, can also cause the same effect on waves and make them break.

BEAUFORT SCALE

The Beaufort Scale is a chart of the visible effects of wind on water and the environment. The scale was originally developed by sailors to help determine what effects the wind would have on their immediate situations, such as whether their sails would be able to hold up under a gale. Rather than relying on scientific measurement, the scale was a simple and straightforward guide that any sailor could use just by being observant—by looking at the sea and observing the wind's effect on skin, clothing, and objects on the boat, a sailor could tell if the wind was going to cause him problems. Over the years the Beaufort Scale has been refined and scaled against scientific measurement and is now an accepted way of measuring wind, particularly wind over water.

continued on the next page

The Beaufort Scale is a handy tool for animators because it gives you the visual effects of various wind strengths on water, smoke, trees, and other objects likely to be visibly affected by wind. You can find the Beaufort Scale in many places online. When creating an outdoor windy scene, consult the Beaufort Scale and determine where your wind falls on the chart, and animate the environment accordingly.

Beaufort number	Description	Wind speed	Wave Height	Sea conditions	Land conditions
6	Strong breeze	38.8–49.9 km/h 24.1–31 mph	3–4 m 9–13 ft	Long waves begin to form. Frequent white foam crests, small amounts of airborne spray.	Large branches move. Umbrella use becomes difficult. Empty garbage bins tip over.

Portion of the Beaufort Scale.

Floating on a Wave

An object bobbing in the waves gives a strong visual cue about the turbulence of the water. Such an object moves back and forth as a circling water droplet does, going up and down the waveform without moving any net distance.

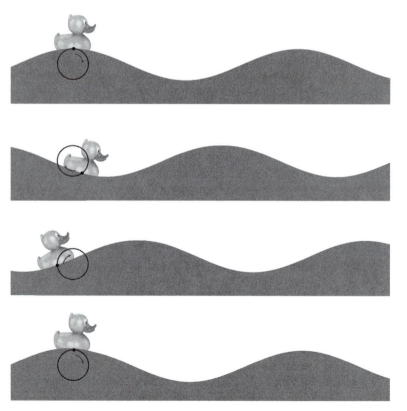

If the wind is strong enough, the water at the crests does get pushed a small distance with each wave. An object bobbing on the water can get pushed along with the water in such a case, which is why something thrown in the ocean can wash up on shore eventually.

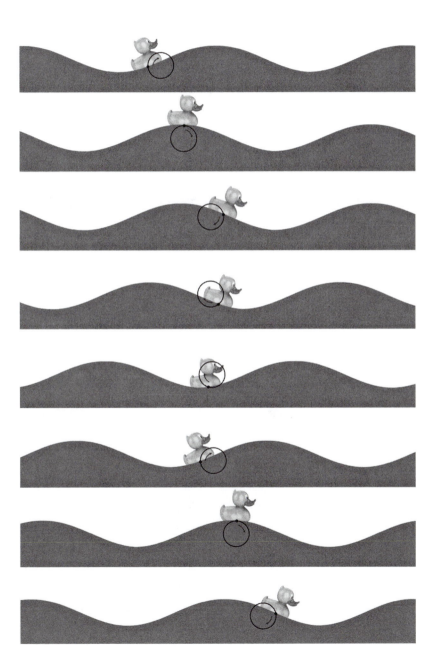

You can barely make out the scuba diver's feet, and can't see the ocean's bottom at all.

OCEAN AND LAKE APPEARANCE

Even though ocean and lake water is transparent, you usually won't see through the surface when looking at it. The reflections, waves, splashes, and foam on a large body of water are what differentiate it visually from paint or other opaque liquids, not its transparency.

Water waves in particular are very shiny and reflective. The smooth, curved shapes of wave peaks generate specular highlights with light from the Sun and Moon. Breaking waves throw shiny water droplets and produce white foam. Wave troughs can appear quite dark in comparison, almost black.

For these reasons, when creating an ocean or other large body of water for animation, it's usually more efficient to treat it as opaque rather than transparent.

Water Reflection

If looking down through still or very shallow ocean water at a high angle in bright sunlight, you can see a refracted version of what's just below the surface, but you can't see very far down. The ocean's bottom is visible only in shallow water, even on a bright day with a calm ocean. The water scatters and absorbs the light once it gets under the surface—the farther down you look, the less light there is.

As your viewing angle goes closer to horizontal, water appears more reflective, so you see the reflected image of the sky and parts of objects above the water rather than what's underneath it. The more disturbed the water is, the more distorted the reflection.

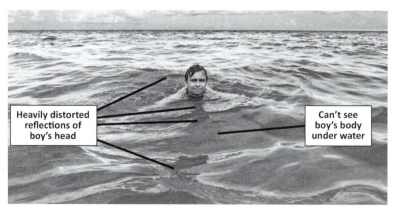

Heavily distorted
reflections of
boy's head

Can't see
boy's body
under water

At this viewing angle, the boy's body under the water isn't visible at all.

The reflection coefficient for water, as listed in the Reflection section of the Light and Color chapter, is only 2%. This value is for reflections of light rays hitting the water perpendicular to the surface. For other angles, the reflection coefficient increases as the angle of incidence moves away from the perpendicular. This means that at viewing angles low to the ground, a reflected image appears in the water in place of the refracted image under the water.

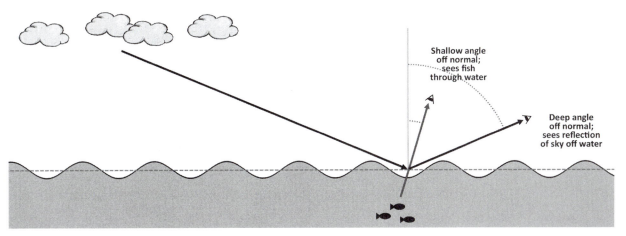

Shallow angle off normal; sees fish through water

Deep angle off normal; sees reflection of sky off water

The smoother the water, the clearer the reflected image. Mud and dirt make the surface less "smooth" and cause light to bounce off in many directions, making reflections less distinct.

In the forefront, rocks under the water's surface are clearly visible due to a viewing angle close to the perpendicular, and no reflections are visible. Farther back on the lake, where the viewing angle is farther from the perpendicular, we see only a reflection of the sky.

Muddy lake. Even though the viewing angle is low to the ground and the lake is calm, only vague reflections appear in the lake's surface.

The peaks of waves can produce specular highlights. As with any medium, specular highlights occur on the water's surface when the light source is at the same angle to the surface as the viewer. Specular highlights, being brighter than reflections, will trump any reflected images and appear as the color of the light source.

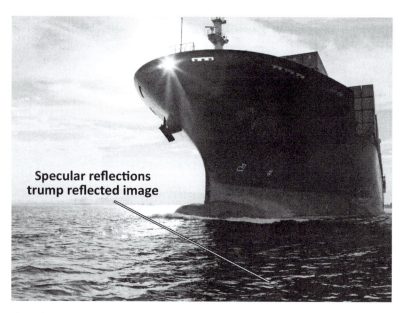

The reflected image of the boat, already chopped up by the waves, is further interrupted by specular reflections on the peaks.

FRESNEL EFFECT

The dependence of reflection level on angle of incidence is called a *Fresnel Effect*, named for the physicist who first documented the relationship between index of refraction, angle of incidence, and reflectivity. The Fresnel Effect explains why water is more reflective at low angles, and why a transparent, curved object like a drinking glass looks different at the sides than in the middle.

The Fresnel equations tells us that the farther the viewing angle from the surface normal, the more light reflects off the surface (rather than refracting into the medium). With water waves, the "viewing angle" for each part of the wave is different even if the viewer stays still. For viewing water an angle, Fresnel equations tell us that reflection will be strongest at the peak of the wave, and weakest between the peak and trough, where the angle between the wave's normal and viewing direction is smallest.

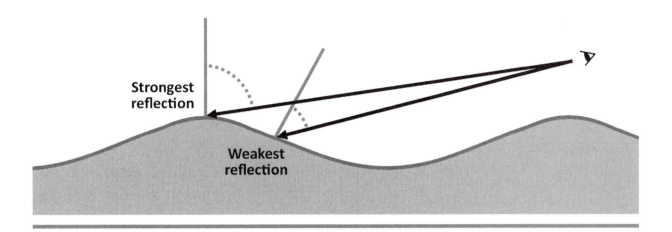

Strongest reflection

Weakest reflection

Color of the Ocean

The base color of deep water in bright white light is blue. This shading is due to the way deep water absorbs and scatters the various wavelengths of light, similar to the way our atmosphere absorbs the Sun's rays and scatters blue light to make the sky appear blue. Microscopic organisms such as algae can also tint the sea with green or brown colors, or can make it bluer.

Shallow water, as at an ocean's shoreline, isn't deep enough to absorb and scatter the different color wavelengths to a visible degree, so it appears clear when you look down through it.

However, if you're looking at the ocean or lake from a large angle off the perpendicular, the visual base color is largely determined by the reflected color of the sky. These bodies of water appear very blue on a sunny day, blue-gray on an overcast day, and blue-black at night.

Spray, Mist, and Foam

Spray and foam make water appear more active and turbulent. When a large wave breaks, the result is a chaotic mass of water droplets and bubbles that looks rather solid, with stray droplets emanating from the mass and mist rising from the chaos.

Spray is fine water particles thrown into the air, which then follow projectile motion and fall back into the sea. Mist is fine water droplets small enough to be suspended in air. Visually, mist is very much like fog.

Mist can be present due to a big splash, or due to water evaporation early in the morning. A waterfall produces a sheet of mist that looks like particles slowly rising then dissipating or evaporating.

Foam is essentially bubbles. Foam in the ocean can form where water meets both a solid and air at the same time, as at the ocean's shoreline or where waves move against rocks. The water is moving yet it clings to the solid (sand

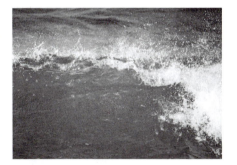

Mist (right) from waterfall.

or rock) to some degree, while the water's surface tension attempts to keep the water together. In comes the air to fill in the gaps, forming bubbles.

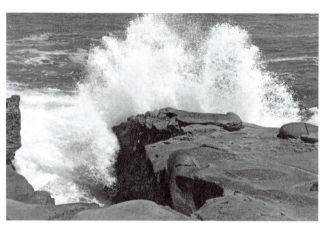

Foam from water crashing on rocks.

In breaking waves, foam forms when the falling water attempts to continue moving through the "solid" of water below it, but is prevented from doing so by the circular motion of water waves.

The amount of foam and its color can be affected by microscopic plant life. Water that contains a lot of algae and other organisms is more prone to foaming.

Splashes, mist, and foam usually appear as white. Foam can also be tinted green or brown if a lot of plant life is present in the water.

Shadows on Water

Shadows can behave differently on water depending on the water's clarity and smoothness. In clear, smooth, shallow water, as in a swimming pool or calm lake, light can get through the water, so shadows are cast on the bottom. In muddy or choppy water, shadows are cast on the surface.

Shadows fall on the bottom of clear, smooth, shallow water.

Shadows fall on the surface of choppy water.

CHAPTER **10**

Earth and Outer Space

If your animation involves the great outdoors, chances are you'll need to know something about Earth. We walk on its lands, swim its waters and fly through the air every day, but a more detailed understanding of its formation can help a great deal when representing it in your art.

And of course, the magic and mystery of outer space has captured artists' imaginations for centuries. The intensely violent processes that formed our universe (and also our planet) continue on much as they have for billions of years, giving us a marvelously enormous canvas that's both visually rich and ripe for interpretation.

Earth Today

The same forces that formed the landscape on Earth over the last several millions of years are still in play today, and account for the shapes of our mountains, valleys, and coastlines as well as natural disasters like earthquakes and volcanic eruptions. Let's take a closer look at Earth's structure and how it came to be that way.

EARTH'S LAYERS

Earth has many layers. Outside Earth is a gaseous atmosphere, and the planet itself is composed of a hot solid metal core surrounded by molten rock layers

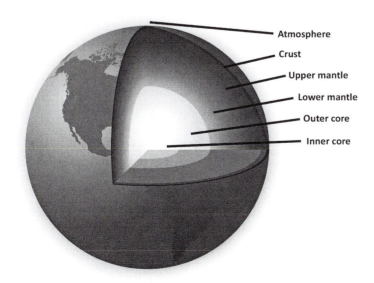

- Atmosphere
- Crust
- Upper mantle
- Lower mantle
- Outer core
- Inner core

that become gradually cooler and more solid until you get to a solid, thin crust on the outside.

The part of the Earth's atmosphere you can see from Earth, where there's enough air to catch the light, is quite thin compared to the size of the planet, as evidenced by this photo taken from space. The outer reaches of the atmosphere extend about 400km into space, and the radius of Earth, by comparison, is 16 times larger at about 6400km. Most of the action, such as clouds and flying jets, occurs within a 10km strip of atmosphere just above the Earth's surface.

Earth's atmosphere as a thin, transparent layer at the outer edge of the planet. Image courtesy of NASA.

A *silicate* is a compound formed from silicon and other elements such as oxygen and aluminum. Clay and quartz are examples of silicates.

The Earth's crust is the hard, relatively thin rocky layer on the outside. The thickness of the crust ranges from about 5km thick in the deepest parts of the ocean to around 30km thick on the continents. The crust is made up mostly of silicates. About 70% of the crust is covered by water.

The next layer down is the mantle, about 3000km deep. The mantle is made up of two basic layers—a rigid upper layer mostly solid, which the crust sits upon, and a low-viscosity layer underneath. The upper layer is less solid than the crust. Liquid lava can form when the mantle gets hot enough for rocks to melt. This is where lava for volcanoes comes from.

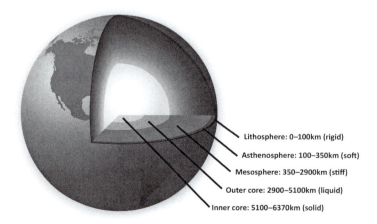

Lithosphere: 0–100km (rigid)
Asthenosphere: 100–350km (soft)
Mesosphere: 350–2900km (stiff)
Outer core: 2900–5100km (liquid)
Inner core: 5100–6370km (solid)

Earth's layers with depths and technical names for crust layers.

The center region of the Earth is the core. The core has two parts: the inner and outer cores. Both cores consist of iron and nickel. The outer core is hot liquid, about 5000°C, which compares to the temperature of the Sun's surface. The inner core is even hotter, but is under such high pressure that it is solid rather than liquid.

This high temperature keeps most of the outer core and much of the lower mantle in a molten state and the mantle only becomes a semi-solid near its outer region. The upper crust is basically floating atop a layer of molten or semi-solid rock around 29 miles deep. This floating quality of the crust is responsible for much of our current topography as well as many natural disasters.

Where the crust meets the mantle are the *tectonic plates*, a series of hard, separate plates with some mobility as they "float" on the softer, sometimes liquid mantle. Understanding tectonic plates is vital to getting a grasp on both landscape formation and natural disasters.

The composition of the Earth's core is theoretical, as no one has actually ever dug down that far. In *A Journey to the Centre of the Earth*, an 1864 novel by early sci-fi author Jules Verne, two German explorers travel down volcanic tubes (tunnels through which lava flows) to visit the Earth's center, enjoying a lively and dangerous adventure along the way. While unbelievable from a scientific point of view, the story is enchanting and has inspired a couple of film versions of the tale.

Separation lines of Earth's major tectonic plates.

ATMOSPHERE

Earth's atmosphere is essential to life as we know it. The atmosphere provides air to breathe as well as protection from the harsh rays of the Sun, and from flying space debris such as asteroids. Scientists separate our atmosphere into several layers for easier study and discussion.

The atmosphere is held to the Earth by gravity. Gravity causes the outer layers to push in on the lower layers, creating the greatest amount of air pressure at the Earth's surface. By comparison, in the outer layers of the atmosphere the air is much less dense.

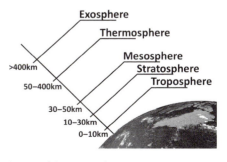

Layers of the atmosphere.

There is no definitive line where our atmosphere meets outer space. At the outermost regions of the exosphere are simple elements like hydrogen and helium which can drift into outer space. This is the level at which many satellites orbit.

Atmospheric Levels

The thermosphere catches a lot of heat from the Sun when compared with the air density at that level. If you were flying around in this area, you wouldn't feel this heat because the air density is so low that there wouldn't be enough air to transfer heat to your skin. Heat is the energy of molecular motion, and when there aren't many molecules around, we just don't feel it. But the air molecules that do heat up can rise to over 1000°C in temperature.

The mesosphere is the coldest atmospheric layer, colder than any place on the Earth's surface. Ice clouds can form in the mesosphere, which are sometimes visible just after sunset.

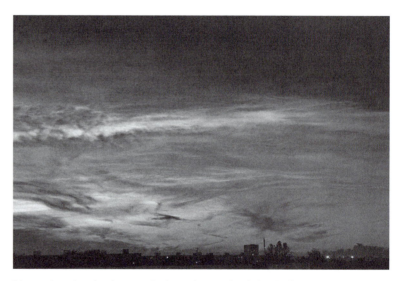

Mesosphere ice clouds are called noctilucent clouds (NLCs) because you can see them only after the Sun has set. These wispy mesosphere clouds are too faint to be seen during the day, but after sunset the lower parts of the atmosphere are in shadow while mesosphere clouds are still illuminated by the Sun due to their height. *Nocti* means night, while *lucent* means light or shining. Noctilucent clouds are most common near the Equator.

The stratosphere contains the ozone layer. It has very stable atmospheric conditions and so has no weather to speak of.

The troposphere is the area closest to the Earth's surface, the turbulent and ever-changing layer where the majority of our weather takes place. All clouds visible during the day are in the troposphere.

Height of Vehicles in Atmosphere

Man-made vehicles that orbit Earth stay within the thermosphere. Vehicles in common use, such as airplanes and hot-air balloons, travel within the stratosphere. Satellites and shuttles orbit in the thermosphere.

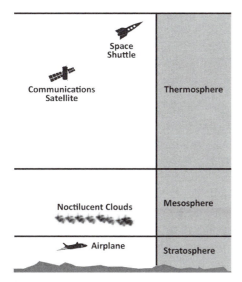

OZONE LAYER

Although the atmosphere started to form 4 billion years ago from condensed water vapor, the level of ozone needed to block out the Sun's lethal ultraviolet radiation developed much later, about 600 million years ago. Before that, the only life that could exist on Earth was in the oceans and seas. The development of a critical level of ozone in the atmosphere made it possible for land-based animals to evolve.

Ozone is an oxygen compound that exists in all parts of our atmosphere. A heavy concentration of ozone in our stratosphere forms the ozone layer, which protects us from the harmful ultraviolet radiation the Sun puts out. The ozone layer varies in altitude over different regions and seasons, but is generally in the range of 10–20 miles overhead. Since the ozone spreads out quite a bit, it's hard to say exactly how "thick" it is—some methods of measurement tell us it's a few millimeters thick, while others say it's several miles thick—but apparently, it's thick enough to keep us all from getting fried.

The whitest areas of the image show a hole in the ozone layer over Antarctica in September, 2014. Satellite image courtesy of NASA.

Scientists didn't start to study the ozone layer until the 1970s. In 1984, scientists noticed a "hole" in the ozone layer over Antarctica. Since then, this hole has appeared every year between August and October. There is still a great deal of debate over when this hole really formed, what caused it, whether it will eventually close up, and if not, what impact it will have on human life going forward.

Formation of Earth

Before we delve into the composition of the Earth's crust, let's take a look at how Planet Earth was formed. Understanding the history behind this rock we live on can help a great deal in understanding its composition today.

It's important to note that scientists are still learning about the formation of Earth, with new evidence coming to light regularly. Nobody knows for sure how it all happened, but we can make some very educated guesses based on space observation and geological evidence.

A protostar is a star in its earliest formative stages, when a mass of gases have just started to come together.

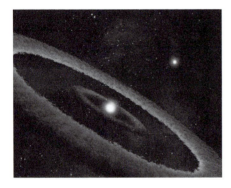

Artist's rendering of planetismal. Image courtesy of NASA/JPL-Caltech.

Surface of the Moon.

Some of the heavy elements that sank to Earth's center are radioactive, and generate the enormous heat that keeps the inner core near 5000°C today.

GASEOUS EARTH

As a protostar, our sun gobbled up about 90% of the material in the nebula that surrounded it during its creation. The remaining 10% of the matter orbiting the Sun, mostly tiny grains of dust and gases, coalesced into large disk-shaped masses called *planetesimals* over a period of about 100,000 years.

Several planetismals formed around the Sun, with chunks in the disk gradually pulling together to form the planets of our solar system, including Earth. Over billions of years, the gravity of the planets that orbit our sun have drawn into them most of the material floating around them in the form of gas, dust, meteors, asteroids, and comets.

Nearly 4 billion years ago, when Earth was still a somewhat loose collection of dust and gases, billions of asteroids and comets collided with this collection, bringing many materials with them, such as heavy metals, oxygen, and water. The period during which Earth received this massive number of collisions is called the Heavy Bombardment Period. One only has to look at the surface of the Moon to get an idea of how many of these objects have similarly struck the Earth.

As Earth (and other planets) became more solid, the energy from the collisions generated enough heat to keep the surface of the Earth molten. Heavy elements like iron and nickel sank to the center of Earth. The Earth remained a molten sphere until the collisions with these objects slowed down long enough for the energy to dissipate, allowing the surface to cool and solidify again about 3.8 billion years ago.

Once the Earth cooled, it would not be long before there was liquid water on the surface and a gaseous atmosphere surrounding the entire planet. The Earth may have become a planetary mass over a period as short as 600 million years.

SUPERCONTINENTS

After the Earth's crust and upper mantle became somewhat stable, distinct landscape features such as continents began to emerge. The Earth's surface has been changing appearance ever since, with tectonic plates moving around to form continents of different shapes.

Scientists have been able to dig around and find ancient rock and mineral deposits that retain the magnetic orientations they had when they were buried, which often differ greatly from present-day magnetism on the surface. This has told us a lot about where these rock deposits were in relation to the magnetic North Pole or South Pole when they were buried millions of years ago. Also, fossils give clues about similar or identical species now separated by thousands of miles, indicating that the tectonic plates on which they were found were once very close together.

From this information, scientists surmise that all the Earth's continents drift around the surface and that on multiple occasions throughout the millennia, have been pushed together as a supercontinent: one single continent with regions separated by relatively small bodies of water. One of the first supercontinents, Rodinia, existed between 1.1 billion and 750 million years ago. While many scientists agree that Rodinia existed, its exact form is still a subject of much speculation and debate.

The study of the Earth's magnetic field in buried rocks and sediment is called *paleomagnetism*.

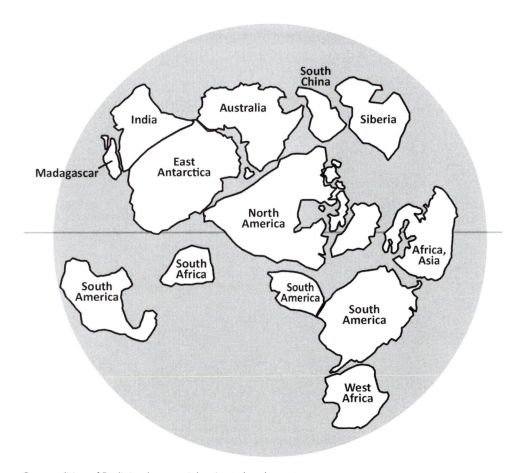

One rendition of Rodinia, shown as it begins to break apart.

Rodinia wouldn't have had any life forms on it, but it is speculated that when it broke apart it gave rise to the earliest life on Earth. Our atmosphere had started to reach its final form, giving it the ability to hold in the heat from the Sun as it does today. The shallow, warm oceans that resulted from Rodinia's breakage made a great breeding ground for algae and other early plant life.

After Rodinia, the tectonic plates continued to move around, smashing into one another and forming larger continents, then breaking apart to form smaller ones. More supercontinents formed after Rodinia. The supercontinent Pangaea existed between 450 and 250 million years ago, during the time when insects and reptiles developed.

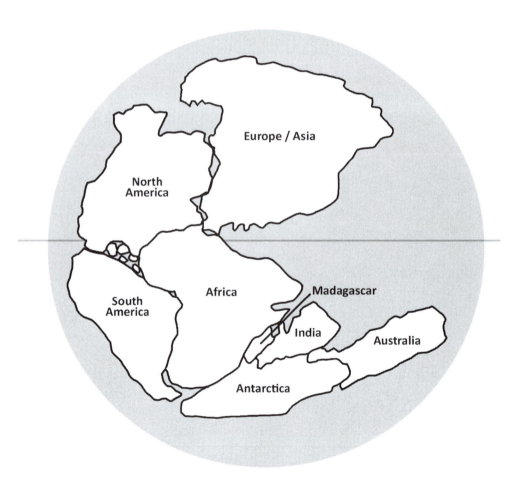

Pangaea.

PREHISTORIC CONTINENT MAPS

In the maps in this chapter, the present-day continent names are shown. However, if you do any research on supercontinents, you'll see unfamiliar continent names like Laurasia and Gondwana. Scientists assign these names when a supercontinent doesn't correspond directly to a present-day continent or country. Giving names to these continents makes it easier for scientists to discuss and theorize about them.

Laurasia, one of Pangaea's continents, is a single land mass that became North America, Europe, and Asia (minus India), while Gondwana was a mass with existing splits that divided into Antarctica, South America, Africa, Madagascar, Australia, and India.

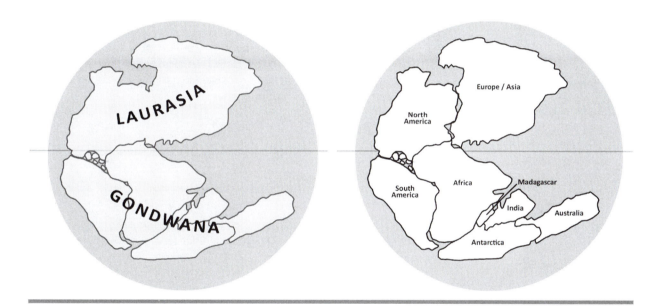

About 250 million years ago, Pangaea began to split into two sections, with one drifting north and the other south. This created one supercontinent in the southern hemisphere, which became Australia, South America, Africa, and Antarctica. From the northern portion came the continental regions of Asia, Europe, North America, and Central America. India was originally part of the southern portion, but moved north to smash into Asia to form the Himalayan mountain range.

A *tsunami* is a very large, high wave caused by a strong disturbance in the ocean, such as a shift of tectonic plates. Tsunami waves can travel over thousands of miles of ocean to devastate any populated land mass that they hit. The surge from the wave can travel several miles inland, destroying property and drowning an entire population in an instant.

When looking to animate a massive event like a tectonic plate shift, figuring out which type it is and how the shift's energy will flow and affect the land around it will help you animate the scene more accurately and convincingly.

Many tectonic plates are currently drifting at a rate of a few inches a year. Scientists surmise that our continents will again look very different in about 50 million years. If Africa keeps drifting north at the current rate, it will collide with Europe and close off the Mediterranean Sea. Australia will drift north to collide with Southeast Asia, and Baja California will slide up the west coast of North America to sit against Alaska.

FORMATION OF MODERN LANDSCAPE

When looking to illustrate or animate the variety of features of Earth's landscape, it helps to know how they were formed. Many of the types of events that affected our landscape millions of years ago are still in play today, constantly reshaping the Earth.

Tectonic Shifts

In the 3.8 billion years since the Earth cooled down enough to form a solid crust, it has undergone constant upheaval and change. As the molten rock moves around under the crust, it causes the tectonic plates to slowly move with the current. Scientists label these plate shifts differently, depending how the plates move relative to one another.

- With a *divergent* plate boundary, plates are pulling away from each other.
- With a *transform* plate boundary, plates slide sideways against one another.
- With a *convergent plate* boundary, plates push directly against one another.

Because of the liquid nature of the mantle, these plates can shift and move at rates of a few inches a year. This might not seem like a lot, but when this movement involves huge land masses and spurting lava, the effects are far reaching. Movement of tectonic plates can change the landscape by creating mountains and valleys, or sudden movements can cause earthquakes, volcanic eruptions, and tsunamis.

Divergent Boundary

A divergent boundary creates a large ridge that can fill with lava coming up from underneath, which quickly cools and becomes solid. Such boundaries are usually located under the world's oceans, but can exist on land too.

One well-known divergent boundary is the Mid-Atlantic Ridge in the Atlantic Ocean, which follows the line of tectonic plates.

Mid-Atlantic Ridge.

Another divergent boundary is the East African Great Rift Valley, a series of rifts which run down through Ethiopia, Kenya, and Tanzania. This rift is expected to cause a separation of this region from the main continent in about 10 million years.

East African Great Rift Valley.

Transform Boundary

A transform boundary is also called a *transform fault*. Such a boundary forms to relieve stress from tectonic plate movement.

Where two plates slide against one another in a transform boundary, they will often get stuck and stress will build up. When the plates finally move, the sudden movement causes earthquakes. The San Andreas Fault in California is a series of transform boundaries that causes earthquakes regularly.

San Andreas Fault along the San Francisco peninsula.

Subduction in a convergent boundary.

Satellite view of Andes mountains. Image courtesy of NASA.

Convergent Boundary

With a convergent boundary, there can be two different outcomes. If one plate is pushed underneath another, the plate on top is forced upward creating mountains and the other plate is forced back down into the mantle to once again become molten magma. This process is known as *subduction*.

Subduction can happen between two plates under the ocean floor, where it creates deep troughs and ridges. Subduction can take place where a plate meets a continent, and it forms mountains on the continent. The Andes, the longest continental mountain range in the world, was formed with this process.

When two plates, both with continents, collide in a convergent boundary, the two continent masses can both be pushed upward, fusing the two continents together and forming mountains on both continents. This is called *continental collision*. However, the subduction plate still continues to move downward after the crash, causing continued earthquakes.

India crashing into Asia after the breakup of Pangaea and forming the Himalayas is an example of this type of convergent boundary.

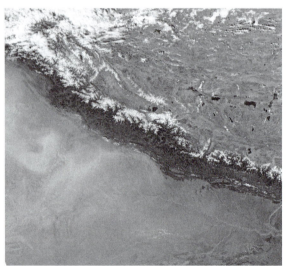

Himalayas, with India below and China above. Image courtesy of NASA.

Volcanism

Not all volcanoes are caused by tectonic shifts. The Earth can form a *hot spot* where the crust is thin and the magma beneath is very hot (and thus under very high pressure). The crust can give way and a volcano can erupt, forming mountain. Such an eruption is referred to as *volcanism*. The Hawaiian islands and Iceland are examples of volcanism at work.

The largest volcanic episode occurred 250 million years ago in Asia. It is estimated to have lasted for a million years, creating the vast Siberian plains and flooding the region with hundreds of feet of basalt and also covering significant portions of current-day Russia with several feet of molten material. It is also believed that this event extinguished about 90% of the life on the planet at the time, making way for the rise of the dinosaurs. Although this event is the largest to be discovered, similar events are believed to occur every few million years. This process has been continuously changing the layers of the crust by depositing new material on the surface.

Bombardment

The late Heavy Bombardment Period ended long ago, but between then and now the Earth has been hit a number of times by asteroids, meteors, and comet debris.

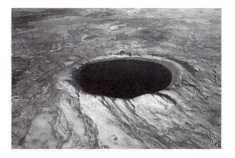

The Pingualuit crater in northern Quebec, about 2 miles (3.5km) in diameter, was formed by a meteorite impact 1.4 million years ago. Image courtesy of NASA.

Even today, there are still objects speeding around our solar system that hit the Earth on a regular basis. Most of these relatively small objects burn up as they enter the atmosphere, eventually landing on the Earth as dust. But occasionally, the object is large enough to make it to the surface and can do much to alter the landscape. We find meteor craters from these impacts throughout the world.

The composition of the impacted material in a crater is a rich source of information about ancient Earth. With the relatively new ability to see Earth from space, scientists have been able to locate huge craters that weren't detectable from the ground. These craters often bring forth new evidence of what happened thousands or millions of years ago to form our planet's surface.

Geological digging for commercial purposes has also led to discoveries of ancient craters in the ocean. Before a fuel company starts the very expensive process of drilling deep into the Earth, it is common practice to have geologists take small samples and look for signs that natural fuel products are likely to be found deep beneath the surface. Such studies have led to discoveries of ancient craters, particularly in the ocean.

Erosion

Of all the forces that can affect our landscape, erosion is the most widespread. Erosion is the process of water, ice, or wind moving rock and soil from one area to another. Over thousands and millions of years, rivers have cut enormous canyons and valleys throughout the world, depositing the material into other areas downstream and reshaping the coastlines of continents.

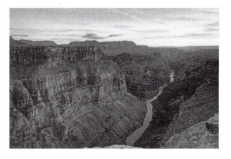

The Grand Canyon was carved out by the Colorado River over millions of years.

The wind carries dust and sand in slow-moving waves across the deserts and sculpts rock into amazing shapes. Ocean waves crash onto the shorelines and carve the land into new and interesting configurations.

White Desert, Egypt.

Twelve Apostles rock formation, Australia.

Path formed from moving glacier.

Glaciers

A glacier is a large body of ice that is so heavy it can move under its own weight due to deformation. Glaciers can form where snow accumulates and doesn't evaporate or erode away, and take up to hundreds of years to form. Sometimes chunks of mountains or rocks are frozen inside them. Eventually the glacier starts to move under its own weight in reaction to gravity, starting the glacier's descent down the path of least resistance.

During the numerous ice ages that have occurred over the millennia, mile-thick glaciers dragged pieces of mountains with them as they slowly marched southward from the polar north. Along the way they scarred the Earth, creating giant lakes and dropping boulders randomly over the landscape.

Earth's Crust

With all of the tectonic, volcanic, meteoric, erosion, and oceanic activity affecting the Earth's crust, it's no wonder we have such a varied topography to the planet. Digging deeply into the Earth reveals it is made up of layer upon layer of rock. All one has to do is look at the steep wall of a canyon that has been dug out by a river to see this. You can clearly see telltale signs of a world that has been buried over and over with new material.

The appearance of these rock layers varies from region to region. Where rock layers are slanted, we see evidence of cataclysmic prehistoric events like subduction due to tectonic plate shifts.

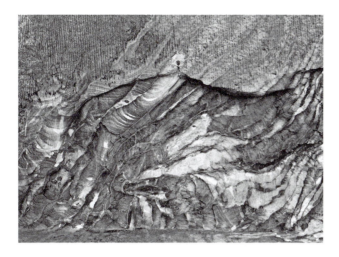

The layers were formed and manipulated by a variety of causes; great upheavals, earthquakes, and volcanoes all play a part in depositing rock on the surface, but the most visibly active component is erosion caused by water and wind.

WHAT'S A ROCK?

Earlier, you learned how the Earth originally formed over many millions of years by the compression of various materials coming in from outer space. This compression (and, occasionally, a release of the pressure) has continued throughout the ages to form many different kinds of rock.

How Rock Forms

All rock is formed in one of three ways:

- From the cooling of magma to a solid, whether it remains under the Earth's crust or comes to the surface from a volcanic eruption. Such rock is called *igneous* rock. Granite and basalt are igneous rocks.

- Compression, where dust, minerals, sediment, the remains of dead organisms, and other particles and debris are compressed together with such force (by weight from water, or layers of sediment and rock above) that they fuse together. Such rock is called *sedimentary* rock because it comes from these deposits. Compression takes place over millions of years. An example of sedimentary rock is limestone, which forms on the ocean floor when the remains of coral and other organisms have been compressed.

- Metamorphism, where a combination of heat and compression change the molecular form of igneous or sedimentary rock into something completely different. Such rock is called *metamorphic*. An example of a metamorphic rock is marble, which forms when enough heat and pressure are applied to the sedimentary rock limestone to cause its molecules to rearrange themselves into crystals.

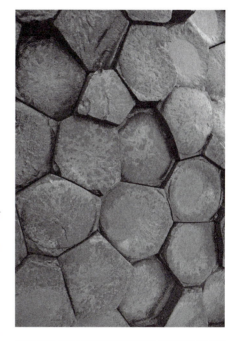

Igneous rock formation has been going on for the longest, so it's not surprising that granite and basalt make up most of the Earth's crust.

Igneous rock.

Sedimentary rock.

Metamorphic rock.

Crystals form in metamorphic rock when certain minerals are given enough time, heat, and pressure to rearrange themselves into a highly ordered structure like a lattice. Crystals are characterized by flat faces at sharp angles to one another, and some are transparent or translucent. The quartz found in granite countertops, for example, makes translucent specks that contribute to its beauty.

Rock Composition

About 75% of the Earth's crust is composed of silicon and oxygen, mostly in combination with other elements like aluminum, copper, and iron in the form of silicates and oxides. One particular silicate mineral, feldspar, is found mixed in with many rocks in the crust, and overall makes up over half of the crust. Quartz, another mineral, also makes up a large portion overall.

On the Earth's surface, the feldspar and quartz are constantly moving around, being washed away to form new sedimentary layers and rising to the top

An *oxide* is a compound formed with oxygen. While we usually think of oxygen as a gas, small amounts of oxygen can combine with solid elements to produce other solid elements. Rust, for example, is a compound formed from iron and oxygen.

Feldspar. Image courtesy of Rob Lavinsky, iRocks.com.

Quartz.

again from tectonic movement. When igneous rocks form, there is usually a large quantity of feldspar and quartz mixed in with the magma.

While there are a lot of different types of rocks, most of them contain some quantity of feldspar, quartz, or both.

Rock Classification

Geologists have classified many different kinds of rock, each with its own story about how it formed and how it arrived where it is currently found. Many of them are classified by the quantity of feldspar they contain, or lack thereof.

- Igneous rocks are classified by the type and quantity of minerals they contain. Granite is a label applied to igneous rock that contains large portions of feldspar and quartz.

- Sedimentary rocks are classified by the minerals they contain. Minerals, in turn, are classified by the elements they contain and the elements' configuration. Limestone, for example, is a sedimentary rock composed of two calcium-rich minerals and little to no feldspar.

- While some metamorphic rocks (like marble) have a specific composition and are easy to label, others are harder to classify because of the variety of materials they can contain. Geologists attempt to classify metamorphic rock by a number of properties such as color, mineral composition, hardness, breakage patterns, and the original sedimentary or igneous rock before heat and pressure were applied.

CAUSES OF GEOLOGY

The formation of rock works hand in hand with other environmental factors to create our varied landscape.

Geology from Magma

All igneous rock comes from magma. The rock that forms is described as *extrusive* or *intrusive*.

Extrusive rock includes two major types: a volcano itself, and the flow it produces. When a large volcano erupts, it deposits layers of material over large areas. Lava and rocks can be ejected from the volcano, and ash can be carried for hundreds of miles before falling back to the Earth. Lava can flow down the side of the mountain to change the local landscape, and can form islands in the ocean.

The lava material that cools on the surface may not be pure lava—it's often mixed with dust, dirt, rocks, and debris. Because of the quick cooling time, the rocks that form tend to have a lot of air mixed in with them, making them less solid than rocks formed over a long period of time.

When magma reaches the Earth's surface, it is then called *lava*.

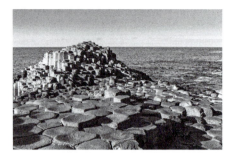

Polygonal basalt columns at Giant's Causeway, Ireland.

The continental (land) crust, having had more time to form, is much thicker, harder and less prone to destruction by tectonic movement than the oceanic crust. The average age of the Earth's continental crust is about 2 billion years, whereas the oldest oceanic crust is only about 200 million years old.

While all the air and water is being squeezed out of the particles during compression, minerals can get into the cracks and help fuse the rock together. This process is called *cementation*.

The base of most of our ocean floors is basalt, an extrusive igneous rock. Basalt flows can also occur on the land, where layers of basalt can cool into hard polygonal columns with 3–12 sides.

Magma can also push up toward the crust very slowly over thousands or millions of years, cooling into minerals on the way up and solidifying with sedimentary and igneous rocks along its path. Rocks formed under the crust from this type of magma flow are called *intrusive* igneous rocks. Such rocks are typically very hard, and are often used for building and road construction. All our continents sit on a base made mostly of granite, an intrusive igneous rock.

As intrusive igneous rock forms, it can fuse sedimentary rock to a continent. We can clearly see this in the Grand Canyon, where multi-colored layers of sedimentary rock sit on granite layers.

Extrusive igneous rock is visible on the Earth's surface until it's buried by some other geological event. Intrusive igneous rock is visible only after being exposed by erosion or tectonic plate movement.

Geology from Compression

Compression of sedimentary rock can occur under the ocean, where the weight of the water presses down on the particles, or on land where additional particles settle in a thick layer on top to provide the necessary pressure down below.

Exposed sedimentary layers.

Sedimentary rock is generally harder than extrusive igneous lava rock, but not as hard as intrusive igneous, basalts, or metamorphic rock. Such rocks aren't visible on Earth's surface until they are exposed by erosion or tectonic upheaval. After exposure, it's not uncommon for sedimentary rock to be washed away and compressed again somewhere else.

Geology from Heat and Pressure

Metamorphic rock needs heat to form. This heat can come from being near magma, or from heavy geological friction such as tectonic plates rubbing together. Rocks far below the crust near the magma layer are subject to this heat and also great pressure from the rocks pressing down from above.

In addition to causing crystals to form, heat and pressure can also cause any small quantities of minerals to create colorful veins within the rock.

Geology from Buoyancy

When a rift opens up in the crust and an area just below the crust is lighter than the semi-solid upper mantle below it, an entire region can be pushed upward by simple buoyancy. Entire continents like Australia may have been formed this way, by floating upward. Rocks in the northwestern region of Australia have been dated to an age of 4.3 billion years, making them the oldest rocks on the crust.

Geology from Weathering and Erosion

Exposure to air and water can also change the composition of rock. We commonly see such changes in cliffs near water, where exposure to air and water can turn silicate-heavy rock into clay or tinge a hillside red.

Air, water, and minerals can seep in through the Earth's crust, and over long periods of time (thousands or millions or years) can break rocks apart while they're still in the ground, and even change the rock's composition. Rocky cliffs exposed to both air and the bashing of water can also change in this way, again over very long periods of time.

Wind, water, and gravity can also move rocks and sand across the Earth's surface quickly and easily. Rain water pours down mountainsides and into valleys and eventually ends up in lakes and oceans, carrying with it softer sediments.

Exposed metamorphic layers.

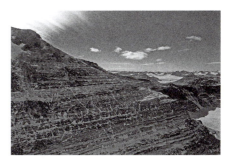

The Transantarctic mountains are believed to have been created by buoyancy about 60 million years ago. Image courtesy of NASA.

When rock changes composition due to exposure to air and water without moving, the process is called *weathering*. If the rock falls down, washes away, or moves in any way because of air and water, the process is called *erosion*. Basically weathering doesn't move rock, while erosion does.

Rock exposed due to erosion.

Designing a Landscape

If it weren't for magma bubbling up above the crust, tectonic plate crashes, glaciers moving around, and water battering away at rocks, we would have a flat, uniformly grayish-red landscape. These processes are responsible for the formation of vertical landscape features such as mountains, gorges, and everything in between.

A landscape's long history determines its appearance. When designing a landscape for art or animation, answering these questions will help you determine how it should look.

- Was the land at the bottom of a body of water at one time?

- After that, was the land part of a tectonic upheaval that brought it to the surface?

- After that, has the land been exposed to water, allowing it to erode and expose the layers?

If the answer to all these questions is Yes, then you have a strong candidate for a landscape that varies in height with a variety of layers, colors, and shapes.

USUAL ROCK COLORS

The colors of our landscape fall within a small range between red and black. Let's take a look at where these colors come from.

Our continents are based on granite, a rough, gray igneous rock, with only slight color variations due to small quantities of minerals. Our ocean floors are based on basalt, which is a smooth, gray igneous rock. On top of these bases are layers of sedimentary rock.

Sedimentary rock that was originally deposited on land usually has a reddish-brown (rust) color due to reactions between iron and oxygen during rock formation or erosion. Sedimentary rock formed under the ocean, where oxygen isn't plentiful enough to turn sediment to rust, includes a large amount of decayed sea life which is black, gray, or white. While layers of exposed sedimentary rock can have distinctly different colors, all these colors fall into the black-gray-brown-red color group, with the occasional white where calcium-rich remains of sea life have compressed without impurities.

Because heat and pressure can produce colorful veins and crystals, metamorphic rock might seem like a great candidate for multi-colored rock. However, when exposed, metamorphic rock is subject to the same effects of erosion as any other rock. Marble, for example, forms deep in the earth as white with colored veins. Marble is usually mined or quarried while still in the earth, then covered in a protective coating before being used as building material. If marble makes it to the surface through tectonic lift, it's not long before iron in the air and water start to make a mess of it and it's not so pretty any more.

Granite can also be tinged with pink, blue, or green due to high content of specific minerals that impart these colors, but the tint is very slight. The most common tint is pale pink from feldspar.

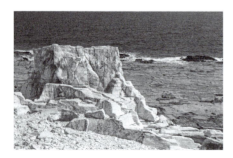

Weathered marble.

UNUSUAL ROCK COLORS

In rock above ground (eroded rock), colors outside the usual group are found only in very small quantities. Blue, green, and yellow mineral veins can form in marble, quartz can crystallize with a purple color to make amethyst, and even feldspar can occasionally be green. However, we see these colors mostly on rocks that are still in the ground, by mining and quarrying, and even then we can only see the colors when we look close up. From a distance, it's all gray, brown, red, and white.

So why don't we see thick layers of bright green, blue, or purple above the ground? You might think that colorful crystals would form and make their own layer. However, formation of crystals, in the larger scheme of things, is rare compared to formation of granite, basalt, and other gray rocks. While large veins of gemstones are occasionally found in the ground, the chance of a crystal-heavy layer getting heaved up and exposed by erosion is low. In addition, rocks exposed to air and water through erosion tend to take on a reddish hue—if the rock contains a quantity of iron, or if rain or water splashing against it contains iron, the iron reacts with oxygen and over time turns the color to rust or brown.

We sometimes see unusually bright red, orange, and white layers after erosion, particularly when the layers are formed from finer sediments like sandstone and chalk. Such sediments create smooth land forms that reflect color more than rough surfaces. The colors of these land forms aren't any different than the colors found in other types of rock—they appear bright to us simply because of their smooth surfaces, which reflect more light.

One of the most striking examples is the Danxia Landform in China. Eighty million years ago, sand and iron washed down into lakes and rivers, then the land was heaved up as the Himalayan mountains shifted. Erosion has since exposed distinct layers of red, white, and orange sandstone. At sunrise and sunset, the rock's iron content coupled with its smooth sandstone surface make the red and orange colors appear very bright.

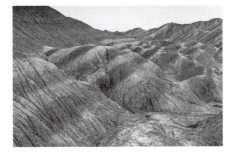

Danxia Landform.

You can also find pure white cliffs and hills formed in this way. If decayed sea life in a sedimentary layer consists mostly of shells or other calcium-rich remains, a white layer can form. The White Cliffs of Dover in Great Britain were formed with this process. The shells of small organisms fell to the floor of the ocean, where they were compressed into chalk. The land then rose to form continental Europe and the United Kingdom, which were all one land mass at the time. When the English Channel formed from a flood less than 100,000 years ago, the relatively smooth white cliffs were eroded and exposed. The chalk contains little or no iron, so the cliffs are able to retain their white color even though they're exposed to air.

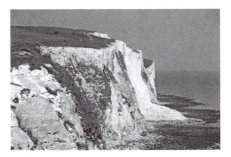

The White Cliffs of Dover.

Life on Earth

Although simple singular cellular life forms have existed on Earth as long as 3.6 billion years, advanced multicellular life only began to appear from about 1 billion years ago, and all of it was located in the ocean. As no ozone layer existed in the atmosphere at the time, the Sun's radiation made it impossible for life to exist on land.

Early in the formation of life on Earth, it is thought that the entire top of the ocean's surface was covered in an extremely thick layer of algae. As the algae died it sank to the bottom of the ocean as new algae grew on top. This went on for nearly 2.8 billion years and created a sedimentary rock layer of vast carbon deposits deep in the earth, which would eventually be compressed into some of the modern Earth's oil and coal.

The air at the time had a heavy concentration of carbon dioxide (CO_2), great for plants but not conducive to the development of animal life. The algae converted the carbon dioxide to oxygen and made the air more oxygen rich over time, which was unfortunate for the algae—the low carbon dioxide content eventually killed it off.

After this age of great algae beds ended, the higher oxygen content in the air and oceans allowed many new life forms to evolve. One billion years ago, vast coral reefs, shellfish, crustaceans, and new oceanic plants began to appear. As these creatures died, they left their mark on the Earth in a thick layer of calcium made by their shells as they sank to the bottom of the oceans. Under the extreme pressure of the Earth's oceans, these shells were transformed into the thick limestone layers that were later heaved up during tectonic events, and which we now find on the Earth's surface worldwide.

As the atmosphere gradually increased in oxygen and decreased in CO_2 and temperature, some of the plants and animals left the seas for land. This gave rise to most all of the plants and animals we see today, after millions of years of evolution and extinction have changed them in a variety of ways.

Coral reef.

This many years ago. these life forms appeared
3.6 billion years	Single-cell organisms in ocean
1 billion years	Multicellular life in water
475 million years	Plants
400 million years	Insects
360 million years	Amphibians
300 million years	Reptiles
250 million years	Dinosaurs
200 million years	Mammals
150 million years	Modern birds
130 million years	Flowers
60 million years	Primates
20 million years	Human ancestors

FOSSILS

Among the upper layers of rock, we find signs of very ancient life in the form of fossils. A *fossil* is evidence of a living thing preserved in rock, either an impression or the actual remains of the plant, animal, or organism itself.

Both dinosaur bones themselves and the impression made by long-decayed dinosaur bones in rock, can be considered fossils.

Due to the great upheavals caused by plate subduction and continent collision, we can find early shellfish fossils in limestone 10,000 feet above sea level in many of the mountain ranges around the world. So much has the Earth's surface changed that many of its mountaintops, great plains, and valleys were once at the bottom of an ocean.

Conversely, areas that were once the top of the world are now many hundreds of miles below ground, being turned to molten rock again, perhaps to make an appearance on the surface millions of years from now.

Fossils that are subject to a great deal of heat and pressure in the Earth's crust over hundreds of millions of years are sometimes converted to *fossil fuels* like oil, coal, and natural gas. Fuel companies digging or drilling deep below the crust are looking for big deposits of these fuels.

METEORITES AND LIFE ON EARTH

Meteorites (giant rocks from space) have played a vital role in the development of life on Earth. One theory holds that amino acids brought to Earth by meteorite impacts combined to form proteins which in turn became the first single-cell organisms within our oceans and lakes.

Bubble algae, a single-cell organism that still grows in the tropics, are typically 1–4cm in diameter.

A small gang of paramecia, a common single-cell organism often used for biological studies. Paramecia are typically 0.05–0.3mm long.

Some meteorite impacts have been large enough to cause dust and debris to be thrown around the entire planet, covering its surface with a thin layer of dust and blocking sunlight from getting through the atmosphere for months to years.

One asteroid in particular had a strong impact on life as we know it: the Chicxulub Asteroid, which landed 65 million years ago in the area that is now

A *single-cell organism*, also called a *unicellular organism*, is one whose entire "body" is one big cell. Single-cell organisms still exist today, and can be up to a couple of inches in diameter with resilient cell exteriors. Bubble algae and paramecia are two examples of such organisms.

The terms *meteorite* and *asteroid* both describe the same type of object—a giant rock from space—but scientists generally use the term *asteroid* for a rock that hasn't gone through our atmosphere, and *meteorite* for a rock that's made it through our atmosphere to Earth. There are additional breakdowns of flying space rock into different categories (such as comet, meteor, and meteoroid) and more technical distinctions which we won't get into here, but in general you can use the terms meteorite and asteroid interchangeably as long as everyone in the conversation knows what you're talking about.

Mexico. The six-mile-wide asteroid landed with such force that it created a crater over a hundred miles wide and gave off 2 million times more energy than the most powerful man-made explosive, generating enough heat to start spontaneous fires. The impact triggered earthquakes and tsunamis, and the resulting debris in the air blocked the Sun and cooled the Earth, affecting animal and plant life worldwide.

The Chicxulub Asteroid is believed to be responsible for the extinction of dinosaurs. More than 70% of all species were wiped out—the only dinosaurs left were the avian (flying) kind, which evolved into birds. The extinction of land-based dinosaurs allowed for the rise of mammals including human beings, so it's not a stretch to say that if it weren't for that asteroid we wouldn't be around today. As soon as we'd evolved, the dinosaurs would have had us for lunch.

EVOLUTION AND DIVERSITY

During the time of Pangaea (450–250 million years ago) temperatures on Earth were similar to the levels we see today, and it was easy for plant and animal life to move from one region to another. While movement was limited by climate and weather conditions—inland areas were dry and far north/south areas were cold—in general, all of Pangaea housed the same species of plants and animals.

After the continents split, the plant and animal life on each continent continued to evolve (and sometimes go extinct) on separate genetic lines, giving us the variations we find today. However, our continents were never as separate as they might seem. North America and Asia have been connected at various times throughout the millennia by a land bridge between Siberia and Alaska, thus connecting all the large continents. This means over the last several million years, animal and plant life has continued to move back and forth between the continents.

Satellite image of the Bering Strait, which lies between Siberia (left) and Alaska (right). Today, only 82km (about 50 miles) separates them. This makes it highly likely that the two were once connected by a land bridge, which scientists call *Beringia*. Image courtesy of NASA.

Descendants of the first cats, for example, are found on every continent with a moderate climate. Early cat ancestors are believed to have evolved in Asia then spread all over Europe and Africa, and then crossed over from Siberia to Alaska about 18 million years ago to spread out into North America. After that, they evolved into species that differ on each continent—cougars evolved only in North America, while leopards evolved only in Asia and Africa.

Cougars (left) evolved with large, strong hind legs for quick sprints, and though cougar cubs have spots, they lose them when they reach adulthood. Leopards (right) keep their spots into adulthood, and evolved with a large skull and strong jaws for catching and dragging prey.

Conversely, land masses that split off permanently many millions of years ago show a dramatic difference in wildlife and plants when compared with the major continents.

Lemurs evolved only in Madagascar. Kangaroos evolved only in Australia.

The island of Madagascar split off from Gondwana about 90 million years ago. This long separation gave the plants and animals on Madagascar time to evolve without input from the rest of the continents; more than 80% of Madagascar's wildlife is unique to the island. Australia has been separated from larger continents for around the same length of time, and it too boasts over 80% of wildlife unique to the continent.

Outer Space

A *light year* is the distance a ray of light travels in a year, about 6 trillion miles or 10 trillion km. This term is used in astronomy to describe long distances. It is also the origin of Buzz's last name in the animated film *Toy Story*.

The first thing to know about outer space is that no one really knows for sure what's going on out there. What information we have has been gathered from telescopes, probes, shuttles, satellites, sensors here on Earth, and a few quick jaunts to the Moon. Most of what we've actually observed has taken place light years away, and has been over and done with for thousands of years before we even see it.

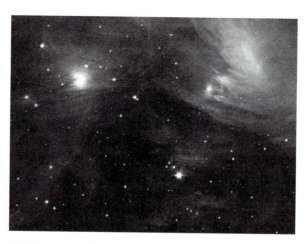

The Pleiades star cluster, also known as the Seven Sisters or M45. Image courtesy of NASA.

ORIGIN OF THE UNIVERSE

The currently prevailing idea about the origin of the universe is the Big Bang theory. This theory surmises that more than 13 billion years ago, there was a very dense, hot point at the center of the universe that contained all matter and energy. This expanded, then eventually cooled to form gases, stars, and solid matter like planets.

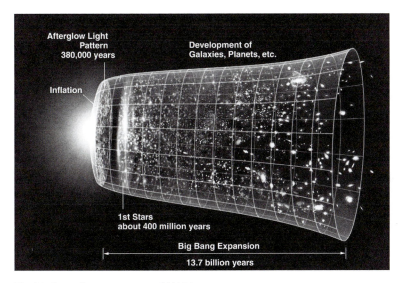

The Big Bang. Image courtesy of NASA.

This giant explosion is believed to have been initially composed of protons and neutrons. As these particles collided, they were fused together and formed hydrogen and helium atoms along with vast amounts of nuclear fusion energy. The very early universe was composed almost entirely of hydrogen and helium.

The Big Bang theory comes from the observation that the universe appears to be expanding. Astronomers have been able to measure the velocities of galaxies, and they find that they're moving apart. This led to the idea that pieces of the universe are still moving outward from the initial thrust of the Big Bang.

The very fast expansion in space right after the Big Bang is called inflation.

ELECTROMAGNETIC WAVES IN SPACE

Here on Earth, we live in a protected bubble where our atmosphere protects us from many of the dangers of outer space. One of these hazards is high-frequency electromagnetic waves emitted by stars and other outer space sources. Most of these waves can't make it through our atmosphere, but any space travel has to take into account the space capsule's or astronaut's exposure to such waves. At the same time, astronomers find such waves useful for detecting outer space activity that can't be seen by other means.

continued on the next page

Scientists give electromagnetic waves different names to make it easier to discuss them. The main difference between these waves is their wavelengths. For example, gamma rays and X-rays are the names given to high-energy, high-frequency electromagnetic waves with short wavelengths, with gamma rays having the shortest wavelengths.

THE ELECTROMAGNETIC SPECTRUM

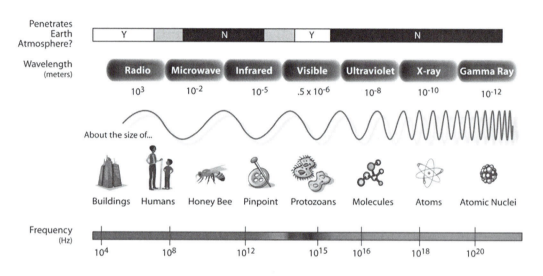

Range (spectrum) of electromagnetic waves in our universe. Image courtesy of NASA.

In outer space there are plenty of X-rays and gamma rays due to star activity, but fortunately our atmosphere blocks them from reaching us. Here on Earth, we can generate these tiny-wavelength rays with medical equipment to get inside the human body without having to cut the skin. These waves can be used to produce imagery of our insides (as with an X-ray machine), or as a treatment to weaken cancer cells.

STARS

Trillions upon trillions of stars have been created in the universe over time and many more have yet to be born. Stars go through a life cycle with different characteristics at each point along the way. The stars we see in the sky are in various stages of their lives.

All matter in the universe possesses some gravitational attraction. A star begins its life when a cloud of gas and dust develops enough gravitational attraction to collapse in on itself. As the matter gets pulled together the gravity increases, and eventually these pockets of extremely dense gas form a *nebula*.

Protostars in the Elephant's Trunk Nebula indicated with dotted circles. Image courtesy of NASA.

As these nebula regions compress further with the intensified gravity over millions of years, the hydrogen and helium gas becomes denser and forms a very large object known as a *protostar*. Over time, these dense regions become quite large and generate enough gravity to fuse the helium and hydrogen atoms together, creating some of the heavier elements and enormous amounts of fusion energy that ignites the mass. Thus a star is born.

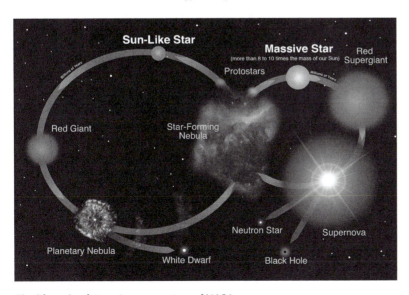

The life cycle of stars. Image courtesy of NASA.

A high-mass star (over 8 times more massive than the Sun) can go beyond the production of helium to set off a chain reaction of nuclear fusion. If you condense helium with another hydrogen atom, you get lithium, which has three protons and three electrons. As you keep adding protons, eventually you end up with silicon, nitrogen, iron, and various heavier-than-helium elements familiar to us here on Earth. This reaction doesn't happen spontaneously under normal Earth pressure and temperature, which is why the carbon in your pencil doesn't turn into iron on its own. But with high temperatures and great forces (like those found at the center of a large star), elements can combine to form new elements.

At some point many millions of years later the star runs out of hydrogen and helium at its core, essentially running out of fuel for its fusion. As the nuclear fusion energy subsides, the core collapses, causing the outer region to cool down and expand. Eventually the core collapses in on itself, releasing all of the energy at once. If the star is big enough, this explosion will be a supernova, emitting more light and energy than all the stars in a single galaxy. Sometimes the cores expel heavier elements like magnesium and gold with this explosion, sending "star dust" throughout the galaxy and universe.

After the explosion, the star takes on one of three possible forms, depending on how big the star was when it was formed. A small star will become a dwarf star until it exhausts the remainder of its fuel for nuclear fusion. When light stops being produced, the star becomes known as a black dwarf. Large stars become neutron stars which emit little light due to extreme gravity. Supergiant stars collapse into black holes.

The larger stars often leave enough material behind to form a new nebula, which will eventually give birth to additional new stars.

GALAXIES

A galaxy is a massive grouping of stars held together by gravity. The stars, although quite distant from each other, possess enough gravity to pull themselves together into extremely large clusters. Galaxies are filled with stars of various sizes and ages at different points of their life cycles. On the scale of size, our sun is a relatively small star.

Our solar system is part of the spiral-shaped Milky Way galaxy, which has a diameter of about 100,000 light years. You can actually see part of the Milky Way on clear nights when no moonlight or man-made light is present. We can't get an accurate picture of the Milky Way from space because we haven't yet developed a camera that can get far away enough to take a picture, but from what we see of other galaxies and the stars around us, we can make a pretty good guess.

Our planet is largely composed of star dust, and this is the reason we have many of these heavier elements on our planet at all.

Our sun was born more than 4.55 billion years ago, and has about 4–5 billion years left before it collapses and becomes a dwarf.

According to NASA, there are at least 100 billion galaxies in the universe.

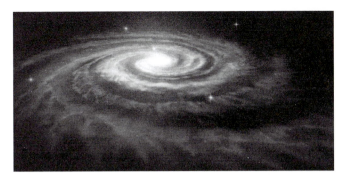

Artist's rendering of the Milky Way.

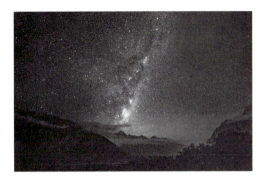

The Milky Way over Mount Cook National Park, New Zealand.

Our nearest neighbor, the Andromeda galaxy, is 2.5 million light years away. Some would argue that the Canis Major Dwarf galaxy is the closest to us at a mere 25,000 light years away, while others say Canis is actually part of the Milky Way so it doesn't count. But until the Galactic Empire comes along and draws up a zoning map, it's all up for debate.

Properties of Galaxies

A galaxy usually forms a discernible ellipse or spiral pattern that spins around a center. The galaxies are believed to be condensing into their own centers, which contain a huge mass with enormous gravity, called a black hole. Such a center has enough gravitational pull that even light cannot escape its grasp. The gravity of galaxies also draws them toward each other to collide and join together.

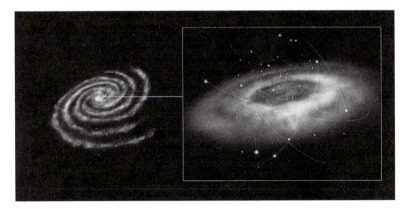

Artist's concept of the black hole at the center of the Milky Way with a mass of about four million times that of our sun and occupying the innermost 15 light years of our galaxy. Hot gas around the black hole is believed to be falling toward it. Image courtesy of NASA.

Astronomer Edwin Hubble played a crucial role in establishing the field of astronomy that studies objects outside the Milky Way. One of Hubble's many contributions to the field was the Hubble Sequence, a method of classifying galaxies by shape.

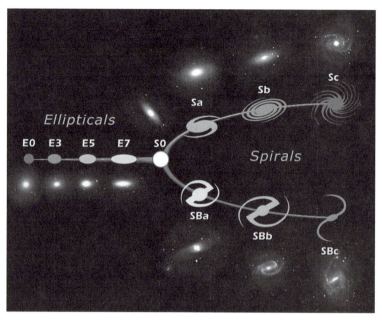

Hubble's "tuning fork" model for galaxy classification. Our Milky Way is an SBb galaxy. Image courtesy of NASA.

NEBULAS

Eagle Nebula. Image courtesy of NASA.

When a star reaches the end of its life, it expands and sometimes explodes, releasing an enormous cloud of gas and dust. These clouds, called nebulas, can contain a variety of elements. Light from stars reflects off the elements in a variety of wavelengths. When images of nebulas are represented with varying colors for different wavelengths, the imagery shows us some of the most beautiful forms in space.

THE COLORS OF SPACE

When looking for reference images for outer space animation, keep in mind that most of what you'll find is not photographs showing how galaxies, stars, and nebulas look to the naked eye, but renderings with various color assignments based on scientific data. Much of the light emitted in space doesn't fall into our visible spectrum, and what light we can see often just looks like a big white blur to our limited vision.

The Hubble Telescope, Spitzer Space Telescope, and Chandra X-Ray Observatory are three major sources of information about outer space, and much of the data they give us is not visible to the human eye. This information is often combined to make colorful imagery that not only gives scientists a fuller view, but also captures the imagination.

One example is the Small Magellanic Cloud (SMC), a neighbor to our Milky Way galaxy that is so bright that navigators like Magellan used it to find their way across the oceans. A typical representation of this cloud shows X-ray data from Chandra as purple, visible light from the Hubble Space Telescope in red, green, and blue, and infrared data from the Spitzer Space Telescope as red. Such a depiction gives us a fuller vision of the cloud and all its components.

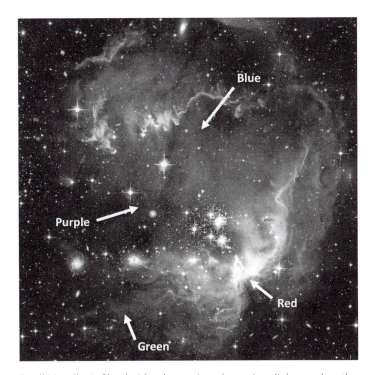

Small Magellanic Cloud with colors assigned to various light wavelengths.

Even if a heavenly body emits visible light, imagery is altered to make it easier to study (or just to make it prettier). A familiar example is the Pillars of Creation formation in the Eagle Nebula, a breathtaking formation of gas clouds in our galaxy. Much of the light it emits is red, but from distinctly different sources. The classic image depicts red light from hydrogen atoms as green, red light from sulfur ions (sulfur atoms with one electron removed) as red, and green light from doubly ionized oxygen (oxygen atoms with two electrons missing) as blue. This depiction is similar to what was used in the striking outer space scene that opens the film *Contact*.

continued on the next page

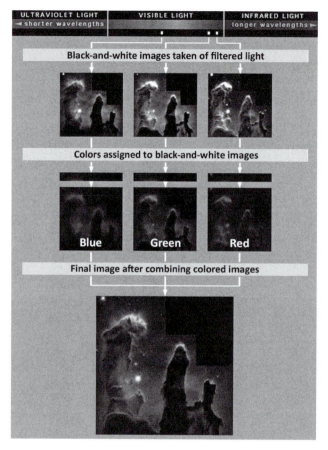

Some images from the Hubble Telescope are cropped with a stair-step pattern due to the instruments used to gather information. Some instruments have four cameras, each of which takes a photo of a quadrant of a larger picture. The camera for the upper right quadrant records a magnified view, which is shrunk down to make the full picture.

Image with stair-step shape from Hubble Telescope (left), produced from four quadrant images, one of which is recorded as magnified (right).

THE VACUUM OF OUTER SPACE

Outer space has no air. We have air because of the atmosphere around our planet. As soon as you get outside the atmosphere, there is no air any more.

A space with nothing in it is called a *vacuum*. Outer space is a vacuum with a few things floating around in it, like stars and gases and rocks. Planet Earth is just another rock floating around in the vacuum, and the air in our atmosphere is just another gas occupying some of that vacuum.

It is possible to simulate outer space conditions by creating a vacuum on Earth. Scientists often perform experiments in a vacuum chamber, a big container from which all the air has been sucked out. The air pressure inside the container is nearly zero, and the normal air pressure outside the container is much greater, so the container has to be strong. It also requires camera equipment to view what's going on inside, and a way to put things inside it to see how they react.

The word *vacuum* comes from the Latin word for *vacant*. We are accustomed to thinking about a vacuum as something that sucks air, but a vacuum cleaner only works in this way because of air pressure. A true, complete vacuum has zero air pressure.

The world's largest vacuum chamber at the NASA facility in Sandusky, Ohio measures 100ft in diameter and is 122ft tall.

A vacuum chamber is necessary for testing equipment that will go into outer space, such as satellites and shuttle parts and even astronauts in space suits.

DEATH BY OUTER SPACE

After several vicious minutes of hand-to-hand combat aboard the spaceship, the hero shoves the villain out of the airlock into the cold vacuum of space, where he immediately explodes. Hurrah! Justice!

It's true that our skin and organs are accustomed to getting oxygen and experiencing air pressure, which is why astronauts need space suits when they enter outer space. But what really happens if you go out there unprotected? Deaths in outer space have been depicted in films in a number of ways, some based on reality and some played out in unrealistic yet dramatic ways.

continued on the next page

"Open the airlock . . . please . . . aggghhhhhhh . . ."

Actually, you would pass out in less than a minute, and your heart would stop due to oxygen deprivation within 10 minutes. Within that time, lack of air pressure would cause your eardrums to burst and your soft tissues to bruise. You might also experience a fast, severe sunburn from starlight or cosmic rays. Then a lot of other bad stuff would happen too, but it would take some time.

Because there's nothing to pass your body's heat to in a vacuum, you'd keep your usual temperature for some time, until perhaps some gases passed by to soak it up. As your body loses its internal pressure, your saliva, tears, and blood would eventually boil (turn to gas), but not from heat. Recall that liquids boil at lower temperatures when air pressure is lower, so lowering pressure is just as effective as heat for making something boil. For both blood and water, a normal body temperature is high enough for boiling when air pressure is very low. We are accustomed to thinking of boiling being caused by heat, but in this case your body would be at a normal temperature or even a little cooler than usual.

The vapor from the boiled blood (which, of course, would try to expand) would cause your skin to bloat. However, on the odd occasion that this has happened to a live person, the skin returned to normal when air pressure was restored, and there was no long-term damage. In outer space your body would eventually cool and your skin would return to its original shape.

So a sunburn, bruising and temporary bloating, then some freezing over time. Not very dramatic. The NASA space program has had a few non-lethal mishaps that confirm these effects. The only death by outer space depressurization occurred in 1971 when the three cosmonauts of the *Soyuz 11* died quietly in a leaky capsule during re-entry. When the capsule landed, they were discovered to have suffered bleeding ears and noses and a few bruises. Strangely, none of them had exploded.

Astronauts wear pressurized suits to keep air pressure at normal levels around the body. Pressurized gloves are designed for maximum mobility while still maintaining pressure. Image courtesy of NASA.

In fact, there is no evidence that exposure to outer space causes a human body to explode, vomit organs, pop its eyeballs, immediately freeze or boil, or do any number of dramatic things sometimes depicted in the movies. But because we'll never see or experience it firsthand, and because we love to see the enemy blow up at the end of the movie, we're happy to temporarily forget these facts and enjoy a filmmaker's imaginative rendition of Death by Outer Space.

Temperature in a Vacuum

A vacuum itself does not actually have a temperature. Our air has a temperature, which is the temperature of the gas molecules themselves. When scientists talk about the temperature in outer space, they are actually talking about the temperature of the radiation in the vacuum of outer space, which is quite cold: about 3K ($-270°C/-454°F$).

An object floating in space will actually retain its temperature for a long time. An object cools off by transferring its heat to something else (like air) or by emitting infrared radiation (as seen with night goggles). In space, heat can't be transferred to a vacuum because the vacuum won't conduct it. Unless there's something touching the object that will accept the heat, like gases or another object, no heat transfer will occur.

On the other hand, if the object is receiving direct light from a nearby star or radiation from any number of sources, it could become very hot very quickly.

All these circumstances affect the temperature of the object in the vacuum, not the vacuum itself.

Sound in a Vacuum

Recall that sound is a longitudinal wave through air, meaning the air itself doesn't travel from point A to point B. Instead, the sound wave pushes air, which vibrates our eardrums. Sound is defined as vibrations against your eardrum or a microphone or something that can grab the pressure wave and make some sense out of it. If there's no eardrum or microphone to interpret the pressure wave, there is no sound.

Because there's no air in space, there's no sound in space, at least not in the way we're accustomed to perceiving it. An exploding star creates a shockwave and push gases around in the same way sound waves push air around on Earth, and if you position yourself inside such a gas cloud you would definitely hear something (at least until your eardrums blow out). But if you clap your hands while floating around in open space, there's no air or gas to carry the sound anywhere, so there's no sound.

SPACE BATTLE SOUND EFFECTS

Suppose you're watching a space battle from a distance. Maybe you're in your own fighter spacecraft, or you're watching from the safety of a nearby space station. You see the bad guy's spaceship explode, and everybody cheers.

Would you actually hear the explosion? If the gases pushed outward from such an explosion reach your spacecraft or the space station, there would be a pressure wave through this gas, and an opportunity to "hear" the explosion. But how would the wave actually get to your ears? The only way it could reach you is by vibrating your spacecraft or space station, which would create another pressure wave inside the vehicle, which you would hear as sound.

continued on the next page

The chances of this pressure wave being just large enough to rock your space station but small enough to not destroy it are pretty slim. If the explosion produced no gases, there would be no pressure wave at all and you'd hear nothing. The pieces of the broken spaceship might drift over and hit your craft, but the chances of that happening are also low.

So technically, an explosion in space would make a sound, but the chances of hearing it without dying are next to zero. But when a spaceship explodes in a movie, we expect a bright orange fireball and a loud noise, so that's what filmmakers provide.

RADIATION

Radiation is the emission of energy as electromagnetic waves or as moving subatomic particles. Electromagnetic waves with lower frequencies, such as radio waves, are not physically dangerous. But at higher frequencies, electromagnetic waves can be extremely dangerous to the human body and other physical objects. Radiation as high-frequency electromagnetic waves can be emitted by nuclear bombs, or can be found in outer space as X-rays and gamma rays.

One of the things that makes these high-energy particles and electromagnetic waves so dangerous is that they don't need a medium to travel in, and ordinary barriers like walls do not stop them. They can travel through a vacuum, through air, and through rocks and other solid objects. Fortunately Earth's magnetic field and thick atmosphere protect us from most of the harmful radiation found in outer space.

Radiation falls into two categories: ionizing and non-ionizing. Ionizing radiation is the most dangerous kind. It has enough energy in it to dislodge electrons and leave behind free electrons (called free radicals) that attach to chemicals and alter them significantly. X-rays commonly used for medical visualization are a type of ionizing radiation. A small amount over a short time is not harmful, but over a longer time can cause cancer or birth defects.

Non-ionizing radiation isn't as dangerous, but can still wreak havoc on objects or bodies. Such radiation isn't strong enough to dislodge electrons but can still change chemical bonds, causing visible effects similar to strong heat. For example, ultraviolet rays from the Sun cause non-ionizing radiation, which can cause sunburn after minutes of exposure.

Outer space has a lot of radiation in it. A few types are:

- Solar wind—A stream of energized, charged particles coming steadily off the Sun.
- Cosmic rays—Extremely high-energy radiation, thought to originate mostly from supernovas outside our solar system.
- Cosmic microwave background (CMB)—Radiation left over from the Big Bang, which is still bouncing around the universe. CMB is considered the "white noise" of outer space.

You might have heard of health products that neutralize free radicals in your body, thus keeping them from altering your body's chemistry in a way that will cause tissue damage.

Sunburn is a mild form of radiation burn.

RADIATION MAKES THINGS GLOW, RIGHT?

Representing radiation in animation and other visual fields is tricky because you can't see it. You can, however, see its effects on the objects in your scenes. The most visible effects of radiation are charring or sunburn, or long-term effects like birth defects. But these results are ugly and no fun at all. It's much more visually pleasing to make an object glow.

Radiation does not actually make an object glow, but artists often represent radiation that way. This is probably due to confusion about the difference between radioactivity and radiation, or between radiation and phosphorescence, which makes glow-in-the-dark paint glow.

A *radioactive* object or substance is one that spontaneously emits radiation due to nuclear decay. It is just one of many sources of radiation in the universe, and not a very common one.

Radium, a highly radioactive element, can cause elements around it to glow. Radium used to be painted onto household items like glow-in-the-dark alarm clocks until the 1960s, when it became apparent that accidental ingestion caused cancer. While very few people were actually affected by the radium, the fact that its radioactive influence is invisible and slow moving fed into newly bred fears of radiation from nuclear bombs, which was also known to cause cancer and other horrible effects. To reinforce the notion that glowing stuff was dangerous, nuclear bombs make a big, bright light when they go off. In the public's mind, radiation means glowing, a big bright light, and cancer.

To further support this idea in the public's mind, we all know that stars (including the Sun) glow. In recent years there have been many campaigns to educate the public about the dangers of long exposure to ultraviolet (UV) light from the Sun, which is a form of radiation that causes sunburn and skin cancer. Again, in the public's mind, a glowing Sun equals radiation and danger.

Plus, we all know that glowing things are hazardous. Fire, a hot stove, a jellyfish, and electrical sparks glow for reasons other than radiation, but they can all hurt you. Therefore, glowing means danger, right?

Because there's really no pretty way to show radiation visually, there's nothing wrong with using a glow, as long as you know you're doing it for artistic reasons and not scientific accuracy.

Glow-in-the-dark clock numbers used to be painted with radium.

In the *Fallout* video game series, characters exposed to high radiation tend to glow. Image courtesy of Bethesda Softworks.

Index